Artists
of the
American
West

Artists of the A

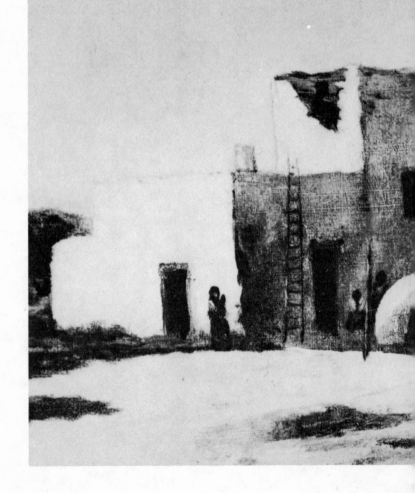

nerican West

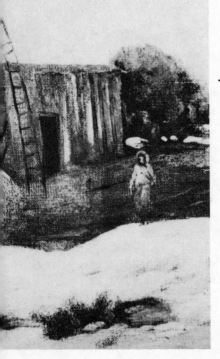

A BIOGRAPHICAL DICTIONARY

Doris Ostrander Dawdy

[v.]

SAGE BOOKS

THE SWALLOW PRESS INC.
CHICAGO

First Edition
 First Printing

Sage Books are published by
The Swallow Press Incorporated
1139 South Wabash Avenue
Chicago, Illinois 60605

ISBN 0-8040-0607-5
Library of Congress Catalog Card Number 72-91919

Contents

Preface

Occasionally there comes to light from some dark corner in attic, basement, garage, or secondhand shop a work of art deserving a longer and better life. Such was W. E. Rollins' "On the Road to Santa Fe," reproduced here (in black and white) as the frontispiece. When this painting was found in Santa Cruz, California, several years ago, it had neither signature nor title. With perforations through the canvas, and the dust and grime of decades hiding from view the Indian figures, it was the decaying Pueblo structure with a faintly discernible adobe oven in the foreground that told the buyer he had found an important painting by an early western artist.

Following restoration, and with knowledge that it might be a Rollins, I purchased the painting and began the search for its identity. Using data collected for this book, I located a daughter of Rollins in Baltimore who remembered the painting, the approximate year it was painted, and the title her father had given it.

The West of Rollins—the West of the hundreds of other artists and illustrators in this book—consists of the seventeen states lying roughly west of the 95th meridian. It is the West of Indians and trappers, cowboys and longhorn cattle, troopers and frontier forts, pioneers and wagon trains, mountains and painted deserts; it is the West of "sod-busting" and dry farming, mining and irrigated agriculture, lumbering and railroad building, ranching and rustling—pursuits in progress to this day, with "sod-busting" replaced by more sophisticated terminology.

The artists in this book, all born before 1900, were in this West —observing, interpreting, and in some cases recording with remarkable exactness the sights they saw. Amateur or professional, trained or untrained, these artists from many countries as well as our own had one thing in common: an insatiable desire to depict

the new and the strange in those early years, the old and the revered in later years. Their drawings and paintings have documentary significance today and form an integral part of Western art and history.

The selection of 300 of these artists for brief biographical treatment seemed sufficiently large to embrace the Western scene from the time the first artist appeared until well into the present century. Selection was not based on fame, for it is the pictorial record that is important here. Many obscure artists about whom little is known are among the 300, as well as many famous ones.

The book was begun in 1968 following publication of my *Annotated Bibliography of American Indian Painting* and was completed in its present form in 1973. Like its predecessor, it brings together in a handy volume material which will aid readers and researchers interested in particular artists who painted in the West. The vital statistics for these artists are by no means as accurate and complete as I would like, for spellings of names and listings of birth and death (when known) have a pattern of changing from reference to reference. Nor is this treatment of over 1,300 artists a complete compilation of all the artists born before 1900 who painted in the West; I excluded those for whom I lacked definite evidence, and some I simply must have missed.

On the pages that follow, then, are some 1,350 men and women whose spirit of adventure, sense of history, and desire for fresh subject matter inspired them to paint *our* West. Much of what they produced has found its way to public and private collections, but not all of it. Suffering the abuse of time are other works of art awaiting the discerning eye and the restorer's touch.

DORIS OSTRANDER DAWDY
Redwood City, California

Artists

Note on Usage

Books and articles are cited by the last name of the author or editor in the listings and in full in the Bibliography. Nine reference works are cited by initials:

AAA	American Art Annual
CAR	California Art Research
DAB	Dictionary of American Biography
NCAB	National Cyclopedia of American Biography
WWA	Who's Who in America
WWAA	Who's Who in American Art
WWC	Who's Who in California
WWPS	Who's Who in the Pacific Southwest
WWWA	Who Was Who in America

Libraries and museums have often been cited in the absence of bibliographical references for an author.

Rather than distinguish (with a ?) between an unknown death year and an indication (with a blank space) that the artist is still living, I have instead used blank spaces throughout—e.g., (1852-) or even (-).

The category "Lived" refers to principal places of residence during the artist's career. The category "Work," used only in the biographical sketches, is not all-inclusive; paintings are bought and sold and exchanged by museums as well as by collectors, but some idea of where they can be seen is useful to the viewing public. It is good policy to query the art museum, the association, or the private collector ahead of time about a convenient date for their showing of specific paintings. Not only is this a matter of simple courtesy, but because of the intricate storage practices involved in preserving works of art, prior notice of a month or more is often required.

A

Abdy, Rowena Meeks (1887-1945)

B. Vienna, Austria, April 24, 1887, of American parents.
D. August 18, 1945. Lived: San Francisco, California. Work:
Mills College Art Gallery, Oakland, California; California
Palace of the Legion of Honor, San Francisco. *CAR*, Vol.
XII; Fielding; Mallett.

Rowena Abdy has helped preserve the California scene for
later generations. Old missions and other historic buildings, coastal
and gold mining towns, and landscapes of picturesque areas off the
beaten trail were her subjects. A selection of her best water colors
was published in portfolio form under the title *Old California*.
Subsequently these paintings appeared on the covers of various
periodicals.

In addition to traveling extensively throughout California
in her "studio" sedan automobile, Mrs. Abdy made several trips
to Europe and a riverboat trip from Saint Louis to Pittsburgh.
From the latter came *On the Ohio*, a book written by Mr. Abdy
which she illustrated.

Abert, James W. (1820-1871)

B. Mount Holly, New Jersey, November 18, 1820. D. 1871.
Lived: U.S. Military Academy, West Point, New York;
Columbia, Missouri. Work: Fred Rosenstock Collection,
Denver, Colorado; Thomas Streeter Collection, Morris-
town, New Jersey. Abert; Groce and Wallace.

James Abert of the Corps of Topographical Engineers illus-
trated his 1846-47 trip from Fort Leavenworth, Kansas, to New
Mexico, and produced one of the most moving reports of record,
A Report and Map of the Examination of New Mexico. Flora and
fauna, insects, birds, animals, reptiles, fossils, and rocks were col-
lected and described in detail while he rode the Santa Fe Trail.
At Bent's Fort, Abert befriended the Cheyennes' largest man,
Nah-mouste, and painted his likeness. From Nah-mouste and other
Cheyenne friends Abert learned and recorded what he could of
their difficult language. In New Mexico he sketched the people and
churches at Laguna, San Miguel, Acoma, and other Pueblos. Re-
cently his charming sketches and illuminating diary were pub-

lished by John Howell of San Francisco, as *Western America in 1846-1847.*

Achey, Mary E. (-)
Lived: Central City, Colorado; Aberdeen, Washington, *Colorado Collectors.*

Achleitner, Otto (-1932)
Lived: Colorado. "Pioneer Artist Dies," *Rocky Mountain News,* January 28, 1932; *Denver Post,* January 27, 1932.

Adair, Ruby (1899-)
B. Pescadero, California. Lived: San Francisco. Mallett; *WWAA.*

Adam, William (1846-)
B. England. Lived: San Francisco; Monterey, California. *AAA;* Fielding; Mallett.

Adams, Cassilly (1843-1921)
B. Zanesville, Ohio, July 18. D. Trader's Point (near Indianapolis), Indiana, May 8. Lived: Cincinnati, Ohio; Saint Louis, Missouri. McCracken 1952; Taft.

Adams, Charles Partridge (1858-1942)
B. Franklin, Missouri, January 12, 1858. D. Pasadena, California, October 15, 1942. Lived: Denver, Colorado; Los Angeles, Laguna Beach, and Pasadena, California. Work: Denver Public Library; Kansas City Art Association, Missouri. Dr. and Mrs. Bruce Friedman Collection, San Francisco Bay area. Fielding; Mallett; *WWAA.*

Adams' western experience began in 1876 when he moved from the East to Denver, where he studied for a time with Mrs. James H. Chain. In 1882, when teacher and pupil submitted their entries to the Denver Exposition, it was Adams who won the gold medal—quite a distinction, for Mrs. Chain, a former pupil of George Innes, was a most talented and competent artist. Adams painted nearly all Colorado's prominent mountain peaks, as well as many in other western states. Long before his departure from Denver in 1916, he was known as one of the state's best landscape artists. A decade afterward, Adams settled permanently in the Los Angeles area and achieved recognition throughout California.

4

Adams, Corrine D. (1870-)

B. Utah, November 21. Lived: Ogden, Utah, where she was art instructor, Ogden Public Schools. Springville [Utah] Museum of Art, *Permanent Collection Catalog.*

Adams, Kenneth M. (1897-1966)

B. Topeka, Kansas, August 6, 1897. D. Albuquerque, June 27, 1966. Lived: Taos and Albuquerque, New Mexico. Work: Denver Art Museum; Los Angeles County Museum; Dallas Museum of Fine Arts; Kansas State University, Manhattan; University of New Mexico. Coke; Mallett; *WWAA.*

Adams, who lived in Taos from 1924 to 1937, is best known for his paintings and lithographs of his northern New Mexico friends and neighbors—the Indians and the Spanish Americans. His interest in them inspired many portraits and genre scenes such as "The Harvest," "New Mexico Village," "Old Spanish Woman," and "The Adobe Maker."

In 1937 Adams became Artist-in-Residence at the University of New Mexico in Albuquerque where he remained until his retirement in 1963. During that period he turned to new subjects, because with the advent of paved highways and modern improvements the once-isolated villages where he had liked to paint lost much of their charm.

Adams, Wayman (1883-1959)

B. Muncie, Indiana, September 23. D. April 7. Lived: Austin, Texas; Elizabethtown, New York. *AAA;* Fielding; Mallett; *WWA, WWAA, WWWA.*

Adams, Willis A. (1854-1932)

Lived: Utah. Haseltine.

Agate, Alfred T. (1812-1846)

B. Sparta, New York, February 14, 1812. D. Washington, D.C., January 5, 1846. Lived: New York and Washington, D.C. Work: Metropolitan Museum of Art, New York. Fielding; Groce and Wallace; Mallett; *Metropolitan Museum Bulletin,* May 1952.

Agate's short career included election in 1832, at the age

of 20, to the National Academy as an associate member and appointment as chief artist for the Charles Wilkes expedition of 1838-42. Agate was credited with many of the important west coast views made during that scientific round-the-world trip which included special attention to the region lying between California and Alaska. When Agate returned, he was employed by the Bureau of Engraving in Washington, D.C., to convert his drawings to illustrations for the multi-volume Wilkes report, *U.S. Exploring Expedition.*

Agate was the younger brother of Frederick S. Agate, also an artist.

Ahrens, Carl Henry (1863-1936)
B. Winfield, Ontario, Canada. D. Toronto. Lived: Galt and Toronto, Ontario. Macdonald; Mallett.

Akin, Louis B. (1868-1913)
B. Portland, Maine, 1868. D. Flagstaff, Arizona, 1913. Lived: New Mexico and Arizona. Work: Museum of Northern Arizona, Flagstaff; Hubbell Trading Post Museum, Ganado, Arizona. Fielding; James 1920; Mallett.

Akin specialized in painting American Indian life. Ultimately his reputation in that field brought him a commission from the Museum of Natural History in New York to decorate the room for its southwestern Indian display.

Much of Akin's work was done in the Taos, New Mexico, and the Grand Canyon areas which provided spectacular scenery for landscapes as well as Indian life. In 1903 he said of these places: "It is simply too good to leave. It's the best stuff in America and has scarcely been touched."

Akin's work can be seen in collections and museums specializing in early western paintings.

Albright, Gertrude Partington (1883-)
B. Heysham, England, September 11, 1883. Lived: San Francisco, California. *CAR,* Vol. XV; Mallett.

Gertrude Partington Albright was born in England but spent most of her life in the San Francisco area. There she studied art with her father, John Partington, sold her first painting at 16, worked as an illustrator for the *San Francisco Examiner,* and

then went to Paris for further study. Upon her return, she began teaching at the California School of Fine Arts.

Mrs. Albright's work is limited to San Francisco Bay area scenes, except for the summer of 1931 when she stayed at Jack London's ranch in Glen Ellen. She is best known for her oils on mahogany panels and her dry-point etchings.

Albright, Hermann Oliver (1876-1944)

B. Germany, January 29, 1876. Lived: San Francisco, California. *CAR*, Vol. XV; Mallett.

Albright's hobby had been photography before he took up art and married his teacher, Gertrude Partington. By 1930 he had developed quite a reputation as an artist and was able to devote full time to it. Several years later he did a series of lithographs and a series of wash drawings in Chinese ink—both of the Oakland-San Francisco Bay Bridge during construction—which were particularly well received and widely exhibited.

In addition to many local scenes of the San Francisco area, Albright painted at Monterey, Shasta, Sierra, Downieville, and along the Eel River. Today these scenes have historic as well as aesthetic appeal.

Alden, James (1810-1877)

B. Portland, Maine, March 31, 1810. D. San Francisco, February 6, 1877. Lived: San Francisco. Work: Yale Collection of Western Americana, New Haven, Connecticut; Washington State Historical Society, Tacoma. Goetzmann 1959; Groce and Wallace; Van Nostrand and Coulter.

Alden was a career officer in the Navy who is now better known for his water-color sketches of the West. From 1838 to 1842 he was with Charles Wilkes, the famous admiral, explorer, and scientist. From 1848 to 1861 he commanded his own survey party for the Navy. His assignment covered the West Coast from Canada to Mexico, and he is known to have helped survey and chart the Sacramento River.

The water-color sketches Alden did for the Northwest Boundary Survey report (1857-61) have been described by one historian as "magnificent." After completion of that assignment, Alden served in the Civil War with the Navy. When he retired in 1873, he settled in San Francisco.

Alden, James Madison (1834-1922)

Lived: California and Northwest coast, 1851-61. Groce and Wallace; Van Nostrand and Coulter.

Alexander, Henry (1860-1895)

B. San Francisco, California. D. New York City. Lived: San Francisco; New York City. Bénézit; Mallett.

Allen, John D. (1851-1947)

B. Italy Hill, New York, 1851. D. Mandan, North Dakota, 1947. Lived: Mandan. Barr; E. B. Robinson.

Allen was a New Yorker about whom little is known regarding his early life. In 1881 he settled in Dakota Territory at Mandan where he opened a taxidermy shop. Among those who brought animals from their hunting trips to Allen for preservation was Theodore Roosevelt.

Allen's paintings were of the Sioux Indians, their camp life, and their buffalo hunts. He knew many of the Indians personally, including Sitting Bull and Rain-in-the-Face. His canvases are said to be the best work done in the slope country of the Dakotas during the time he painted there, and he is credited with being one of the first artists to settle in North Dakota.

Allen, Marion Boyd (1862-1941)

B. Boston, Massachusetts, October 23. D. Boston, December 28. Lived: Boston. *AAA;* Fielding; Mallett; *WWA, WWAA.*

Allen, Thomas (1849-1924)

B. Saint Louis, October 19, 1849. D. Worcester, Massachusetts, August 25, 1924. Lived: Boston. Work: Boston Museum of Fine Arts; San Antonio Public Library. Fielding; Mallett; Pinckney.

During the summer of 1869, Allen, a student at Washington University in Saint Louis, went on a sketching trip into the Rockies west of Denver. The experience was to change the course of his career from business to art, and upon completion of his university work he went to Europe to study. Allen opened a studio in Boston upon his return, then went to Texas for the winter of 1878-79. A number of paintings resulted from this trip,

such as "The Market Place, San Antonio," "Mexican Women Washing at San Pedro Spring," and "The Portal of San Jose Mission."

Altmann, Aaron (1872-)
B. San Francisco, California, October 28. Lived: San Francisco. *AAA;* Fielding; Mallett; *WWAA.*

Alvarez, Mabel (-)
B. Waialua, Oahu, Hawaii. Lived: Los Angeles and Beverly Hills, California. *AAA;* Fielding; Mallett; *WWAA.*

Ames, Albert (-1897)
D. Santa Barbara, California, October 26. *San Francisco Call,* October 27, 1897.

Amick, Robert Wesley (1879-1969)
B. Canon City, Colorado, October 15. Lived: Old Greenwich, Connecticut; New York City. *AAA;* Fielding; Mallett; *WWAA.*

Anderson, Carl (1856-)
Lived: Coalville and Salt Lake City, Utah; Hawaii 1879-83; Ogden, Utah, where he was supervisor of art in the public schools. Carter.

Anderson, Clarence William (1891-)
B. Wahoo, Nebraska, April 12. Lived: New York City; Mason, New Hampshire. Mallett; *WWAA.*

Anderson, George (-)
In Arizona and New Mexico, late 1800s. Forrest.

Anderson, Gunda J. Evensen (-)
Lived: Hawaii; Ogden, Utah. Carter.

Applegate, Frank G. (1882-1931)
B. Atlanta, Illinois, February 9. D. February 13. Lived: Santa Fe, New Mexico. *AAA;* Fielding; Mallett; *WWA, WWWA.*

Armann, Kristinn P. (1889-)
B. North Dakota. Lived: North Dakota; San Luis Obispo,
California. Barr.

Armstrong, Thomas (1818-1860)
B. Northumberland, England. D. December 21. Lived: San
Francisco, California. Groce and Wallace; *Hutching's California Magazine,* April 1861.

Armstrong, William W. (1822-1914)
B. Dublin, Ireland. D. Toronto, Canada. Lived: Toronto.
Hubbard and Ostiguy.

Arpa, Jose (1868-)
B. Seville, Spain. Lived: San Antonio, Texas. *AAA;* Fielding; Mallett.

Arriola, Fortunato (1827-1872)
B. Mexico. Lived: San Francisco, California. Groce and
Wallace; Neuhaus 1931.

Askenazy, Mischa (1888-1961)
B. Odessa, Russia, February 22. D. July 13. Lived: Los Angeles, California. Collins; *WWAA.*

Atkins, Arthur (1873-1899)
• B. Egremont, Cheshire, England. D. Piedmont, California,
January 8. Lived: Piedmont. *CAR,* Vol. V.

Attridge, Irma Gertrude (1894-)
B. Chicago, Illinois, November 21. Lived: Beverly Hills,
California. Collins; *WWAA.*

Atwood, Robert (1892-)
B. Orange, New Jersey, May 23. Lived: Scottsdale, Arizona; Bartonsville, Vermont. Mallett; *WWWA.*

Audubon, John James (1785-1851)
B. Les Cayes, Haiti, April 26. D. New York City, January
27. Lived: New York City. Bénézit; *DAB;* Fielding; Groce
and Wallace; Mallett; *WWWA.*

Audubon, John Woodhouse (1812-1862)
B. Henderson, Kentucky, November 30. D. New York, February 21. Lived: New York. Bénézit; Fielding; Groce and Wallace; Mallett; *WWWA*.

Austin, Amanda Petronella (-1917)
B. Carrollton, Missouri. D. New York City, March 25. Lived: California. *Sacramento Bee*, March 26, 1917; *San Francisco Chronicle*, March 26, 1917.

Austin, Charles Percy (1883-)
B. Denver, Colorado, March 23. Lived: Santa Monica and San Juan Capistrano, California. Fielding; Mallett; *WWAA*.

Ayres, Thomas A. (-1858)
B. New Jersey. D. April 26, 1858. Lived: New Jersey and New York. Work: M. H. De Young Museum, San Francisco; New York Public Library. Ewers 1965; Groce and Wallace; Peters.

Little is known about this New Jersey artist who went to California in 1849 to prospect for gold, apparently without success. He did, however, become the first known artist to sketch the wonders of Yosemite when he was selected by James Mason Hutchings in 1855 to provide views for *California Illustrated*. The following year Ayres returned to Yosemite to paint scenes for an exhibition in New York City. Ayres' first visit to California covered a period of seven years during which he is known to have sketched Indian and mining scenes in the central and northern areas of the state. His second visit began in 1858 when he was commissioned by *Harper's Weekly* to make sketches of Southern California. Upon completion of the assignment, Ayres boarded the *Laura Bevan* at San Pedro and was lost at sea en route to San Francisco.

B

Babcock, Dean (1888-1969)

B. Canton, Illinois. D. about January 18. Lived: Denver and Estes Park, Colorado. *AAA;* Fielding; Mallett; *WWAA.*

Babcock, Ida Dobson (1870-)

B. Darlington, Wisconsin. Lived: Redlands, California. *AAA;* Mallett; *WWAA.*

Bacon, Irving R. (1875-1962)

B. Fitchburg, Massachusetts, November 29. D. El Cajon, California, November 21. Lived: Detroit, Michigan; Florida; California. *AAA;* Fielding; Mallett; *WWAA.*

Bagdapoulos, William Spencer (1888-)

B. Zante, Greece, July 23. Lived: Santa Barbara, California. *AAA;* Mallett; *WWAA.*

Bagg, Henry Howard (1853-1928)

B. Wanconda, Illinois, June 30. D. Lincoln, Nebraska, July 23. Lived: Lincoln. *AAA;* Bucklin; Mallett.

Bagley, James M. (1837-1910)

B. Maine, 1837. D. Colorado, 1910. Lived: Denver. Work: Denver Public Library. Mumey; Denver Public Library.

Bagley began his career as a wood engraver for *Frank Leslie's Illustrated Weekly* in 1859. He moved to Denver in 1872 and by the end of the decade had achieved success as wood engraver, cartoonist, and painter. Also about that time he became a director of the Silver Lodge Mining Company. One of Bagley's most famous pictures is a black and white drawing of the Georgetown Loop, perhaps the best representation ever done of that narrow-gauge railroad where it negotiated a mountain curve. Many other historic landmarks and scenic wonders of Colorado have been preserved through his work. In his late years Bagley retired with his wife to a mountain cabin where he continued to paint the life he saw about him.

Bailey, Minnie M. (1890-)

B. Oberlin, Kansas. Lived: Dallas, Texas. Fielding.

Bailey, Vernon Howe (1874-1953)

B. Camden, New Jersey, April 1. D. October 27. Lived: New York City. *AAA;* Fielding; Mallett; *WWA; WWAA.*

Baker, George (1882-)

B. Omaha, Nebraska, February 20. Lived: Pacific Palisades, California, *WWAA.*

Baker, George Holbrook (1827-1906)

B. East Medway, Massachusetts, March 9, 1827. D. California, January, 1906. Lived: Sacramento and San Francisco, California. Groce and Wallace; Peters; Van Nostrand and Coulter.

Outside of California few know the work of George Baker. Yet in Sacramento and San Francisco he was well known for his lithographs of historical northern California scenes.

Baker's art background was as apprentice to a commercial artist and later an art student. It was the Gold Rush that lured him from the National Academy of Design where he was a promising pupil and brought him to the mines where, after a few days, he decided in favor of a business career in San Francisco. In 1852 Baker moved to Sacramento, remaining until the great flood of 1862, and then he returned to San Francisco. His lithographs of actual events, such as the flood, and his panoramic views of California cities are of particular importance.

Bakos, Joseph G. (1891-)

B. Buffalo, New York, September 23. Lived: Buffalo; Santa Fe, New Mexico. *AAA;* Fielding; Mallett; *WWAA.*

Baldridge, Cyrus Leroy (1889-)

B. Alton, New York, May 27. Lived: New York; Santa Fe, New Mexico. *AAA;* Fielding; Mallett; *WWA; WWAA.*

Baldwin, Clifford Park (1889-)

B. Cincinnati, Ohio. Lived: Montrose, Carlsbad, and Oceanside, California. *AAA;* Mallett; *WWAA.*

Balink, Henry C. (1882-1963)

B. Amsterdam, Holland, June 10, 1882. D. Santa Fe, New Mexico, April 3, 1963. Lived: Santa Fe. Work: Museum of New Mexico, Santa Fe; Gilcrease Institute of Art, Tulsa, Oklahoma; Read Mullan Gallery of Western Art, Phoenix, Arizona. Ewing 1966; Fielding; Museum of New Mexico, Santa Fe.

Inspired by a picture of New Mexico in a New York railway station, Hendricus Balink, of Holland, made his way to Taos in 1917. Several years later, after first visiting his homeland, Balink moved to Santa Fe. There he is remembered not only for his art, but for such philosophical remarks as: "An artist's life is a funny life—you eat chicken today and the guts and feathers tomorrow."

Balink's work comprises a significant record of the American Indian. He painted from real life Indians of 63 tribes, and in 1927 he was commissioned to paint the portraits of Oklahoma's Indian chiefs.

Ballin, Hugo (1879-1956)

B. New York, March 7. D. Santa Monica, California, November 27. Lived: Santa Monica and Pacific Palisades, California. *AAA;* Bénézit; Fielding; Mallett; *WWA; WWAA; WWWA.*

Ballou, Addie L. (1837-1916)

B. Ohio. Lived: San Francisco, California. *San Francisco Chronicle,* August 15, 1916.

Ballou, Bertha (1891-)

B. Corning, New York, February 14. Lived: Spokane, Washington. *AAA;* Binheim; Mallett; *WWAA.*

Bancroft, Albert Stokes (1890-1972)

B. Denver, Colorado, May 15. D. about March 1, 1972. Lived: Denver and Bailey, Colorado. Mallett; *WWAA.*

Bancroft, William H. (1862-1920)

B. England, 1862. D. Colorado Springs, Colorado, 1920. Lived: Colorado. Work: William and Dorothy Harmsen

Collection, Denver, Colorado. Hafen 1948, Vol. II; McClurg.

By way of Halifax, Nova Scotia, Bancroft came to this country from England where he had been an art student at the Royal Academy. The excitement of an untamed land brought him to Leadville, Colorado, in 1877, and then to Arizona as an Indian scout with General George Crook who was in pursuit of the Apaches.

Crude, colorful mining camps as well as mountain landscapes were the subjects of Bancroft's art—the landscapes often painted in the open during a storm in order to capture their dynamic atmosphere. Bancroft's work was popular with easterners, and he is known to have had at least one solo exhibition in Philadelphia. His work is now popular with collectors of Western Americana and is most frequently seen in Colorado.

Banta, Mattie Evelyn (1868-1956)
B. Illinois. D. Colorado Springs, Colorado. Lived: Cripple Creek and Colorado Springs, Colorado. Shalkop.

Banvard, John (1815-1891)
B. New York, November 15. D. Watertown, South Dakota, May 16. Lived: New Orleans, Louisiana; Watertown. *DAB;* Fielding; Groce and Wallace; Mallett; Saint Louis City Art Museum, *Mississippi Panorama.*

Barber, Edmund L. (c.1808-1870)
B. New Haven, Connecticut. D. San Francisco, January 9. Lived: Connecticut; California. Groce and Wallace; *Sacramento Daily Union,* January 12, 1870.

Barbieri, Leonardo (-)
Lived: California 1847-53. *Alta California,* December 31, 1849 and January 2, 1850.

Barile, Xavier J. (1891-)
B. Italy, March 18. Lived: New York. *AAA;* Fielding; Mallett; *WWA; WWAA.*

Barker, George (1882-)
 B. Omaha, Nebraska, February 20. Lived: Corona, California. *AAA;* Mallett; *WWAA.*

Barker, Olive Ruth (1885-)
 B. Chicago, Illinois. Lived: Corona, California. *AAA;* Mallett; *WWAA.*

Barnes, Mathew Rackham (1880-1951)
 B. Scotland, November 26. Lived: San Francisco, California. Mallett; *WWAA.*

Barr, Paul E. (1892-1953)
 B. Goldsmith, Indiana, 1892. D. Grand Forks, North Dakota, 1953. Lived: North Dakota. Work: University of North Dakota, Grand Forks; State Building, Bismarck, North Dakota. Mallett; E. B. Robinson; *WWAA.*

 Barr was not an early arrival on the North Dakota scene, but nearly all his professional life was spent there. From 1928 until his death he was head of the Art Department at the University of North Dakota. He exhibited widely and became one of the state's best known artists.

 Barr's landscape subjects include the Badlands (he was the first to paint there extensively), the National Parks, the West Coast, and the Southwest. He also painted in the Canadian Rockies, on the East Coast, in Europe, and in Mexico. In 1940 Barr's oil painting "Ranch and Rider" was chosen to represent the state of North Dakota in a national exhibition held by International Business Machines in New York City.

Barr, William (1867-1933)
 B. Glasgow, Scotland. D. San Francisco, California. *AAA;* Fielding; Mallett.

Barrett, Lawrence (1897-)
 B. Guthrie, Oklahoma. Lived: Colorado Springs, Colorado. Meigs.

Barrington, George (-)
 Lived: California during the Gold Rush. Baird 1973.

Bartholomew, W. N. (1822-1898)

B. Boston, Massachusetts, February 13. D. Newton Centre, Massachusetts. Lived: Boston. Groce and Wallace; *WWWA*.

Bartlett, Dana (1878-1957)

B. Ionia, Michigan. D. July. Lived: Los Angeles, California. *AAA;* Fielding; Mallett; *WWAA*.

Bartlett, Gray (1885-1951)

B. Rochester, Minnesota, July 3, 1885. D. Los Angeles, California, 1951. Lived: Denver; Los Angeles; Moab, Utah. Work: Arizona State University, Tempe; Santa Fe Railway Collection; Read Mullan Gallery of Western Art, Phoenix. Carlson 1951; California State Library, Sacramento.

At 16 Bartlett was a Colorado cowboy with a sketchbook in his pocket, trying to decide whether to be a rancher or an artist. Economic difficulties at home made the decision for him, and he went into the engraving business.

Not until his retirement in 1937 was Bartlett able to resume his painting. He began with camera, sketchbook, and pencil to travel into Utah, Colorado, Texas, Arizona, and New Mexico. For short periods of time he lived among the Indians, learning their ways and making sketches which would be completed in his home studio in Los Angeles or his ranch studio near Moab, Utah. His paintings of southwestern subjects are now in various public and private collections, especially in the West.

Bartlett, John R. (1805-1886)

B. Providence, Rhode Island, October 23, 1805. D. Providence, May 28, 1886. Lived: Providence. Work: The John Carter Brown Library, Brown University, Providence. Groce and Wallace; Hine.

In 1850 Bartlett was appointed Commissioner in charge of the Mexican Boundary survey. During more than two years in the field he made drawings and water colors to illustrate his travels through Texas, New Mexico, Arizona, Mexico, and California, and kept a detailed account of his ethnological and botanical observations. In January 1852 Bartlett sailed from Acapulco to San Diego and then on to San Francisco to purchase equipment and

supplies for his men. While in Northern California he visited the quicksilver mines of New Almaden and the geysers near Napa, making numerous drawings which he left in San Francisco to be completed by Harrison Eastman and Henry Brown. A representative selection of Bartlett's work can be seen in *Bartlett's West* by Robert Hine.

Barton, Loren R. (1893-)
B. Oxford, Massachusetts. Lived: Los Angeles, California; New York City. *AAA;* Fielding; Mallett; *WWA; WWAA.*

Bassett, Reveau (1897-)
B. Dallas, Texas, January 9. Lived: Dallas. *AAA;* Fielding; Mallett; *WWAA.*

Bauer, Frederick (c.1855-)
B. Germany. Lived: Louisville, Kentucky; Visalia, California. Groce and Wallace.

Baumann, Gustave (1881-1971)
B. Magdeburg, Germany, June 27, 1881. Lived: Chicago, Illinois; Santa Fe, New Mexico. Work: Art Institute of Chicago; Metropolitan Museum of Art, New York; National Gallery, Toronto, Canada; Boston Museum of Fine Arts. Coke; Fielding; Mallett; *WWAA.*
Baumann, the master printmaker, grew up in Chicago; he studied at the Art Institute there and also in his native Germany. In 1918 he moved to Santa Fe where he became interested in the ancient Indian cultures of New Mexico. At Frijoles Canyon, not far from Santa Fe, he made rubbings and drawings of the numerous figures and designs which the Ancients had cut into their cave walls. Years later he published *Frijoles Canyon Pictographs* for which he received the "50 Books of the Year" award in 1940.
Baumann also worked with oils, but his woodcuts overshadowed all else. He did not limit himself to New Mexico subjects, nor was he tied to objective art. Some of his abstract work shows the influence of Indian art.

Baumgras, Peter (1827-)
B. Bavaria, Germany. Lived: New York; California. *AAA;* Mallett.

Baxter, Martha W. (1869-1955)
B. Castleton, Vermont. D. September 2. Lived: Santa Barbara, California. *AAA;* Bénézit; Fielding; Mallett; *WWA; WWAA.*

Beard, Daniel (1850-1941)
B. Cincinnati, Ohio, June 21. D. New York City, January 11. Lived: Suffern, New York; Hawley, Pennsylvania. *AAA;* Bénézit; Fielding; Mallett; *WWA; WWAA.*

Beard, George (1855-1944)
Lived: Coalville, Utah. Haseltine.

Beard, James Carter (1837-1913)
B. Cincinnati, Ohio, June 16. D. November 15. Lived: Brooklyn, New York; New Orleans, Louisiana. *AAA;* Bénézit; *DAB;* Groce and Wallace; Mallett; *WWA, WWWA.*

Beard, James Henry (1812-1893)
B. Buffalo, New York, May 20. D. Flushing, New York, April 4. Lived: Flushing. Bénézit; *DAB;* Fielding; Groce and Wallace; Mallett; *WWA; WWWA.*

Beard, William Holbrook (1825-1900)
B. Painesville, Ohio, April 13. D. New York City, February 20. Lived: New York City. *AAA;* Bénézit; *DAB;* Fielding; Mallett; *WWA; WWWA.*

Beaumont, Arthur Edwaine (1890-)
B. Norwich, England, March 25. Lived: Long Beach, California. *AAA;* Mallett; *WWAA.*

Beauregard, Donald (1884-1914)
B. Fillmore, Utah, August 7, 1884. D. Fillmore, May 2, 1914. Lived: Ogden, Utah; Santa Fe, New Mexico. Work: Museum of New Mexico, Santa Fe. Horne; Museum of New Mexico, Santa Fe.

Beauregard was a promising Utah painter and muralist whose work is best known in his native state, and in New Mexico

where he went in 1910 to participate in an archaeological study of the Rito de los Frijoles ruins. There he met Frank Springer who commissioned him to do murals illustrating the life and words of Saint Francis for the Museum of New Mexico in Santa Fe. Further study in Europe interrupted the assignment, and an untimely death shortly after Beauregard's return prevented completion of the murals. Carlos Vierra and Kenneth Chapman later were engaged by Springer to complete the work with the aid of Beauregard's preliminary sketches.

A large collection of Beauregard's desert scenes and Indian subjects were given to the Museum of New Mexico by Mr. Springer.

Becker, Frederick (1888-)
B. Vermillion, South Dakota, March 24. Lived: New York City; Oklahoma City, Oklahoma; Cathedral City and Palm Springs, California; San Antonio, Texas. *AAA;* Fielding; Mallett; *WWAA.*

Becker, Joseph [Carl J.] (1841-1910)
B. Pottsville, Pennsylvania, 1841. D. Brooklyn, New York, January 27, 1910. Lived: New York. Work: Gilcrease Institute of Art, Tulsa, Oklahoma. Mallett; Taft.

Becker advanced from errand boy for *Frank Leslie's Illustrated Weekly* in 1859 to art department head in 1875. He accomplished this without training but with an interest in learning to sketch and with encouragement from Leslie and his staff.

In 1869 Becker traveled through the West and made about 40 illustrations. These were published in *Leslie's* from December of that year through mid-1870, and later Becker painted several oils from them. Becker's trip also resulted in drawings for an observation car which were submitted to and utilized by George Pullman. Years later Becker wrote: "I may therefore fairly claim to have been the inventor of what is now a feature of all great railways."

Becker, Otto (1854-1945)
B. Dresden, Germany, January 28. D. Milwaukee, Wisconsin, November 12. Lived: Saint Louis, Missouri; Milwaukee. Taft.

Beckwith, Arthur (1860-1930)
B. London, England. Lived: San Francisco, California. *AAA;* Fielding; Mallett.

Beecher, Genevieve T. (1888-)
B. Chicago, Illinois, August 27. Lived: Los Angeles and Hermosa Beach, California. Mallett; *WWC.*

Beechey, Richard Brydges (1808-1895)
Visited Monterey, California. Van Nostrand.

Beek, Alice D. Engley (1867-1951)
B. Providence, Rhode Island, June 17. D. January 26. Lived: Tacoma, Washington. *AAA;* Fielding; Mallett; *WWA; WWAA; WWWA.*

Belden, George P. (-)
B. Ohio (probably). Lived: Brownville, Nebraska. Bucklin.

Bellows, George Wesley (1882-1925)
B. Columbus, Ohio, August 12. D. New York, January 8. Lived: New York. *AAA;* Bénézit; *DAB;* Fielding; Mallett; *WWA; WWWA.*

Benda, Wladyslaw (1873-1948)
B. Poznan, Poland. D. November 30. Lived: New York City. *AAA;* Fielding; Mallett; *WWA; WWAA; WWWA.*

Berninghaus, Oscar E. (1874-1952)
B. Saint Louis, Missouri, October 2, 1874. D. Taos, New Mexico, April 27, 1952. Lived: Taos. Work: Gilcrease Institute of Art, Tulsa, Oklahoma; City Art Museum of Saint Louis; Los Angeles County Museum; University of New Mexico, Albuquerque. Coke; Fielding; Mallett; Wuerpel.

In 1899 Berninghaus visited Taos, New Mexico, after traveling 25 miles by trail from the nearest railroad. He remained a week and decided to establish a summer studio there; two decades later he settled there permanently.

Like many late 19th and early 20th century artists, Bern-

inghaus was also an illustrator. With little art training beyond that received as a lithographer's apprentice in his native Saint Louis, he had achieved considerable success before going to New Mexico. Berninghaus' excellent draftsmanship and exceptional understanding of Navajo and Pueblo life account for the accuracy, candor, and objectivity with which he depicted it. "No puzzling inquiry, no psychological bewilderment here," wrote Edmund Wuerpel. "All is quite straightforward, simple and clear."

Bennett, Bertha (1883-)
B. Eastland, Texas, March 5. Lived: San Antonio, Texas. Collins; *WWAA*.

Bennett, Gertrude (1894-)
B. Monterey, California. Lived: Pleasanton, California. Mallett.

Bennett, Joseph Hastings (1889-)
B. San Diego, California, March 27. Lived: Piedmont, California. Mallett; *WWAA*.

Benton, Mary P. S. (-)
Lived: San Francisco, California, about 1850. Groce and Wallace; Van Nostrand and Coulter.

Benton, Thomas Hart (1889-)
B. Neosho, Missouri, April 15. Lived: Kansas City, Missouri. *AAA;* Fielding; Mallett; *WWAA*.

Berg, George Lewis (1868-1941)
B. McGregor, Iowa, October 27. D. Los Gatos, California, July 1. Lived: South Norwalk and Stony Creek, Connecticut; San Francisco and La Jolla, California. *AAA;* Fielding; Mallett; *WWAA*.

Bergmann, Frank Walter (1898-)
B. Dinling, Austria, August 6. Lived: San Francisco, California. Mallett; *WWAA*.

Berlandier, Jean Louis (c.1804-1851)
B. near Swiss border. Lived: Mexico; Texas 1828-29. Colorado State University, Fort Collins.

Berlandina, Jane (1898-)
B. Nice, France, March 15. Lived: San Francisco, California. Mallett; *WWAA.*

Best, Arthur W. (-)
Lived: San Francisco, California. James 1917.

Best, Harry C. (1863-1936)
B. Peterboro, Canada. Lived: San Francisco. *AAA;* Mallett.

Bettinger, Hoyland B. (1890-1950)
B. Lima, New York, December 1. D. May 17. Lived: Newton Lower Falls and Waltham, Massachusetts; Carmel, California. *AAA;* Mallett; *WWAA.*

Betts, E. C. (1856-1917)
B. Hillsdale, Michigan. D. Denver, Colorado. Lived: Denver. Fielding; Mallett.

Betts, Harold Harrington (1881-)
B. New York. Lived: Chicago, Illinois. *AAA;* Bénézit; Mallett.

Beznics, George (1829-1902)
B. Dusseldorf, Germany. Springville [Utah] Museum of Art, *Permanent Collection Catalog.*

Biddle, George (1885-)
B. Philadelphia, Pennsylvania, January 24. Lived: Croton-on-Hudson, New York. *AAA;* Fielding; Mallett; *WWA; WWAA.*

Bierstadt, Albert (1830-1902)
B. Solingen, Germany, January 7, 1830. D. New York City, February 18, 1902. Lived: New Bedford, Massachusetts;

Tappan Zee, New York; New York City. Work: Walker Art Center, Minneapolis; Museum of New Mexico, Santa Fe; Corcoran Gallery of Art, Washington, D.C.; City Art Museum of Saint Louis. *CAR*, Vol. II; Ewers 1965; Fielding; Groce and Wallace; Mallett; Richardson.

In covered wagon and on horseback, Bierstadt traveled to the most spectacular sights in the West. Indians as well as grand views are depicted in his huge canvases, based on sketching trips as early as 1858 when he wrote from his camp in the Rockies: "The Indians are as they were hundreds of years ago, and now is the time to paint them."

By putting the West on canvas Bierstadt felt he was serving humanity, for he knew that much of it would be changed by expansion. Ultimately a mountain peak in the Rockies was named for him, Congress appropriated $20,000 for one of his paintings, and five foreign countries awarded him medals.

Bigot, Toussaint Francois (1794-1869)
B. Rennes, France. D. New Orleans, Louisiana. Lived: New Orleans. Fielding; Groce and Wallace.

Bingham, George Caleb (1811-1879)
B. Augusta County, Virginia, March 20. D. Kansas City, Missouri, July 7. Lived: Missouri; Washington, D.C. *DAB*; Fielding; Groce and Wallace; Mallett; *WWA*; *WWWA*.

Birch, Geraldine Rose (1883-)
B. Forest Row, Sussex, England, November 12. Lived: Pasadena, California. *AAA*; Mallett; *WWAA*.

Birch, Reginald Bathurst (1856-1943)
B. London, England, May 2. D. New York City, June 17. Lived: Dover, New Jersey. *AAA*; Bénézit; Fielding; Mallett; *WWA*; *WWAA*; *WWWA*.

Birren, Joseph P. (1864-1933)
B. Chicago, Illinois, May 14. D. Milwaukee, Wisconsin, August 4. Lived: Chicago; Laguna Beach, California. *AAA*; Bénézit; Fielding; Mallett; *WWA*; *WWWA*.

Bischoff, Eugene Henry (1880-1954)
 B. Pfortzheim, Germany, September 20. Lived: Benning-
ton, Vermont; Taos, New Mexico. Mallett; *WWAA.*

Bischoff, Franz Albert (1864-1929)
 B. Austria. D. California. Lived: California. *AAA;* Mallett.

Bistram, Emil (1895-)
 B. Hungary, April 7. Lived: New York City; Taos, New
Mexico. Fielding; *WWAA.*

Black, LaVerne Nelson (1887-1939)
 B. Kickapoo Valley, Wisconsin, April 15, 1887. D. Chicago,
1939. Lived: New York City; Taos, New Mexico; Phoenix,
Arizona; Chicago, Illinois. Work: Santa Fe Railway Col-
lection; Read Mullan Gallery of Western Art, Phoenix.
Bimson; Luhan.
 It is said that when Black died, art enthusiasts searched for
every scrap of canvas and every piece of sculpture he had ever
worked on. Yet, when he lived in Taos during the second decade
of this century, and Phoenix during the third, his portrayals of
southwestern Indians brought little recognition.
 Black was born in the Kickapoo Valley of Wisconsin,
studied art in Chicago where he won a scholarship, worked in
Minneapolis as an illustrator, and later moved to New York. His
summers were spent in the far West during his early years as
illustrator and commercial artist. Ill health caused him to take up
permanent residence in the West. In Taos, Black is best remem-
bered for his snow scenes with Indians draped in colorful blankets,
enduring stoically the bitter cold of a high altitude in winter.

Blake, William P. (1825-1910)
 B. New York City, June 1, 1825. D. May 22, 1910. Lived:
San Francisco Bay area; Tucson, Arizona. Groce and Wal-
lace; Taft.
 Blake was a geologist with the R. S. Williamson Survey
which started out from Benicia, California, in 1853. Most of
Blake's illustrations were of the Sierra Nevada Mountains and
the California desert and were drawn to show the geology of the
country. Historically and scenically many of them are of interest,

especially the sketches of San Gabriel Mission and San Diego.

For years Blake was professor of minerology and geology at the College of California (now the University of California), and later became director of the School of Mines at the University of Arizona. In addition he achieved distinction as a naturalist.

Blakelock, Ralph Albert (1847-1919)

B. Greenwich Village, New York, October 15, 1847. D. Adirondack Mountains, New York, August 9, 1919. Lived: New York. Work: National Gallery, Washington, D.C.; Metropolitan Museum of Art, New York; University of Arizona Museum of Art, Tucson; Toledo Museum of Art. Barker; Fielding; McCracken 1952; Mallett.

Art historians are uncertain of the exact length of time Blakelock was in the West, for he also sketched in Mexico, Panama, and the West Indies before returning to his home in New York. The trip, which began in 1869, lasted seven years during which he sketched in Kansas, Colorado, Wyoming, Utah, Nevada, and California, before entering Mexico.

The tragedy of Blakelock's life had its origin in the West, for from his experiences in portraying that region came his impressionist style, a style which at that time the American art-buying public could not comprehend. Belatedly it brought Blakelock wide recognition, but by then he had been confined to a mental institution, his heroic attempt to support a large family having caused him to break under the strain in 1899. Neither he nor his family benefited financially from his famous works which became so popular that forgeries are common.

Blanch, Arnold (1896-1968)

B. Mantorville, Minnesota, June 4. D. October 23. Lived: New York City and Woodstock, New York. *AAA;* Mallett; *WWAA.*

Blanch, Lucille (1895-)

B. Hawley, Minnesota, December 31. Lived: New York City and Woodstock, New York. *WWAA.*

Bloch, Albert (1882-1961)

B. Saint Louis, Missouri, August 2. D. December 9. Lived: Lawrence, Kansas. *AAA;* Fielding; Mallett; *WWA; WWAA; WWWA.*

Bloomer, Hiram Reynolds (1845-1910)

B. New York. Lived: San Francisco and Marin County, California. Bénézit; Fielding; Mallett.

Blumenschein, Ernest Leonard (1874-1960)

B. Pittsburgh, Pennsylvania, May 26, 1874. D. Taos, New Mexico, 1960. Lived: New York; Paris; Taos. Work: Metropolitan Museum of Art, New York; Fort Worth Museum of Art, Texas; Toronto Art Gallery, Canada; Arizona State University, Tempe; Milwaukee Art Institute, Wisconsin. Coke; Fielding; Mallett.

Blumenschein, co-founder with Bert Phillips of the Taos Society of Artists in 1912, felt there were but two places in the world for him—Paris and Taos. He visited the latter briefly in the fall of 1898 while fulfilling an illustrating assignment for *McClure's Magazine,* and then he went back to Paris for further study.

Not until 1909, after achieving recognition in the East as an artist and illustrator, did Blumenschein return to Taos. Yearly visits continued for a decade until he was able to convince his artist wife, Mary Greene Blumenschein, to make it their permanent home. From the turn of the century on, much of his work reflects his interest in the Indians of the Southwest.

Blumenschein, Mary Shepard Greene (1868-1958)

B. New York City. D. Taos, New Mexico, May 24. Lived: New York City; Paris; Taos. *AAA;* Bénézit; Fielding; Mallett; *WWA; WWAA; WWWA.*

Bodmer, Karl (1809-1893)

B. Riesbach, Switzerland, February 6, 1809. D. Barbizon, France, October 30, 1893. Lived: Barbizon. Work: Joslyn Art Museum, Omaha, Nebraska; Smithsonian Institution, Washington, D.C.; New York Historical Society. Ewers 1965; Fielding; Groce and Wallace; McCracken 1952; Mallett; E. B. Robinson; Taft.

27

Bodmer was engaged by Maximilian, a Prussian prince, to accompany him on his western exploration. In April of 1833 they left Saint Louis by steamboat for Fort Pierre on the Missouri where Bodmer sketched the Sioux; at Fort Clark he sketched the Mandan; at Fort McKenzie he sketched the Blackfeet.

Bodmer's work is most important to the western scene. In addition, he encouraged the Indians to explore a new art media by giving them drawing and painting supplies.

Upon Bodmer's return to Europe he achieved wide recognition for his works which included etchings, lithographs, and woodblock prints. In 1962, 427 of his original water colors and drawings were purchased by Northern Natural Gas Company of Omaha, Nebraska.

Bogert, George Hirst (1864-1944)
B. New York. D. New York City, December 12. Lived: Lyme, Connecticut; New York City. *AAA;* Bénézit; Fielding; Mallett; *WWA; WWAA; WWWA.*

Bolton, Hale William (1879-1920)
B. Fredericksburg, Iowa, September 27. D. Dallas, Texas. Lived: Dallas. *AAA;* Mallett.

Bonner, Mary (1885-1935)
B. Bastrop, Louisiana. D. San Antonio, Texas, June 26. Lived: Texas. *AAA;* Mallett.

Borein, Edward (1873-1945)
B. San Leandro, California, October 21, 1873. D. Santa Barbara, California, May 19, 1945. Lived: New York City; Mexico; Oakland, California; Santa Barbara. Work: Los Angeles County Museum; M. H. De Young Museum, San Francisco; Read Mullan Gallery of Western Art, Phoenix, Arizona; Bradford Brinton Memorial, Big Horn, Wyoming. Fielding; Galvin; McCracken 1952; Mallett; Spaulding.

At the age of 17 Borein quit using the margins of his textbooks for drawing practice and tried the walls by the bunkbeds where he slept when he wasn't out on the range learning to be a cowboy. The West and Mexico never ceased to interest him, and he made thousands of sketches—finished and unfinished—of the scenes he saw there.

Except for studying the etching process in New York, Borein was self taught. He was a stickler for having things just right, and in later years he took moving pictures, both standard and slow motion, for a further check on his accuracy. He wanted his work to tell the western story as it was, not as someone imagined it to be.

Borg, Carl Oscar (1879-1947)
B. Grinstad, Sweden, March 3, 1879. D. Santa Barbara, California, May 8, 1947. Lived: Europe; Santa Barbara. Work: M. H. De Young Museum, San Francisco; Milwaukee Art Institute; Seattle Art Museum. Ainsworth 1968; Fielding; Mallett; *WWAA*.

Borg was a Swedish painter who arrived on the western scene rather late but found it as exciting and portrayable as earlier artists had. Navajo and Hopi Indians, cowboys, landscapes, and historical landmarks were the subjects of many paintings from the turn of the century until the end of his life. During that period he also painted in Europe, Mexico, and South America. His paintings and etchings are in many museums here and abroad, and he is especially well known in Sweden and the western United States.

In 1936 Borg published a book of dry-point etchings and poetry, *The Great Southwest Etchings,* devoted primarily to the Navajo and Hopi Indians.

Borglum, Elizabeth (1849-)
B. Racine, Wisconsin. Lived: Sierra Madre, California. Married Gutzon Borglum 1889. *WWPS*.

Borglum, Gutzon (1867-1941)
B. Bear Lake, Idaho, March 25, 1867. D. March 6, 1941. Lived: California; Stamford, Connecticut. Work: Oakland Art Museum, California. Fielding 1965 and Addendum; Mallett.

The full name of this Idaho-born painter and sculptor is John Gutzon de la Mothe Borglum. His brother Solon was also a sculptor, and Gutzon's wife Elizabeth was a painter and art teacher.

Western themes were utilized by Borglum in his oil paintings,

murals, and sculptures, as well as historical figures. He is of course most famous for his Mount Rushmore heads of Washington, Jefferson, Lincoln, and Theodore Roosevelt, an unforgettable sight to those who have visited the Black Hills.

Borglum traveled extensively in this country and in Europe, and he had studios in New York City, Raleigh, North Carolina, San Antonio, Texas, and Los Angeles.

Borglum, Solon Hannibal (1868-1922)
B. Ogden, Utah, December 22. D. Stamford, Connecticut, January 31. Lived: Nebraska; Santa Ana, California; Silvermine, Connecticut. *AAA;* Bénézit; *DAB;* Fielding; Mallett.

Boronda, Lester David (1886-)
B. Reno, Nevada. Lived: New York City; Mystic, Connecticut. *AAA;* Fielding; Mallett; *WWAA.*

Borthwick, John David (1825-c.1900)
B. Edinburgh, Scotland. D. London. Lived: California 1851-54. Groce and Wallace; Hogarth; *WWWA.*

Bosqui, Edward (1832-1917)
B. Montreal, Canada, July 23. D. San Francisco, California, December 8. Lived: San Francisco. Groce and Wallace; Peters; *San Francisco Examiner,* December 9, 1917.

Boss, Homer (1882-1956)
B. Blanford, Massachusetts, July 9. Lived: Santa Cruz, New Mexico. *AAA;* Fielding; Mallett; *WWAA.*

Botke, Cornelius (1887-1954)
B. Leewarden, Holland, July 6. D. Santa Paula, California, September 16. Lived: Santa Paula. *AAA;* Bénézit; Fielding; Mallett; *WWAA.*

Botke, Jesse Arms (1883-)
B. Chicago, Illinois, May 27. Lived: Los Angeles and Santa Paula, California. *AAA;* Bénézit; Fielding; Mallett; *WWA; WWAA.*

Boundey, Burton Shepard (1879-1962)
B. Oconomowoc, Wisconsin, February 2. D. Monterey, California, November 12. Lived: Monterey. *AAA;* Mallett; *WWAA.*

Boynton, Ray (1883-1951)
B. Whitten, Iowa, 1883. D. New Mexico, 1951. Lived: Spokane, Washington; San Francisco, California. Work: Mills College Art Gallery, Oakland, California; M. H. De Young Museum, San Francisco. *CAR,* Vol. IX; Mallett.

Boynton became a westerner in 1908 when he moved to Spokane, following several years at the Chicago Academy of Fine Arts. In 1915 he settled permanently in San Francisco.

Though adept in various media, it is Boynton's drawings and pastels of the Mother Lode towns in the early 1930s which are of interest here. Having gained permission to sketch 3,000 feet below the earth's surface in the Empire Mine at Grass Valley, California, Boynton was one of the first to depict mining activity from its lower depths. He also sketched many of the old landmarks before progress took over—for example, the grand old courthouse in Nevada City received a coat of stucco, Downieville was changed by construction of a concrete bridge, and numerous other transformations took place.

Bradford, William (1823-1892)
B. Fairhaven, Massachusetts, April 30. D. New York, April 25. Lived: Massachusetts; California. Bénézit; *DAB;* Fielding; Groce and Wallace; Mallett; *WWWA.*

Bradley, H. W. (-)
Lived: San Francisco, California, about 1850. Groce and Wallace.

Brandon, John A. (1870-)
B. Franklin, Tennessee, November 25. Lived: Sacramento, California. Mallett; *WWAA.*

Brandriff, George Kennedy (1890-1936)
B. Millville, New Jersey. Lived: Beverly Hills, California. *AAA;* Mallett; *WWAA.*

Brannan, Sophie Marston (-)

B. Mountain View, California. Lived: California; New York. *AAA;* Fielding; Mallett; *WWAA.*

Braun, Maurice (1877-1941)

B. Nagy Bittse, Hungary, October 1, 1877. D. San Diego, California, November 7, 1941. Lived: Connecticut; San Diego. Work: Phoenix Art Museum, Arizona; Fine Arts Gallery of San Diego; Wichita Art Association, Kansas; Waco Art Gallery, Texas. Comstock 1925; Fielding; Mallett; *WWAA.*

Braun was born in Hungary, brought to this country at the age of three, and grew up in New York. There he studied art at the National Academy of Design and with William Merritt Chase. In 1910 he opened a studio at Point Loma on San Diego Bay where, except for two years in the early 1920s, he made his home.

Essentially Braun's approach to landscape painting was to make art subservient to nature. He chose the southwestern desert and the High Sierras for much of his work, but he also painted in Colorado, Connecticut, and the Ozark Mountains. As director of the San Diego Art Academy for many years, he became especially well known in the West.

Bremer, Anne (1872-1923)

B. San Francisco, California, May 21, 1872. D. San Francisco, October 26, 1923. Lived: San Francisco. *CAR,* Vol. VII; Fielding; Mallett.

Miss Bremer was not primarily a landscape artist, but her numerous paintings and drawings of old barns and other dilapidated buildings near the San Francisco Bay communities of Saratoga, San Jose, and Belvedere qualify her as an able interpreter of the California scene. She also did a number of landscapes in that area and around Monterey.

By birth a San Franciscan, Miss Bremer studied with two of that city's prominent artists and in Europe. She exhibited in various eastern cities and is said to have been the first California woman artist to have a one-person show in New York. At that time Marsden Hartley considered her one of the three California artists of real distinction.

Breneiser, Elizabeth Day [Babs] (1890-)
B. April 20. Lived: Santa Maria, California; Santa Fe, New Mexico. *WWAA.*

Breneiser, Stanley Grotevent (1890-)
B. Reading, Pennsylvania, January 10. Lived: Santa Maria, California; Santa Fe, New Mexico. *AAA;* Mallett; *WWAA.*

Brenner, Carl Christian (1838-1888)
B. Bavaria. D. Louisville, Kentucky, July 22. Lived: Kentucky. Mallett; Saint Louis City Art Museum, *Mississippi Panorama.*

Brett, Dorothy E. (1883-)
B. London, England. Lived: Taos and San Cristobal, New Mexico. *AAA;* Mallett; *WWAA.*

Breuer, Henry Joseph (1860-1932)
B. Philadelphia, Pennsylvania, August 10, 1860. D. San Francisco, California, February 19, 1932. Lived: San Francisco and Santa Barbara, California. Work: Los Angeles County Museum. *CAR,* Vol. V; Fielding; Mallett.

Breuer painted along the Pacific Coast from Santa Barbara to Oregon, and inland to Yosemite and the High Sierras. His combination home and studio was a wagon weighing a ton and a half, drawn by two horses. With small sketches he and his wife purchased most of their provisions.

From a contemporary of Breuer's came the following comment: "When we were all painting our California landscapes in brown tones, along came Breuer painting glaciers and snow-capped peaks, and the blue skies. . . ." The Saint Louis beer baron and art patron Adolphus Busch liked Breuer's work so well he bought enough paintings to give a one-man exhibition.

Brewer, Nicholas Richard (1857-1949)
B. High Forest, Olmsted County, Minnesota, June 11. D. February 15. Lived: Saint Paul, Minnesota. *AAA;* Fielding; Mallett; *WWA; WWWA.*

Brewerton, George Douglass (1820-1901)
B. Rhode Island. Lived: Brooklyn, New York; Southwest 1847-48 and perhaps 1853. Groce and Wallace.

Britton, Joseph (1825-1901)
B. Yorkshire, England. D. San Francisco, California. Lived: California. Groce and Wallace; Peters.

Brockman, Ann (1899-1943)
B. Alameda, California, November 6. D. March 29. Lived: New York; Rockport, Massachusetts. *AAA;* Mallett; *WWAA.*

Brodt, Helen Tanner (1834-1908)
D. Berkeley, California. Lived: California; explored mountain regions of Northern California.

Bromley, Thomas L. (-)
Lived: California 1889-c.1920. Oakland Art Museum.

Bromley, Valentine Walter (1848-1877)
B. London, England. D. near London, April. Accompanied the Earl of Dunraven on hunting expedition in Montana and Wyoming 1874. Hogarth.

Bromwell, Henrietta (-)
B. Charleston, Illinois. Lived: Denver, Colorado. *AAA;* Fielding.

Brooks, Samuel Marsden (1816-1892)
B. Newington, England, April 8. D. San Francisco, California, January 31. Lived: Milwaukee, Wisconsin; San Francisco. Mallett; Groce and Wallace.

Browere, Alburtis D. O. (1814-1887)
B. Tarrytown, New York, 1814. D. Catskill, New York, February 17, 1887. Lived: San Francisco, California; Catskill. Work: Robert B. Honeyman, Jr. Collection, Southern California. Barker; Fielding; Groce and Wallace; Mallett; Richardson.

Browere was a picturesque and venturesome New York artist who sailed around the Horn in 1852 to depict the gold rush. He made a second trip several years later, and in all spent about four years in California.

Influenced as Browere was by Thomas Cole and other Hudson River School painters, he found the spectacular mountains of the West a challenging subject and painted some commendable landscapes. However, his sketches of mining towns and camps constitute a more significant contribution to early California art.

Most of Browere's life was spent in New York painting anecdotal subjects, signs, and the Catskills—the last far less capably than the California mountains.

Brown, Benjamin Chambers (1865-1942)
B. Marion, Arkansas, July 14, 1865. D. January 19, 1942. Lived: Pasadena, California. Berry, May 1925; Fielding; Mallett; *WWAA*.

Brown was one of the most successful of the Southern California landscape artists. Prior to moving there in the late 19th century, he had lived in Arkansas, his native state; in Saint Louis, where he was a prize-winning art student; and in Paris, where he had gone for further study. After settling in the Los Angeles area, he abandoned much of his Paris style and developed another more suitable to the California landscape. It brought him numerous awards and wide recognition.

Brown is best known for his paintings and etchings of California, but he also painted landscapes of the Grand Canyon, the Royal Gorge, and the Painted Desert.

Brown, Dorothy Woodhead (1899-)
B. Houston, Texas, March 13. Lived: Los Angeles, California. Collins; *WWAA*.

Brown, Grafton Tyler (1842-1918)
B. Pennsylvania. D. Minnesota. Lived: California 1850s-1881, 1885-91. Groce and Wallace; Mallett; *Art in America*, September-October 1969.

35

Brown, Henry Box [Brown, Harrison B.] (1831-1915)
B. Portland, Maine, 1831. D. London, England, March 10, 1915. Lived: England; Maine; San Francisco. Fielding; Groce and Wallace; Hine; Mallett.

Before this artist became a successful marine painter in Maine under the name of Harrison B. Brown, he spent some time in California. In 1852, when Commissioner John Bartlett brought his sketches of Northern California to Henry Brown and Harrison Eastman for completion, Brown was known as a San Francisco artist. Because Bartlett was especially interested in Indian ethnology, he commissioned Brown to compile a vocabulary of native Indian words, paint portraits of the chiefs, and make studies of life in the Indian villages of Northern California. Brown brought back a number of Mount Shasta landscapes as well as complying with Bartlett's request. Three of his upper Sacramento river valley studies have been reproduced in *Bartlett's West* by Robert Hine.

Brown, Howell C. (1880-)
B. Little Rock, Arkansas, July 28. Lived: Pasadena, California. *AAA;* Fielding; Mallett; *WWAA.*

Browne, Belmore (1880-1954)
B. New Brighton, Staten Island, New York, June 9. D. May 3. Lived: Rye, New York; Ross, California; summers: Banff, Alberta, Canada. *AAA;* Fielding; Mallett; *WWA; WWAA; WWWA.*

Browne, J. Ross (1821-1875)
B. Dublin, Ireland, February 11, 1821. D. Oakland, California, December 9, 1875. Lived: Oakland. Browne; Taft.

Browne's introduction to the West came in 1849 when the U.S. Treasury Department sent him to San Francisco to see what could be done about mass desertions of sailors to the gold fields. From 1853 to 1859, Brown was Inspector of Custom Houses and then Inspector of Indian Agencies. His assignments took him to Washington, Oregon, Nevada, Arizona, and Texas, as well as California where he later made his home.

Browne is best known as a travel writer and humorist, but from the time of his first book he made sketches to illustrate his

work. Seventy-eight illustrations appeared in "Adventures in the Apache Country," published in serial form by *Harper's Magazine* in 1864. This exciting story was to see print again when it was published as a book in 1869 and republished in 1950.

Browning, J. Wesley (1868-1951)
B. Salt Lake City, Utah, September 24, 1868. D. Salt Lake City, October 11, 1951. Lived: Salt Lake City. Work: Springville Art Museum, Utah. Fielding; Horne; Mallett.

Browning was a Salt Lake City businessman who from boyhood had been interested in art and nature study. He used both water color and oil successfully, particularly the former. His interest in nature led him to paint landscapes, Utah flora, and birds. Browning's landscapes are said to be outstanding for their display of light and shadow, and his illustrated articles about Utah birds are important for the thoroughness of his study and observation. Nature in all her varied moods provided subject matter for a lifetime of painting for this self-taught, part-time artist. One of his water colors was awarded a first prize by the Utah Art Institute.

Bruff, Joseph G. (1804-1889)
B. Washington, D.C., October 2, 1804. D. April 14, 1889. Lived: Washington, D.C. Work: Huntington Library, San Marino, California. Groce and Wallace; Read and Gaines.

In search of adventure and riches, Bruff left Washington, D.C., for the California gold fields in April 1849, and returned two years later. His experiences and observations of the country he crossed and the camps in which he stayed, both pictorial and written, were edited and published almost 100 years later in a two-volume work called *Gold Rush*.

Bruff was a draftsman by profession. His carefully identified drawings, though crude in execution, are among the few known made during the cross-country treks to the gold fields and therefore are of considerable historical importance. The originals can be seen at the Huntington Library in San Marino, California.

Brush, George de Forest (1855-1941)
B. Shelbyville, Tennessee, September 28, 1855. D. Hanover, New Hampshire, April 24, 1941. Lived: New York; Dublin,

New Hampshire. Work: Metropolitan Museum of Art, New York; Boston Museum of Fine Arts, Massachusetts; Corcoran Gallery of Art, Washington, D.C. Fielding 1965 and Addendum; McCracken 1952; Mallett; Taft.

In 1881, following six years of study in Paris, Brush began his career by painting western Indians. He lived among the Crows in Montana Territory and on several Sioux reservations. After four years in the West, during which he gained acclaim but made few sales, Brush regretfully gave up this theme and settled in the East to paint more lucrative subjects. "Mourning Her Brave," "Killing the Moon," "The Indian and the Lily," and "The Picture Writer" are some of this internationally known artist's most popular paintings. During his later years, Brush occasionally painted an Indian picture from memory; he had been very fond of the Indians and never forgot his early impressions of them.

Bruton, Esther (1896-)
B. Alameda, California. Lived: Alameda and Monterey, California. Mallett; *WWAA*.

Bruton, Helen (1898-)
B. Alameda, California. Lived: Alameda and Monterey, California. Mallett; *WWAA*.

Bruton, Margaret (1894-)
B. Brooklyn, New York, 1894. Lived: Alameda and Monterey, California. *CAR*, Vol. XVI.

The story of Margaret Bruton extends in some degree to her sisters Esther and Helen, for they frequently joined her on sketching trips. However, they are known respectively for fashion illustrating and mosaic murals.

Margaret Bruton's Indian portraits and street scenes of Taos and Santa Fe were done in 1929 when she spent six months in New Mexico. In 1933 she spent several months in Nevada, sketching at Virginia City and other mining towns. Subsequent trips were made across country and to Mexico. Miss Bruton, who lived most of her life in Alameda, California, and later in Monterey, exhibited principally in Los Angeles and San Francisco.

Bryant, Harold Edward (1894-1950)

B. Pickrell, Nebraska, March 10, 1894. D. Grand Junction, Colorado, January 19, 1950. Lived: Chicago; New York City; Grand Junction. Work: Ruth R. Bryant Collection, Grand Junction. Look.

Following two years at the Art Institute of Chicago and a stint with the Army in World War I, Bryant returned to the family ranch near Grand Junction, Colorado. From there he went on a camping trip to northern Arizona where he mingled with the Navajo and the Hopi, making sketches with the idea of painting them later. In 1919 Bryant returned to Chicago to do commercial work. Two years later he visited the Four Corners area for more sketching. By the late twenties Bryant was a successful illustrator in New York, wondering if he should break loose from his profession and paint the kind of ranch life he had experienced as a boy—a life without the violence so ably depicted by Remington and Russell a half century earlier. Many years of discouragement intervened before the public found Bryant's ranch life paintings acceptable and accorded them the appreciation they deserved.

Buchser, Frank (1828-1890)

B. Switzerland, 1826. D. Solothurn, Switzerland, 1890. Lived: Switzerland. Work: City Art Museum of Saint Louis, Missouri. Bénézit.

In 1866 the Swiss artist Buchser came to this country to paint for his government key figures in the Civil War—generals, statesmen, and Negroes. He also painted in the West where he spent the summer with General Sherman. Buchser traveled along the Platte River, visited Fort Laramie in Wyoming, went on to Idaho, and back to Virginia Dale in northern Colorado; then he returned East by way of Denver and the Arkansas River. His oil paintings and drawings were entitled according to place and subject, adding to their historical value.

Some of Buchser's work can be seen at the City Art Museum of Saint Louis, and reproductions of his work are in *Westward the Way*, published by the Museum in collaboration with Walker Art Center in Minneapolis.

Buff, Conrad (1886-)
B. Speicher, Switzerland, January 15, 1886. Lived: Pasadena, California. Work: Fine Arts Gallery of San Diego, California; Detroit Institute of Art, Michigan; Boston Museum of Fine Arts, Massachusetts; Metropolitan Museum of Art, New York. Ainsworth 1960; Mallett; *WWAA*.

Much of Buff's work reflects his love of the West which began with his pleasant associations on a Wyoming ranch not long after leaving Switzerland in 1905. Desert country was his special interest, and he painted many landscapes in Utah, Arizona, New Mexico, and Southern California. He also illustrated several books about Southwest Indian life, such as *Dancing Cloud,* written by his wife Mary Marsh.

In Switzerland Buff was apprenticed to a baker when he was 14. Later his parents sent him to Munich to learn lace making. In the U.S.A. his early years were spent in the West doing ranch work, railroading, and house painting. Yet he found time to draw and paint, and without formal training he became one of the West's most capable artists.

Buisson, Daniel Shaw (1882-1958)
B. Wabasha, Minnesota, June 2. D. August 10. Lived: Montana, where he was known as the Painting Dentist.

Bull, Charles Livingston (1874-1932)
B. New York. D. May 22. Lived: Oradell, New Jersey. *AAA;* Bénézit; Fielding; Mallett; *WWA; WWWA.*

Bullock, Mary Jane Mc Lean (1898-)
B. Fort Worth, Texas, April 10. Lived: Fort Worth; summers: Woodland Park, Colorado. Mallett; *WWAA.*

Bunnell, Charles Ragland (1897-1968)
B. Kansas City. D. Colorado Springs, Colorado. Lived: Colorado Springs. Musick; Shalkop.

Burbank, Elbridge Ayer (1858-1949)
B. Harvard, Illinois, 1858. D. San Francisco, March 21, 1949. Lived: Muskogee, Oklahoma; San Francisco, California. Work: Field Museum and Newberry Library, Chicago,

Illinois; Smithsonian Institution, Washington, D.C.; Hubbell Trading Post Museum, Ganado, Arizona. Fielding; Mallett; Taft; Taylor.

Before Geronimo's death in 1909 he told Burbank that he liked him better than any white man he had ever known. Their friendship had begun in 1898 when Geronimo sat for his portrait, and thereafter Burbank often visited and painted the old warrior. Burbank made friends among the Indians not just because he paid them well for posing but because he liked them. Frequently they were his guests at meals, and on occasion they spent the night at his studio. They were painted whether they were famous or not, for Burbank chose them for their character. In all he painted representatives of more than 125 western tribes.

Burgdorff, Ferdinand (1883-)
B. Cleveland, Ohio, November 7. Lived: Pebble Beach, California. *AAA;* Fielding; Mallett; *WWAA.*

Burgess, George H. (1831-1905)
B. London, England. D. San Francisco, California, April 22. Lived: San Francisco. Groce and Wallace; *San Francisco Call,* April 23, 1905.

Burgess, Henrietta (1899-)
B. Auburn, California. Lived: Seattle, Washington. *AAA;* Mallett.

Burlin, H. Paul (1886-1969)
B. New York City, September 10. Lived: Paris; New York City; Taos, New Mexico. *AAA;* Fielding; Mallett; *WWA; WWAA.*

Burr, George Elbert (1859-1939)
B. Munroe Falls, Ohio, April 14, 1859. D. November 17, 1939. Lived: Denver, Colorado; Phoenix, Arizona. Work: Denver Public Library. Fielding; Mallett; Morse.

Burr began experimenting with etching techniques some time before going to Chicago in 1880 to study art. He did not remain there long, nor did he immediately take up art as a profession. In 1889 he went to work for *Leslie's Weekly* as a traveling

artist, a job he held for four years.

The largest collection of Burr's work is in Denver where he achieved recognition for his Rocky Mountain scenes which now make up a large part of the A. Reynolds Morse collection in the Denver Public Library. Also in that collection are many Arizona desert scenes, for ill health forced Burr to spend considerable time there, and finally in 1924 to move there permanently. Burr is nationally known for his etchings, pastels, and water colors of the West, and his work is in many museums and collections.

Burrell, Alfred Ray (1877-)
B. Oakland, California, March 4. Lived: Honolulu, Hawaii; San Francisco, California. Mallett; *WWAA*.

Bush, Ella Shepard (-)
B. Galesburg, Illinois. Lived: Seattle, Washington; Sierra Madre, California. *AAA;* Bénézit; Fielding; Mallett; *WWAA*.

Bush, Norton (1834-1894)
B. Rochester, New York, February 22. D. San Francisco, California. Lived: San Francisco. Bénézit; Fielding; Groce and Wallace; Mallett.

Bush, Richard J. (-)
Lived: California, 1865-1897. Oakland Art Museum.

Butler, George Bernard (1838-1907)
B. New York City. D. Croton Falls, New York, May 4. Lived: Europe; New York. *AAA;* Bénézit; Fielding; Groce and Wallace; Mallett; *WWWA*.

Butman, Frederick A. (1820-1871)
B. Gardiner, Maine, 1820. D. Gardiner, 1871. Lived: San Francisco, California, and Maine. Work: California Historical Society, San Francisco. Groce and Wallace; California State Library, Sacramento.

It has been claimed that Butman was California's first landscape painter, but at least one other, Thomas A. Ayres, preceded him by a number of years. Butman arrived in San Fran-

cisco sometime prior to his first exhibition there at the Mechanics
Institute Fair in 1857. Other exhibitions followed, including one
each in New York and Philadelphia.

In 1871 Butman returned to his home in Maine. At the
time of his death three months later, a San Francisco paper wrote
that he was "one of the most popular of our local artists." The
California Historical Society has a few of his historically impor-
tant oils of early San Francisco scenes.

Byxbe, Lyman (1886-)
B. Pittsfield, Illinois, February 28. Lived: Estes Park,
Colorado. Mallett; *WWAA*.

C

Cadenasso, Giuseppe (1858-1918)
B. Marogolla, Italy, 1858. D. San Francisco, California,
February 11, 1918. Lived: San Francisco. Work: Oakland
Art Museum and Mills College Art Gallery, Oakland, Cali-
fornia. *CAR*, Vol. XI; Mallett.

Cadenasso was born in Italy, but lived most of his life in
California. After spending several years on his uncle's ranch near
San Francisco, Cadenasso set out for the city, where he got a job
in a restaurant catering to artists. His caricatures of them—drawn
upon the restaurant walls during free time—brought his drawing
ability to their attention. With encouragement and a few free
lessons they got him off to a good start, but for economic reasons
it was many years before he completed his training.

In the late 1880s Cadenasso's atmospheric paintings of the
San Francisco Bay region with its picturesque eucalyptus trees
brought him recognition. The critics wrote about the "intense
light and shadow effects" in his landscapes and compared him
with Corot. For the last 16 years of his life Cadenasso taught art
at Mills College in Oakland.

Cahill, Arthur James (1878-)

B. San Francisco, California, May 15. Lived: San Antonio, Texas; Pasadena, California. Fielding; Mallett; *WWA*.

Cahill, William Vincent (-1924)

B. Syracuse, New York. D. Chicago, Illinois. Lived: Lawrence, Kansas; New York. *AAA;* Bénézit; Fielding; Mallett.

Caldwell, George Walker (1866-)

B. Lincoln, Vermont, September 12. Lived: Hollywood, California. *WWC*.

Calyo, Nicolino (1799-1884)

B. Naples, Italy. D. New York City, December 9. Lived: Spain; Baltimore, Maryland; New York City. Fielding; Mallett; Groce and Wallace; *WWWA*.

Camerer, Eugene (1830-)

B. Germany. D. Wurtenburg, Germany. Lived: Stockton and San Francisco, California. Groce and Wallace; Peters.

Cameron, Anna Field (1849-1931)

B. Berwick, Illinois, November 29. D. October 7. Lived: Chester, Nebraska. Bucklin.

Camfferman, Peter M. (1890-1957)

B. The Hague, Holland. D. Langley, Washington, November 15. Lived: Langley. *AAA;* Fielding; Mallett; *WWAA*.

Campbell, Albert H. (1826-1899)

B. Charleston, West Virginia, October 23, 1826. D. Ravenswood, West Virginia, February 23, 1899. Lived: West Virginia. Groce and Wallace; Peters; Taft.

Most of Campbell's art work was done from 1853 to 1855 while he was engineer and surveyor for the Whipple and Parke railway explorations. His sketches of Mojave villages on the Colorado river appeared in Lt. A. W. Whipple's published report (see *Pacific Railroad Reports,* Vol. III). Campbell's southern Arizona and California landscape sketches were made while he was with Lt. John G. Parke. The survey began at San Jose, proceeded south

to San Diego, and then east along the 32nd parallel to connect with Capt. John Pope's New Mexico-Texas survey.

During the Civil War, Campbell was chief of the Confederacy's Topographic Bureau. After the War he settled in West Virginia and worked as chief engineer for railroads.

Campbell, Blendon Reed (1872-)
B. Saint Louis, Missouri, July 28. Lived: New York City; Marysville, California. *AAA;* Bénézit; Fielding; Mallett; *WWAA.*

Campbell, Orson D. (1876-1933)
B. Fillmore, Utah, August 17. D. Provo, Utah, February 12. Lived: Utah. Haseltine; Mallett.

Capps, Charles Merrick (1898-)
B. Jacksonville, Illinois, September 14. Lived: Wichita, Kansas. Mallett; *WWAA.*

Carlsen, Emil (1853-1931)
B. Copenhagen, Denmark, October 19. D. January 4. Lived: San Francisco, California; New York City. *AAA;* Bénézit; Fielding; Mallett; *WWA; WWWA.*

Carlson, John Fabian (1875-1945)
B. Province of Smaland, Sweden, May 4. D. March 20. Lived: Woodstock, New York. *AAA;* Fielding; Mallett; *WWA; WWAA; WWWA.*

Carpenter, Ellen Maria (1830-c.1909)
B. Killingly, Connecticut, November 23. Lived: Boston, Massachusetts. Bénézit; Fielding; Groce and Wallace; Mallett; *WWA.*

Carter, Charles Milton (1853-1929)
B. North Brookfield, Massachusetts. Lived: Chicago, Illinois. *AAA;* Bénézit; Fielding; Mallett.

Carter, Pruett A. (1891-1955)
B. Lexington, Missouri. D. Hollywood, California, December 1. Lived: Los Angeles and Hollywood. *AAA;* Mallett; *WWAA.*

Carvalho, Solomon Nunes (1815-1897)

B. Charleston, South Carolina, April 27, 1815. D. New York City, May 21, 1897. Lived: Philadelphia, Pennsylvania; New York City. Work: Oakland Art Museum, California. Groce and Wallace; Taft.

Except for family portraits, little of Carvalho's work has come to light. In 1853-54 he served as artist and daguerreotypist for John Fremont's fifth expedition through the Rocky Mountains. The ordeal taxed Carvalho's strength beyond endurance, forcing him to recuperate in Utah. There he painted numerous portraits of Mormons before moving on to Los Angeles.

In Utah Carvalho was befriended by Brigham Young who invited him to join a party of Mormons bound for California. En route Carvalho sketched a number of Indian chiefs as well as places of scenic interest.

An account of Carvalho's experiences was published soon after his return to the East entitled *Incidents of Travel and Adventure in the Far West;* a 1954 edition of this book contains reproductions of the artist's few known works.

Casilear, John William (1811-1893)

B. New York City, June 25. D. Saratoga Springs, New York, August 17. Lived: New York. *DAB;* Fielding; Groce and Wallace; Mallett; *WWWA.*

Cary, William Montagne (1840-1922)

B. 1840. D. Brookline, Massachusetts, January 7, 1922. Lived: New York City. Work: Gilcrease Institute of Art, Tulsa, Oklahoma. Groce and Wallace; McCracken 1952; Taft.

Cary was an eastern artist and illustrator whose career began with a trip up the Missouri River in 1861. At Fort Union, Cary and two New York City companions joined an ox-wagon train for Fort Benton, and narrowly escaped capture by Crow Indians. At Fort Benton the three young men hired a guide and a cook and set out to cross the mountains. Fortunately they ran into the John Mullan railroad survey crew and accompanied them to Walla Walla, Washington.

For almost 30 years Cary illustrated the West for national magazines, mostly from recollection, as he made only one other western trip.

Cassidy, Gerald (1879-1934)

B. Cincinnati, Ohio, November 10, 1879. D. Santa Fe, New Mexico, February 12, 1934. Lived: Denver, Colorado; Albuquerque and Santa Fe. Work: Freer Collection, Washington, D.C.; Museum of New Mexico, Santa Fe; Fine Arts Gallery of San Diego, California. Coke; Fielding; Mallett.

Cassidy began his career in New York City as a poster painter. The desire to do serious painting led westward where he could paint Indians, the subject of his choice. He began in Denver, but in 1899 moved to Albuquerque for his health. There he drew New Mexico's Indians for the postcard trade. Following his move to Santa Fe in 1912, Cassidy achieved recognition for his murals, portraits, and landscapes. Although primarily a studio painter, much of his work came from first-hand observations, for his lifelong interest in the Indians led to frequent sketching trips to their domain.

Casterton, Eda Nemoede (1877-)

B. Brillion, Wisconsin, April 14. Lived: Chicago and Evanston, Illinois; Missoula, Montana. *AAA;* Fielding; Mallett; *WWAA.*

Catherwood, Frederick (1799-1854)

B. London, England, February 27. D. September 27, when S.S. *Arctic* sank en route to New York City. Lived: California 1850-54. Groce and Wallace.

Catlin, George (1796-1872)

B. Wilkes-Barre, Pennsylvania, July 26, 1796. D. Jersey City, New Jersey, December 23, 1872. Lived: New York; England; France. Work: American Museum of Natural History, New York; Smithsonian Institution, Washington, D.C.; University of Pennsylvania, Philadelphia. Barker; Ewers 1965; Fielding; Groce and Wallace; McCracken 1952; Mallett.

Catlin began the great work of his life in 1832 at Fort Union on the Missouri. From there he made canoe and overland trips to the various Indian tribes of that region. He was treated by them as a friend, invited into their homes, and allowed to paint their portraits and their ceremonies.

Late in 1836, after several trips to other regions of the West, Catlin returned east to prepare his exhibitions. He had visited some 48 tribes, made hundreds of paintings, and collected many costumes and artifacts.

The public flocked to Catlin's exhibitions in this country and abroad, but the kind of support he needed to place his collection in a great museum where it could be kept intact was not forthcoming. Moths and mice, water and fire took their toll before his Indian Gallery reached its Smithsonian home.

Caylor, H. Wallace (1867-1932)

B. Noblesville, Indiana, November 20, 1867. D. Big Spring, Texas, December 25, 1932. Lived: Kansas; Big Spring, Texas. Work: Heritage Museum, Big Spring. Dobie; Taft.

Caylor's aptitude for drawing led to his earning a living as an itinerant portrait painter during the early years of his life when he would have preferred being a cowboy—though he was one once for a few months in Kansas. Caylor sent Frederic Remington some samples of his work and asked if he could study under him. Remington wrote back: "You paint a better horse than I do. Go to nature for your study." In 1889 Caylor married Florence Nephler, and in 1893 they settled in Big Spring, Texas, on two sections of land. Caylor bought a few of the vanishing longhorns for sketching practice, rigged up a horse-drawn vehicle to carry his painting supplies and camping equipment, and accompanied by his wife followed the cattle drives and roundups.

In later years the entirely self-taught Caylor achieved considerable success in Texas with his ranch and roundup themes. Cattlemen, especially, were eager to have his work. Among his better-known paintings are "The Passing of the Old West," "Disputing the Trail," and "Prayer for Rain."

Chadwick (-)

Lived: California, 1850s. Boswell; Groce and Wallace.

Chain, Helen [Mrs. James A.] (1852-1892)

D. October 10, 1892, when S.S. *Bokhara* sank. Lived: Denver, Colorado. Hafen 1927, Vol. III.

Chalmers, Helen Augusta (1880-)
B. New York City, March 29. Lived: Laguna Beach, California. *AAA;* Mallett; *WWAA.*

Chamberlain, Norman Stiles (1887-)
B. Grand Rapids, Michigan, March 7. Lived: Los Angeles and Hermosa Beach, California; summers: Taos, New Mexico. *AAA;* Mallett; *WWAA.*

Chamberlin, Frank Tolles (1873-1961)
B. San Francisco, California, March 10. D. July 24. Lived: Pasadena, California. *AAA;* Bénézit; Fielding; Mallett; *WWA; WWAA; WWWA.*

Chapman, Kenneth Milton (1875-1968)
B. Ligonier, Indiana, July 13. Lived: Santa Fe, New Mexico. *AAA;* Fielding; Mallett; *WWA; WWAA.*

Charlot, Jean (1898-)
B. Paris, France, February 7. Lived: Mexico; New York City; Colorado Springs, Colorado. *AAA;* Mallett; *WWAA.*

Cheney, Russell K. (1881-1945)
B. South Manchester, Connecticut, October 16. D. July 12. Lived: Kittery, Maine; South Manchester. *AAA;* Fielding; Mallett; *WWA; WWAA; WWWA.*

Chin, Chee [Cheung-Lee, S.] (1896-)
B. Hoy Ping, Canton, China, May 4. Lived: San Francisco, California. *CAR,* Vol. XX; Mallett.

Chittenden, Alice Brown (1860-1934)
B. Brockport, Maine. Lived: San Francisco, California. *AAA;* Fielding; Mallett; *WWAA.*

Choris, Ludovik [Louis] (1795-1828)
B. Russia. D. Vera Cruz, Mexico, March 22. Lived: Russia; France; Mexico; California, as official artist for Otto von Kotzebue expedition of 1815-16. Mallett; Groce and Wallace; *WWWA.*

Chouinard, Nelbert Murphy (1879-1969)

B. Montevideo, Minnesota. D. Pasadena, California, July
9. Lived: Los Angeles and Pasadena. *AAA;* Fielding; Mallet; *WWA; WWAA.*

Christensen, C. C. A. (1831-1912)

B. Copenhagen, Denmark, November 28, 1831. D. Ephraim,
Utah, July 3, 1912. Lived: Ephraim, Utah; Denmark 1887-
89. Federal Writers' Project, *Utah;* Haseltine.

Carl Christensen was born in Denmark. His talent for cutting from paper any manner of object attracted the attention of
an admiral's widow who sent him to a Copenhagen art institute
for five years.

In 1857 Christensen moved to Utah, crossing the plains by
handcart and painting incidents and scenes of interest from
Nauvoo to Salt Lake City. In Sanpete County he settled down
to a life of hardship and sacrifice. His poetry and art work received little recognition from his pioneering neighbors, for they
could not understand why one would devote valuable time to
painting wheat fields and frontier life. His happiest years were
those during which he assisted with the decorating of Mormon
temples at Saint George, Manti, and Logan.

Clark, Allan (1896-)

B. Missoula, Montana, June 8. Lived: New York City;
Santa Fe, New Mexico. *AAA;* Fielding; Mallett; *WWAA.*

Clark, Alson Skinner (1876-1949)

B. Chicago, Illinois, March 25. D. March 22. Lived: Palm
Springs and Pasadena, California. *AAA;* Bénézit; Fielding;
Mallett; *WWA; WWAA; WWWA.*

Clark, Benton (1895-1964)

B. Coshocton, Ohio, July 25. Lived: New York. Mallett;
WWAA.

Clark, Emelia M. Goldworthy (1869-c.1956)

B. Platteville, Wisconsin, June 3. Lived: Los Angeles, California; Kalamazoo, Michigan. *AAA;* Fielding; Mallett;
WWAA.

Claveau, Antoine (-)
Lived: California 1854-72, principally in San Francisco. Groce and Wallace; *Alta California,* June 5, 1858.

Clawson, John W. (1858-1936)
Lived: California; Utah. Federal Writers' Project, *Utah.*

Clements, Edith Schwartz (-)
B. Albany, New York. Lived: Santa Barbara, California. Mallett; *WWC.*

Cloudman, J. D. (-)
Lived: San Francisco, California, 1852-53. San Francisco Directory; Oakland Art Museum.

Clunie, Robert (1885-)
B. Eaglesham, Scotland, June 29. Lived: Santa Paula, California. Mallett; *WWAA.*

Coast, Oscar Regan (1851-1931)
B. Salem, Oregon, July 2. D. Santa Barbara, California, February 28. Lived: Santa Barbara. *AAA;* Fielding; Mallett.

Cockcroft, Edythe (1881-)
B. Brooklyn, New York. Lived: Ramapo, Sloatsburg, and New York City, New York. *AAA;* Fielding; Mallett.

Coe, Ethel Louise (-1938)
B. Chicago, Illinois. D. March 22. Lived: Evanston, Illinois. *AAA;* Bénézit; Fielding; Mallett; *WWAA.*

Cogswell, William F. (1819-1903)
B. Fabius, New York, July 15. D. South Pasadena, California, December 25. Lived: New York; Missouri; Washington. *AAA;* Fielding; Groce and Wallace; Mallett; *WWWA.*

Colbert, F. Overton (1896-1935)
B. Riverside, Oklahoma, August 10. D. Fort Lyon, Colorado, March 20. *American Art News,* January 1, 1921.

Colburn, Elanor (1886-1939)

B. Dayton, Ohio. D. Laguna Beach, California, May 7. Lived: Chicago, Illinois; Laguna Beach. *AAA;* Fielding; Mallett; *WWAA.*

Colby, James (c.1822-)

B. Massachusetts. Lived: California 1858-64. Groce and Wallace.

Cole, George Townsend (1874-1937)

B. California. D. Los Angeles, October 4. Lived: Los Angeles. Comstock 1922; Fielding.

Coleman, Edmund Thomas (1823-1892)

B. England, 1823. D. London, 1892. Lived: London; Victoria, B.C. Work: Washington State Historical Society, Tacoma; Dr. and Mrs. Franz Stenzel Collection, Portland, Oregon. Stenzel and Stenzel 1963; Washington State Historical Society, Tacoma.

Coleman was an English artist who painted in the Pacific Northwest from 1863 until 1877. During those years he lectured, published articles about the mountain peaks of that region, climbed Mount Rainier, and painted coastal scenes along the Pacific Ocean and many spectacular mountain peaks along the Northern Pacific Railway passes.

A man of many interests, Coleman also served for a time as librarian for the Mechanics Institute in Victoria, B.C. He traveled and painted extensively in Vancouver as well as in Washington and Oregon. Not only was he one of the earliest artists in that area, but one of the most competent.

Colman, R. Clarkson (1884-)

B. Elgin, Illinois, January 27. Lived: La Jolla and Laguna Beach, California. *AAA;* Fielding; Mallett; *WWAA.*

Colman, Samuel (1832-1920)

B. Portland, Maine, March 4. D. New York, March 27. Lived: New York. *AAA;* Bénézit; *DAB;* Fielding; Mallett; *WWA; WWWA.*

Colton, Mary Russell (1889-)

B. Louisville, Kentucky, March 25. Lived: Flagstaff, Arizona. *AAA;* Mallett; *WWAA.*

Colton, Walter (1797-1851)

B. Rutland County, Vermont, May 9. D. Philadelphia, Pennsylvania, January 22. Lived: California, 1845-49. Groce and Wallace; *WWWA.*

Colyer, Vincent (1825-1888)

B. Bloomington, New York, September 30, 1825. D. Rowayton, Connecticut, July 12, 1888. Lived: New York; Darien and Rowayton, Connecticut. Fielding; Groce and Wallace; Mallett; Taft.

Colyer was both artist and public servant. In the latter capacity he served as a special United States Indian Commissioner from the late 1860s until the early 70s, traveling extensively in the West. He made many drawings and water colors, including such important pictorial records of the Southwest as "Old Fort Arbuckle, 1868," "Fort Gibson, March 11, 1869," and "On the Big Canadian River—May 1869."

Following Colyer's service as Commissioner, he returned east to resume his career as artist. He enlarged some of his western sketches for exhibitions in 1875 and 1876. Two Columbia River paintings were sent to the National Academy, and his "Cascade Mountains" and "Pueblo, Indian Village" were sent to the Philadelphia Centennial Exhibition.

Comparet, Alexis (1850-1906)

B. Indiana, 1850. D. Coronado Beach, California, May 14, 1906. Lived: Denver, Colorado; San Diego and Coronado Beach. Work: William and Dorothy Harmsen Collection, Denver, Colorado. Hafen 1948, Vol. II; Denver Public Library.

When Comparet was looking for a job in Denver, the story goes, he was asked by a bartender what he could do. "Play the guitar, paint pictures, and sing," was his reply. He was about 13 at the time, and had just run away from home.

Comparet was an artist of mystery. He is reported to have been discovered by Sarah Bernhardt, to have studied in Paris, to

have gotten his art training from Harvey Young in Colorado, to have been sent by his admirers to the East for art training, and to have exhibited in the better New York galleries. It is definitely known, however, that Comparet was a landscape artist of considerable talent, that he changed his name to Compera because it so often was mispronounced, and that his later years were spent in San Diego, California.

Coolidge, John Earle (1882-)
B. Carbondale, Pennsylvania. Lived: Los Angeles, California. *AAA;* Fielding; Mallett; *WWAA.*

Cooper, Astley David Montague (1856-1924)
B. Missouri, 1856. D. San Jose, California, September 10, 1924. Lived: San Jose. Work: Dr. and Mrs. Bruce Friedman Collection, San Francisco Bay area. California Historical Society, San Francisco; California State Library, Sacramento.

By the time Cooper was roaming the West from border to border, most of the Indians were on reservations, and the buffalo were almost gone. Nevertheless, he pictured himself following in the steps of George Catlin and painted the western scene as he imagined it to have been several decades earlier. Sometimes he did a creditable job, sometimes not.

Cooper was born in Missouri, but lived in California much of his life. He had studios in San Francisco and in San Jose but seldom exhibited in either place. His work is frequently seen in the Bay cities and occasionally in private collections throughout the Western states.

Cooper, Colin Campbell (1856-1937)
B. Philadelphia, Pennsylvania. D. November 6. Lived: Europe; Santa Barbara, California. *AAA;* Fielding; Mallett; *WWA; WWWA.*

Cooper, Frederick G. (1883-1926)
B. McMinnville, Oregon, December 29. Lived: Belvedere, California; Westfield, New Jersey. Fielding; Mallett; *WWA; WWAA.*

54

Cooper, George Victor (1810-1878)

B. Hanover, New Jersey, January 12. D. New York City, November 12. Lived: California 1849-1852. Groce and Wallace; Mallett; *WWWA*.

Cooper, James Graham (1830-1902)

B. New York City, June 9, 1830. D. Hayward, California, July 19, 1902. Lived: Hayward. Groce and Wallace; Taft.

Cooper was a physician, naturalist, and illustrator. During the 1853-55 War Department survey of a western railway route, headed by Isaac I. Stevens, Cooper did some sketches of Puget Sound and Mount Rainier which were reproduced in Stevens' published report (see *Pacific Railroad Reports*, Vol. XII). Although Cooper was a practicing physician when he joined the Stevens survey party, his reputation rests on his professional career as a naturalist. In California, where he ultimately settled, he became known as an ornithologist and a zoologist.

Cordero, Jose [Cardero] (1768-)

Artist with Galiano-Valdes expedition to California in 1792. Groce and Wallace; Van Nostrand and Coulter.

Cornell, John V. (-)

Lived: New York City; California, 1851-52. Groce and Wallace.

Cornwell, Dean (1892-1960)

B. Louisville, Kentucky, March 5. D. December 4. Lived: New York City. *AAA;* Fielding; Mallett; *WWA, WWAA, WWWA*.

Corwin, Charles Abel (1857-1938)

B. Newburg, New York. Lived: Chicago, Illinois; New York City. *AAA;* Fielding; Mallett.

Cory, Kate T. (1861-1958)

B. Waukegan, Illinois, February 8, 1861. D. Prescott, Arizona, June 12, 1958. Lived: Prescott. Work: Smithsonian Institution, Washington, D.C.; Sharlot Hall Museum and Smoki Museum, Prescott. Binheim; Fielding; Mallett; Shar-

lot Hall Museum, Prescott, Arizona.

Early in the 20th century Kate Cory left New York City and spent seven years on the Hopi Reservation. Her paintings of that period had special ethnological interest, so a collection of them quite appropriately ended up in the Smithsonian Institution.

Miss Cory was born in Illinois. She received her art education at Cooper Union and the Art Student's League in New York. Following her residence among the Hopi, Miss Cory settled in Prescott, Arizona, remaining there for 47 years. She was an artist of considerable stature whose choice of southwestern subjects for her landscapes and Indian studies added significantly to the art work of the West.

Cotton, John Wesley (1868-1932)
> B. Canada. D. Canada. Lived: Canada; Glendale, California. *AAA;* Fielding; Mallett; Selkinghaus.

Coulter, Mary J. (-)
> B. Newport, Kentucky. Lived: Santa Barbara, California; Amherst, Massachusetts. *AAA;* Fielding; Mallett; *WWAA.*

Coulter, William Alexander (1849-1936)
> B. Glengariff, Ireland. D. Sausalito, California, March 15. Lived: San Francisco, California. Mallett; *WWAA.*

Couse, Irving (1866-1936)
> B. Saginaw, Michigan, September 3, 1866. D. Taos, New Mexico, April 23, 1936. Lived: Washington; Taos, New Mexico. Work: Dallas Art Museum, Texas; Toledo Museum of Art, Ohio; Santa Barbara Art Museum, California. Coke; Fielding; Mallett.

Much has been made of the Indian's belief that his soul would pass to his portrait if his likeness were painted. Because Couse had trouble obtaining models among the Yakima and the Clickitat in Oregon, he believed this to be the cause. However, his compositional demands suggest a possible explanation, for his paintings exude a beauty and romance which the Indian unaccustomed to posing must have found an ordeal as he strove to please so exacting an employer.

In 1902, at the suggestion of Ernest Blumenschein and

Joseph Sharp, Couse spent a summer in Taos where the natives were more accustomed to posing for white artists. Thereafter Couse devoted most of his life to painting Pueblo Indians, and in 1909 made Taos his home.

Couthouy, J. P. (-)
In West Coast states. Groce and Wallace; Rasmussen (ms.).

Coutts, Alice (-)
Lived: Piedmont, California. Sloss Collection, California Historical Society, San Francisco.

Coutts, Gordon (1880-1937)
B. Scotland. Lived: Piedmont and Palm Springs, California. Bénézit; Fielding; Mallett.

Cowles, Russell (1887-)
B. Algona, Iowa, October 7. Lived: New York; Santa Fe, New Mexico. *AAA;* Fielding; Mallett; *WWAA.*

Cox, Charles Brinton (1864-1905)
B. Philadelphia, Pennsylvania. D. Camden, New Jersey. Lived: Camden. Eberstadt; Fielding; Mallett.

Cox, Kenyon (1856-1919)
B. Warren, Ohio, October 27. D. New York City, March 17. Lived: New York; Cornish, New Hampshire. *AAA; DAB;* Fielding; Mallett; *WWWA.*

Cox, Louise Howland King (1865-1945)
B. San Francisco, June 23. D. December 10. Lived: Hawaii; Mount Kisco, New York. *AAA;* Fielding; Mallett; *WWA; WWAA; WWWA.*

Cox, Palmer (1840-1924)
B. Granby, Quebec, Canada, April 28. D. Granby, July 24. Lived: New York; California; Granby. *AAA; DAB;* Fielding; Mallett; *WWA; WWWA.*

Cox, W. H. M. (-)
Lived: Colorado 1870s-1880s. *Colorado Collectors.*

Coxe, R. Cleveland (1855-)
B. Baltimore, Maryland. Lived: Seattle, Washington; Bronxville, New York. *AAA;* Fielding; Mallett.

Craig, Charles (1846-1931)
B. Morgan County, Ohio, 1846. D. Colorado Springs, c. October 1, 1931. Lived: Colorado Springs. Work: William and Dorothy Harmsen Collection, Denver, Colorado. Fielding; Mallett; Taft.

Craig made his first paints from indigo, gaboge, ground pebbles, and macerated cornstalks. With equal ingenuity he made his canvas from old bed sheets which he coated with flour paste and boiled in linseed oil.

Craig's first Indian portraits were painted when he went to Fort Benton by river packet in 1865. Those portraits marked the beginning of a long career as a painter of Indians, cowboys, and western landscapes. Craig was especially interested in the Utes, with whom he stayed for awhile, and the Pueblo Indians of Taos. Throughout the 1880s and the 1890s they were the subjects for much of his work.

For many years the lobby of the Antlers Hotel in Colorado Springs was Craig's exhibition hall, but many of his canvases were destroyed when the hotel burned down in 1898.

Craig, Thomas Bigelow (1849-1924)
B. Philadelphia, Pennsylvania, February 14. D. September 1. Lived: California; Rutherford, New Jersey. *AAA;* Fielding; Mallett; *WWA; WWWA.*

Cram, Alan Gilbert (1886-1947)
B. Washington, D.C., February 1. Lived: Santa Barbara, California. *AAA;* Fielding; Mallett; *WWAA.*

Crawford, Will (1869-1944)
Lived: Scotch Plains, New Jersey. Dykes; Mallett.

Critcher, Catharine Carter (1868-)
B. Westmoreland County, Virginia. Lived: Taos, New Mexico; Washington, D.C. *AAA;* Fielding; Mallett; *WWA; WWAA.*

58

Crocker, Charles Mathew (-)
Lived: Chicago, Illinois; California. *AAA*.

Cross, Henry H. (1837-1918)
B. Flemingville, New York, November 23, 1837. D. Chicago, Illinois, April 2, 1918. Lived: Chicago. Work: Walker Art Center, Minneapolis; Chicago Historical Society. Bucklin; Groce and Wallace; Mallett.

Although Cross painted various aspects of Indian life during his travels, he is best known for Indian portraits. His work, however, is more frequently seen in the midwestern states than it is in the West. Probably the largest collection is in the Walker Art Center in Minneapolis.

Cross was born in New York. In 1852 he traveled with a circus, and in 1853 he went to France for two years of study with Rosa Bonheur. Upon his return, he again traveled with a circus before settling in Chicago in 1860. During his western trips, Cross painted Sitting Bull, Spotted Tail, and many other famous Indians, and he also painted some of the early western heroes such as Kit Carson and Wild Bill Hickok.

Culmer, Henry L. A. (1854-1914)
B. Davington, England, March 25, 1854. D. Salt Lake City, Utah, February 10, 1914. Lived: Salt Lake City. Work: University of Utah and Utah State Capitol, Salt Lake City. Federal Writers' Project, *Utah;* James 1922; Mallett.

Culmer was born in England and moved to Utah at an early age. From boyhood he had wanted to be an artist, but not until four years before his death was he able to be a full-time one.

Early in Culmer's adult life he met Thomas Moran; the occasion was an exhibition of the latter's work in Salt Lake City. From then on Moran was Culmer's inspiration, even to the extent of his copying Moran's "Shoshone Falls"; it is said to be a commendable likeness but lacks the luminosity so characteristic of Moran's work.

During the last several decades, Culmer has come to be known as an important early Utah artist. He was adept with water color and oil, and his subjects extended beyond the confines of his adopted state to the Tetons of Wyoming and the cypresses of Monterey, California.

59

Cumming, Charles Atherton (1858-1932)
B. Knox County, Illinois, March 31. D. February 16. Lived:
Des Moines, Iowa; San Diego, California. *AAA;* Fielding;
Mallett; *WWA; WWWA.*

Cuneo, Cyrus (1879-1916)
B. San Francisco, California. D. London, England. Trip
through California 1908. Hogarth.

Cuneo, Rinaldo (1877-1939)
B. San Francisco, July 2, 1877. D. December 29, 1939.
Lived: San Francisco and Ross, California. Work: San
Francisco Academy of Fine Arts. *CAR,* Vol. XI; Fielding;
Mallett.
　　Cuneo was a lifelong resident of the San Francisco area.
While establishing himself as an artist he worked as an overseer
for a launch and tugboat service. Many sketches and paintings
of waterfront scenes were done during those years, some while
cruising on the Bay. Cuneo's paintings were small in size and
usually oil on paper, the latter an economy he defended by point-
ing out that even some of the old masters had used that medium.
Cuneo painted many landscapes from Marin to Salinas counties,
and from the High Sierras to Owens Valley. In 1928 he went to
Arizona to paint the desert. "The Alabama Range," "Hoodlum
Peak," "Rainy Season in the Desert," and "The Ancient Sea Bed"
are a few of his paintings singled out by art critics for special at-
tention.

Cuprien, Frank W. (1871-1948)
B. Brooklyn, New York. D. Laguna Beach, California, June
21. Lived: Laguna Beach. *AAA;* Fielding; Mallett; *WWAA.*

Currier, Cyrus Bates (1868-　　)
B. Marietta, Ohio, December 14. Lived: Los Angeles, Cali-
fornia. *AAA;* Fielding; Mallett; *WWAA.*

Currier, Edward Wilson (1857-1918)
B. Marietta, Ohio. Lived: San Francisco, California. *AAA;*
Mallett.

Currier, Walter B. (1879-1934)
B. Springfield, Massachusetts. Lived: San Gabriel and Santa Monica, California. *AAA;* Fielding; Mallett.

Curry, John Steuart (1897-1946)
B. Dunavant, Kansas, November 14. D. August 29. Lived: Westport, Connecticut; Madison, Wisconsin. *AAA;* Mallett; *WWWA.*

Curtis, Leland (1897-)
B. Denver, Colorado, August 7. Lived: Los Angeles and Twenty-nine Palms, California; summers: Moose, Wyoming. *AAA;* Mallett; *WWAA.*

Cutting, Francis Harvey (-)
Lived: Paso Robles and Campbell, California. *San Francisco News Letter,* Christmas 1925 issue; *Western Woman,* Vol. 13, No. 4.

D

Dahlgren, Carl (1841-1920)
B. Denmark. Lived: California. *Art in America,* September-October 1969.

Dahlgren, Marius (1844-1920)
B. Denmark. Lived: California; Arizona. *Art in America,* September-October 1969.

Dakin, Sidney Tilden (1876-1935)
Lived: Georgetown, San Francisco, and Oakland, California. California Historical Society, San Francisco.

Dale, John B. (-1848)
Naval officer and artist, Wilkes' U.S. Exploring Expedition,
1838-42. D. January 24. Groce and Wallace; Rasmussen.

Dann, Frode Nielsen (1892-)
B. Jelstrup, Havbro, Denmark, September 10. Lived: Los
Angeles and Pasadena, California. Mallett; *WWC.*

Danner, Sara Kolb (1894-)
B. New York City, October 2. Lived: South Bend, Indiana;
Santa Barbara, California. *AAA;* Mallett; *WWAA.*

Dasburg, Andrew Michael (1887-)
B. Paris, France, May 4. Lived: Santa Fe and Ranchos de
Taos, New Mexico. *AAA;* Fielding; Mallett; *WWAA.*

Davenport, Homer Calvin [Cari] (1867-1912)
B. Silverton, Oregon, March 8. D. May 2. Lived: Morris
Plains, New Jersey. *AAA;* Mallett; *WWWA.*

Davey, Randall (1887-1964)
B. East Orange, New Jersey, May 24. D. Santa Fe, New
Mexico, November 4. Lived: Santa Fe. *AAA;* Fielding;
Mallett; *WWA; WWAA; WWWA.*

David, Lorene (1897-)
B. Independence, Missouri, May 31. Lived: Beaumont,
Texas. Collins; *WWAA.*

Davies, Arthur Bowen (1862-1928)
B. Utica, New York, September 26. D. Florence, Italy, Oc-
tober 24. Lived: Rockland Lake, New York. *AAA;* Bénézit;
DAB; Fielding; Mallett; *WWA; WWWA.*

Davis, Cecil Clark (1877-1955)
B. Chicago, Illinois, July 12. D. September 12. Lived: Mar-
ion, Massachusetts; Santa Barbara, California. *AAA;* Field-
ing; Mallett; *WWA; WWAA; WWWA.*

Davis, Cornelia Cassady (1870-1920)
B. Cleveland, Ohio. D. Cincinnati, Ohio. Lived: Cincinnati.
AAA; Fielding; Mallett.

Davis, Jessie Freemont Snow (1887-)
B. Williamson County, Texas, February 22. Lived: Dallas,
Texas. *AAA*; Mallett; *WWAA.*

Davis, Leonard Moore (1864-1938)
B. Winchendon, Massachusetts, May 8. D. May 5. Lived:
Alaska; Los Angeles and Tarzana, California. *AAA;* Field-
ing; Mallett; *WWA; WWWA.*

Davis, Theodore R. (1840-1894)
B. Boston, Massachusetts, 1840. D. Asbury Park, New York,
November 10, 1894. Lived: New York. Work: New York
Public Library. Ewers 1965; Groce and Wallace; Taft.

During an illustrating assignment for *Harper's* in 1865,
Davis made a trip west by way of Louisiana, Texas, and Kansas
where he took the Butterfield Stage for Denver. En route the
stage was attacked by Indians which he helped to drive off. Davis
spent several months in the vicinity of Denver, principally in the
mining region around Central City; then he went on to Santa Fe.
His sketches were published in subsequent issues of *Harper's.*
Davis returned to the states in February 1866, but went west
again the following year. Indian troubles then were even more
prevalent, and Davis witnessed several skirmishes with the Sioux.
When cholera made its unwelcome appearance, he decided to
leave. His illustrations of western life continued to appear in
Harper's for a number of years, many of them apparently from
recollection, as no other western trips are known.

Dawes, Edwin M. (1872-1945)
B. Boone, Iowa, April 21. D. Los Angeles, California, March
26. Lived: Fallon and Reno, Nevada; Los Angeles. *AAA;*
Fielding; Mallett; *WWAA.*

Dawson-Watson, Dawson (1864-1939)
B. London, England. D. September 3. Lived: San Antonio,
Texas. *AAA;* Fielding; Mallett; *WWA; WWAA; WWWA.*

Deakin, Edwin (1838-1923)

B. Sheffield, England, May 21, 1838. D. Berkeley, California, May 11, 1923. Lived: California. Work: Oakland Art Museum, California. Fielding; Mahood; Mallett.

In California, where Deakin lived most of his adult life, he is best known for his paintings of the 21 Franciscan Missions. In 1900 he published a series in black and white, and in 1966 the Ward Richie Press published a series in color under the title *A Gallery of California Mission Paintings.*

Deakin was a competent landscapist who spent many months in Yosemite. He painted in other parts of California as well, and in Utah, Wyoming, Colorado, the eastern states, and Europe. However much Deakin considered himself a landscapist, it was to the Missions that he turned in 1870. His interest in ruins and historic architecture, which began in his native England where the "picturesque" style was in vogue, found its most satisfying outlet in painting these California missions.

Deas, Charles (1818-1867)

B. Philadelphia, Pennsylvania, December 22, 1818. D. 1867. Lived: Saint Louis and New York. Work: Brooklyn Museum, New York; Yale University Art Gallery, New Haven, Connecticut. Fielding; Groce and Wallace; McCracken 1952; Mallett.

"Rocky Mountain" was the name the dragoons gave Deas during his western trip with Major Wharton to the Pawnee villages on the upper Platte in 1844. It was inspired by the artist's colorful trapper's attire. Deas was no newcomer to the art of painting Indians. He had painted them in 1841 at Prairie du Chien where his brother was an army officer, and soon afterward had opened a studio in Saint Louis to serve also as headquarters for trips farther west. His paintings of the Indians were done in the romantic style of that day rather than in the realistic vein so popular with most other painters of the western scene.

De Camp, Ralph (1858-1936)

B. New York. Lived: Helena, Montana, 1896-1924. Federal Writers' Project, *Montana.*

De Cora, Angel (1871-1919)

B. Dakota County, Nebraska, May 3, 1871. D. Northhampton, Massachusetts, February 11, 1919. Lived: Pennsylvania and Massachusetts. Bucklin; Curtis.

The Winnebago artist Angel De Cora was born in Dakota County (later Thurston County), Nebraska. Her Indian name was Hinook Mahiwi Kilinaka, meaning "Fleecy Clouds Wafting into Place."

Miss De Cora studied at several famous eastern colleges and with Howard Pyle, the well-known illustrator and teacher. Upon one occasion he was asked whether he had ever had a real genius in his classes. "Yes, once," he replied, "But unfortunately she was a woman, and still more unfortunately, an American Indian."

Little is known of Miss De Cora's career, except that she exhibited at the Paris Salon in 1910, taught at Carlisle Indian School for several years, and worked as an illustrator. *Old Indian Legends,* a selection of Dakota Indian stories told by Zitkala Sa, and published in 1901, contains 14 illustrations by Miss De Cora.

De Forest, Lockwood (1850-1932)

B. New York, June 23. D. April 3. Lived: Santa Barbara, California. *AAA;* Fielding; Mallett; *WWA, WWWA.*

De Gavere, Cornelia [Cor] (1877-c.1956)

B. Java, West Indies, January 25, of Dutch parents. Lived: Santa Cruz, California. *AAA*; Mallett; *WWAA.*

Degen, Ida Day (1888-)

B. San Francisco, California, October 10. Lived: Glen Ellen, Mill Valley, and San Francisco, California. Mallett; *WWAA.*

De Haven, Franklin B. (1856-1934)

B. Bluffton, Indiana, December 26. D. New York, January 10. Lived: New York. *AAA;* Fielding; Mallett; *WWA; WWWA.*

Dehn, Adolf (1895-1968)

B. Waterville, Minnesota, November 22, 1895. D. New York City, May 19, 1968. Lived: New York City. Work: Metropolitan Museum of Art, New York; Art Institute of Chicago; Boston Museum of Fine Arts; City Art Museum of Saint Louis. Mallett; *Life,* August 11, 1941; *WWAA.*

Dehn was widely known for lithographs and water colors when the first of two Guggenheim awards made it possible for him to travel some 17,000 miles in 1939 to paint the American scene. Much of his time was spent in the western states which so impressed him that he returned frequently to paint them. His oils made their appearance in the 1950s and his acrylics in the 60s, adding new textures and techniques to his landscapes but never to the exclusion of lithographs and water colors.

With the idea in mind of becoming a cartoonist, Dehn began his studies at the Minneapolis School of Art in his native Minnesota. During the 1920s his satirizing of human foibles brought him to the attention of New York art critics. His paintings and lithographs since then—mostly landscapes—have kept him continuously in the public eye.

De Jong, Betty (1886-1917)

B. Paris, France. D. San Francisco, California. *AAA;* Mallett.

De Kruif, Henry Gilbert (1882-1944)

B. Grand Rapids, Michigan, February 17. D. Los Angeles, California, July 6. Lived: Los Angeles. *AAA;* Fielding; Mallett; *WWAA.*

De Lamater, Edgar (1859-)

B. Rockville, California, June 11. Lived: Utah. Carter.

Delano, Gerard Curtis (1890-1972)

B. Marion, Massachusetts, April 14, 1890. Lived: New York; Summit County and Denver, Colorado. Work: National Cowboy Hall of Fame, Oklahoma City; Santa Fe Railway Collection; William and Dorothy Harmsen Collection, Denver, Colorado. Carlson 1951; Mallett.

Delano's first drawings and paintings were of Indians on

horses, but his first trip to Indian country did not materialize until 1919. By then he was a New York illustrator of subjects far removed from his favorite theme. Two years later Delano returned west to homestead a claim on Cataract Creek in Colorado where he built a cabin. In 1933 he settled there permanently. It was not an easy life; winters in the high altitude were extreme; sales so far from the art market were few. Not until after his successful illustrations and text for "The Story of the West," a weekly western magazine feature, was Delano able to afford a winter studio in Denver.

Delano, who did not limit his work to Colorado scenes, is perhaps even better known for his paintings of Navajo country.

Dellenbaugh, Frederick Samuel (1853-1935)

B. McConnelsville, Ohio, September 13, 1853. D. New York City, January 29, 1935. Lived: New York. Work: Arizona Historical Society, Tucson; Museum of New Mexico, Santa Fe. Dellenbaugh; Fielding; Mallett.

In 1871 Dellenbaugh began his career as artist, writer, and explorer when he joined John Wesley Powell's second Grand Canyon expedition. Although only 17 at the time, Dellenbaugh served as artist and assistant topographer. From his sketches came the first oil paintings of the newly explored area. Many years later he published *A Canyon Voyage*, a detailed account of the venture.

Dellenbaugh's interest in the West was lifelong. He frequently sketched there and wrote several illustrated books about its history such as *The North Americans of Yesterday* (1900), *The Romance of the Colorado River* (1902), and *Breaking of the Wilderness* (1905).

Del Mue, Maurice August (1875-1955)

B. Paris, France. Lived: Forest Knolls, California. *AAA;* Fielding; Mallett; *WWAA.*

De Longpre, Paul (1855-1911)

B. Lyons, France, April 18. D. Los Angeles, California, June 29. Lived: New York City; Los Angeles and Hollywood, California. *AAA;* Mallett; *WWA; WWWA.*

Del Pino, Jose Moya (1891-)
B. Cordoba, Spain, March 3. Lived: San Francisco and Ross, California. Mallett; *WWAA*.

Deming, Edwin Willard (1860-1942)
B. Ashland, Ohio, August 26, 1860. D. New York City, October 15, 1942. Lived: New York. Work: Herron Art Institute of Indianapolis, Indiana; Metropolitan Museum of Art, New York; Black Hawk Museum, Wisconsin Historical Society, Madison, Wisconsin. Fielding; Mallett; Taft.

"Man-Afraid-of-His-Name" is the way Deming and De Cost Smith signed their illustrated articles for *Outing* magazine in the 1890s. The articles were about their experiences as artists among the Sioux and Crow Indians. For Deming it was the beginning of many years of illustrating books and articles as well as painting canvases for exhibition and sale.

Deming's training was typical of artists of his day, with study in Paris and at the Art Students' League in New York. His work among the Indians began in 1887 when he visited the Apaches, Pueblos, and Umatillas. It was the beginning of a lifetime interest in the West and its native inhabitants, and resulted in many landscapes and Indian paintings.

Dennison, George Austin (1873-)
B. New Boston, Illinois, November 20. Lived: Alma, California. Mallett; *WWA*.

Denny, Gideon Jacques (1830-1886)
Lived: California, principally in San Francisco. California Historical Society, San Francisco.

Deppe, Ferdinand (-)
In California 1832. Alfred Robinson, *Life in California* (1846); Webb.

De Suria, Tomas (1761-)
In California 1790 or 1791. Groce and Wallace; Van Nostrand and Coulter.

De Vol, Pauline Hamill (1893-)

B. Chicago, Illinois, October 7. Lived: San Diego, California. Mallett; *WWAA*.

Dewey, Alfred James (1874-)

B. Tioga, Pennsylvania, March 24. Lived: California. *WWC*.

De Wolf, Wallace L. (1854-1930)

B. Chicago, Illinois, February 24, 1854. D. Chicago, December 25, 1930. Lived: Chicago. Fielding; Mallett.

De Wolf was a businessman whose frequent trips from Chicago to the Pacific coast brought him in contact with southwestern desert country. Gradually his initial repugnance for that region turned to reverence, and he attempted to put on canvas the desert flora and atmospheric effects he found there. He also made a number of etchings of the area. Examples of his work are in George Wharton James' *New Mexico The Land of the Delight Makers.*

The self-taught De Wolf found subjects for his art in other areas of the West as well, and in British Columbia. He also found time as a member of the Chicago Art Institute's Print Committee to help build for that institution a remarkable collection of fine etchings.

De Yong, Joe (1894-)

B. Webster Grove, Missouri, 1894. Lived: Pasadena and Santa Barbara, California. Work: National Cowboy Hall of Fame, Oklahoma City. Ainsworth 1968; Mallett; *WWAA*.

De Yong's career as an artist began after his convalescence from meningitis which left him deaf. He first experimented with soap carvings in order to understand light and shadow values requisite for painting. Correspondence with Charlie Russell about an article Russell had written on that subject led to a lifelong friendship and many helpful suggestions. Those informal lessons, along with helpful hints from other Southern California artists, were all the instruction De Yong ever had.

Like Russell, De Yong had grown up in Saint Louis, had ridden for wages at an early age, and loved the West with a passion he yearned to express.

De Young, Harry Anthony (1893-1956)

B. Chicago, Illinois, August 5. D. January 15. Lived: San Antonio, Texas; summers, Alpine, Texas. *AAA;* Fielding; Mallett; *WWA; WWAA; WWWA.*

Diaz, Cristobal (-)

In California 1770. Groce and Wallace.

Dickey, S. (c.1840-)

B. Missouri. Lived: Coast Fork Precinct, Lane County, Oregon. Groce and Wallace.

Dickman, Charles John (1863-1943)

B. Demmin, Germany, May 14, 1863. D. October 24, 1943. Lived: San Francisco and Monterey, California. Work: San Francisco Museum of Art; Crocker Art Gallery, Sacramento, California. *CAR*, Vol. XI; Fielding; Mallett.

Dickman, a California resident for half a century, arrived in that state not as an artist but as a lithographer. He was 33 before he began formal art study in Europe which lasted five years. Thereafter he lived in Monterey 14 years and then moved to San Francisco.

Dickman preferred to paint marines, but made a number of sketching trips to Shasta, Lake Tahoe, Mexico, Death Valley, and Tonopah, Nevada. His reputation as "the painter of California sunlight" came in 1904 when he and Charles Rollo Peters exhibited at the Bohemian Club in San Francisco. Peters, a painter of moonlight scenes, interpreted the "blue" and Dickman the "gold" of California's state colors.

Dillingham, John E. (-)

Groce and Wallace; Hafen 1948, Vol. II.

Little is known about Dillingham, except that he settled in Colorado in 1861 and became a pictorial recorder of scenes now of historical importance. His lithographs, rarest of all early Colorado prints, were of the mining industry at Central City and the prominent buildings in Denver. He also did panoramic views of both places. His work ranks with that of Alfred Mathews and James Bagley whom he preceded.

Dillingham probably lived in or near Chicago before mov-

ing to Colorado, for the *Chicago Daily Press* of October 15, 1855 commented upon his winning a prize with a drawing he submitted to the Illinois State Fair.

Dinning, Robert James (1887-)
B. Omaha, Nebraska, June 8. Lived: Pasadena, California. Mallett; *WWAA*.

Dixon, Maynard (1875-1946)
B. Fresno, California, January 24, 1875. D. Tucson, Arizona, November 13, 1946. Lived: San Francisco; New York; Mount Carmel, Utah; Tucson, Arizona. Work: Brigham Young University, Provo, Utah; Southwest Museum, Los Angeles; M. H. De Young Museum, San Francisco; Fine Arts Gallery of San Diego. *CAR*, Vol. XI; Fielding; Mallett; Taft.

Dixon sought to "interpret the vastness, the loneliness" of the western scene. On the theory that by showing a little, much could be conveyed, he succeeded in bringing to his audience the very essence of an untamed and oftentimes inhospitable land. He did this through keen observation and unrelenting effort, for he was almost entirely without formal training.

In 1900 Dixon left California for a brief look at Arizona. The following year he studied life on the cattle ranches of Oregon, Northern California, and western Nevada. A year later Navajo and Hopi came under his scrutiny. Year after year, to all parts of the West and into Mexico, Dixon traveled by horseback, buckboard, or Model T. Notations as to person, place, and date appear on many of his drawings.

Dobson, Margaret A. (1888-)
B. Baltimore, Maryland, November 9. Lived: Santa Monica and Los Angeles, California. *AAA;* Mallett; *WWAA*.

Dolan, Elizabeth Honor (1884-1948)
B. Fort Dodge, Iowa, May 20. D. May 28. Lived: Lincoln, Nebraska. *AAA;* Mallett; *WWAA; WWWA*.

Donnelly, T. J. (-)
D. San Francisco, California, before 1868. Lived: San Francisco. Groce and Wallace.

Doolittle, Harold L. (1883-)
B. Pasadena, California, May 4. Lived: Pasadena. *AAA;*
Fielding; Mallett; *WWAA.*

Doolittle, Marjorie Hodges (c.1888-1972)
B. Nebraska. D. December 27. Lived: Los Angeles and
Carmel, California. Carmel Library.

Dorgan, Thomas Aloysius [Tad] (1877-1929)
B. San Francisco, California, April 29. D. Great Neck, New
York, May 2. Lived: New York. *AAA; DAB;* Mallett;
WWWA.

Dougal, William H. (1822-1895)
B. New Haven, Connecticut, January 20. D. Washington,
D.C. Lived: Washington, D.C. Fielding; Groce and Wallace;
WWWA.

Dougherty, Paul (1877-1947)
B. Brooklyn, New York, September 6. D. Palm Springs,
California, January 9. Lived: Carmel, California. *AAA;*
Fielding; Mallett; *WWA; WWAA; WWWA.*

Dow, Arthur Wesley (1857-1922)
B. Ipswich, Massachusetts. D. New York, December 13.
Lived: Ipswich. *AAA;* Fielding; Mallett; *WWWA.*

Drayton, Joseph (-)
Lived: Philadelphia, Pennsylvania; Washington, D.C.
Artist with Charles Wilkes expedition 1838-42. Groce and
Wallace.

Dressel, Emil (-)
In California and Oregon 1850s. Groce and Wallace; Peters.

Dripps, Clara Reinicke (1885-)
B. Amelia, Ohio, July 3. Lived: Culver City and Manhat-
tan Beach, California. Collins; *WWAA.*

Du Bois, Patterson (1847-1917)
B. Philadelphia, Pennsylvania. D. Philadelphia, August 8.
Lived: Philadelphia. *AAA;* Mallett; *WWWA.*

Ducasse, Mabel Lisle (1895-)
B. La Porte, Colorado. Lived: East Providence, Rhode
Island. *AAA;* Mallett; *WWAA.*

Duhaut-Cilly, Bernard Auguste (1790-1849)
In California 1828. Groce and Wallace; Van Nostrand.

DuMond, Frederic Melville (1867-1927)
B. New York. D. Monrovia, California. *AAA;* Bénézit;
Mallett.

DuMond, Helen S. (1872-)
B. Portland, Oregon, August 31. Lived: Lyme, Connecti-
cut. *AAA;* Fielding; Mallett; *WWAA.*

Dunbier, Augustus William (1888-)
B. Osceola, Nebraska, January 1. Lived: Omaha, Nebraska.
AAA; Fielding; Mallett; *WWAA.*

Duncan, Charles Stafford (1892-)
B. Hutchinson, Kansas, December 12. Lived: San Francisco,
California. *AAA;* Mallett; *WWAA.*

Duncan, Johnson Kelly (-)
In Fort Colville, Washington 1853-55. Smithsonian Institu-
tion, Anthropology Department.

Dunlap, Helena (-)
B. Los Angeles, California. Lived: Fullerton, California.
Fielding; *WWAA.*

Dunlap, James Bolivar (1825-1864)
B. Indianapolis, Indiana, May 7. D. Indianapolis, Septem-
ber 4. Lived: San Francisco, California 1850s. Groce and
Wallace; *WWWA.*

Dunlap, Mary Stewart (-)
B. Ohio. Lived: Pasadena, California. Fielding; Mallett.

Dunn, Harvey T. (1884-1952)
B. Manchester, South Dakota, March 8, 1884. D. October 29, 1952. Lived: Tenafly, New Jersey. Work: South Dakota State College, Brookings. Mallett; Reed 1966; *WWAA;*
Dunn grew up on the South Dakota prairie which he helped tame for the homesteading farmers by plowing under the prairie grass—"sod-busting" it was called. The money earned from that strenuous job enabled him to study at the Art Institute in Chicago, and later with Howard Pyle at Chadd's Ford, Pennsylvania.
Pyle's influence was widespread among illustrators, particularly so with Dunn who passed on Pyle's principles to later generations. As Harold Von Schmidt so aptly put it, Dunn showed his students how to paint the epic rather than the incident. It was that quality in Dunn's own work which made him one of the outstanding illustrators of his day. South Dakota State College in Brookings has a large collection of his work.

Dunn, Marjorie Cline (1894-)
B. Eldorado, Kansas, September 7. Lived: Sierra Madre and Laguna Beach, California. Mallett; *WWAA.*

Dunnell, John Henry (1813-1904)
B. Millbury, Massachusetts. D. New York City, January 25. Lived: California and New York. *AAA;* Groce and Wallace; Mallett.

Dunphy, Nicholas (1891-1955)
B. Seward, Nebraska, July 4. D. January 25. Lived: San Carlos and San Francisco, California. Mallett; *WWAA.*

Dunton, W. Herbert (1878-1936)
B. Augusta, Maine, August 28, 1878. D. Albuquerque, New Mexico, March 18, 1936. Lived: New York; Taos, New Mexico. Work: Witte Memorial Museum, San Antonio, Texas; Harwood Foundation, Taos, New Mexico; Whitney Gallery of Western Art, Cody, Wyoming. Fielding; Grant; Mallett; Reed 1966; Ringe.

Dunton had always liked to draw outdoors, and early in life he developed the practice of carrying a sketchbook, food, and a rifle wherever he went. Following his schooling he went to Livingston, Wyoming, where he rode the range as a cowboy, following the herds of cattle across the western states.

During the early years of his career, Dunton was an illustrator of western stories for several popular magazines. His natural attention to detail and desire for accuracy conflicted with a job where deadlines were more important. He therefore abandoned that kind of work in order to portray the West as it really had been in the early days. Cowboys, Indians, old settlers, hunters, and animals were painted in settings where even the atmospheric conditions had to be just right.

Duval, Ella Moss (1843-1911)
B. Pass Christian, Mississippi. D. Saint Louis, Missouri. Lived: Austin and San Antonio, Texas. Pinckney.

Duvall, Fannie Eliza (1861-)
B. Port Bryan, New York. Lived: Los Angeles, California. Mallett; *WWAA.*

Dye, Clarkson (1869-)
B. San Francisco, California. Lived: California. Fielding; Mallett.

Dye, Olive Bagg (1889-)
B. Lincoln, Nebraska, August 19. D. Lincoln. Lived: Los Angeles, California; Lincoln. *AAA;* Mallett; *WWAA.*

Dyer, Agnes S. (1887-)
B. San Antonio, Texas. Lived: East Orange, New Jersey. Collins; Fielding.

E

Eakins, Thomas (1844-1916)
B. Philadelphia, Pennsylvania, July 25. D. Philadelphia,
June 25. Lived: Philadelphia. *AAA;* Bénézit; *DAB;* Fielding; Mallett; *WWA; WWWA.*

East, Pattie Richardson (1894-)
B. Hardesty, Oklahoma, March 6. Lived: Fort Worth,
Texas. *AAA;* Mallett; *WWAA.*

Eastman, Harrison (1823-)
B. New Hampshire, c. 1823. Lived: San Francisco. Work:
Robert B. Honeyman, Jr. Collection, Southern California.
Groce and Wallace; California State Library, Sacramento.

Most of Eastman's adult life was spent in San Francisco
where he settled about 1849. As wood engraver, lithographer, illustrator, marine and landscape painter, he left many pictorial records of historical importance. He also established the lithographic
firm of Eastman and Loomis.

In 1852 John Bartlett brought Eastman a sheaf of field
sketches from his Mexican Boundary survey and his trip to the
quicksilver mines at New Almaden, California. Eastman made
some water colors from them which have been reproduced in
Bartlett's West by Robert V. Hine, and in other published works.
Eastman also did illustrations for *Annals of San Francisco, Weekly
Wide West,* and *Hutchings Illustrated California Magazine.*

Eastman, Seth (1808-1875)
B. Brunswick, Maine, January 24, 1808. D. Washington,
D.C., August 31, 1875. Lived: Washington, D.C. Work:
Corcoran Gallery of Art, Washington, D.C.; Peabody Museum, Harvard University, Cambridge, Massachusetts.
Barker; Fielding; Groce and Wallace; Mallett; Pinckney.

Eastman received his early training at West Point, and later
taught drawing there. His first government assignment of long
duration was a seven-year hitch at Fort Snelling, Minnesota,
among the Sioux.

In 1848 Eastman was sent to western Texas. *A Seth East-*

man Sketchbook, 1848-1849, published in 1961 by the University of Texas Press, contains reproductions of work done around San Antonio, Seguin, and Fredericksburg. In May 1855 Eastman was sent to Fort Duncan on the border of western Texas, and several months later to Fort Chadborne, well into Comanche country. About 70 of some 500 known works—drawings, water colors, and oils—were sketched during his Texas trips.

Eastmond, E. H. (1876-1936)
B. American Fork, Utah, June 1. D. Provo, Utah, August 17. Lived: Utah. Haseltine.

Eaton, Charles Frederick (1842-)
B. Providence, Rhode Island, December 12. Lived: Santa Barbara and El Montecito, California. Fielding; Mallett; *WWA, WWWA.*

Eaton, Charles Harry (1850-1901)
B. Akron, Ohio, December 13. D. Leonia, New Jersey. Lived: Leonia. *AAA;* Bénézit; Fielding; Mallett; *WWWA.*

Eaton, W. R. (1850-1922)
B. near Boston, Massachusetts. D. December 15. Lived: Park Ridge, New Jersey; Santa Monica, California. Bucklin.

Edmonston, William D. (-)
B. Scotland. Lived: Larkspur, Colorado, about 1871. Hafen 1948, Vol. II.

Edouart, Alexander (1818-1892)
B. London, England, November 5, 1818. D. Los Angeles, California, 1892. Lived: San Francisco and Los Angeles. Work: Robert B. Honeyman, Jr. Collection, Southern California. Mills.
 Edouart was born in England, received his college education in Edinburgh, Scotland, and his art education in Italy. In 1852 he went by Clipper ship to San Francisco where he remained until 1890 when he set up a photographic business with his sons in Los Angeles.

Edouart's historic painting, "Blessing of the Enrequita Mine in the Year 1859," is in the Robert B. Honeyman, Jr. collection in California. It depicts the dedication ceremony of a New Almaden quicksilver mine south of San Jose. (The use of cinnabar by the local Indians for body painting is said to have led to the discovery of quicksilver in that area.) An article by Edouart about the Enrequita Mine was published in the February 1860 issue of *Hutchings Illustrated California Magazine*.

Eggenhofer, Nick (1897-)

B. Gauting, Bavaria, 1897. Lives: Cody, Wyoming. Work: Read Mullan Gallery of Western Art, Phoenix, Arizona; National Cowboy Hall of Fame, Oklahoma City. Eggenhofer; Reed 1966.

Eggenhofer, who came to this country when he was 16, was born in Bavaria. Upon his arrival in New York, he studied art at night at Cooper Union with the idea of becoming a painter of the western scene, for he was a great admirer of Remington and Russell and an avid reader of western lore. Eggenhofer began his career by illustrating western stories for pulp magazines but soon found markets for his work among leading magazine and book publishers. More recently he has written and illustrated his own book, *Wagons, Mules and Men*, published in 1961, and been the subject of a book published in 1974.

Egloffstein, F. W. von (1824-1885)

B. Aldorf, Bavaria, May 18, 1824. D. New York City, 1885. Lived: New York. Groce and Wallace; Taft.

Egloffstein set out with John Fremont during the winter of 1853 to map a central route across the Rockies to the Pacific, and suffered hardships so severe he had to abandon the trip in February 1854. After resting a few weeks in Salt Lake City, he joined E. G. Beckwith's Survey of a route through Utah, Wyoming, Nevada, and California. Later he joined the 1857-58 Joseph C. Ives Survey of the Colorado River.

The Prussian-born Egloffstein was a man of many talents: inventor, writer, editor, artist, and topographical engineer. His ability and cooperation elicited most favorable comment from both Beckwith and Ives, and his many drawings of western scenes were reproduced in their published reports (see *Pacific Railroad Report*, Vols. II, XI; *Report upon the Colorado River of the West*).

Eilshemius, Louis Michel (1864-1941)
 B. Arlington, New Jersey, February 4. D. New York
City, December 29. Lived: New York City. *AAA;* Mallett;
WWAA; WWWA.

Eisenlohr, Edward G. (1872-1961)
 B. Cincinnati, Ohio, November 9. D. Dallas, Texas, June
6. Lived: Dallas. *AAA;* Fielding; Mallett; *WWAA.*

Elkins, Henry Arthur (1847-1884)
 B. Vershire, Vermont, May 30, 1847. D. Georgetown, Colo-
rado, July 1884. Lived: Chicago, Illinois; Kansas; Colorado.
Work: William and Dorothy Harmsen Collection, Denver,
Colorado. McCracken 1952; Mallett; Taft.
 Elkins, Henry Chapman Ford, and James F. Gookins, three
Chicago artists, left with their families early in the summer of
1866 for a vacation in the Rocky Mountain parks. Traveling by
wagon they joined an immigrant train at the Missouri River for
protection through Indian country. Their only frightening experi-
ence, however, was the "hurricane" which collapsed their tents
and blew over their wagons near Cottonwood, Nebraska.
 The lure of the West brought Elkins back several times
for landscape work in both Colorado and California. He had a flair
for mountain scenery, and enhanced his reputation considerably
with such paintings as "Storm on Mount Shasta," "Elk Park, Colo-
rado," and "The Thirty-eighth Star."

Elliott, Florence (1856-1942)
 B. Florence, Italy. D. Los Angeles, California. Lived: Colo-
rado; California. Society of California Pioneers, San Fran-
cisco.

Elliott, Henry Wood (1846-)
 B. Cleveland, Ohio, November 13. Lived: Cleveland.
WWWA; Kennedy Quarterly, June 1967.

Elliott, Ruth Cass (1891-)
 B. Los Angeles, California, July 22. Lived: Los Angeles and
Santa Monica, California. *AAA;* Mallett; *WWAA.*

Ellis, Fremont F. (1897-)

B. Virginia City, Montana, October 2, 1897. Lived: Santa Fe, New Mexico. Work: El Paso Museum of Art, Texas; Museum of New Mexico, Santa Fe. Coke; Fielding; Mallett; WWAA.

Ellis and four other new arrivals in Santa Fe formed an organization similar to the Taos Society of Artists which they called *Los Cinco Pintores.* Their dedication exhibition was held in 1921 at the Museum of New Mexico. The art backgrounds and interests of the five painters differed widely, and only Ellis and Will Shuster painted the western scene in representational style.

Ellis was born in Montana and had lived in California and Texas before moving to Santa Fe in 1919. He was largely self-taught, but like many other artists it did not prevent him from becoming a competent painter of landscapes, street scenes, and Indians.

Ellsworth, Clarence Arthur (1885-1961)

B. Holdredge, Nebraska, September 23, 1885. D. Hollywood, California, February 17, 1961. Lived: Omaha, Nebraska; Denver, Colorado; Los Angeles and Hollywood. Work: Southwest Museum, Los Angeles; Charles W. Bowers Memorial Museum, Santa Ana, California. Ainsworth 1968; Mallett 1940 Supplement; WWAA.

Ellsworth's lifelong interest in Indians began during boyhood in Nebraska where his many friendships among them began. Quite naturally they become the subjects of his paintings.

The self-taught Ellsworth worked ten years as an artist for Denver newspapers and seven years as a motion-picture title artist for Paramount Studios, the latter beginning in 1924. In addition he illustrated books and magazines. Among the former were two on the North American Indians for Mark Harrington when Harrington was curator of the Southwest Museum in Los Angeles. During the last years of Ellsworth's life, O. D. Wearin wrote a book about him called *Ellsworth—Artist of the Old West* which contains many reproductions of his work.

Elwell, R. Farrington (1874-1962)

Lived: Wickenburg and Phoenix, Arizona. Work: Read Mullan Gallery of Western Art, Phoenix. Ainsworth 1968;

Mallett 1940 Supplement.

Buffalo Bill Cody played a deciding role in Elwell's becoming an artist when he saw Elwell sketching cowboys and Indians at his Wild West show and invited him to spend a summer on his Wyoming ranch. That experience enabled Elwell to learn the West first-hand and to turn his sketching ability into a career. Later he was to become adept in sculpture as well. Elwell's friendship with Cody ultimately led to many years of employment as Cody's ranch manager. Thereafter Elwell lived for a time in Wickenburg, Arizona, where many of his western illustrations for Little Brown & Company were painted. His last years were spent in Phoenix where he continued to turn out competent work.

Emeree, Berla Iyone (1899-)
B. Wichita, Kansas, August 7. Lived: El Paso, Texas. *AAA;* Mallett; *WWAA.*

Englehart, Joseph E. (-)
Lived: Tacoma, Washington, late 1890s. Washington State Historical Society.

English, Harold M. (1890-)
B. Omaha, Nebraska, April 28. Lived: Paris; Beverly Hills, California. *AAA;* Mallett; *WWAA.*

Ertz, Edward Frederick (1862-)
B. Canfield, Illinois, March 1. Lived: Sussex, England. *AAA;* Bénézit; Fielding; Mallett; *WWA; WWAA; WWWA.*

Euwer, Anthony Henderson (1877-)
B. Allegheny, Pennsylvania, February 11. Lived: California; Portland, Oregon. Fielding; Mallett; *WWA.*

Evans, Edwin (1860-1946)
B. Lehi, Utah, February 2, 1860. D. California, March 4, 1946. Lived: Salt Lake City, Utah. Work: University of Utah, Salt Lake City; Brigham Young University, Provo, Utah. Fielding; Haseltine; Horne; Mallett.

Evans was a Western Union telegraph operator when his art work came to the attention of some Mormon church officials.

In 1890 they sent John Fairbanks, John Hafen, Lorus Pratt, and Evans to Paris for the study of art. Upon Evans' return to Salt Lake City, he organized the University of Utah's art department which he headed for 25 years. He was the first Utah art teacher to break with the teaching methods of Academie Julien where so many artists of his time studied, and to insist that his students be given a free hand in developing their style.

The charm of Evans' landscapes was due largely to his successful handling of atmospheric phenomena such as fog and mist and the varied moods of evening and daytime light.

Evans, Jessie Benton (1866-1954)
B. Akron, Ohio, March 24. Lived: Chicago, Illinois; Scottsdale, Arizona. *AAA;* Fielding; Mallett; *WWA; WWAA.*

Everett, Joseph Alma Freestone (1884-1945)
B. Salt Lake City, Utah, January 7. D. Salt Lake City, April 24. Lived: Salt Lake City. *AAA;* Mallett; *WWAA.*

Everett, Mary (1876-)
B. Miffinburg, Pennsylvania, December 30. Lived: Los Angeles, California. *AAA;* Mallett; *WWAA.*

Everett, Raymond (1885-)
B. Englishtown, New Jersey, August 10. Lived: Austin, Texas. *AAA;* Fielding; Mallett; *WWAA.*

Eytel, Carl (1862-1925)
B. Stuttgart, Germany. D. Palm Springs, California, 1925. Lived: Palm Springs. Work: California State Library, Sacramento. Ainsworth 1960; James 1906; Mallett.

Eytel learned about western ranch life and desert country in a Stuttgart library in his native Germany, and became so enamored with the prospect of painting it that neither lack of funds nor art training could deter him. Following his arrival in the West, he worked on ranches in California and Arizona and sketched horses and cattle in his spare time; when he had some money saved for art supplies and food, he set off alone for the Mojave or Colorado deserts.

In 1898 Eytel visited Germany, and upon his return settled

permanently in a little shack near Palm Springs. There he eeked out a meager living by painting cards and writing and illustrating articles for German newspapers. The high point in the career of this shy and sensitive artist came in 1906 with the publication of George Wharton James' *The Wonders of the Colorado Desert* which Eytel had illustrated.

F

Fairbanks, J. Leo (1878-1946)

B. Payson, Utah, April 30, 1878. D. Corvallis, Oregon, October 3, 1946. Lived: Salt Lake City and Corvallis. Work: Springville Art Museum, Utah. Fielding; Haseltine; Mallett; *WWAA.*

J. Leo Fairbanks was the son of one of Utah's early artists, John B. Fairbanks. His early training was taken in Paris, followed by further study at universities in New York and Chicago.

As director of art for Salt Lake City Public Schools and then as art department head for Oregon State College in Corvallis, much of Fairbanks' time was spent broadening the outlook of his students. But like his father he did not neglect Utah scenery, and was well known in that state as well as in Oregon for his landscapes. Murals, etchings, portraits, and sculptures were other areas in which Fairbanks became competent.

Fairbanks, John B. (1855-1940)

B. Payson, Utah, December 27, 1855. D. June 15, 1940, Salt Lake City. Lived: Payson, Provo, Ogden, and Salt Lake City, Utah. Work: Brigham Young University, Provo, Utah. Fielding; Haseltine; Horne; James 1922; Mallett.

Fairbanks was one of the early Utah artists who went to Paris in 1890 to study art at the behest of the Mormon church. Upon his return he assisted in the decoration of the Salt Lake City temple.

In 1900 Fairbanks was official artist and photographer for an exploration party which traveled through southern Utah, Arizona, Mexico, and Central and South America. Following that experience he went to New York for a short period of study.

Fairbanks is best known for his glowing harvestscapes, a subject he well knew from years of farming. He also did many landscapes of Zion National Park when it was called Little Zion Canyon, spending four summers there; in 1920 he began his Bryce Canyon paintings.

Fairchild, Hurlstone (1893-1966)
B. Danville, Illinois. Lived: Tucson, Arizona. Steadman, *La Tierra Encantada.*

Farnsworth, Alfred Villiers (1858-1908)
B. England. Lived: San Francisco, California. California Historical Society, San Francisco.

Farny, Henry F. (1847-1916)
B. Ribeauville, Alsace, 1847. D. Cincinnati, Ohio, December 24, 1916. Lived: Cincinnati and New York. Work: Cincinnati Art Museum; The Taft Museum, Cincinnati. Fielding; Mallett; Taft; *Cincinnati Gazette,* November 8, 1881.

In the fall of 1881 Farny returned to Cincinnati loaded down with sketches and Indian attire from his visit with the Sioux. To a reporter he remarked: "The plains, the buttes, the whole country and its people are fuller of material for the artist than any country in Europe."

About a hundred paintings were inspired by Farny's western trips in the 1880s. "Ration Day at Standing Rock Agency," "The Song of the Talking Wire," and "The Last Vigil" are among his most famous. His understanding of the Indian's plight is often apparent in his work. Farny's interest in Indians began during his boyhood in western Pennsylvania where he made friends among the Senecas, and it remained with him a lifetime.

Fausett, Lynn (1894-)
B. Price, Utah, February 27. Lived: Price. Mallett; *WWAA.*

Fechin, Nicolai (1881-1955)

B. Kazan, Russia, November 28. Lived: Taos, New Mexico; Los Angeles, California. *AAA;* Fielding; Mallett; *WWAA.*

Fenderich, Charles (-)

B. Baden, Germany. Lived: San Francisco, California. Groce and Wallace; Oakland Art Museum.

Fenn, Harry (1838-1911)

B. Richmond, England, September 14. D. Montclair, New Jersey, April 21. Lived: Montclair. *AAA;* Bénézit; Fielding; Mallett; *WWWA.*

Ferran, Augusto (1813-1879)

B. Palma, Island of Mallorca. Lived: California 1849-50. Groce and Wallace; Mills.

Fery, John (c.1865-1934)

B. Hungary. D. Everett, Washington, September 10. Lived: Arizona; Utah; California; Oregon; Washington. Haseltine.

Fiene, Ernest (1894-1965)

B. Elberfield, Germany, November 2. D. Paris, France, August 10. Lived:: Southbury, Connecticut; Colorado Springs, Colorado; New York City. *AAA;* Mallett; *WWAA; WWWA.*

Fisher, Harrison (1875-1934)

B. Brooklyn, New York, July 22. D. New York City, January 19. Lived: New York City. *AAA;* Fielding; Mallett; *WWA; WWWA.*

Fisher, Hugo (1867-1916)

B. Brooklyn, New York. D. Alameda, California. Lived: California. *AAA;* Fielding; Mallett.

Fiske, Frank Bennett (1883-1952)

B. Old Fort Bennett, Dakota Territory, 1883. D. 1952. Lived: Fort Yates, North Dakota. Barr; E. B. Robinson.

Fiske is better known as a photographer than as an artist,

partly because of his collection of 3,600 photographs of Indians at Standing Rock Reservation which he took over a period of many years. Whether Fiske was writing, telling stories, painting, or taking pictures, his subjects usually were cowboys and Indians. In 1950 his name was added to the Honor Roll of the American Artists Professional League "for the faithful recording and loyal interpretation of the culture of a people."

Fiske was born at old Fort Bennett in Dakota Territory. From the age of six he lived at Fort Yates where he pursued his various professions, including that of newspaperman, as well as artist and photographer.

Fleck, Joseph A. (1893-)
B. Vienna, Austria, August 25, 1893. Lived: Taos, New Mexico; Kansas City, Missouri. Work: Oklahoma City Municipal Collection; Museum of Fine Arts, Houston, Texas; University of Kansas City, Missouri; Breckenridge Museum, San Antonio, Texas. Luhan; Mallett; *WWAA*.

The Taos Society of Artists was organized in 1912 to handle traveling exhibitions for its members, and it was just such an exhibition that Joseph Fleck saw in 1924 in Kansas City. His immediate reaction was to move to Taos, which he did before the year was out. In Taos Fleck became as imbued with the scenes around him as earlier artists had. His portraits, landscapes, and murals reflected the new environment until 1941 when he became Artist-in-Residence and Dean of Fine Arts at the University of Kansas City. There his style of the Taos period was abandoned in favor of an experimental form more in keeping with the modern trend.

Fletcher, Calvin (1882-)
B. Provo, Utah, June 24. Lived: Logan, Utah. *AAA;* Fielding; Mallett; *WWAA*.

Fletcher, Frank Morley (1866-)
B. Whiston, England, April 25. Lived: Santa Barbara, Los Angeles, and Ojai, California. *AAA;* Mallett; *WWA; WWAA; WWWA*.

Fletcher, Godfrey B. (1888-1923)
B. Watsonville, California. D. Watsonville. Lived: Watsonville. *AAA;* Fielding; Mallett.

Fonda, Harry Stuart (1863-1942)
Lived: San Francisco and Monterey, California. *AAA*.

Foote, Mary Hallock (1847-1938)
B. Melton, New York, November 19, 1847. D. Boston, Massachusetts, June 25, 1938. Lived: Leadville, Colorado; Boise, Idaho; Grass Valley, California. Work: Worcester Art Museum, Massachusetts; Art Institute of Chicago, Illinois. Fielding; Mallett; Rogers; Taft.

Mary Hallock became an illustrator about 1865. Following marriage in 1876 to DeWint Foote, a mining engineer, she lived in the West. *Scribner's Monthly* published her illustrated articles about life in New Almaden, California, and nearby Santa Cruz. Other illustrated articles followed Mrs. Foote's Leadville, Colorado, experiences and appeared in both *Scribner's* and *The Century*.

Beginning in 1883 the Footes spent 10 years in Idaho, then moved to Grass Valley, California, where they lived for 30 years. Mrs. Foote's "Pictures of the Far West," an Idaho series published by *Century* in 1888 and 1889, is considered her most important contribution to Western illustration.

William Allen Rogers, staff artist for Harper Brothers, called Mrs. Foote "one of the most accomplished illustrators in America." She was also a novelist and a short-story writer.

Forbes, Helen K. (1891-1945)
B. San Francisco, California, February 3, 1891. Lived: San Francisco and Palo Alto, California. Work: Mills College Art Gallery, Oakland; San Francisco Museum of Art; San Diego Museum of Art. *CAR*, Vol. XVI; Fielding; Mallett.

Helen Forbes was a native San Francisco artist who studied both locally and abroad. She was best known for her frescoes, but many of her easel paintings are important to the California scene. In the late 1920s she depicted the arid wastes and stark ruggedness of the Mono Lake country, and her exhibits of this work received excellent reviews. In the early 1930s Miss Forbes lived for a time at an old deserted inn in Death Valley, 16 miles from the nearest gas station. She also painted at Virginia City, Nevada. The work done at those locations likewise enjoyed good reviews.

Ford, Helen Louise (1879-)

B. Placerville, California, June 29. Lived: San Francisco, California. *WWC*.

Ford, Henry Chapman (1828-1894)

B. Livonia, New York, 1828. D. Santa Barbara, California, February 27, 1894. Lived: Chicago; Santa Barbara. Work: Dr. and Mrs. Bruce Friedman Collection, San Francisco Bay area. Groce and Wallace; McCracken 1952; Taft.

Following discharge for physical disability during the second year of the Civil War, Ford returned to the life of an artist. In Chicago, where he opened a studio, he became known as the city's first professional landscape painter.

Early in the summer of 1866 Ford and his family set out in a wagon with the Henry Elkins and James Gookins families for a vacation of sketching in the Rocky Mountain parks. Like Elkins, Ford returned west several years later to paint more grand mountain landscapes. In 1875 he moved to Santa Barbara, California, where his interest in the missions resulted in a series of 24 etchings published in 1883 with the title *Etchings of the Franciscan Missions of California*.

Forsythe, Clyde (1885-1962)

B. Orange, California, 1885. D. 1962. Lived: New York City; San Marino, California. Work: Read Mullan Gallery of Western Art, Phoenix, Arizona. Ainsworth 1960; Fielding; Mallett; Perceval 1949.

Forsythe painted his first western landscape in 1904 while traveling on a train from California to New York City. It was a miniature oil on canvas of the desert. Following study at the Art Students' League, Forsythe became a successful cartoonist. In the 1920s he began painting the California desert and surrounding mountains, the prospectors, and the ghost towns. A decade or so later he had the novel experience of witnessing a gold strike in Nevada. Overnight a community of tents and shanties sprang up, reminiscent of earlier western mining towns. Forsythe did a lot of painting there during the little boom town's brief existence.

Fortune, E. Charlton (1885-1969)
B. Sausalito, California, January 15, 1885. D. Carmel, California, May 1969. Lived: San Francisco, Monterey, and Carmel, California. *CAR*, Vol. XII; Fielding; Mallett; Maribeth.

California, where Miss Charlton was born, is the scene of many of her landscapes and seascapes. Exhibitions of her work in San Francisco brought enthusiastic reviews, and such paintings as "Late Afternoon—Point Lobos," "Fisherman's Wharf of Monterey," and 'Interior of Carmel Mission" (purchased by artist William Chase) brought prizes as well. Miss Charlton also exhibited in various other American cities and in Glasgow, London, and Paris. From 1912 to 1921 she maintained a studio in Carmel, and in Monterey from 1927 until the close of her long career. About her work Miss Charlton said: "The conservatives think I am very modern and the moderns think I am completely conservative." Art critics, however, consider her work a bridge between the old and the new.

Foster, Ben (1852-1926)
B. North Anson, Maine. D. New York City, January 28. Lived: New York City. *AAA;* Bénézit; *DAB;* Fielding; Mallett; *WWA; WWWA.*

Foster, Will (1882-1953)
B. Cincinnati, Ohio, August 13. Lived: New York City. *WWAA; WWWA.*

Francisco, J. Bond (1863-1931)
B. Cincinnati, Ohio, December 14, 1863. D. Los Angeles, California, January 8, 1931. Lived: Los Angeles. Ainsworth 1960; Fielding; McWilliams; Mallett; *WWPS.*

Francisco, who moved from Cincinnati to Los Angeles in 1883, had studied art in Paris, and art and music in Berlin. Technically competent and proficient in several areas of painting by the time he reached Southern California, it was to desert subjects that he gave his greatest effort. Challenged by the "mocking" brilliance of Southwestern skies whose light changed the very "texture and shape" of surrounding mountains, Francisco sought to capture the essence of desert country. His inclusion of an oc-

89

casional burro and prospector place his paintings in an historical context as well. Like many other artists, Francisco painted the Grand Canyon, and for many years his painting was used to advertise one of the major railroad lines.

Franklin, Dwight (1888-)
B. New York City, January 28. Lived: New York City. *AAA;* Fielding; Mallett; *WWA; WWAA.*

Fraser, Douglass (1883-1955)
B. Vallejo, California, December 29. D. August 6. Lived: Vallejo and Santa Cruz, California. *AAA;* Mallett; *WWAA.*

Fraser, John Arthur (1838-1898)
B. London, England. D. New York City. Lived: Canada; New York. Hubbard 1960; Mallett.

Frazer, Mabel Pearl (1887-)
B. West Jordan, Utah, August 28. Lived: Salt Lake City, Utah. *AAA;* Mallett; *WWAA.*

Frederiksen, Mary (1869-)
B. Copenhagen, Denmark. Lived: Taos, New Mexico; Tucson, Arizona. *AAA;* Mallett; *WWAA.*

Freeman, W. R. (c.1820-c.1906)
B. New York. D. Saint Louis, Missouri. Lived: Indiana; Missouri; San Francisco, California. Groce and Wallace.

Fremont, John (1813-1890)
B. Savannah, Georgia, January 21. D. New York City, July 13. Lived: California, about 1850. Groce and Wallace; *WWWA.*

Frenzeny, Paul (1840-)
B. France. Lived: New York City and San Francisco, California. Taft.
In 1873 *Harper's Weekly* sent Frenzeny and Jules Tavernier on an extended tour across the country. It announced that they would not restrict themselves to main traveled routes but

would proceed by horseback into the remote areas of the West and Southwest. Both artists were from France—Tavernier having been in the country but two years and Frenzeny somewhat longer. The artists began their western sketching in Texas, working northward into Kansas and westward to California. Frenzeny remained in San Francisco five years before returning east, where he was last heard of. He did over a hundred western illustrations for Harrington O'Reilly's *Fifty Years on the Trail,* in addition to those he and Tavernier did for *Harper's.*

Fries, Charles Arthur (1854-1940)
B. Hillsboro, Ohio, August 14. D. December 15. Lived: San Diego, California. *AAA;* Fielding; Mallett; *WWAA.*

Fripp, Charles Edwin (1854-1906)
B. London, England, September 4. D. Montreal, Canada, September 21. In Alaska, British Columbia, and the Yukon 1898. Hogarth.

Froelich, Maren M. (-)
B. Fresno, California. Lived: San Francisco. Porter et al.

Froment-Delormel, Jacques Victor Eugene (1820-1900)
B. Paris, France. Bénézit; Mallett.

Frost, Arthur Burdett (1851-1928)
B. Philadelphia, Pennsylvania. D. Pasadena, California, June 22. Lived: Pasadena. *AAA;* Bénézit; Fielding; Mallett; *WWA; WWWA.*

Frost, George Albert (1843-)
B. Boston, Massachusetts. Lived: California 1872-89. Bénézit; Mallett.

Frost, John (1890-1937)
B. Philadelphia, Pennsylvania, May 14. D. June 5. Lived: Haverford and Bryn Mawr, Pennsylvania. *AAA;* Fielding; Mallett; *WWA; WWWA.*

Fulton, Fitch (1879-)
B. Beatrice, Nebraska. Lived: Glendale, California. Mallett.

G

Gale, Edmund Walker (1884-)
B. Corydon, Kentucky, December 28. Lived: Los Angeles, California. Mallett; *WWA; WWAA.*

Gamble, John Marshall (1864-1957)
B. Morristown, New Jersey, November 25. Lived: Santa Barbara, California. *AAA;* Fielding; Mallett; *WWAA.*

Gaspard, Leon (1882-1964)
B. Vitebsk, Russia. Lived: Chicago, Illinois; New York City; Taos, New Mexico. Fielding; Mallett; Waters; *WWA; WWAA.*

Gaul, William Gilbert (1855-1919)
B. Jersey City, New Jersey, March 31, 1855. D. New York City, December 21, 1919. Lived: New York City. Work: Toledo Museum of Art, Ohio; Peabody Institute, Baltimore, Maryland; Democratic Club, New York. Fielding; McCracken 1952; Mallett; Taft.

Gaul was in the West on several occasions from about 1882 to 1891, going as far as California. Although best known for his military scenes, he did a number of Indian and cowboy subjects. His western illustrations appeared in *Harper's Weekly, The Century Magazine,* and other periodicals.

With Peter Moran, Henry Poore, Julian Scott, and Walter Shirlaw, Gaul fulfilled a government census assignment in 1890 and 1891. Like the other artists, he not only depicted the Indians—he was assigned the Standing Rock and Cheyenne River agencies—but wrote about his observations for the 683-page document entitled *Report on Indians Taxed and Indians Not Taxed.* However, only two of Gaul's illustrations were reproduced in the report.

Gaw, William A. (1891-1973)
B. San Francisco, California, November 26. D. Berkeley, California, February 2. Lived: Berkeley. *AAA;* Mallett; *WWAA.*

Gearhart, May (-)
B. Gladstone, Illinois. Lived: Pasadena, California. Mallett; *WWAA*.

Gellert, Emery (1889-)
B. Budapest, Hungary, July 24. Lived: Hollywood, California. *AAA;* Mallett; *WWAA*.

Gentilz, Theodore (1819-1906)
B. France, 1819. D. San Antonio, Texas, 1906. Lived: Castroville and San Antonio, Texas. Work: Witte Museum, San Antonio; Dallas Museum of Fine Arts; Daughters of the Republic of Texas Library, San Antonio. Barker; Groce and Wallace; Pinckney.

In 1843 the French artist Gentilz moved to Texas where he spent the first year in San Antonio awaiting Count Castro's settlement of a French colony on the Medina River. When Castroville got under way the Count found Gentilz' knowledge of English helpful in dispensing his official correspondence and soon expanded Gentilz' duties to include surveying. While living at Castroville, Gentilz maintained a studio in San Antonio in order to market his work. He regularly walked the intervening 30 miles and frequently traded a sketch for some buffalo meat when he passed an Indian camp.

During surveying assignments in Texas and Mexico, Gentilz utilized every opportunity to draw and paint the Mexicans and the Indians. Although many of the latter were considered hostile, he was usually able to win their friendship and cooperation.

Geritz, Franz (1895-1945)
B. Hungary, April 16. Lived: Los Angeles, California. Fielding; Mallett; *WWAA*.

Gerste, William Lewis (1868-)
B. San Francisco, California, January 28. Lived: San Francisco. *AAA;* Fielding; Mallett; *WWAA*.

Gibberd, Eric Waters (1897-)
B. London, England. Lived: Taos, New Mexico. Gibberd; *WWAA*.

Gibbs, George (1815-1873)

B. Sunswick, Long Island, New York, July 17, 1815. D. New Haven, Connecticut, April 9, 1873. Lived: Fort Steilacoom, Washington; New York; Washington, D.C.; Connecticut. Work: Smithsonian Institution, Washington, D.C. Groce and Wallace; California State Library, Sacramento.

Gibbs accompanied the Mounted Rifle Regiment to Oregon in 1849, and remained in the Pacific Northwest for about 12 years. Some of his drawings during that period, and quite possibly some of Andrew J. Lindsay's, appeared in Major Osborne Cross' book about his experiences, but in error were credited to Cross.

Gibbs had been librarian for the New York Historical Society for about seven years before settling in the West. At Fort Steilacoom, Washington, where Gibbs lived for nearly 10 years, he studied Indian linguistics and ethnology. The materials he compiled and the drawings he made are in the Smithsonian Institution in Washington, D.C.

Gifford, Charles B. (1823-1880)

B. Massachusetts. Lived: California. Groce and Wallace; Mallett.

Gifford, Robert Swain (1840-1905)

B. Naushon Island, Massachusetts, December 23. D. New York City, January 15. Lived: New York City. *AAA;* Bénézit; *DAB;* Fielding; Groce and Wallace; *WWAA.*

Gifford, Sanford Robinson (1823-1880)

B. Greenfield, New York, July 10. D. New York City, August 29. Lived: New York City. Bénézit; *DAB;* Fielding; Groce and Wallace; Mallett; *WWWA.*

Gilbert, Arthur Hill (1894-)

B. Chicago, Illinois, June 10. Lived: Stockton and Monterey, California. *AAA;* Fielding; Mallett; *WWA; WWAA.*

Gilder, Robert Fletcher (1856-1940)

B. Flushing, Long Island, New York, October 6, 1856. D. Omaha, Nebraska, March 7, 1940. Lived: Omaha and Lincoln, Nebraska. Bucklin; Fielding; Mallett.

Gilder was a well-known Nebraska landscape painter and archeologist. In the latter capacity he discovered much prehistoric material in Nebraska and adjoining states and also served for 12 years as archeologist at the University of Nebraska Museum.

Gilder's landscapes cover an even broader area, encompassing the southwestern states and the Missouri River basin. Such paintings as "Arizona Desert," "San Gabriel Canyon, California," and "Where Rolls the Broad Missouri" are in public buildings and clubs in many cities. His numerous landscapes featuring the Missouri River have contributed substantially to his reputation as one of Nebraska's most prominent artists.

Gile, Selden Connor (1877-1947)
B. Stow, Maine, March 20. Lived: Belvedere, California. *AAA;* Mallett; *WWAA.*

Gilliam, Marguerite Hubbard (1894-)
B. Boulder, Colorado. Lived: Boulder. *AAA;* Mallett; *WWAA.*

Gilstrap, W. H. (1840-1914)
B. Effingham County, Illinois, April 24. D. Tacoma, Washington, August 2. Lived: Tacoma. *AAA;* Groce and Wallace; Mallett.

Glass, Bertha (1884-)
B. Maryville, Missouri, January 28. Lived: San Francisco, California. Mallett; *WWAA.*

Gleason, Duncan (1881-1959)
B. Watsonville, California, August 3. D. Los Angeles, March 9. Lived: Hollywood, California. *AAA;* Mallett; *WWAA.*

Gloe, Olive (1896-)
B. Murray, Utah. Lived: Utah. Springville [Utah] Museum of Art, *Permanent Collection Catalog.*

Goddard, George Henry (1817-1906)
B. Bristol, England. D. Berkeley, California. Lived: Sacramento and San Francisco, California. Groce and Wallace; Peters.

Golden, Charles O. (1899-)
B. Newlon, West Virginia. Lived: Pennsylvania; Tucson, Arizona. Mallett; *WWAA*.

Gollings, Elling William (1878-1932)
B. Pierce City, Idaho, 1878. D. Sheridan, Wyoming, 1932. Lived: South Dakota, Montana, and Wyoming. Work: Dr. and Mrs. Franz Stenzel Collection, Portland, Oregon. Federal Writers' Project, *Wyoming;* Gollings; Wills.

Gollings grew up on a ranch in Idaho, went to high school in Chicago, and then returned West to work as a cowboy. He saw action in many a notorious but romantic mining and cattle town, especially in Wyoming and the Dakotas. Gollings' hero was Remington, but the thought of following in his footsteps did not occur to Gollings until he was 31 and had been painting for about six years. Thereafter he established a studio in Sheridan, Wyoming, but continued to supplement his earnings by breaking horses and punching cattle. As the Old West withered away, his work became important for its accuracy as well as its beauty.

Goodwin, Richard La Barre (1840-1910)
B. Albany, New York, March 28. D. Orange, New Jersey, December 10. Lived: Colorado Springs, Colorado; Portland, Oregon; California. Groce and Wallace; Richardson.

Gookins, James F. (1840-1904)
B. Terre Haute, Indiana, December 10. D. New York City, May 23. Lived: Chicago, Illinois; Terre Haute and Indianapolis, Indiana. Groce and Wallace; Mallett.

Gordon-Cumming, Constance Frederica (1837-1924)
In California 1878. Oakland Art Museum.

Gotzsche, Kai G. (1886-)
B. Copenhagen, Denmark. Lived: Taos, New Mexico; Los Angeles, California; Elmhurst, Long Island, New York. *AAA;* Mallett.

Gourley, Bess E. (-)
> B. American Fork, Utah. Lived: Los Angeles, California; Provo, Utah. Springville [Utah] Museum of Art, *Permanent Collection Catalog.*

Grafstrom, Olaf (1855-1933)
> B. Sweden. "View of Portland, Oregon" in De Young Museum permanent collection, San Francisco, California.

Graham, Charles (1852-1911)
> B. Rock Island, Illinois, 1852. D. New York City, August 9, 1911. Lived: California; New York City. Work: Denver Art Museum, Colorado. Rogers; Taft.
>
> Graham's career paralleled that of his friend William Rogers. They began their employment at *Harper's* about the same time, and neither had formal art training. Graham's first important western assignment was to illustrate the driving of the golden spike joining the Northern Pacific in 1883; years earlier he had been the topographer for the Northern Pacific Survey.
>
> During the decade of the 1880s well over a hundred of Graham's western illustrations appeared in *Harper's Weekly.* More followed in 1890 and 1891 when he was assigned to South Dakota, the Pacific Coast, and New Mexico. Graham also did a number of water colors for exhibition, and in later life turned to oils. Few of those paintings, however, are of western subjects.

Graham, Robert Alexander (1873-1946)
> B. Iowa, June 29. D. August 19. Lived: New York City; Denver, Colorado. *AAA;* Fielding; Mallett; *WWAA.*

Graham, William (1832-1911)
> B. New York. D. Buffalo, New York. Fielding; Groce and Wallace; Mallett.

Grandmaison, Nickola de (1892-)
> B. Russia, February 24, 1892. Lived: Banff, Alberta, Canada. Work: Manitoba Law Society; Woolaroc Museum, Bartlesville, Oklahoma. Macdonald; *WWAA.*
>
> Grandmaison, a Canadian artist, spent a good deal of time painting portraits of Indians. Shortly after moving from Russia

to Banff, Alberta, in 1923, he began his sketching trips southward. In 1925 he switched from oils to pastels which he found more suitable for use while traveling through the reservations of the western tribes. Grandmaison considered it an honor to paint the Indians, and this attitude undoubtedly was conducive to cooperation on their part. He is said to be the only painter allowed to portray High Eagle, last survivor of the Custer fight. In recounting his experiences, Grandmaison has had nothing but praise for the exemplary demeanor of Indian sitters; on the other hand, he has been extremely critical of his other sitters, among whom were a number of Canadian political leaders.

Grant, Blanche Chloe (1874-1948)

B. Leavenworth, Kansas, September 23, 1874. D. Taos, New Mexico, 1948. Lived: Taunton, Massachusetts; Taos, New Mexico. Work: Harwood Foundation, Taos; murals, Taos Community Church. Binheim; Mallett; *WWAA.*

Blanche Grant was an artist of considerable talent and training who had achieved recognition in the East before coming to Taos, New Mexico, in 1920. Not only did she do many oil paintings of the Indians, in whom she became intensely interested, but she wrote a number of books about Taos and the Southwest and also researched material for other authors. Of special interest is *When Old Trails Were New,* an historical account of northwestern New Mexico, for in this book Miss Grant devoted a chapter to early Taos artists.

Although Miss Grant exhibited widely and is represented in art museums in this country and abroad, her work is seldom seen in the Southwest.

Grant, Charles Henry (1866-1939)

B. Oswego, New York, February 6. D. January 21. Lived: San Francisco, California. *AAA;* Fielding; Mallett; *WWA; WWWA.*

Graves, Martha Primrose (1873-1966)

B. near Gainesville, Texas, January 3. D. Ruidoso, New Mexico, June 23. Lived: Ysleta, Texas; Ruidoso; Wickenburg, Arizona.

Gray, Percy (1869-1952)

B. San Francisco, California, October 3. Lived: San Francisco and Monterey, California. *AAA;* Fielding; Mallett; *WWAA.*

Greatorex, Eliza Pratt (1820-1897)

B. Manor Hamilton, Ireland, December 25. D. Paris, France, February 9. Lived: Colorado Springs, Colorado; New York City; Europe. Fielding; Groce and Wallace; Mallett; *WWWA.*

Green, Rena (1874-)

B. Sedalia, Missouri, February 10. Lived: San Antonio, Texas. Mallett; *WWAA.*

Greenbaum, Joseph (1864-)

B. New York City, November 17. Lived: San Francisco and Los Angeles, California. *WWPS.*

Greene, Le Roy E. (1893-)

B. Dover, New Jersey, November 25. Lived: Billings, Montana. Mallett; *WWAA.*

Gregg, Paul (1876-1949)

B. Baxter Springs, Kansas. Lived: Denver, Colorado.

Gremke, Henry Dietrick [Dick] (1869-1939)

B. California. Lived: California. *Sunset,* March 1901.

Grenet, Edward Louis (1857-1922)

B. San Antonio, Texas, November 13, 1857. D. 1922. Lived: San Antonio and France. Work: Private collections in Austin, Texas, and Maitland, Florida. Federal Writers' Project, *Texas;* Mallett; Pinckney.

The Texas-born Grenet set the stage for his career by doing a portrait of a neighbor who also had some knowledge of painting, and then got both father and neighbor to admit he had done a good job. Thus he obtained his father's permission to study art in New York.

Grenet early recognized the importance of foreign study to

artists of his day, and soon left New York for France. In 1878 he returned to San Antonio, opened a studio, and painted genre subjects and portraits. In 1884 he returned to France for 20 years, exhibiting in various European cities. In portraiture he was especially successful, but his genre subjects are more important to the western scene.

Griffin, James Martin (-)
Lived: California 1885-1931. Oakland Art Museum.

Griffith, William Alexander (1866-1940)
B. Lawrence, Kansas, August 9. D. Laguna Beach, California. Lived: Laguna Beach. *AAA;* Fielding; Mallett; *WWAA.*

Grigware, Edward T. (1889-)
B. Caseville, Michigan, April 3. Lived: Oak Park, Illinois; summers: Cody, Wyoming. *AAA;* Fielding; Mallett; *WWAA.*

Griset, Ernest Henry (1844-1907)
B. France. D. England, March 22. Lived: England. Bénézit; Mallett; McCracken 1952.

Grob, Trautman (-)
Lived: San Francisco, California, 1856-61. Groce and Wallace; Peters.

Groll, Albert Lorey (1866-1952)
B. New York City, December 8, 1866. D. New York City, October 2, 1952. Lived: Santa Fe, New Mexico; New York City. Work: Corcoran Gallery of Art, Washington, D.C.; Metropolitan Museum of Art, New York City; Museum of Northern Arizona, Flagstaff. Fielding; McCormick; Mallett; *WWAA;* Museum of Northern Arizona, Flagstaff.

Chief Bald-Head-Eagle-Eye was the name given this New York City artist by his Pueblo Indian friends in the Southwest. Groll's ability to depict their land brought not only their admiration but that of many others; by the early 1920s his work was in art museums throughout the country and in Europe.

Much of Groll's New Mexico work was done around Laguna Pueblo, Taos, and Santa Fe. He also painted in Arizona, Colorado, California, and Nevada. The style of his Nevada and California landscapes is reminiscent of his Rockaway Beach and Sandy Hook paintings of the 1890s. His Arizona and New Mexico landscapes are distinctive for their towering cloud formations over deserts and bare mesas.

Grunsky, Carl Ewald (1855-1934)
B. San Joaquin County, California, April 4. D. January 9. Lived: Berkeley, California. *WWWA.*

Guenther, Pearl Harder (1882-)
B. Winnipeg, Manitoba, Canada. Lived: Los Angeles, California. Collins; *WWAA.*

Guislane, J. M. (1882-)
B. Louvain, Belgium. Lived: New York; Colorado Springs, Colorado 1908-09. Fielding.

Gullickson, Gustav I. (1855-1941)
B. Norway. Lived: Grand Forks, North Dakota. Barr.

Gustin, Paul Morgan (1866-)
B. Vancouver, Washington. Lived: Seattle, Washington. *AAA;* Fielding; Mallett; *WWAA.*

H

Haag, Herman H. (1871-1895)

B. Stuttgart, Germany, October 15. D. Salt Lake City, Utah, October 12. Lived: Salt Lake City. Haseltine.

Hadra, Ida Weisselberg (1861-1885)

B. Castroville, Texas, 1861. D. San Antonio, Texas, 1885. Lived: Austin and San Antonio, Texas. Work: Private collection in Dallas, Texas. Pinckney.

During the development of the West, when few women had either the time or the training to paint, Texas was fortunate in having several who did. Ida Weisselberg began studying art with Ella Moss Duval, a portrait painter of considerable ability. When Mrs. Duval moved from Austin to San Antonio, Miss Weisselberg studied with Herman Lungkwitz at the Texas Female Institute. Like the Lungkwitz family, the Weisselbergs were refugees from the German revolution of 1848.

In 1882 Miss Weisselberg married Dr. Berthold Hadra and moved to San Antonio where again she studied with Mrs. Duval. Her landscapes are primarily of Austin and San Antonio scenes such as "View of the Military Academy from East Austin" and "Bridge over the San Antonio River," now in a private collection in Dallas.

Hafen, John (1856-1910)

B. Scherzingen, Switzerland, March 2, 1856. D. Brown County, Indiana, June 3, 1910. Lived: Salt Lake City, Utah; Monterey, California; Indiana. Work: Springville Art Museum, Utah. Federal Writers' Project, *Utah;* Haseltine; Horne; Mallett.

Hafen began frontier life at the age of five when his parents moved from Switzerland to Payson, Utah. The woodcuts and engravings his mother hung on dugout and log cabin walls during early years helped him decide to be an artist at age eight. Three years later his mother showed some of his drawings to a friend who bought them for a dollar and a half, which enabled him to buy drawing paper and colors.

Poverty haunted Hafen much of his life. Even his decision

to be a landscape painter was dictated by his inability to afford models. Though one of Utah's finest landscape artists, Hafen was unable to find a market for his work and found it necessary to live in other states more appreciative of his delicate and subtle Corot-like paintings.

Hafen, Virgil O. (1887-1949)
B. Springville, Utah. Lived: Springville; Eugene, Oregon. Mallett.

Hager, Luther George (1885-1945)
B. Terre Haute, Indiana, March 19. Lived: Seattle, Washington. Fielding; Mallett; *WWA; WWWA.*

Hagerman, Percy (1869-1950)
Lived: Colorado Springs, Colorado. Colorado Springs Fine Arts Center.

Hagerup, Nels (1864-1922)
Lived: California. California Historical Society, San Francisco; San Bruno Public Library, San Bruno, California.

Hahn, Carl William (1829-1887)
B. Ebersbach, Saxony. D. Dresden, Germany. Lived: California 1867-82. Bénézit; Mallett.

Haig, Mabel George (1884-)
B. Blue Earth, Minnesota. Lived: Whittier, California. *AAA;* Mallett; *WWAA.*

Hall, Arthur William (1889-)
B. Bowie, Texas, October 30. Lived: Howard, Kansas; Alcalde, New Mexico. *AAA;* Mallett; *WWAA.*

Hall, Cyrenius (1830-)
In the West 1870s. *Antiques,* November 1968.

Hall, Norma B. (1889-)
B. Halsey, Oregon, May 21. Lived: Howard, Kansas; Alcalde, New Mexico. *AAA;* Mallett; *WWAA.*

Hall, Sydney Prior (1842-1922)
B. Newmarket, Cambridgeshire, England. D. London, England. In Montana, Wyoming, and Nebraska during early October 1881. Hogarth.

Hamilton, Hamilton (1847-1928)
B. Oxford, England, April 1. D. January 4. Lived: Buffalo, New York; Norwalk, Connecticut. *AAA;* Bénézit; Fielding; Mallett; *WWA; WWWA.*

Hamilton, James (1819-1878)
B. Belfast, Ireland, October 1. D. San Francisco, California, March 10. Lived: England; Pennsylvania. Bénézit; Fielding; Groce and Wallace; Mallett; *WWWA.*

Hamilton, Minerva Bartlett (1864-)
B. Gallatin, Missouri, November 21. Lived: California. *WWC.*

Hammock, Earl G. (1896-)
B. Sunset, Texas, 1896. Lived: Gunnison, Colorado; Phoenix, Arizona. Hammock interview; *Arizona Highways,* July 1960.

Hammock grew up with a desire to paint but was unable to afford instruction. He got his first and only professional help in 1936 from some of the Taos, New Mexico, artists who were his neighbors during his brief residence there. Like the Taos artists who befriended him, Hammock was interested in painting the Indians. Both the Pueblos and the Navajos sat for him during those early years of his career. Hammock is now best known in Arizona where he does still life paintings of southwest Indian handicrafts. Many of these paintings are of his own large collection of beautiful rugs, pottery, and jewelry, arranged as if for a window display, and painted in minute detail.

Hamp, Margaret [Mrs. Francis] (-)
B. England. Lived: Colorado Springs, Colorado. Ormes and Ormes.

Handforth, Thomas Schofield (1897-1948)

B. Tacoma, Washington, September 16. D. Los Angeles, California, October 19. Lived: Wilmington, Delaware. *AAA;* Mallett; *WWAA; WWWA.*

Hanscom, Trude (1898-)

B. Oil City, Pennsylvania, December 6. Lived: Arcadia, California. Collins; *WWAA.*

Hansen, Armin Carl (1886-1957)

B. San Francisco, California, October 23. D. April 23. Lived: Monterey, California. *AAA;* Fielding; Mallett; *WWA; WWAA; WWWA.*

Hansen, Ejnar (1884-)

B. Copenhagen, Denmark. Lived: Pasadena, California. Mallett; *WWAA.*

Hansen, Herman W. (1854-1924)

B. Dithmarschen, Germany, June 22, 1854. D. Oakland, California, April 12, 1924. Lived: New York City; Chicago; and San Francisco. Work: Private collections. *CAR,* Vol. IX; Taft.

The lure of Indians, cowboys, and wild horses can be credited with bringing this German-born artist to the United States in 1877. Two years later, Hansen visited the West, remaining until he "had all the studies of Indians and buffalo" he wanted at that time. During subsequent visits he depicted life on the cattle ranges of Montana, Wyoming, Arizona, New Mexico, and Texas— the horse providing the central force in his paintings, the means for telling his story.

Hansen's friendship with the Indian Agent at the Crow Reservation enabled him to paint the Crows with documentary exactness, paying particular attention to the harmonious colors and artistic designs in their bead and leather work.

European demand for Hansen's paintings sharply reduced the number available to American buyers.

Harding, Goldie Powell (1892-)

B. San Leandro, California, January 11. Lived: Palm Desert and Santa Monica, California. Mallett; *WWAA*.

Harley, Steven W. (1863-1947)

B. Michigan. D. Scottville, Michigan. Lived: Alaska; Northwest states; Michigan. Lowry.

Harmer, Alexander F. (1856-1925)

B. Newark, New Jersey, August 21, 1856. D. Santa Barbara, California, January 8, 1925. Lived: Santa Barbara. Work: Dr. and Mrs. Franz Stenzel Collection, Portland Oregon. Mallett; Taft.

Harmer, who had always liked to sketch, studied art in the late 1870s, and then re-enlisted in the army in 1881. His western service provided an opportunity to illustrate the Apache wars for *Harper's Weekly*, and for John G. Bourke's *An Apache Campaign in the Sierra Madre*. He also illustrated Bourke's *The Snake-Dance of the Moquis of Arizona*.

By 1881 Harmer had decided to be a painter of the western scene. Many sketches made during his years with the army were later translated into oil and water color. In the 1890s he settled in Santa Barbara where his interest changed to the painting of Mission Indians, the Missions, and old California families.

Harmon, Charles H. (-)

Lived: San Jose, California; Colorado. Work: William and Dorothy Harmsen Collection, Denver, Colorado. California Historical Society, San Francisco; California State Library, Sacramento; Denver Public Library.

California and Colorado provided inspiration for most of Harmon's work. During the 1880s he began exhibiting in the San Francisco Bay region, principally in San Jose where he lived.

Not until 1923 was Harmon's work given much public attention; the occasion was an exhibition at the Stanford University Art Gallery of redwood forests, coastal scenes, and rugged mountain views. The Gallery's director, Pedro J. Lemos, described Harmon's work as follows: "The varying qualities of lighting effects and moods shown in the paintings exemplify the artistic perception of the painter in recording those exceptional moments when

nature is at its best." Several of the paintings had been done almost entirely with a palette knife.

Although it appears that Harmon continued to merit some attention from San Francisco area critics, he is today better known in Colorado where his work is frequently seen.

Harpold, Gertrude M. (1888-)
B. near Buffalo, Missouri, October 1. Lived: Santa Paula, California. *WWC.*

Harrington, Joseph A. (-)
Lived: California 1870-1900. Oakland Art Museum.

Harris, Grace Griffith (1885-)
B. near Santa Rosa, California, May 9. Lived: Berkeley, California. *WWC.*

Harrison, Lowell Birge (1854-1929)
B. Philadelphia, Pennsylvania, October 28. D. May 11. Lived: Woodstock, New York. Fielding; *WWWA.*

Harrison, Thomas Alexander (1853-1930)
B. Philadelphia, Pennsylvania, January 17. D. Paris, France. Lived: New York City; Paris. *AAA;* Bénézit; Fielding; Mallett; *WWA.*

Hart, Alfred A. (1816-)
B. Norwich, Connecticut. Lived: California 1868-1900. Fielding; Groce and Wallace; Mallett.

Hart, Cornelia (1889-)
B. Boise, Idaho, July 31. Lived: Boise; Carmel, California. Binheim.

Hartley, Marsden (1877-1943)
B. Lewiston, Maine, January 4. D. Ellsworth, Maine, September 2. Lived: New York City; France. *AAA;* Fielding; Mallett; *WWAA.*

Hartman, C. Bertram (1882-1960)

B. Junction City, Kansas. D. New York City, July 9. Lived: New York City. *AAA;* Fielding; Mallett; *WWAA.*

Hartnett, Eva Valker (1895-)

B. Wahpeton, North Dakota, December 10. Lived: Minot, North Dakota. Barr; *WWAA.*

Harvey, Eli (1860-1957)

B. Ogden, Ohio, September 23. D. February 10. Lived: Alhambra, California. *AAA;* Bénézit; Fielding; Mallett; *WWA; WWAA; WWWA.*

Harwood, Burt (1897-1924)

B. Iowa, 1897. D. Taos, New Mexico, 1924. Lived: Paris, France; Taos. Work: Harwood Foundation, Taos. Fielding; Grant; Mallett.

Burt and Elizabeth Harwood were living permanently in Paris when conditions brought about by the First World War made it wise to return to their native land. Ultimately they settled in Taos where they bought and remodeled the historic adobe house of Captain Simpson. A studio was built in the courtyard and decorated with Navajo and Chimayo blankets. There Burt Harwood specialized in painting the Taos Indians until death cut short his promising career.

From the generosity of the Harwoods has come the Harwood Foundation. The old adobe house was first turned into a gallery where all artists could exhibit, and later bequeathed to the University of New Mexico. It has played a significant role in the cultural life of the Southwest.

Harwood, James T. (1860-1940)

B. Lehi, Utah, April 8, 1860. D. Salt Lake City, Utah, October 16, 1940. Lived: California; Salt Lake City; Paris, France. Work: Utah State University, Logan; Springville Art Museum, Utah; Brigham Young University, Provo, Utah. Haseltine; Horne; Mallett; *WWAA.*

Harwood's first efforts in art began with slate drawings in grades A, B, and C in Lehi, Utah. Later he studied in American and European art centers and became proficient in various media

and a capable teacher as well. His love of nature prompted many sketches of the Lehi countryside where he had rambled about during his early years, and in later years it was his landscapes, painted in all seasons and at different times of day and night, that brought him recognition.

Several Utah institutions have examples of Harwood's work, including Utah State University which has a group of 24 water colors called "The Seasons."

Haskell, Ernest (1876-1925)
B. Woodstock, Connecticut, June 30. D. Bath, Maine, November 2. Lived: California; Maine. *AAA;* Bénézit; *DAB;* Fielding; Mallett.

Haswell, Robert (　-　)
In Oregon 1788, 1792. Groce and Wallace; Rasmussen (ms.).

Hauser, John (1859-1918)
B. Cincinnati, Ohio, 1859. D. Clifton, Ohio, 1918. Lived: Clifton. Work: Cincinnati Art Museum, Ohio; The Royal Gallery, London, England; Santa Fe Railway Collection. Forrest 1961; Mallett.

Hauser was one of several early Ohio artists to have his name associated primarily with the painting of the Indians. About 1880, following study in Germany, he began his sketching trips among the Navajo, Pueblo, Sioux, and other tribes. In 1901 he had the distinction of being made a member of the Sioux nation. Hauser's paintings of Indian life as he saw it in their villages are considered especially important for their authentic detail, and the same can be said for his Indian portraits.

Hauswirth, Frieda (1886-　)
B. Switzerland. Lived: Berkeley, California. *WWC.*

Hayden, Sara S. (　-　)
B. Chicago, Illinois. Lived: Chicago; Lincoln, Nebraska. *AAA;* Mallett; Bucklin.

Hays, William Jacob (1830-1875)

B. New York City, August 8, 1830. D. New York City, March 13, 1875. Lived: New York. Work: Denver Art Museum, Colorado; Museum of Natural History, New York. Fielding; Groce and Wallace; Mallett; Taft.

In 1860 Hays made a three-month trip up the Missouri River to sketch animals, particularly the buffalo. When these sketches were made into paintings and exhibited, Hays received much adverse publicity from the western "experts." He was criticized for the nature of the ground cover, the shape of the buffalo, and the absence of buffalo chips in the foreground. Somewhat a naturalist as well as an artist, Hays defended himself ably on the first two counts, but admitted the absence of buffalo chips in the interest of a more aesthetically pleasing picture. His controversial paintings are now in several large museums. Hays also sketched the forts along the Missouri. Some of his sketches are the only known pictorial record of those important landmarks of frontier days.

Heade, Martin Johnson (1819-1904)

B. Lumberville, Pennsylvania, August 11. D. Saint Augustine, Florida, September 4. Lived: Philadelphia; Florida. Bénézit; Fielding; Groce and Wallace; Mallett; *WWWA*.

Heaney, Charles Edward (1897-)

B. Oconto Falls, Wisconsin, August 22. Lived: Portland, Oregon. *AAA;* Fielding; *WWAA*.

Heap, Gwinn Harris (1817-1887)

B. Chester, Pennsylvania, March 23, 1817. D. Constantinople, Turkey, March 3, 1887. Lived: Belfast, Ireland; Turkey, where he was Consul General. Groce and Wallace; Peters.

As topographic artist and journalist, Heap accompanied his cousin E. F. Beale on a War Department expedition in 1853 from Westport, Missouri, to Los Angeles, to map a suitable railway route to the West Coast. On June 30 of that year Beale wrote from the vicinity of the Grand River (now the Gunnison) that "full notes of every day's work and sketches of all camping places of note are taken by Heap." Thirteen of these sketches and the map

were published in lithographic form the following year with Heap's diary account of his adventures. In 1957 his diary, sketches, and map were reprinted in LeRoy and Ann Hafen's *Central Route to the Pacific by Gwinn Harris Heap*.

Heath, Frank L. (-)
Lived: California 1870-1921, principally in Santa Cruz. Oakland Art Museum; *Western Woman*, Vol. 13, No. 4.

Heger, Joseph (1835-)
B. Hesse, Germany, January 11, 1835. Lived: Goodlettsville, Tennessee. Work: Yale University Library, New Haven, Connecticut; Arizona Historical Society, Tucson. Groce and Wallace; Taft.

Heger, who was a lithographer in his native Germany, came to this country as a young man. During his five-year hitch in the army from 1855 to 1860 he did many excellent pencil sketches of southwestern towns and other places of scenic interest; these are now in the Coe Collection at Yale and the W. J. Halliday Collection at the Arizona Historical Society in Tucson.

In 1856 Heger was thrown from a horse and injured while marching through Texas. Many years later he applied for a pension claiming ill health resulted from the injury. The pension was denied on the basis that soldiers in the Indian wars were not entitled to them. Nothing further is known of this early artist, except that he was living in Goodlettsville, Tennessee, in 1897.

Heine, Minnie B. (1869-)
B. Norton, New Brunswick, Canada, September 25. Lived: Montana; Oregon. Binheim.

Heizer, Dell (1877-1965)
D. Colorado Springs, Colorado. Lived: Colorado Springs. Ormes and Ormes; Shalkop.

Heming, Arthur (1870-1940)
B. Paris, Ontario, Canada, January 17. D. October 30. Lived: Toronto and Hamilton, Canada. *AAA;* Bénézit; Fielding; Mallett; *WWA; WWAA; WWWA*.

Henderson, William Penhallow (1877-1943)

B. Medford, Massachusetts, 1877. D. Santa Fe, New Mexico, October 15, 1943. Lived: Santa Fe; Chicago, Illinois. Work: Art Institute of Chicago; Museum of New Mexico, Santa Fe. Coke; Fielding; Mallett; *WWAA*.

Henderson is best known in New Mexico where he moved in 1916 with his wife Alice Corbin Henderson, the writer and poet. He also painted in Arizona and in Mexico.

Henderson's interest in the Indians of the Southwest and in the small band of Penitentes in northern New Mexico provided inspiration for his work in several media. Six of his murals hang in the Federal Building in Santa Fe, and the Museum of New Mexico houses a large collection of his work. In addition to his career as artist, he designed Santa Fe's Seña Plaza and the Museum of Ceremonial Art. The latter is a hogan-shaped structure now famous for its collection of Navajo sand paintings and the appropriateness of its design.

Hennings, E. Martin (1886-1956)

B. Pennsgrove, New Jersey, February 5, 1886. D. Taos, New Mexico, May 19, 1956. Lived: Chicago, Illinois; Taos. Work: Los Angeles County Museum, Los Angeles, California; Museum of Fine Arts, Houston, Texas; Gilcrease Institute of Art, Tulsa, Oklahoma; Harwood Foundation, Taos; Pennsylvania Academy of Fine Arts, Philadelphia. Coke; Fielding; Mallett.

Hennings decided to be an artist during an afternoon at the Chicago Art Institute. Stopping at the desk on his way out, he looked over some folders about the school and later enrolled. His obvious ability brought recognition and a traveling scholarship which he declined because he wanted to do commercial work. When Hennings found that field unsuitable he went to Germany for further study but returned in 1915 because of the war.

Like Victor Higgins and Walter Ufer, Hennings went to Taos at the suggestion of Carter Harrison, art patron and a former Chicago mayor. Hennings' first Taos trip was made in 1917; four years later he moved there permanently and joined the Taos Society of Artists.

Henri, Robert (1865-1929)
B. Cincinnati, Ohio, June 24. D. New York City, July 12.
Lived: Santa Fe, New Mexico; New York City. *AAA;*
DAB; Fielding; Mallett; *WWA; WWWA.*

Herbert, Marian (1899-1960)
B. Spencer, Iowa. D. Santa Barbara, California, July 15.
Lived: Santa Barbara. Mallett; *WWAA.*

Herkimer, Herman Gustave (1863-)
B. Cleveland. Lived: Auburn, California. *AAA;* Bénézit;
Mallett.

Herold, Don (1889-1966)
B. Bloomfield, Indiana, July 9. D. June 1. Lived: Los An-
geles, California; Bronxville, New York; Brookfield, Con-
necticut; Vero Beach, Florida. Fielding; Mallett; *WWA;*
WWAA; WWWA.

Herrick, Margaret Cox (1865-)
B. San Francisco, California. Lived: Piedmont, California.
AAA; Fielding; Mallett.

Herrick, William F. (-c.1906)
Lived: San Francisco. Groce and Wallace; *California His-
torical Society Quarterly,* Fall 1947.

Hersch, Lee (1896-)
B. Cleveland, Ohio, September 5. Lived: New York; Pa-
cific Palisades, California. Mallett; *WWAA.*

Herzog, Herman (1832-1932)
B. Bremen, Germany. D. Philadelphia, Pennsylvania.
Lived: Philadelphia. *AAA;* Bénézit; Fielding; Mallett.

Heuston, George Z. (1855-1939)
B. Galesville, Wisconsin. D. Tacoma, Washington. Lived:
Tacoma. Mallett.

Higgins, Eugene (1874-1958)
B. Kansas City, Missouri. D. February 19. Lived: New York City. *AAA;* Bénézit; Fielding; Mallett; *WWA; WWAA; WWWA.*

Higgins, Victor (1884-1949)
B. Shelbyville, Indiana, June 28, 1884. D. Taos, New Mexico, August 23, 1949. Lived: Chicago, Illinois; Taos. Work: Arizona State University, Tempe; Santa Fe Railway Collection; Harwood Foundation, Taos; Butler Institute of American Art, Youngstown, Ohio. Coke; Fielding; Mallett; Richardson.

Higgins' introduction to Taos came in 1914 with a commission from Carter Harrison of Chicago to paint a landscape of the place Harrison had found so charming. Higgins also succumbed to the charm and built a small adobe "castle" with a tower from which to view *El Valle de Taos.* Higgins spent most of his time in Taos, specializing in impressionist paintings of Indian subjects and landscapes. Nominally he remained a Chicago artist, exhibiting there regularly and receiving most of his awards from the Chicago Institute of Art. With Walter Ufer, who also enjoyed the patronage of ex-mayor Harrison, Higgins was a member of the exclusive Taos Society of Artists which by 1914 had grown to eight members.

Hill, Abby Williams (1861-1943)
B. Grinnell, Iowa, September 25. D. Tacoma, Washington. Lived: Tacoma. *AAA;* Mallett; *WWAA.*

Hill, Andrew Putnam (-)
Lived: California 1867-1922, principally in San Jose. Oakland Art Museum.

Hill, Edward Rufus (1852-)
Lived: California. California Historical Society, San Francisco.

Hill, Evelyn Corthell (1886-)
B. Laramie, Wyoming, May 4, 1886. Lived: Laramie, Wyoming. Work: Private collections in Wyoming. Binheim;

Mallett; University of Wyoming Library, Laramie.

For many years Mrs. Hill was Wyoming's most prominent landscape painter. Except for extensive periods of study elsewhere, she was a lifetime resident of the state. Before her marriage in 1911 she staked out a homestead near Laramie, the town where she was born and where the name Corthell was well known. That Mrs. Hill understood and knew how to depict her Wyoming surroundings was borne out by the statement of a Chicago art critic in 1928: "It's the quality of familiarity [with mountains] that arrests one's attention before Evelyn Hill's 'The Hump.' She has lived among them all her life and they are no strangers to her though they change in appearance from moment to moment."

Hill, Thomas (1829-1908)

B. Birmingham, England, September 11, 1829. D. Raymond, California, June 30, 1908. Lived: San Francisco; Boston; Raymond, California. Work: State Capitol, Sacramento, California; Crocker Art Gallery, Sacramento. *CAR*, Vol. II; Fielding; Groce and Wallace; Mallett.

Thomas Hill made California his home in 1861, and became famous there as a landscapist. He did many oils of Yosemite National Park where he maintained a studio. He also painted in Washington, Oregon, Alaska, and New England.

It was Hill who was chosen by Leland Stanford to paint "Driving the Last Spike," commemorating that historical event of May 10, 1869. He was to have been paid $50,000 for the detailed work which took four years to complete. Stanford, however, broke the contract because his colleague Fred Crocker claimed to have been less prominently displayed than Stanford. The controversial painting, which now hangs in the California State Capitol, was not sold until after Hill's death, and then for only one-fifth of its original price.

Hills, Anna Althea (1882-1930)

B. Ravenna, Ohio. Lived: Laguna Beach, California. *AAA;* Fielding; Mallett; *WWAA*.

Hinckley, Thomas Hewes (1813-1896)

B. Milton, Massachusetts, November 4. D. Milton, February 15. Lived: Milton; California. Fielding; Groce and Wallace; Mallett.

Hind, William G. R. (-1888)

Lived: California 1862-63. Oakland Art Museum.

Hinkle, Clarence K. (1880-1960)

B. Auburn, California. D. Santa Barbara, July 20. Lived: Laguna Beach and Santa Barbara, California. *AAA;* Mallett; *WWAA.*

Hitchcock, David Howard (1861-1943)

B. Honolulu, Hawaii, May 15. Lived: Honolulu. *AAA;* Mallett; *WWAA.*

Hitchens, Joseph (1838-1893)

B. England, December 22, 1838. D. 1893. Lived: Pueblo, Colorado. Work: Colorado State Museum, Denver; Musuem of New Mexico, Santa Fe. McClurg; Marturano; Denver Public Library.

Shortly after Hitchens settled in Colorado he conceived the idea of commemorating an event yet to transpire— the admission of the state to the Union in 1876. Years later the *Denver Post* was to caption an item, "Artist Was a Prophet When He Painted 'Admission of Colorado.'" The painting was first hung in the County Commissioners' room in the Court House, then in the law library of the State Supreme Court, and finally in the State Museum.

Hitchen's other claim to fame was less spectacular but no less enduring. In the 1880s he moved to Pueblo and became the city's first artist; during his Colorado residence he painted many landscapes in the San Luis and Arkansas River valleys which testify to his competence.

Hittell, Charles J. (1861-)

B. San Francisco, California, August 4. Lived: San Francisco and San Jose, California. *AAA;* Fielding; Mallett; *WWA; WWWA.*

Hobart, Clark (c.1880-)
B. Rockford, Illinois. Lived: San Francisco and Monterey, California. *AAA;* Fielding; Mallett.

Hockaday, Hugh (1892-1968)
B. Little Rock, Kansas, December 2. D. Lakeside, Montana, May 7. Lived: Lakeside. Burk; *WWAA.*

Hoffman, Frank B. (1888-1958)
B. Chicago, Illinois, August 28, 1888. D. Taos, New Mexico, March 11, 1958. Lived: New York; Chicago; Taos. Work: Brown and Bigelow Collection, Saint Paul, Minnesota. Luhan; Mallett; Reed 1966; *WWAA.*

Hoffman's early sketches of horses prompted an admirer of his work to obtain for him a job on the old *Chicago American,* and eventually Hoffman became its art department head. In 1916 Hoffman went west, and two years later he established a ranch near Taos which he stocked with longhorn cattle, cow ponies, thoroughbred horses, burros, dogs, and eagles to use as models for his illustrations. In addition to working for *McCalls, Ladies Home Journal, Cosmopolitan, Saturday Evening Post, American,* and *Woman's Home Companion,* Hoffman had an exclusive contract to supply Brown and Bigelow with calendar art. Over 150 canvases of the West were painted for that firm.

Hoftrup, Julius Lars (1874-1954)
B. Sweden, January 21. D. Elmira, New York, April 10. Lived: Pine City and Elmira, New York. *AAA;* Fielding; Mallett; *WWAA.*

Hogner, Nils (1893-)
B. Whiteville, Massachusetts, July 22. Lived: Litchfield, Connecticut; Taos, New Mexico. Mallett; *WWAA.*

Hogue, Alexander (1898-)
B. Memphis, Missouri, February 22, 1898. Lived: Dallas, Texas; Tulsa, Oklahoma. Work: Philbrook Art Center and Gilcrease Institute of Art, Tulsa, Oklahoma; Dallas Museum of Fine Art; Library of Congress, Washington, D.C.; Musee National d'Art Moderne, Paris, France. Federal

117

Writers' Project, *Texas;* Mallett; *WWAA.*

Hogue was born in Missouri, but grew up in west Texas. He studied art at the Minneapolis Art Institute and with Frank Reaugh, well known painter of the open range. For many years Hogue has been known as the artist of the Dust Bowl. Windmills, cattle, country stores, and the unending stretches of southwestern desert country characterize his work. His paintings and lithographs are in collections throughout the country, and his dynamic "Drought Survivors" was purchased by the French government. Since 1925, Hogue taught art, principally in Dallas, Texas, and was head of the art department at the University of Tulsa until 1968.

Holden, Sarah G. (-)
Lived: Georgetown, Colorado, 1880s and 1890s. Maturano.

Holdredge, Ransom G. (1836-1899)
B. New York, 1836. D. California, 1899. Lived: New York; San Francisco and Alameda, California. Work: Oakland Art Museum, California; Dr. and Mrs. Bruce Friedman Collection, San Francisco Bay area. Forrest 1961; Neuhaus 1931; California State Library, Sacramento.

A good part of Holdredge's career was spent in the San Francisco Bay region, where at one time his work was considered better than that of the famous William Keith. Many of Holdredge's landscapes included Indians; frequently they were authentic scenes witnessed by the artist, but on occasion they were from imagination, especially during his latter years. In California, Holdredge is known for his paintings of "Vernal Falls" and other Sierra views, as well as his Bay Area scenes. Unfortunately Holdredge had an affinity for the bottle which kept him in a state of poverty and compromised his art. This unhappy circumstance reduced his production and ultimately sent him to a pauper's grave.

Holmes, F. Mason (1858-1953)
B. Stonington, Connecticut. D. Tacoma, Washington. Lived: Tacoma. LeRoy.

118

Holmes, Ralph (1876-)
 B. La Grange, Illinois. Lived: Los Angeles and Twin Lakes, California. *AAA;* Mallett; *WWAA.*

Holmes, William Henry (1846-1933)
 B. near Cadiz, Ohio, December 1, 1846. D. Washington, D.C., April 20, 1933. Lived: Washington, D.C. Work: National Collection of Fine Arts, Smithsonian Institution, Washington, D.C.; National Park Service, Washington, D.C. Fielding; Goetzmann 1966; Mallett; Swanton; Taft; *WWA; WWWA.*

 Trained as a scientist and self-taught as an artist, Holmes sketched Rocky Mountain regions while a member of the 1872 Hayden Survey, and later as geologist for the U.S. Geological Survey. Of his remarkable work in the Atlas for the *Tertiary History of the Grand Cañon District,* which he and Thomas Moran illustrated, Wallace Stegner said, "To open . . . to any of its double-page panoramas is to step to the edge of forty miles of outdoors."

 During the late 19th century, Holmes was professor of geology at the University of Chicago and a curator at the Field Museum of Natural History; thereafter he was with the Smithsonian Institution and the National Collection of Fine Arts of which he became a director. These impressive contributions to art and science have been amplified by his paintings, especially his delicate, traditional water colors which have received a number of awards.

Holt, Henry (1843-1922)
 B. Townsend, Massachusetts. D. Tacoma, Washington. Lived: Tacoma. Washington State Historical Society, Tacoma.

Hooper, Will Phillip (1855-1938)
 B. Biddleford, Maine. D. January 24. Lived: Forest Hills, New York. *AAA;* Fielding; Mallett; *WWAA.*

Hopkins, Charles Benjamin (1882-)
 B. Toledo, Ohio, October 23. Lived: Marysville, California. *AAA;* Mallett; *WWAA.*

Hopkins, Lin (1886-)

B. Omaha, Nebraska, March 5. Lived: Fremont, Nebraska; summers: Casper, Wyoming. *WWAA.*

Hopkins, Ruth Joy (1891-)

B. Fremont, Nebraska, August 17. Lived: Fremont; summers: Casper, Wyoming. Mallett; *WWAA.*

Hopper, Edward (1882-1967)

B. Nyack, New York, July 22. D. May 15. Lived: New York City. *AAA;* Fielding; Mallett; *WWA; WWAA; WWWA.*

Hoppin, Augustus (1828-1896)

B. Providence, Rhode Island, July 13. D. Flushing, New York, April 1. Lived: Flushing. Bénézit; *DAB;* Fielding; Groce and Wallace; Mallett; *WWWA.*

Horder, Nellie P. (1885-)

B. Mount Hope, Kansas. Lived: Seattle, Washington. Collins; *WWAA.*

Horsfall, Robert Bruce (1868-1948)

B. Clinton, Iowa, October 21. D. March 24. Lived: Portland, Oregon; Fairport, New York. Fielding; Mallett; *WWA; WWAA; WWWA.*

Houghton, Arthur Boyd (1836-1875)

B. Bombay, India. D. London, England, November 25. In the West 1870. Hogarth.

Howard, Robert Boardman (1896-)

B. New York City, September 20. Lived: San Francisco, California. Mallett; *WWAA.*

Howell, Eugenie James (1883-)

B. Pine Bluff, Arkansas, March 7. Lived: Hollywood, California. *WWC.*

Howland, John Dare (1843-1914)

B. Zanesville, Ohio, May 7, 1843. D. Denver, Colorado, September 10, 1914. Lived: Mexico; Utah; Denver. Work: State Historical Society of Colorado, Denver. Charles; C. S. Jackson 1949; Taft; "The John D. Howland Collection," *The Colorado Magazine,* January 1931.

Howland ran away from home in 1857 and got a job with the American Fur Company. When news of a gold strike in the Pikes Peak region reached him the following year he tried his luck at mining, but found the pickings meager and soon returned to the fur company.

Howland's study of art began in Paris after service in the Civil War. He returned in 1867 following his appointment as secretary of the Indian Peace Commission. In addition to secretarial duties he illustrated the Medicine Lodge treaty negotiations for *Harper's Weekly* and *Leslie's.* After his Commission assignment was over, he went to Mexico for five years as an artist-correspondent for *Harper's.* The money thus earned was used for further study in Europe in 1882. Most of his life was spent in the West, and Denver claims him as its first resident artist.

Huddle, William Henry (1847-1892)

B. Wytheville, Virginia. D. Texas. Lived: Paris, Texas. Mallett; Pinckney.

Hudson, Charles Bradford (1865-1939)

B. Ontario, Canada. D. Pacific Grove, California, June 27. Lived: Pacific Grove. *AAA;* Mallett; *WWAA.*

Hudson, Grace Carpenter (1865-1937)

B. Potter Valley, California, February 21, 1865. D. March 23, 1937. Lived: Ukiah, California. Work: Field Museum, Chicago, Illinois; Dr. and Mrs. Bruce Friedman Collection, San Francisco Bay area. Baird 1962; Febraché.

Grace Hudson's fame rests as much with her perceptive studies of Pomo Indian children as with the excellence of her work. She painted them under most favorable circumstances because she knew their mothers who on occasion also sat for her. Although the Pomos were Mrs. Hudson's specialty, she painted portraits of Pawnees in 1904 for the Field Museum, and the

Paiutes of Pyramid Lake, Nevada, in 1917. She also painted in Hawaii and in Europe.

Toward the end of Grace Hudson's life she was considered by some art critics to be California's greatest painter. Although much of her work is in private collections, it is frequently on exhibit in group shows of early western artists.

Huett, Fred (1828-1912)
B. France. D. Georgetown, Colorado. Lived: Georgetown. Denver Public Library.

Hull, Marie A. (1890-)
B. Summit, Mississippi. Lived: Jackson, Mississippi. *AAA;* Fielding; Mallett; *WWAA.*

Hunt, Thomas L. (-1939)
D. California. Lived: Laguna Beach, California. Fielding; Mallett.

Hunter, Isabel (-)
B. San Francisco, California. Lived: Alameda, California. *AAA;* Mallett.

Hutton, William Rich (1826-1901)
In Los Angeles and Monterey, California, during Mexican War. Groce and Wallace; Webb.

Hutty, Alfred Heber (1878-1954)
B. Grand Haven, Michigan, September 16. D. June 28. Lived: Charleston, South Carolina. *AAA;* Fielding; Mallett; *WWA; WWWA.*

Hyde, Helen (1868-1919)
B. Lima, New York, April 6. D. Pasadena, California, May 14. Lived: Chicago, Illinois. *AAA;* Bénézit; Fielding; Mallett; *WWWA.*

I

Ilyin, Peter A. (1887-)
B. Kazan, Russia, June 19. Lived: San Francisco, California. Mallett; *WWAA.*

Imhoff, Joseph A. (1871-1955)
B. Brooklyn, New York, 1871. D. Taos, New Mexico, 1955. Lived: New York; Europe; Albuquerque and Taos, New Mexico. Work: Harwood Foundation, Taos; University of New Mexico, Albuquerque; Museum of New Mexico, Santa Fe. Coke; Luhan.

Imhoff's paintings of Indians are so anthropological that some critics have deprecated their importance as art. From his observations of Pueblo culture, he had become aware of the importance of corn in their lives and had used the medium of his art to explain its secular and ceremonial use.

Imhoff's lithographs received better treatment from the critics. Although largely self-taught, he was an excellent draftsman and printmaker. He had the first lithographic press in Taos which he set up sometime after his arrival in 1929. Imhoff was not a newcomer to New Mexico, however, for from 1906 to 1912 he lived in Albuquerque. The Department of Anthropology at the University there has 60 of his oil paintings.

Inness, George (1825-1894)
B. Newburgh, New York, May 1. D. Scotland, August 3. Lived: Medfield and Boston, Massachusetts; Montclair, New Jersey; New York City. Bénézit; *DAB;* Fielding; Groce and Wallace; Mallett; *WWA; WWWA.*

Inness, George, Jr. (1854-1926)
B. Paris, France, January 5. D. Cragsmoor, New York, July 27. Lived: Boston; New York City; Tarpon Springs, Florida. Bénézit; Fielding; Mallett; *WWA; WWWA.*

Ivey, Joseph (-)
Lived: California, 1880-1900. Oakland Art Museum.

Iwonski, Carl G. von (1830-1922)

B. Hildersdorf, Germany, April 23, 1830. D. Breslau, Germany, 1922. Lived: New Braunfels, Horton Town, and San Antonio, Texas; Germany. Work: Sophienburg Museum, New Braunfels; Witte Museum, San Antonio; Library of Congress, Washington, D.C. Groce and Wallace; Pinckney.

Texas was an independent republic when the German-born Iwonski and his parents moved to New Braunfels in 1845. Soon thereafter they moved to Horton Town, and then to San Antonio.

Iwonski's art training was sketchy, but his talent made up for the deficiency. In addition he had a sense of history which inspired him to paint scenes of local interest such as stage productions at the theater, escapades of the Texas Rangers, and political events such as General Twigg's surrender of some United States forts and military supplies just prior to the outbreak of the Civil War. For 27 years Iwonski made drawings and paintings of Texas personalities, Indians, and historical happenings.

J

Jackson, William Franklin (1850-1936)

B. Council Bluffs, Iowa. D. Sacramento, California. Lived: California. Mallett; *Sacramento Bee,* January 9, 1936, and December 23, 1939.

Jackson, William Henry (1843-1942)

B. Keesville, New York, April 4, 1843. D. June 30, 1942. Lived: Omaha, Nebraska; Denver, Colorado; Detroit, Michigan; Washington, D.C.; New York. Work: Nebraska State Historical Society, Lincoln; William and Dorothy Harmsen Collection, Denver, Colorado. Hafen and Hafen 1959; C. S. Jackson 1947; W. H. Jackson; Mallett 1940 Supplement.

Jackson, one of the earliest and most famous western pho-

tographers, was also a painter of considerable ability. In 1866 he began making sketches of western scenery and events during his job as helper with a wagon train bound for the Montana mines. Near the Wind River Mountains he left the wagon train and headed for Los Angeles by way of Utah. Jackson returned the following year, covering much the same route with a drove of half-broken horses bound for Omaha—a trip for which he received only $20 for over three months' work. Unable to face his family as a failure, he remained in Omaha and got a job as a photographer. Thereafter Jackson headed West with a camera as well as a sketchbook. In later years he reconstructed in color many of his experiences and observations of his western assignments.

Jacobson, Oscar Brousse (1882-)
B. Westervik, Sweden, May 16. Lived: Norman, Oklahoma; summers: Allenspark, Colorado. *AAA;* Fielding; Mallett; *WWA; WWAA.*

James, Will (1892-1942)
B. Saint Nazaire de Acton, Quebec, June 6, 1892. D. Hollywood, California, September 3, 1942. Lived: Pryor, Montana, New York City, and Los Angeles, California. Work: Private collections in Southern California. Ainsworth 1968; Mallett.

"Will James" was born Joseph-Ernest-Nepthali Dufault in Quebec Province, Canada. He was not, as represented in his writings, born in a covered wagon and orphaned before he was five. The subterfuge has never been explained. He was, instead, a Montana cowboy until a severe injury from a rodeo accident forced him to seek other work.

In San Francisco, James had the good fortune to interest Harold Von Schmidt and Maynard Dixon in his cowboy drawings. They gave him financial assistance and helped him get a job with *Sunset* magazine. From there he went to New York where he wrote and illustrated for *Scribner's*. In 1924 his first book was published. It was followed by 19 others and many short stories, bringing him lasting fame as a cowboy artist and writer.

Jenks, Albert (1824-1901)

B. New York City. D. Los Angeles, California, July 22. Lived: California. *AAA;* Bénézit; Groce and Wallace; Mallett.

Jepperson, Samuel Hans (1855-1931)

B. Copenhagen, December 2. D. Provo, Utah, June 2. Lived: Provo. Haseltine.

Jewett, William Smith (1812-1873)

B. South Dover, New York, August 6. D. Springfield, Massachusetts, December 3. Lived: California. Fielding; Groce and Wallace; Mallett; *WWWA.*

John, Grace Spaulding (1890-)

B. Battle Creek, Michigan. Lived: Houston, Texas. *AAA;* Mallett; *WWAA.*

Johnson, Cordelia (1871-)

B. Omaha, Nebraska. Lived: Omaha. *AAA;* Fielding; Mallett.

Johnson, Frank Tenney (1874-1939)

B. Big Grove (later Oakland), Iowa, June 28, 1874. D. Alhambra, January 1, 1939. Lived: New York City and Alhambra. Work: National Gallery, Washington, D.C.; Dallas Art Association, Texas; Arizona State University, Tempe; Read Mullan Gallery of Western Art, Phoenix. Ainsworth 1968; Fielding; Mallett.

Like other outstanding painters of the cowboy theme, Frank Tenney Johnson was exposed to western lore as a boy and painted the real thing as soon as he could get to cowboy country. In the interim he had art lessons with Richard Lorenz, a former Texas Ranger, followed by formal training at the Art Students' League and the New York School of Art. Johnson's first studio was in New York where he gained recognition as an illustrator. Close friendship with the cartoonist Clyde Forsythe resulted in their sharing a studio together in Alhambra, California, where Forsythe had moved in order to be near the western scenes he wanted to paint. Success in their work encouraged them to establish the Biltmore Art Gallery in nearby Los Angeles.

Johnson, Wayne (1871-)
B. Springville, Utah. Lived: California; Springville. Springville Museum of Art, *Permanent Collection Catalog.*

Jones, Elberta Mohler (1896-)
B. Kansas City, Missouri, March 16. Lived: Hollywood, California. *AAA;* Fielding; *WWAA.*

Jones, Ida Stone (1867-1944)
D. Palm Springs, California. Lived: California; possibly Washington. LeRoy.

Jonnevold, Carl Henrik (1856-c.1930)
Lived: California, 1887-1930. Oakland Art Museum.

Jonson, Raymond (1891-)
B. Chariton, Iowa. Lived: Chicago, Illinois; Santa Fe and Albuquerque, New Mexico. *AAA;* Fielding; Mallett; *WWA; WWAA.*

Jorgensen, Christian (1859-1935)
B. Oslo, Norway, 1859. D. Piedmont, California, June 9, 1935. Lived: Oakland, Yosemite National Park, Carmel, and Piedmont, California. Work: Yosemite National Park; Bohemian Club and Press Club, San Francisco. *CAR,* Vol. IV; California Historical Society, San Francisco.

During a two-year residence in Italy Jorgensen was asked about the Yosemite Valley he had never seen. In 1899 he pitched his tent there and after several months decided to make Yosemite his home. Jorgensen built a house and remained there for 19 years, but most of his important Yosemite scenes were produced while he camped out alone. By the terms of his wife's will, 250 of his paintings were given to Yosemite National Park.

Jorgensen's other areas of interest were the Grand Canyon, the San Francisco waterfront, Carmel, the desert, and the old missions. He and his wife made sketching trips to the missions by horse and buggy, camping out during periods of fair weather. In later years Jorgensen spoke of his five-year mission project as one of the happiest times of his life.

Joullin, Amedee (1862-1917)

B. San Francisco, California, June 13, 1862. D. San Francisco, February 3, 1917. Lived: San Francisco. *CAR,* Vol. IV; Fielding; Mallett.

Although Joullin is best known for his San Francisco Bay area landscapes, his interest in color prompted him to establish contact with the Indians of the Southwest. His most productive period among them was in 1898 when he remained in New Mexico for nine months. He did not find it easy to endure the discomfort of their ancient adobes, nor did he like their food; but he knew that only by becoming a trusted member of their household would he be allowed to paint their portraits and their way of life.

Joullin also did some landscapes of the western plains. As a result of the attention they attracted at a New York exhibition, he received a commission to depict the driving of the last spike of the Northern Pacific Railroad for the State Capitol in Helena, Montana.

Joullin, Lucile (1876-1924)

B. Geneseo, Illinois, 1876. D. San Francisco, 1924. Lived: San Francisco. Work: Bohemian Club, San Francisco. *CAR,* Vol. IV; Fielding; Mallett.

Lucile Joullin's paintings are now as highly prized by California collectors as her husband Amedee's. Her landscapes are primarily of San Francisco Bay area scenes; her genre paintings are of Pueblo Indians.

Early in Mrs. Joullin's married life she accompanied her husband to the Southwest where they lived and painted among the Indians. During those intervals she grew to love the country and to respect the native inhabitants. After her husband's death in 1917, she went to Isleta, New Mexico, to recover from her loss. There she lived with an Isleta widow and her son, shared their life, and made lasting friendships. Much of her work from this period is devoted to Indian subjects.

Judson, C. Chapel (1864-1946)

B. Detroit, Michigan, October 15. D. Carmel, California, November 4. Lived: San Francisco and Pebble Beach, California. Mallett.

Judson, William Lees (1842-1928)
B. Manchester, England. D. Los Angeles, California. Lived: Canada; Chicago, Illinois; New York City; Los Angeles. *AAA;* Bénézit; Fielding; Mallett; *WWA; WWWA.*

Jump, Edward (1838-1883)
B. France. D. Chicago, Illinois, April 21. Lived: San Francisco, California; Washington, D.C.; New York City. Groce and Wallace; Taft.

K

Kane, Paul (1810-1871)
B. Mallow, County Cork, Ireland, September 3. D. Toronto, Canada, February 20. Lived: Toronto; in United States 1836-1840. Groce and Wallace; Harper; Mallett.

Kasimer, Luigi (1881-1962)
B. Germany. Lived: Paris, France; Arizona. Mallett.

Keeler, Charles Butler (1882-)
B. Cedar Rapids, Iowa, April 2. Lived: Cedar Rapids; Glendora and Dana Point, California. *AAA;* Fielding; Mallett; *WWA; WWAA.*

Keener, Anna E. (1895-)
B. Flagler, Colorado, October 16. Lived: Dalhart, Texas; Gallup, Portales, and Santa Fe, New Mexico. *AAA;* Fielding; Mallett; *WWAA.*

Keith, William (1838-1911)
B. Aberdeenshire, Scotland, November 21, 1838. D. Berkeley, California, April 13, 1911. Lived: San Francisco and Berkeley, California; Dusseldorf, Germany, 1869-71. Work:

129

Brooklyn Museum, New York; Cincinnati Art Museum, Ohio; Delgado Museum, New Orleans, Louisiana; Crocker Art Gallery, Sacramento, California. *CAR,* Vol. II; Fielding; Groce and Wallace; Mallett; Neuhaus 1938.

"When I began to paint," wrote Keith, "I could not get mountains high enough or sunsets gorgeous enough for my brush." In later years Keith could produce a masterpiece from "a clump of trees, a hillside and sky."

By the turn of the century Keith was California's best-known landscapist. He was a prolific painter whose work still is seen frequently despite the loss of over 2,000 paintings, sketches, and studies in the San Francisco fire of 1906. Although almost 70 years old at the time, Keith doggedly set out to reproduce as many of them as possible. Unfortunately his popularity has prompted others to do likewise, and buyers will want to exercise caution in purchasing his work.

Keller, Arthur I. (1867-1924)
B. New York City, July 4. D. December 2. Lived: Riverdale, New York. *AAA;* Bénézit; *DAB;* Fielding; Mallett; *WWA; WWWA.*

Keller, Henry George (1870-1949)
B. Cleveland, Ohio, April 3. D. August 2. Lived: Cleveland; San Diego, California. *AAA;* Fielding; Mallett; *WWAA; WWWA.*

Kemble, Edward Windsor (1861-1933)
B. Sacramento, California, January 18. D. Ridgefield, Connecticut, September 19. Lived: California; Connecticut; New York. *AAA;* Fielding; Mallett; *WWA; WWWA.*

Kensett, John Frederick (1816-1872)
B. Cheshire, Connecticut, March 22. D. New York City, December 14. Lived: New York City. Bénézit; *DAB;* Fielding; Groce and Wallace; Mallett; *WWWA.*

Kepps, Alfred (-)
Lived: California, 1863-1902. Oakland Art Museum.

Kerby, Joseph (1857-1911)

B. Sheffield, Yorkshire, England, March 16. D. Provo, Utah, September 16. Lived: Provo. Haseltine.

Kern, Edward M. (1823-1863)

B. Philadelphia, Pennsylvania, October 26, 1823. D. Philadelphia, November 25, 1863. Lived: Washington, D.C.; Philadelphia. Work: Huntington Library and Art Gallery, San Marino, California. Groce and Wallace; Taft.

Kern was the artist for Fremont's third expedition which left Saint Louis in 1845 for California, where Kern River was named for him. The following year he was with Fremont as a lieutenant in the U.S. Army.

Kern's brothers Richard and Benjamin, a doctor, also had considerable sketching ability. All three were with Fremont in 1848 when he made a fourth expedition.

During the summer of 1849 Edward Kern left Santa Fe with the J. H. Simpson military expedition into Navajo country, accompanied by Richard. Seventy-two reproductions of Indian subjects and scenery, sketched by the brothers, were used to illustrate Simpson's published report (see *Journal of a Military Reconnaissance from Santa Fe*).

Kern, Richard H. (1821-1853)

B. Philadelphia, Pennsylvania, April 11, 1821. D. near Sevier Lake, Utah Territory, October 26, 1853. Lived: Washington, D.C. Work: Huntington Library and Art Gallery, San Marino, California. Groce and Wallace; Taft.

In 1849 Kern worked on Lt. J. H. Simpson's exploration and survey of a route from Fort Smith to Santa Fe, and also Simpson's military expedition to Navajo country. Kern's brother Edward joined him on the latter assignment. Kern did many illustrations for Simpson's published reports, and redrew some of Edward's sketches for the military report.

In 1851 Kern joined Capt. Lorenzo Sitgreaves' expedition and did many illustrations of Indians and scenery in the Southwest. Two years later he joined the E. G. Beckwith central railway survey and he was with the ill-fated detachment under Captain John W. Gunnison which was ambushed near Lake Sevier in Utah territory. His earlier sketches of the trip were redrawn by

John Mix Stanley and published in Beckwith's report, but the
sketchbook with him at the time of his death was taken by the
Indians.

Kerns, Maude Irvine (1876-)
B. Portland, Oregon, August 1. Lived: Eugene, Oregon.
Collins; *WWAA*.

Kerr, Irene Waite (1873-)
B. Pauls Valley, Oklahoma. Lived: Oklahoma City, Okla-
homa. Collins; Fielding.

Key, John Ross (1832-1920)
B. Hagerstown, Maryland, July 16. D. Baltimore, Mary-
land, March 24. Lived: Charleston, South Carolina; New
York City; Boston, Massachusetts; Baltimore. *AAA;* Béné-
zit; Fielding; Groce and Wallace; Mallett.

Kihn, Wilfred Langdon (1898-1957)
B. Brooklyn, New York, September 5, 1898. D. East Had-
dam, Connecticut, December 12, 1957. Lived: Indian res-
ervations in western United States and Canada; East Had-
dam, Connecticut. Work: Wesleyan University, Middle-
town, Connecticut. Mallett; Arizona State Museum, Tucson.

Kihn spent most of his life painting portraits of Indians in
the western United States and Canada. His fear that the Indians
were vanishing was so great that not even the scholarships re-
ceived during his art training in New York could hold him to
further study. His portraits are of the Stoney Indians of Canada;
the Navajos, Papagos, and Hopi of Arizona; the Blackfeet of
Montana; the Pueblos of New Mexico; and the Nootkas and Koo-
tenay of the Northwest. Kihn and his wife lived among these
Indians, eating their food and attending their ceremonies.

Hundreds of portraits and some landscapes, mostly done
during the 1920s and 1930s, have been purchased by museums in
England, Canada, and the United States.

Kilpatrick, Aaron Edward (1872-)
B. Saint Thomas, Canada. Lived: Eagle Rock, California.
AAA; Fielding; Mallett; *WWA; WWAA*.

Kingan Fred J. (-)
Lived: Denver, Colorado; explored Salmon River country of Idaho, 1879. Denver Public Library.

Kingan, Samuel Latta (1869-1943)
B. Pittsburgh, Pennsylvania, November 8. Lived: Tucson, Arizona. Mallett; *WWAA.*

Kingsley, Rose (1845-1925)
B. England. D. England, August 18. Lived: Colorado Springs, Colorado early 1870s; England. *New York Times,* August 19, 1925; Kingsley, *South by West or Winter in the Rocky Mountains and Mexico* (1874).

Kinney, Charlotte Conkright (-)
B. Ionia, Michigan. Lived: Baldwin, Kansas. Mallett; WWA.

Kirkham, Ruben (c.1850-1886)
D. Logan, Utah, April 10. Lived: Logan. Haseltine.

Kirsch, Agatha B. (1879-)
B. Creston, Iowa, May 9. Lived: Seattle, Washington. Mallett; *WWAA.*

Kirsch, Frederick Dwight (1899-)
B. Lincoln, Nebraska, January 28. Lived: Lincoln; Iowa. *AAA;* Mallett; *WWAA.*

Kissel, Eleanor M. (1891-1966)
B. Morristown, New Jersey. Lived: Taos, New Mexico; New York City. Mallett; *WWAA.*

Klauber, Alice (1871-)
B. San Diego, California, May 19. Lived: San Diego; Santa Fe, New Mexico. *AAA;* Mallett; *WWAA.*

Kleiber, Hans (1887-1967)
B. Vogelmuehle, Germany, August 24, 1887. D. December 8, 1967. Lived: Dayton, Wyoming. Work: Bradford Brinton Memorial, Big Horn, Wyoming; University of Wyoming,

Laramie. Federal Writers' Project, *Wyoming;* Forrest 1968; Mallett; *WWAA.*

Kleiber brought from Austria to Wyoming in 1907 "an abiding love of whatever the out-of-doors with its forests and mountains had to offer mankind," and stayed to become one of the state's best-known artists. In the Big Horn Mountains, Kleiber found work in a lumber camp, and six weeks later with the Forest Service where he remained for many years. His duties took him from eastern Washington to the International Boundary in Minnesota and gave him vast knowledge of that region. Without training in art Kleiber began expressing in water color, oil, print making, and poetry his feeling about the land he knew so well.

Kleiber's work has since been exhibited throughout this country, and the National Museum in Washington has given his prints and water colors a special showing.

Kleitch, Joseph (1885-)
 B. Banad, Hungary. Lived: Laguna Beach, California. *AAA;* Mallett.

Klepper, Frank Earl (1890-)
 B. Plano, Texas, May 3. Lived: Dallas, Texas. *AAA;* Fielding; Mallett; *WWAA.*

Klinker, Orpha (1895-1964)
 B. Fairfield, Iowa, November 20, 1895. D. Hollywood, California, 1964. Lived: Hollywood. Work: Los Angeles City Hall; Los Angeles Polytechnic High School; Los Angeles Art Association; Metropolitan Museum of Art, New York. Ainsworth 1960; *WWAA.*

Not long after Miss Klinker moved with her family from Iowa to California, she traveled in an improvised covered wagon from Chico to San Bernardino. Though very young she never forgot the wonders of that trip and in later years credited it with her choice of a career.

Miss Klinker is known for portraits and for paintings and etchings of California landmarks and southwestern landscapes. At Death Valley she painted Shoshone Johnny, an Indian who had seen Forty-niners cross that desolate valley. For the *Los An-*

geles Times she did a 40-portrait series called "Speaking of Pioneers," writing a biographical sketch for each. Her competent work has brought international recognition.

Klumpke, Anna Elizabeth (1856-1942)
B. San Francisco, California. Lived: San Francisco; France. *AAA;* Bénézit; Fielding; Mallett; *WWAA.*

Knapp, William A. (-1934)
Lived: Colorado. *Denver Post,* "Exhibit of Colorado Paintings in Paris," April 12, 1927, and "Artist Dies," May 14, 1934.

Knee, Gina (1898-)
B. Marietta, Ohio, October 31. Lived: Santa Fe, New Mexico; New York. Mallett; *WWAA.*

Knott, Franklin Price (1854-1900)
D. Santa Barbara, California. *AAA;* Mallett; *Rocky Mountain News,* July 13, 1879.

Knott, John Francis (1878-1963)
B. Austria, December 7. D. February 16. Lived: Dallas, Texas. Mallett; *WWA; WWAA; WWWA.*

Koerner, William Henry Dethlef (1878-1938)
B. Nunn, Schleswig-Holstein, Germany, November 19, 1878. D. Santa Barbara, California, August 11, 1938. Lived: Interlaken, New Jersey; Santa Barbara. Work: Whitney Galery of Western Art, Cody, Wyoming; private collections in California and Colorado. Ainsworth 1968; Mallett; Reed 1966.

For many years Koerner was known as one of this country's foremost illustrators of books and magazines. Now, posthumously, he is achieving recognition for his paintings which only in recent years have been exhibited.

Koerner was a prolific artist who worked with oils, water colors, crayons, and charcoal. His studio was at Interlaken, New Jersey, but his love of the West took him there for many sketching trips, particularly in Montana where he stayed at ranches near

135

Lodge Grass and Cooke City. Indians, miners, cowboys, and ponies were depicted by him with perceptiveness and understanding. His paintings, like his illustrations, have brought the Old West to life.

Koppel, Charles (-)
Groce and Wallace; Peters; Taft.
Little is known about Koppel other than that he was assistant engineer and official artist for Lt. Robert S. Williamson's railroad survey of 1853. With Williamson he left New York City by ship in May of that year, and began his work with the survey in July. The area covered was from Benicia, California, to the Sierra Nevada, thence south along the mountain range and across the desert to San Diego, with a side excursion by a small detachment through San Fernando Pass to Los Angeles. Koppel's view of that town is his best-known work. Twenty-six woodcuts and twenty-one full page lithographs are credited to Koppel in Williamson's published report (see *Pacific Railroad Reports,* Vol. V).

Krieghoff, William G. [Bill] (1876-1930)
B. Philadelphia, Pennsylvania. Lived: Ardmore and Philadelphia, Pennsylvania. *AAA;* Fielding; Mallett.

Kroll, Leon (1884-)
B. New York City, December 6. Lived: New York City. *AAA;* Fielding; Mallett; *WWA; WWAA.*

Kuchel, Charles Conrad (1820-)
B. Zweibrucken, Germany. Lived: San Francisco, California. Groce and Wallace; Peters.

Kuhler, Otto C. (1894-)
B. Remscheid, Germany, July 1894. Lived: ranch near Pine, Colorado; Santa Fe, New Mexico. Work: Denver Public Library, Colorado. Kuhler; Mallett 1940 Supplement; Denver Public Library.
Kuhler did not go West until 1947 when he settled on a ranch near Pine, Colorado. Some years later he visited the Trinidad mines, once important for their coal. Since his youth in Germany, Kuhler had been interested in the role played by coal in

the industrial revolution. His first residence in this country was Pittsburg where he settled in 1923 to make etchings and paintings of coal-powered industries. His work brought recognition as an artist.

When Kuhler sketched the Trinidad region, remnants of the coal industry were in ruins. He thought it important to record what little remained. He called his series of paintings "The Land of Lost Souls," as that area had once been known, and presented it to the Western History Department of the Denver Public Library.

Kuhn, Walt (1880-19:9)
 B. New York City, October 27. D. July 13. Lived: New York City. *AAA;* Fielding; Mallett; *WWAA; WWWA.*

Kummer, Julius Hermann (1817-c.1869)
 B. Dresden, Germany, 1817. D. sometime after 1868. Lived: Saint Louis, Missouri. Groce and Wallace; Powell.
 Like many other German artists of the 1840s, Kummer's career was interrupted by the Revolution. Shortly after arriving in the United States he gained recognition in New York City, and some time later in Boston. Despite his success Kummer moved to Saint Louis. During Kummer's few remaining years he repeated his eastern success with landscapes of the prairie and the Rockies. In late December 1868 the *Daily Missouri Republican* made note of Kummer's "Twelve Views of the Rocky Mountains": "They represent spots in the vicinity of Sidney, Benton, the Snowy Ridge, the Elk Mountain, taken from the east and west sides, the Table Rock, and other interesting sights."

Kunath, Oscar A. (-1904)
 B. Dresden, Germany. D. San Francisco, California. Lived: California 1878-1904. Oakland Art Museum.

Kuniyoshi, Yasuo (1893-1953)
 B. Okayama, Japan, September 1. D. May 14. Lived: New York City. *AAA;* Fielding; Mallett; *WWAA; WWWA.*

Kurz, Rudolph Friederich (1818-1871)
 B. Berne, Switzerland, January 18, 1818. D. Berne, Switzerland, October 16, 1871. Lived: Saint Louis and Saint Joseph,

Missouri; Fort Berthold and Fort Union; Berne, Switzerland. Work: Gilcrease Institute of Art, Tulsa, Oklahoma; Fine Arts Museum, Berne; Peabody Museum, Harvard University, Cambridge, Massachusetts. Groce and Wallace; McCracken 1952; Taft.

From Switzerland in 1847, Rudolph Kurz came to this country to paint the Indians in whom he had been interested since his youth. For five years he lived among them along the Missouri and Mississippi Rivers. At Saint Joseph, Missouri, in 1850, Kurz married the 16-year-old daughter of an Iowa chief, apparently a happy marriage for both until her people moved away and she became lonely. Not long after she left to rejoin her people, Kurz took over the job of a fur company clerk who had died of cholera, spending about two years at Fort Berthold and Fort Union. His spare time was devoted to sketching, taking notes, and compiling a dictionary of Mandan words. His journal was translated and was published by the Smithsonian Institution in 1937.

L

Labaudt, Lucien (1880-1943)
B. Paris, France. D. December 13. Lived: San Francisco, California. *AAA;* Mallett; *WWAA.*

Lambdin, Robert L. (1886-)
B. Dighton, Kansas, October 7. Lived: Westport, Connecticut. Mallett; *WWAA.*

Lambourne, Alfred (1850-1926)
B. England, February 2, 1850. D. Salt Lake City, Utah, June 6, 1926. Lived: Salt Lake City; Gunnison Island, Utah. Work: University of Utah, Salt Lake City. Federal Writers' Project, *Utah;* Haseltine; Horne.

Lambourne, whose pioneering life in Utah began at age

138

six, devoted his brief career in art to the painting of Great Salt Lake and the mountains of the western states. The lake inspired "Pictures of an Inland Sea" for which he combined his talents as writer, poet, and artist while living the life of a recluse on Salt Lake's Gunnison Island. Many of Lambourne's mountain landscapes are of the Wasatch range; to him these were the most magnificent mountains of all.

Lambourne was one of Utah's first home-trained painters, and like his colleagues he had a stint at scenery painting for the Salt Lake Theater. Before reaching his middle years, however, Lambourne gave up painting to write stories and poems about western life.

Lamson, J. (-)
Lived: California 1852, 1856-60; Maine. Groce and Wallace; Van Nostrand and Coulter.

Landacre, Paul Hambleton (1893-1963)
B. Columbus, Ohio, July 9. D. June 3. Lived: Los Angeles, California. Mallett; *WWA; WWAA; WWWA.*

Langsdorff, George Heinrich (1773-)
Visited California during Mexican rule. Mills.

Lapham, J. M. (-)
Lived: California, 1852-58. Groce and Wallace; Peters.

LaPlace, Cyrille (1793-1875)
Lived: France; California 1839. Groce and Wallace; Van Nostrand and Coulter.

Larsen, Bent Franklin (1882-1970)
B. Monroe, Utah, May 10, 1882. Lived: Provo, Utah. Work: Springville Art Association, Springville, Utah; Utah State University, Logan; Brigham Young University, Provo, Utah; Weber College, Ogden, Utah. Federal Writers' Project, *Utah;* Haseltine; Mallett; *WWAA.*

For many years Larsen taught and painted in Utah, his native state. His art training was extensive and included both French and American teachers; his work reflects both influences.

139

The subtle oils of his early period and his bolder work which made its appearance in the 1930s are in tune with the western landscape he made his specialty. He exhibited widely and is represented in museums throughout the country.

Since 1901 Larsen was an educator in Utah schools, lecturing on art history and appreciation and writing articles for magazines and newspapers. From 1931 to 1953 he was professor of art at Brigham Young University in Provo.

La Salle, Charles (c.1893-1958)
 D. Arizona. Lived: Texas; New York. Mallett.

Latham, Barbara (1896-)
 B. Walpole, Massachusetts. Lived: Taos, New Mexico; Norwichtown, Connecticut. *AAA;* Mallett; *WWAA.*

Latimer, Lorenzo Palmer (1857-1941)
 B. Gold Hill, Placer County, California, 1857. D. 1941. Lived: Reno, Nevada; San Francisco Bay cities. Work: Dr. and Mrs. Bruce Friedman Collection, San Francisco Bay area. Ferbraché; *WWC* 1928-29; California State Library, Sacramento.

 Latimer is known for his water colors of Nevada and California. He was born in California of pioneer parents who had settled at Gold Hill in Placer County, but he taught and painted so many years in Nevada that he is frequently thought of as a Nevada artist. Some of his early paintings there specified place and date, adding to their importance.

 Latimer's schooling included study at a military academy in Oakland before deciding upon a career in art which he prepared for at the School of Design in San Francisco. Later he taught there when it was the Mark Hopkins Art Institute. He also taught in Reno, Nevada, where he founded the Latimer Art Club in 1921, and at the University of California in Berkeley.

Lauritz, Paul (1889-)
 B. Larvik, Norway, April 18, 1889. Lived: Los Angeles, California. Work: University of California; University of Chicago; Fine Arts Gallery of San Diego; Ebell Club, Los Angeles. Ainsworth 1960; Mallett; *WWAA.*

Lauritz, who is internationally known for marines as well as landscapes, was born and educated in Norway. He went to Canada in his late teens to earn money for further study, then to Oregon where he married in 1912. Five years later, after he had failed in an Alaska mining venture and lost his health besides, he moved to Los Angeles.

Lauritz began painting the desert in 1920. With his wife he camped out for weeks at a time, becoming familiar with cloudbursts and sandstorms, extremes in temperature, and quaint, sandy roads. From that experience Lauritz recreated the mood, light, and coloring of California and Nevada desert country.

Lavender, Christ (-)
Lived: Waco, Texas about 1840. Groce and Wallace.

Lavender, Eugenie Aubanel (1817-1898)
B. France, 1817. D. 1898. Lived: Waco and Corpus Christi, Texas. Work: Incarnate Word Academy, Corpus Christi. Barker; Groce and Wallace; Pinckney.

Before her marriage, Mrs. Lavender studied art in Paris where, in 1838, she and Rosa Bonheur won medals for their work at the Academy. A desire for adventure in a new country prompted the Lavenders to settle in Texas with their two small daughters in 1852. From New Orleans they traveled by covered wagon to Waco, surviving the hazards of prairie fires, Indian raids, food shortages, and yellow fever.

Mrs. Lavender continued to paint and gave many small paintings to her neighbors. When she ran out of pigment she made her own from wild plants and colored clays. Corpus Christi, where the Lavenders lived for some time, has the largest collection of her work.

Lawson, Ernest (1873-1939)
B. Halifax, Canada. D. Coral Gables, Florida, December 18. Lived: New York City; Colorado Springs, Colorado; Florida. *AAA;* Fielding; Hubbard and Ostiguy; Mallett; *WWA; WWWA;*

Leach, Maud A. (-)
Lived: Denver, Colorado. *Times,* December 6, 1911; Denver Public Library.

Leaming, Charlotte (1878-c.1972)
B. Chicago, Illinois, January 16. Lived: Colorado Springs, Colorado. *AAA;* Mallett; *WWAA.*

Learned, Harry (-)
Lived: Colorado, where he was active 1870-90. Denver Public Library; *Colorado Collectors.*

Lee, Bertha Stringer (1873-1937)
B. San Francisco, California. Lived: San Francisco. *AAA;* Fielding; Mallett; *WWAA.*

Lee, Joseph (1827-1880)
Lived: California, 1859-79. *Antiques,* June 1969; Oakland Art Museum.

Leggett, Lucille (1896-)
B. Tennessee, 1896. Lived: El Paso, Texas; Capitan, Carrizozo, Ruidoso, and Santa Fe, New Mexico. Work: almost all in private collections. *Artists of Santa Fe* (catalog); Montes.

Lucille Leggett moved to New Mexico from Tennessee in 1914. Following her marriage several years later to a railroad engineer, she moved to El Paso, Texas, where she studied art at the college there. Later she lived and painted in Capitan, Carrizozo, and Ruidoso, New Mexico. In 1952 she moved to Santa Fe, where she had a studio-home on Canyon Road, a quaint street of adobe houses that has attracted artists for many years.

Mrs. Leggett's work reflects her interest in ghost towns, ranches, old adobe buildings, small village churches, and desert landscapes. Most of her work was done at the site but finished in her studio. Her oil paintings have been exhibited in one-woman shows in the Southwest, in Florida, and in Mexico.

Leigh, William Robinson (1866-1955)
B. Falling Waters, Berkeley County, West Virginia, September 23, 1866. D. New York, March 11, 1955. Lived: Baltimore, Maryland; Munich, Germany; New York City. Work: Gilcrease Institute of Art, Tulsa, Oklahoma; University of Arizona Museum of Art, Tucson; Hubbell Trad-

ing Post Museum, Ganado, Arizona; Woolaroc Museum, Bartlesville, Oklahoma. Fielding; Mallett; Taft.

Leigh is sometimes called the "Sagebrush Rembrandt." He wasn't born in the West and never really lived there, but from 1906 it was his greatest inspiration. "Never in the whole of human history, at any time or anywhere, has there been a terrain more suitable for making pictures or telling stories than our own West," he said.

During frequent trips to Arizona and New Mexico, Leigh lived and sketched among Indians, cowboys, and bad men. He wrote stories about the Indians and did illustrations for *Scribner's* and other magazines. He also wrote a small book called *The Western Pony* in which he discussed his philosophy about art and the methods he used to show animal movement. His action-packed, epical paintings of the West are in museums throughout the country, especially in Tulsa, Oklahoma, where Gilcrease Institute has hundreds of his charcoals and oils.

Leighton, Kathryn Woodman (1876-1952)

B. Plainfield, New Hampshire, March 17, 1876. D. Los Angeles, California, July 1, 1952. Lived: Los Angeles; summers: Blackfoot Reservation. Work: Gilcrease Institute of Art, Tulsa, Oklahoma. Binheim; Mallett; *Ward Shelby's Southwest Magazine,* October 1930.

Kathryn Leighton's portraits of American Indians brought her fame in the United States, in Paris, and in London. Remarking upon her work, *The Connoisseur* referred to "the innate dignity, the inscrutability of expression, and the look of command habitual to the best type of the chiefs" which she had captured with paint. Many of these portraits are also signed by the sitter; Chief Eagle Calf, for example, drew an eagle and a calf in one corner of his portrait.

Mrs. Leighton was introduced to the Blackfeet Indians by her friend Charlie Russell. Thereafter she spent many summers with them and was adopted into the tribe and allowed to witness their ceremonies. She is also known for her paintings of the Sioux and the Cherokee and for her western landscapes and flower studies.

Lemmon, Sara Allen Plummer (-)
B. New Gloucester, Maine. Lived: Oakland, California.
WWA.

Lemos, Pedro J. (1882-1945)
B. Austin, Nevada, May 25. Lived: Palo Alto, California.
Fielding; Mallett; *WWA; WWAA.*

Lenders, Emil W. (-1934)
B. Germany. D. Oklahoma City, Oklahoma, April 5. Lived:
Oklahoma City. Mallett; *WWAA.*

Lent, Frank T. (-)
Lived: New Brunswick, New Jersey; Colorado Springs,
Colorado. McClurg.

Leutze, Emanuel (1816-1868)
B. Wurttemberg, Germany, May 24. D. Washington, D.C.,
July 18. Lived: Washington, D.C. Bénézit; Fielding; Mal-
lett; *WWWA.*

Lewis, Jeannette Mayfield (1894-)
B. Oakland, California, April 19. Lived: Fresno and Pebble
Beach, California. *AAA;* Mallett; *WWAA.*

Lewis, Minard (c.1812-)
B. Maryland. Lived: Boston, Massachusetts; New York
City. Groce and Wallace; Taft.

Lewis, Phillips Frisbie (1892-1930)
B. Oakland, California, August 26. D. Oakland, February
24. Lived: Oakland. *AAA;* Fielding; Mallett.

Lillywhite, Raphael (1891-1958)
B. Woodruff, Arizona, December 7, 1891. D. Evanston, Wy-
oming, December 24, 1958. Lived: Denver and Walden,
Colorado. Work: Museum of Natural History, Denver;
William and Dorothy Harmsen Collection, Denver. Denver
Public Library.
 Lillywhite, who was named Raphael because his mother

was fond of the artist's work, grew up at his father's trading post on the Little Colorado River in Arizona. His first-hand experiences with Indians and pack trains were subjects for his paintings both before and following his return from four years of formal training at the University of Utah and private lessons from a Hungarian marine painter.

After moving to Denver, Colorado, ranch scenes became Lillywhite's favorite theme. His lifelike portrayals of cowboys and animals in his landscapes have endeared him to many a collector of western art. In later years Lillywhite lived in Walden, a small community in the heart of northern Colorado ranching country.

Lindneux, Robert Ottakar (1871-1970)

B. New York, 1871. Lived: Great Falls, Montana; Denver, Colorado. Work: Colorado State Museum, Denver. Ainsworth 1968; Fielding; Mallett.

Lindneux was nine when his art training began and 16 when he went to Europe for further study. There he met Buffalo Bill, and also Rosa Bonheur who had painted the famous showman. These associations influenced him to go west.

Much of Lindneux' work is in Denver where he lived for many years. He also spent time at Billings, Montana, and at Great Falls where he shared Charlie Russell's studio. Intermittently he traveled about, and during his trips he collected so many relics it became necessary to settle permanently; in 1909 he chose Denver and opened a studio. Lindeaux' work reflects a historical interest in many facets of western life, especially some of the early Indian battles, and during his lifetime he often was referred to as the "Historian of the West."

Lindsay, Andrew Jackson (-1895)

In Oregon 1849. Groce and Wallace; his known works, however, may be those of George Gibbs, a member of the same expedition.

Link, Carl (1887-1968)

B. Munich, Germany, August 13. Lived: New York City; summers: Lake Tahoe, California. Mallett; *WWAA*.

Lloyd, Lucile (1894-)

B. Cincinnati, Ohio. Lived: Los Angeles and Hollywood, California. *AAA;* Mallett; *WWAA.*

Lochrie, Elizabeth (1890-)

B. Deer Lodge, Montana, July 1, 1890. Lived: Butte, Montana. Work: murals in public buildings in Burley and Saint Anthony, Idaho; Dillon and Galen, Montana. *WWAA;* "The Painter of the Blackfoot," *Denver Post Empire Magazine,* May 9, 1954.

Elizabeth Lochrie is a Montana-born artist and lecturer. Her special interest is the Blackfeet tribe of her state, and she has done more than a thousand water colors, oils, murals, frescoes, and sculptures of them. The price of her lectures frequently has been a donation of clothing and other necessities for the needy members of the tribe. To the Blackfeet Indians, Mrs. Lochrie is Netchitaki, Woman Alone in Her Way, and about her they say: "She came to us from over the Western Mountains, this white woman. She was friendly and understanding, and we brought her into the medicine tepee and made her our sister."

Mrs. Lochrie has exhibited throughout the northwestern states and in New York City. From 1936 to 1941 she was staff artist for the Great Northern Railroad in Glacier National Park.

Lockwood, Ward (1894-1963)

B. Atchison, Kansas, September 22. D. July 6. Lived: Austin, Texas; Santa Fe, New Mexico. *AAA;* Mallett; *WWA; WWAA.*

Lone Wolf [see Schultz]

Long, Stanley M. (1892-1972)

B. Oakland, California, May 4, 1892. D. San Carlos, March 30, 1972. Lived: San Francisco and San Carlos, California. Work: Shasta City Museum and Gallery, Shasta, California; Prudential Life Insurance Company, New Jersey. Ainsworth 1968; Mallett 1940 Supplement; *WWAA.*

Long grew up on a ranch in Napa County, California. At 19 he entered the San Francisco Art Institute and three years later went to Europe for further study. As a boy, Long broke

wild horses, and from observation and experience he learned a great deal about them. Upon his return from Europe he made horses the central theme of his work.

Long is known primarily in the San Francisco Bay region where he lived for many years and where for 17 years he taught art at San Francisco's Polytechnic High School.

Loomis, Pascal (1826-1878)
B. Hartford, Connecticut, July 24. D. January 3. Lived: California. Groce and Wallace; Oakland Art Museum.

Lopp, Harry Leonard (1888-)
B. Highmore, South Dakota, May 1. Lived: Somers, Montana. *WWAA.*

Lorenz, Richard (1858-1915)
B. Voigtstaedt, Germany, February 9. D. Milwaukee, Wisconsin, August 3. Lived: Milwaukee. *AAA;* Bénézit; Fielding; Mallett; *WWWA.*

Lotave, Carl G. (1872-1924)
B. Sweden. D. New York. Lived: New York; Colorado Springs, Colorado. *AAA;* Fielding; Mallett.

Lotz, Matilda (1861-1923)
Lived: California 1871-1900. Oakland Art Museum.

Love, Charles Waldo (1881-1967)
B. Washington, D.C. Lived: Denver, Colorado. Hafen 1948, Vol. II; Hafen and Hafen 1943.

Ludlow, Fitz-Hugh (-)
In Colorado 1860s. Federal Writers' Project, *Colorado;* Ormes and Ormes.

Ludovici, Alice Emilie (1872-)
B. Dresden, Germany. Lived: Pasadena, California. *AAA;* Fielding; Mallett; *WWA.*

Ludovici, Julius (-)
Lived: California 1890-1905. Oakland Art Museum.

Lundborg, Florence (-)
B. San Francisco, California. Lived: New York; France.
AAA; Fielding; Mallett; *WWAA.*

Lungkwitz, Herman (1813-1891)
B. Halle, Germany, March 14, 1813. D. Austin, Texas, 1891.
Lived: New Braunfels, Fredericksburg, San Antonio, and
Austin, Texas. Work: Amon Carter Museum of Western
Art, Fort Worth, Texas; San Antonio Public Library; Witte
Museum, San Antonio. Barker; Groce and Wallace; Mal-
lett; Pinckney.

In 1851 Lungkwitz and Richard Petri—fellow artist, brother-
in-law, and close friend—established a log-cabin home in New
Braunfels, Texas, and later in Fredericksburg. Despite pioneering
hardships, both artists found time to paint. Lungkwitz did a num-
ber of landscapes of the Pedernales River country at that time
and in later years returned to make sketches of the region.

Lungkwitz moved in 1866 to San Antonio where he be-
came interested in photography, a medium which taught him
much about light. This knowledge, together with the newly de-
veloped coal-tar pigments, aided Lungkwitz in painting canvases
of brighter hue and greater luminosity. In 1871 Lungkwitz moved
to Austin to become official photographer of maps in the General
Land Office. There he continued his art work and taught at the
Texas Female Institute.

Lungren, Fernand H. (1857-1932)
B. Toledo, Ohio, November 13, 1857. D. Santa Barbara,
1932. Lived: Cincinnati, Ohio; Santa Barbara, California.
Work: University of California at Santa Barbara; Hubbell
Trading Post Museum, Ganado, Arizona. Berger; Fielding;
Neuhaus 1931; Taft.

Lungren, who studied art under Thomas Eakins, started
his career as an illustrator and ended it as an art instructor in
Santa Barbara, California. Although he painted many Death
Valley and Mojave Desert scenes, he is best known for his
work in Arizona and New Mexico which began in 1892 while on
a Santa Fe Railway sketching trip. He became a trusted friend
of the Hopi who were the principal subjects of his paintings; ulti-
mately he was honored by initiation into one of their fraternities.

Lungren's paintings have appeared as illustrations in various periodicals. His famous painting "Thirst," said to have been based on personal experience, was reproduced in *Harper's Weekly*, February 8, 1896, with comments by Owen Wister.

M

McArdle, Henry Arthur (1836-1908)
B. Belfast, Ireland, June 9. D. February 16. Lived: Independence, Texas. Mallett; Groce and Wallace.

MacChesney, Clara Taggart (1860-1928)
B. Brownsville, California. D. London, England. Lived: New York City; summers: Onteora, New York. *AAA;* Fielding; Mallett; *WWA.*

McClung, Florence White (1896-)
B. Saint Louis, Missouri, July 12. Lived: Waxahachie and Dallas, Texas. Mallett; *WWAA.*

McClusky, Grace Dictover (1891-)
B. Long Beach, California, December 25. Lived: San Marino, California. Collins; *WWAA.*

McClymont, John I. (1858-1934)
B. Scotland. Lived: Colorado Springs, Colorado. Ormes and Ormes.

McComas, Francis John (1874-1938)
B. Fingal, Tasmania, October 1, 1874. D. Pebble Beach, California, December 28, 1938. Lived: San Francisco, Carmel, and Pebble Beach. Work: California Palace of the Legion of Honor, San Francisco; M. H. De Young Memorial Museum and California Historical Society, San Francisco.

CAR, Vol. IX; Fielding; Mallett; Seavey, *McComas*.

McComas was born in Tasmania, received his schooling in Australia, and worked his way to San Francisco in 1898 as a seaman. Ten years later he was an artist of note, having exhibited twice in London and having been presented to the Royal family of Greece.

From McComas' 1909-10 sketching trip to New Mexico and Arizona came such paintings as "Mesa Land," "The Zuni Pass," and "A Navajo Village." Other trips to the Southwest were made in subsequent years. McComas also painted in Mexico, Tahiti, and several European countries. Most of his work was in water color.

In 1910, when California had more artists than any other western state, the outspoken McComas was asked: "Don't you respect all California artists?" "Most assuredly," he replied, "I respect the whole four of them."

McCord, George Herbert (1848-1909)
B. New York, August 1. D. New York. Lived: New York. *AAA;* Fielding; Mallett; *WWWA.*

McCormick, Howard (1875-1943)
B. Hillsboro, Indiana. D. about October 11. Lived: Leonia, New Jersey. Mallett; *WWAA; WWWA.*

McCormick, M. Evelyn (1869-)
B. Placerville, California. Lived: Monterey, California. *AAA; Overland Monthly*, January 1908.

Macdonald-Wright, Stanton (1890-)
B. Charlottesville, Virginia, July 8. Lived: Los Angeles, California. Fielding; Mallett; *WWAA.*

McEwen, Katherine (1875-)
B. Nottingham, England, July 19. Lived: Alaska; Detroit, Michigan; Dragoon, Arizona. *AAA;* Fielding; Mallett.

McGlynn, Thomas A. (1878-1966)
D. Pebble Beach, California, June 21. Lived: San Francisco and Pebble Beach. Mallett; *WWAA.*

McIllwraith, William Forsyth (1867-1940)

B. Gault, Ontario, 1867. D. Fishkill, New York, 1940. Lived: New York; Hood River and Portland, Oregon. Work: Dr. and Mrs. Franz Stenzel Collection, Portland, Oregon. Stenzel and Stenzel 1963.

McIllwraith is well known in Oregon for his authentic scenes of Indian fishing and river shipping along the Columbia and Willamette—scenes which have changed drastically with the passage of time. His work is therefore of documentary as well as aesthetic importance.

From a successful commercial art career in New York City, McIllwraith moved to the Hood River in 1911 to try his hand at farming. Twelve years later he returned to the art field. Etching and water color were his principal media. Many of his etchings appeared on calendars and are now being sought by collectors as are his other works.

McIlvaine, William, Jr. (1813-1867)

B. Philadelphia, Pennsylvania, June 5. D. Brooklyn, New York, June 16. Lived: New York City. Groce and Wallace; *WWWA*.

Mack, Leal (1892-1962)

B. Titusville, Pennsylvania. D. Taos, New Mexico. Lived: Taos. Bent Gallery, Taos.

MacLaren, T. (-)

B. England. Lived: Colorado Springs 1890s. McClurg.

MacLennan, Eunice Cashion (1886-1966)

B. Marquand, Missouri. D. Carmel Valley, California, June 24. Lived: Santa Barbara and Carmel, California. *AAA;* Mallett; *WWAA*.

MacLeod, Alexander (1888-)

B. Canada. Lived: San Francisco and San Mateo, California; Hawaii. *AAA;* Fielding; Mallett; *WWAA*.

McMicken, Helen Parker (1856-1942)

B. Olympia, Washington. D. Olympia. Lived: Olympia. University of Washington, Seattle.

McMurtrie, William Birch (1816-1872)

Lived: Philadelphia, Pennsylvania. Work: California Historical Society, San Francisco; Museum of Fine Arts, Boston. Groce and Wallace; Mills.

McMurtrie was an amateur Philadelphia painter who exhibited there from 1837 to 1844, and sold at least one landscape to the Pennsylvania Academy. He is best known for his 1850 painting "Gold Rush Town" which was made famous by Currier and Ives. Several others of the San Francisco area can be seen at the California Historical Society. As draftsman for the Navy's Pacific Coast Survey Expedition which began in 1849, McMurtrie sketched areas from San Francisco to Vancouver Island. Fifteen of his drawings and water colors are at the Museum of Fine Arts in Boston, including "San Bar near the Cascades of the Columbia," "Departure Bay," and "Indian Graves, Vancouver."

McNeely, Perry (1886-)

B. Lebo, Kansas. Lived: Los Angeles, California. Mallett; *WWAA.*

MacNeil, Hermon Atkins (1866-1947)

B. Chelsea, Massachusetts, February 27. D. October 2. Lived: College Point, Long Island, New York. *AAA;* Bénézit; Fielding; Mallett; *WWA; WWAA; WWWA.*

Mahier, Edith (1892-)

B. Baton Rouge, Louisiana. Lived: Norman, Oklahoma. *AAA;* Fielding; Mallett; *WWAA.*

Major, William Warner (1804-1854)

B. Bristol, England, January 27, 1804. D. London, England, October 2, 1854. Lived: Salt Lake City, Utah; London. Work: Beehive House, Church of Jesus Christ of Latter Day Saints, First Presidency, Salt Lake City; Groce and Wallace; Haseltine; James 1922.

Major is known to have been the first Mormon artist in Utah to devote full time to painting. He was born in England and immigrated to this country in 1844, two years after joining the Latter Day Saints. He was best known for his small profile portraits and his illustrations of Mormon sufferings. His painting of

152

Joseph Smith's assassination was exhibited at Nauvoo, Illinois, in 1845. The following year Major left Nauvoo for Utah with a wagon train of Mormons. Along the route he sketched Indians and western landscapes. After spending about five years in Salt Lake City, Major returned to England late in 1853.

Mangravite, Pepino (1896-)
B. Lipari, Italy, June 28. Lived: New York; Colorado Springs, Colorado. *AAA;* Fielding; Mallett; *WWAA.*

Mannheim, Jean (1863-1945)
B. Kreuznach, Germany. D. September 6. Lived: Pasadena, California. *AAA;* Fielding; Mallett; *WWA; WWAA; WWWA.*

Marchand, John N. (1875-1921)
B. Leavenworth, Kansas. D. Westport, Connecticut. Lived: New York City; Westport. Baird; Dykes.

Marlatt, H. Irving (-1929)
B. Woodhull, New York. D. Mount Vernon, New York. Lived: New York. *AAA;* Mallett.

Marple, William L. (1827-1910)
Lived: California. California State Library, Sacramento; Oakland Art Museum.

Marriott, Fred M. (1805-1884)
B. England. D. San Francisco. Lived: California. Society of California Pioneers, San Francisco.

Marryat, Samuel Francis (1826-1855)
B. London, England, April 18, 1826. D. London, 1855. Lived: San Francisco, California; England. Work: Oakland Art Museum, California. Groce and Wallace; Peters.

Marryat was a topographical artist from London who spent three years depicting California as he saw it from the autumn of 1849 until his final departure in 1853. During that period, except for returning briefly to England in 1852, San Francisco was Marryat's home.

Harry Twyford Peters, who compiled *California on Stone,* a huge book of early lithographs, considered Marryat a fine artist. His work is of documentary as well as artistic importance, and occasionally it is used to illustrate books about western history and early western art. Of particular significance is Marryat's own book which he called *Life in California: Mountains and Mole Hills,* an illustrated book of his recollections published in New York and in London the year of his death.

Martin, John A. Lee (-)
In California 1850. Groce and Wallace; Van Nostrand and Coulter.

Martin, John Breckenridge (1857-)
B. London, Kentucky. Lived: Dallas, Texas. *AAA;* Mallett.

Martin, Thomas Mower (1839-1934)
B. London, England. D. Toronto, Ontario, Canada. Lived: New York; Toronto. Mallett; Stenzel and Stenzel 1963.

Martinez, Pete (1894-)
B. Porterville, California. Lived: Tucson, Arizona. Ainsworth 1968.

Martinez, Xavier (1874-1943)
B. Guadalajara, Mexico, February 7, 1874. D. Piedmont, California, January 13, 1943. Lived: Piedmont. Work: Oakland Art Museum, California; Hubbell Trading Post Museum, Ganado, Arizona; M. H. De Young Museum, San Francisco, California. *CAR,* Vol. X; Fielding; Genthe; Mallett.

One of the most colorful as well as capable of the California artists was Xavier Tizoc Martinez y Orozco, who was born in Mexico of Spanish and Indian stock. He moved to San Francisco in 1893 to study art, and in 1895 he went to France, Italy, and Spain for six more years of study.

When William Merritt Chase saw one of Martinez' paintings in a New York studio, he remarked, "Why don't we know this man's work? He is a great artist." But Martinez preferred to remain in the San Francisco area where he taught many years at

the California School of Arts and Crafts. Most of his impressionist paintings are of the Piedmont hills where he lived. He also made sketching trips to Mexico, Arizona (where he painted the Hopi in 1913), and the Monterey Peninsula.

Mason, Elizabeth (1880-)
B. Jacksonville, Illinois, June 9. Lived: Denver, Colorado; California. Binheim.

Mason, Roy Martell (1886-)
B. Gilbert Mills, New York. Lived: Batavia, New York; La Jolla, California. *AAA;* Fielding; Mallett; *WWA; WWAA.*

Masterson, James W. (1894-1970)
B. Wisconsin, June 27. D. Miles City, Montana. Lived: Miles City. *WWAA;* "Noted Artist Dead at 84," *Fort Collins Coloradoan,* May 5, 1970.

Mathews, Alfred E. (1831-1874)
B. Bristol, England, June 24, 1831. D. near Big Thompson River, Colorado, October 30, 1874. Lived: Nebraska City, Nebraska; Denver and near Big Thompson River, Colorado. Work: Nebraska State Historical Society, Lincoln; Denver Public Library. Groce and Wallace; Taft.

Upon Mathews' arrival in Denver in the fall of 1865, he began immediately to draw street scenes, industrial developments, and the Rocky Mountains. These drawings he either lithographed himself or had lithographed in the East. Two of his most noteworthy publications are *Pencil Sketches of Colorado* and *Pencil Sketches of Montana;* both provide important pictorial records.

Mathews sketched in most of the western states. He generally traveled alone with a pack pony and a riding pony. In *Gems of Rocky Mountain Scenery* he explained his method of work and means of transportation. Mathews also wrote and illustrated *Canyon City, Colorado, and Its Surroundings.* His enthusiasm for that area prompted him to attempt a colonization scheme there, but it did not materialize.

Mathews, Arthur Frank (1860-1945)
B. Markesan, Wisconsin, October 1. D. February 19. Lived:
San Francisco, California. *AAA;* Fielding; Mallett; *WWA;*
WWWA.

Mathews, Felix Angel (c.1833-)
B. Morocco. Lived: California 1855-69, 1887-90. Oakland
Art Museum.

Mathews, Lucia Kleinhaus (1882-)
B. San Francisco, California. Lived: San Francisco. *AAA;*
Fielding; Mallett.

Mattern, Karl (1892-1969)
B. Durkheim, Germany, March 22. D. Des Moines, Iowa,
January 18. Lived: Des Moines; Lawrence, Kansas. *AAA;*
Mallett; *WWAA.*

Maurer, Louis (1832-1932)
B. Biebrich, Germany, February 21. D. New York City,
July 19. Lived: New York City. *AAA;* Groce and Wallace;
Mallett.

Mauzey, Merritt (1898-)
B. Clifton, Texas. Lived: Dallas, Texas. Mallett; *WWAA.*

Maxwell, Laura (1877-1967)
B. Carson City, Nevada, October 13. D. August 7. Lived:
Carmel Valley, California. Monterey Public Library.

Mays, Paul Kirtland (1887-1961)
B. Cheswick, Pennsylvania, October 4. D. Carmel, Cali-
fornia, June 30. Lived: Bryn Athyn, Pennsylvania; Carmel
and Monterey, California. Mallett; *WWA; WWAA; WWWA.*

Meakin, Louis Henry (1853-1917)
B. New Castle, England. D. Boston, Massachusetts, August
14. Lived: Cincinnati, Ohio. *AAA;* Fielding; Mallett;
WWWA.

Megargee, Lon (1883-1960)
B. Philadelphia, Pennsylvania. Lived: Phoenix, Arizona. Mallett; *WWAA*.

Melcher, Bertha Corbett (1872-)
B. Denver, Colorado, February 8. Lived: Topanga, California. *AAA;* Fielding.

Melrose, Andrew (1836-1901)
D. New York, February 23. Lived: Hoboken and Guttenberg, New Jersey. Eberstadt; Groce and Wallace.

Merrild, Knud (1894-)
B. Jutland, Denmark, May 10. Lived: Los Angeles, California; Taos, New Mexico. Mallett; *WWAA*.

Merrill, Arthur (1885-1973)
B. Saint Louis, Missouri, April 11. D. Santa Fe, New Mexico, April 21. Lived: Taos, New Mexico. Harwood Foundation Library, Taos.

Mersfelder, Jules (1865-1937)
B. Stockton, California, August 26. D. Alameda County, California, October 23. Lived: California. California State Library, Sacramento.

Metcalf, Willard Leroy (1858-1925)
B. Lowell, Massachusetts, July 1, 1858. D. New York, March 9, 1925. Lived: Boston and New York. Work: Museums in Philadelphia, Chicago, Boston, Pittsburgh, Cincinnati, Saint Louis, and Buffalo. Fielding; Mallett; Taft.

Although Metcalf is known as a New England landscape painter, he did some important work in the Southwest. His ethnological illustrations for Frank H. Cushing's "My Adventures in Zuni" appeared in *The Century Magazine* in 1882 and 1883, and other Pueblo illustrations appeared in *Harper's Magazine.*

During the early summer of 1881, Metcalf was in Santa Fe where he met John C. Bourke, whose diary later referred to Metcalf's many "successful" sketches in water color, oil, and crayon. The following year Metcalf was in El Paso, Texas. In June of

157

1883 he returned east via Chicago, and the *Inter Ocean* newspaper of that city published an interview on June 14 wherein Metcalf related some of his experiences in the Southwest.

Mewhinney, Ella K. (1891-)
B. Nelsonville, Texas, June 21. Lived: Holland, Texas. *AAA;* Mallett; *WWAA.*

Meyer, Richard Max (-)
Lived: Portland, Oregon; Washington. LeRoy.

Meyers, Ralph (1885-1949)
B. Michigan. Lived: Denver and Colorado Springs, Colorado; Taos, New Mexico. Harwood Foundation Library, Taos.

Meyers, William Henry (1815-)
In California 1846-47. Groce and Wallace; Taft.

Mezzerer, Peter (c.1825-)
Lived California 1855-95. Groce and Wallace; Oakland Art Museum.

Miller, Alfred Jacob (1810-1874)
B. Baltimore, Maryland, January 2, 1810. D. Baltimore, Maryland, June 26, 1874. Lived: Baltimore. Work: Walters Art Gallery, Baltimore; Joslyn Art Museum, Omaha, Nebraska; Yale University Library, New Haven, Connecticut; Gilcrease Institute of Art, Tulsa, Oklahoma; Amon Carter Museum, Fort Worth, Texas. Barker; DeVoto; Ewers 1965; Fielding; Groce and Wallace; McCracken 1952; Mallett.

Miller had no prior interest in Indians when he was invited by the Scotsman he met in New Orleans to make sketches of western scenes for the family castle. Leaving Saint Louis in 1837, they proceeded by wagon train to the Rockies, crossed at South Pass, and turned north to visit areas now in the states of Oregon and Wyoming. Although Miller's written account of the trip is perhaps more informative than his paintings, for European art training and influences had not prepared him for documentary portrayals, he was among the first to provide a pictorial record of western Indians.

After spending a year in Scotland fulfilling his commitment to his Scotch friend, William Drummond Stewart, Miller returned home to Baltimore where he painted portraits and repeated many of his Indian scenes.

Miller, Evylena Nunn (1888-1966)
B. Mayfield, Kansas, July 4. D. Santa Ana, California, February 25. Lived: Santa Ana. *AAA;* Mallett; *WWAA.*

Miller, Marie Clark (1894-)
B. Springville, Utah, June 27. Lived: Glendale, California. Collins; *WWAA.*

Miller, Mildred Bunting (1892-)
B. Philadelphia, Pennsylvania. Lived: Chester Springs, Pennsylvania; Valley Center and Escondido, California. Fielding; Mallett; *WWAA.*

Miller, Ralph Davison (1858-1945)
B. Cincinnati, Ohio, September 7. D. Los Angeles, California, December 14. Lived: New Mexico 1880s; California. Marquis; *WWAA.*

Millier, Arthur (1893-)
B. England. Lived: California. *AAA;* Mallett; *WWAA.*

Mills, John Harrison (1842-1916)
B. near Buffalo, New York, January 11, 1842. D. Buffalo, October 23, 1916. Lived: Denver and Middle Park, Colorado; Buffalo; New York City. Work: Albright Gallery, State University of New York, Buffalo. Mallett; Taft.
Mills, who lived in Colorado from 1872 to 1883, was a Buffalo, New York, artist. He did many paintings, illustrations, and engravings of Denver area scenes which have been widely reproduced. Mills' interest in developing the arts in Denver led to teaching at the Colorado Academy of Fine Arts and serving for one year as its president. He also managed the first exhibition of Colorado's Mining and Industrial Exposition for which he obtained paintings from New York and Philadelphia.
In addition to landscapes Mills painted portraits, animal

scenes, and figures. He was also an accomplished sculptor, poet, and writer. Following his return to the East, Mills won awards for poetry and sculpture and was elected honorary member of the Denver Art Club.

Mitchell, Alfred R. (1888-)
B. York, Pennsylvania. Lived: San Diego, California. *AAA;* Fielding; Mallett; *WWAA.*

Mitchell, Arthur R. (1889-)
B. Trinidad, Colorado. Lived: New York; Leonia, New Jersey; Trinidad. Pioneer Museum, Trinidad; Trinidad State Junior College.

Mitchell, Laura M. D. (1883-)
B. Halifax, Nova Scotia, Canada. Lived: Alhambra, California. *AAA;* Fielding; Mallett; *WWAA.*

Mitchell, Minnie B. Hall (1863-)
B. Denver, Colorado. Lived: Denver. Collins; Fielding.

Mizen, Frederic Kimball (1888-1965)
Lived: Chicago, Illinois; Taos, New Mexico. Work: Santa Fe Railway Collection. Mallett; Reed 1966.

Mizen was one of the foremost illustrators of his time. Among his employers were the *Saturday Evening Post, Cosmopolitan,* and the Coca-Cola Company. His paintings for Coca-Cola made him a dominant figure in the field of outdoor advertising. In addition to his work as illustrator, Mizen conducted an art school in Chicago, and, during summers, an art school in Taos, New Mexico. It was the latter, combined with a flair for portraiture, that altered the course of Mizen's career. He did many fine portraits of Navajo and Pueblo Indians during his summers in the Southwest, and painted a number of typical scenes associated with that region. During the rest of the year he specialized in portraits of prominent public figures.

Möllhausen, Heinrich Baldouin (1825-1905)
B. near Bonn, Germany, January 27, 1825. D. Germany, 1905. Lived: Berlin, Germany. Work: U.S. National Mu-

seum, Washington, D.C.; Staatliches Museum Für Volkerkunde, Berlin, Germany. Groce and Wallace; McCracken 1952; Taft.

Möllhausen of Germany made three exploring trips in the West during the 1850s. Fort Laramie was as far as he got during the first trip, but in 1853 he was draftsman and topographer for A. W. Whipple's 35th Parallel Survey which traveled from Fort Smith, Arkansas, to Pueblo de Los Angeles, arriving in March of 1854. In 1857 Möllhausen joined the Joseph C. Ives mapping expedition which explored the Colorado River a distance of 530 miles from its mouth. The trip was completed in May of 1858, and Möllhausen returned east by way of Albuquerque and the Santa Fe Trail. His illustrations are in the published reports of Whipple and Ives (see *Pacific Railroad Reports,* Vol. III; *Report upon the Colorado River of the West*).

Möllhausen, called the "German Cooper" because he wrote so many books about Indians, also published in 1858 an illustrated diary of his Western travels, translated into English, Dutch, and Danish.

Moerenhout, Jacques Antoine (c.1796-1879)
B. France. Lived: Antwerp, Belgium; Valparaiso, Chile; in California during Mexican rule. Hammond, Vols. VII, X; Van Nostrand; California State Library, Sacramento.

Moody, Edwin (-)
Lived: San Francisco, California, about 1850-60. Groce and Wallace; Peters.

Moon, Carl (1878-1948)
B. Wilmington, Ohio, October 5, 1878. D. June 24, 1948. Lived: Albuquerque, New Mexico; Grand Canyon, Arizona; Pasadena, California. Work: Huntington Library, San Marino, California; National Collection of Fine Arts, Washington, D.C.

It was probably inevitable that a photographer in Albuquerque, New Mexico, in 1904, would specialize in depicting Southwestern Indians. Moon not only achieved distinction for his photographs but for the oil paintings he began making shortly after his arrival in New Mexico. Moon left Albuquerque in 1907

to handle Fred Harvey's art business at the Grand Canyon. He also assisted Harvey and the American Museum of Natural History in New York in acquiring collections of paintings of Indians which are now highly prized. Following his work for Harvey, Moon settled in Pasadena, California, in 1914. There he is remembered as a landscape painter and an author. Mrs. Moon shared his interest in Indians and collaborated with him on several books.

Moore, Edwin S. (-)
Lived: Oakland, California 1891-92, 1895. Society of California Pioneers, San Francisco.

Moore, Frank Montague (1887-1967)
B. Taunton, England, November 24. D. Carmel, California, March 5. Lived: Carmel and Pasadena, California. *AAA;* Fielding; Mallett; *WWAA.*

Moore, Tom James (1892-)
B. Dallas, Texas, February 2. Lived: Hamilton, Montana. Mallett; *WWAA.*

Mora, Francis Luis (1874-1940)
B. Montevideo, Uruguay, July 27. D. New York City, June 5. Lived: New York City; Gaylordsville, Connecticut. *AAA;* Fielding; Mallett; *WWA; WWAA; WWWA.*

Mora, Joseph Jacinto (1876-1947)
B. Montevideo, Uruguay, 1876. D. Monterey, California, 1947. Lived: Carmel and Mountain View, California. Work: Hubbell Trading Post Museum, Ganado, Arizona. Fielding; Mallett; Mora 1946.
Jo Mora, now famous as a sculptor, was born in Uruguay. At the turn of the century he began sketching the southwestern states, camping first near Walpi on the Hopi Reservation. From there he ranged far, studying and sketching both the Navajo and the Hopi. "Keams Canyon Trading Post" and "Navajo Riding" are among the water colors Mora gave to Lorenzo Hubbell when he visited his trading post at Ganado, Arizona. (The trading post is now a historic site, its interior full of paintings given to Hubbell by early artists.)

When Mora moved on to Monterey, California, he followed the route of the padres along El Camino Real, camping and sketching along the way. His illustrated book about the mission era, *Californios,* was published in 1949.

Moran, Edward (1829-1901)

B. Bolton, England, August 29. D. New York City, June 9. Lived: Philadelphia, Pennsylvania; New York City. *AAA;* Bénézit; *DAB;* Fielding; Groce and Wallace; Mallett; *WWWA.*

Moran, Peter (1842-1914)

B. Bolton, Lancashire, England, March 4, 1842. D. Philadelphia, Pennsylvania, November 11, 1914. Lived: Philadelphia. Work: Corcoran Gallery of Art, Washington, D.C. Fielding; Groce and Wallace; Mallett; Taft.

Peter Moran, brother of Thomas and Edward, is best known as an animal painter and etcher. Although he had a keen interest in Indian ethnology, there is little artistic evidence of his western trips. A painting called "Bannack Indians Breaking a Pony" was mentioned in the *New York Tribune* early in 1880, and in *Report of Indians Taxed and Indians Not Taxed* there are three reproductions of Shoshone Indian subjects which he did while working on the 1890 census. In his book *Snake Dance of the Moqui,* John G. Bourke wrote enthusiastically about Moran's excellent drawings and genial disposition—Moran had accompanied him to Walpi—but none of the drawings were used as illustrations, and what became of them is not known.

Moran, Thomas (1837-1926)

B. Bolton, Lancashire, England, January 12, 1837. D. Santa Barbara, California, August 25, 1926. Lived: Philadelphia; Newark, New Jersey; New York City; East Hampton, Long Island; Santa Barbara. Work: Phoenix Art Museum, Arizona; Kimball Art Foundation, Fort Worth; Gilcrease Institute of Art, Tulsa, Oklahoma; Metropolitan Museum of Art, New York; U.S. Department of the Interior, Washington, D.C. Fielding; Fryxell; Groce and Wallace; Mallett; Wilkins.

"T. Yellowstone Moran," his companions on the Territorial

163

Surveys called him. He was 34 years old when as guest artist he sketched the Yellowstone region. The following year, in 1872, he sketched Yosemite Valley; in 1873 the north rim of the Grand Canyon and the mountains and plateaus of Utah; in 1874 the Mountain of the Holy Cross in central Colorado. Moran painted many other mountain regions of the western states and some Pueblo Indian scenes. He was also an illustrator, with well over 1,500 illustrations to his credit.

Late in life Moran moved from the East to Santa Barbara, but by that time his mountain climbing days were over. In recognition of his work on the Hayden Surveys is Mount Moran in the Grand Teton range which to him was the "finest pictorial range in the United States."

Morey, Anna Riordan (1857-1925)
B. Columbus, Ohio, October 12. D. Hastings, Nebraska. Lived: Nebraska. Bucklin.

Morgan, Mary De Neale (1868-1948)
B. San Francisco, California. D. Carmel, California, October 10. Lived: Carmel. *AAA;* Mallett; *WWAA.*

Morris, Florence Ann (1876-1947)
B. Nevada, Missouri, March 5. D. September 3. Lived: Roswell, New Mexico. *AAA;* Mallett; *WWA; WWAA; WWWA.*

Morris, William Charles (1874-1940)
B. Salt Lake City, Utah, March 6. D. April 5. Lived: Spokane, Washington; Grand View, New York. Mallett; *WWA; WWWA.*

Morris, William H. (1834-1896)
Lived: Fort Yuma, Arizona 1852-53. Arizona Historical Society, Tucson.

Morris, William V. (-)
Lived: Utah, 1852-1880s. Groce and Wallace; *WWWA.*

Moser, John Henri (1876-1951)
B. Switzerland, September 22. D. Logan, Utah, September 1. Lived: Malad, Idaho; Payson and Logan, Utah. Haseltine.

Mosler, Henry (1841-1920)
B. New York, June 6. D. April 21. Lived: New York. *AAA;* Bénézit; *DAB;* Fielding; Mallett; *WWWA.*

Moss, Charles Eugene (1860-1901)
B. Pawnee City, Nebraska. Lived: Nebraska; Canada. *AAA;* Mallett.

Mount, William Sidney (1807-1868)
B. Setauket, New York, November 26. D. Setauket, November 19. Lived: Setauket. *DAB;* Fielding; Groce and Wallace; Mallett; *WWWA.*

Moylan, Lloyd (1893-)
B. Saint Paul, Minnesota. Lived: Colorado Springs, Colorado; Gallup, New Mexico. Mallett; *WWAA.*

Mudge, Zachariah (-)
In Pacific Northwest 1790-95. Groce and Wallace; Federal Writers' Project, *Washington.*

Mulford, Laura Lenore (1894-)
B. Stuart, Nebraska, October 24. Lived: Valley City, North Dakota. Barr; *WWAA.*

Muller, Dan (1888-)
Lived: Nevada; Port Washington, Wisconsin. Federal Writers' Project, *Nevada;* Mallett.

Mulvany, John (1844-1906)
B. Ireland, 1844. D. New York, c. May 22, 1906. Lived: Kansas City; New York. Barker; McCracken 1952; Mallett; Taft.

Mulvany's paintings reflect his wide range of interests. In the early 1870s he began collecting western material. For his

165

famous "Custer's Last Rally," he visited the battleground, consulted both army officers and the Sioux, and studied every conceivable detail of that scene. It took two years to complete the painting, but when it was exhibited here and abroad it brought Mulvany international acclaim.

After doing a number of paintings unrelated to the West, Mulvany spent the summer of 1890 sketching in the Colorado mountains. According to the *Denver Republican,* many of those sketches were "paintings in themselves." In his later years Mulvany turned to portraits and political subjects.

Mundy, Louise E. (1870-)
B. Nokomis, Illinois. Lived: Lincoln, Nebraska. *AAA;* Mallett; *WWAA.*

Munger, Gilbert (1836-1903)
B. Madison, Connecticut. D. Washington, D.C., January 27. Lived: Paris, France; Washington, D.C. *AAA;* Bénézit; Groce and Wallace; Mallett.

Murie, Olaus J. (1889-1963)
B. Moorhead, Minnesota, March 1. D. Moose, Wyoming, October 21. Lived: Oregon; Hudson Bay; Labrador; Moose. *WWWA.*

Murray, Frederick S. [Feg] (1894-1973)
B. San Francisco, California, May 15. D. Carmel, California, July 16. Lived: Great Neck, New York; Pacific Grove, California. Mallett.

Musgrave, Arthur Franklin (1880-1970)
B. Brighton, England. Lived: Cambridge, Massachusetts; Santa Fe, New Mexico. *AAA;* Fielding; Mallett; *WWAA.*

Myers, Frank Harmon (1899-1956)
B. Cleves, Ohio, February 23. D. San Francisco, California, March 7. Lived: Cincinnati, Ohio; Pacific Grove, California. *AAA;* Mallett; *WWAA.*

N

Nahl, Charles Christian (1818-1878)

B. Cassel, Germany, October 13, 1818. D. San Francisco, March 1, 1878. Lived: Sacramento and San Francisco, California. Work: Crocker Art Gallery, Sacramento; Huntington Library and Art Gallery, San Marino, California; New York Public Library. *CAR*, Vol. I; Groce and Wallace; Mallett; Richardson.

In 1850 Nahl came to this country in search of gold and worked at the Rough and Ready Camp on the Yuba River in Northern California. The following year he was at Coloma for a short time and then moved to Sacramento, where his early sketches of mining life were destroyed in the 1852 fire, necessitating their reconstruction from memory. After the fire Nahl moved to San Francisco.

Nahl continued to use the mining motif in much of his later work, both in easel paintings and illustrations. His famous "Sunday Morning in the Mines," now in the Crocker Art Gallery in Sacramento, was painted in 1872. Nahl's mining scenes were depicted with accuracy, but in a style reminiscent of his German training.

Nahl, H. W. Arthur (1820-1881)

B. Cassel, Germany. D. San Francisco, California, April 1. Lived: San Francisco Bay Area. Groce and Wallace; *WWWA*.

Nahl, Perham Wilhelm (1869-1935)

B. San Francisco, California, January 11. D. April 9. Lived: Oakland, California. *AAA;* Fielding; Mallett.

Nahl, Virgil Theodore (1876-1930)

B. Alameda, California, August 20. D. San Francisco, February 9. Lived: San Francisco. *AAA;* Fielding; Mallett.

Nappenbach, Henry (1862-1931)

B. Bavaria, Germany. D. New York. Lived: California; New York. *AAA;* Mallett.

Narjot, Erneste (1826-1898)

B. France, 1826. D. San Francisco, 1898. Lived: Mexico; San Francisco. Work: Dr. and Mrs. Bruce Friedman Collection, San Francisco Bay area; Robert B. Honeyman, Jr. Collection, Southern California. Groce and Wallace; Mc-Cracken 1952.

Narjot came from France to California in 1849 to look for gold. Two years later he went to Mexico on a mining venture. He returned after 13 years, re-entered the field for which he was trained, and for the most part painted murals for churches and other buildings. His career was brought to an end when, as a result of getting paint in his eyes while executing a mural in the Leland Stanford tomb on the university grounds, his eyesight was impaired and blindness followed.

Today Narjot is best known for his early portraits and character sketches of California gold miners. Had his Mexico venture not intervened, he could have added considerably more to the western scene.

Nash, Willard Ayer (1898-1943)

B. Philadelphia, Pennsylvania, March 29. D. Los Angeles. Lived: California; Colorado Springs, Colorado; Santa Fe, New Mexico. *AAA;* Fielding; Mallett; *WWAA.*

Nason, Daniel W. (-)

Lived: Epping, New Hampshire; in California 1849-52. Groce and Wallace.

Neal, David Dalhoff (1838-1915)

B. Lowell, Massachusetts, October 20. D. Munich, Germany, May 2. Lived: San Francisco, California late 1850s to early 1860s; Germany. *AAA;* Bénézit; *DAB;* Fielding; Mallett; *WWA; WWWA.*

Nedwill, Rose (1882-)

B. New York City, July 10. Lived: New York City; Santa Fe, New Mexico. Mallett; *WWAA.*

Nelson, Bruce (1888-)

B. San Jose, California. Lived: California; New York City. Mallett.

Nesemann, Enno (1861-1949)
B. Marysville, California, April 25. Lived: Berkeley, California. *AAA;* Fielding; Mallett; *WWAA.*

Neuhaus, Eugen (1879-1963)
B. Wuppertal, Germany, August 18. Lived: Berkeley and Orinda, California. *AAA;* Fielding; Mallett; *WWA; WWAA.*

Newberry, John Strong (1822-1892)
B. Windsor, Connecticut, December 22. D. New Haven, Connecticut, December 7. Lived: New Haven; in the Far West 1855-59. Groce and Wallace; *WWWA.*

Newcombe, Warren (1894-)
B. Waltham, Massachusetts, April 28. Lived: Los Angeles and Brentwood Heights, California. *AAA;* Mallett; *WWAA.*

Newell, George Glenn (1870-1947)
B. Michigan. D. May 7. Lived: Dover Plains and New York City. Fielding; Mallett; *WWWA.*

Newsom, Archie T. (c.1896-)
Lived: Sacramento, California. Sacramento County Historical Society; Crocker Art Gallery, Sacramento.

Nicholl, Thomas Jeffs (1851-1931)
B. Dublin, Ireland. D. Tacoma, Washington, December 18. Lived: Chicago, Illinois; Washington. Washington State Historical Society, Tacoma.

Nichols, Harley De Will (1859-)
B. Barton, Washington. Lived: Brooklyn, New York; San Juan Capistrano, California. *AAA;* Fielding; Mallett; *WWAA.*

Nimmo, Louise Everett (1899-)
B. Des Moines, Iowa, April 9. Lived: Los Angeles and Ojai, California. *AAA;* Mallett; *WWAA.*

169

Noble, John (1874-1934)
B. Wichita, Kansas, March 15. Lived: New York City. *AAA;* Fielding; Mallett; *WWA; WWAA; WWWA.*

Noble, Mamie Jones (1875-)
B. Auburn, Texas. Lived: Corsicana, Texas. *AAA;* Mallett; *WWAA.*

Nordfeldt, Bror Julius Olsson (1878-1955)
B. Tulstorg, Sweden, April 13. Lived: Santa Fe, New Mexico; Lambertville, New Jersey. *AAA;* Fielding; Mallett; *WWA; WWAA; WWWA.*

Norton, Elizabeth (1887-)
B. Chicago, Illinois, December 16. Lived: Palo Alto, California. *AAA;* Fielding; Mallett; *WWAA.*

Norton, Helen Gaylord (1882-)
B. Portsmouth, Ohio, April 12. Lived: Laguna Beach and Riverside, California. *AAA;* Fielding; Mallett; *WWAA.*

Norton, John Warner (1876-1934)
B. Lockport, Illinois, March 7. D. January 7. Lived: Chicago, Illinois; Charleston, South Carolina. *AAA;* Mallett; *WWA; WWWA.*

O

Oakes, M. (c.1826-)
Possibly Mrs. W. H. Oakes. Lived: San Francisco, California 1860. Groce and Wallace; Oakland Art Museum.

Obata, Chiura (1885-)
Lived: Berkeley, California. Mallett; *WWAA.*

Officer, Thomas S. (c.1810-1859)
B. Carlisle, Pennsylvania. D. San Francisco, California. Lived: Philadelphia, Pennsylvania; New Orleans, Louisiana; New York; California. Fielding; Groce and Wallace.

Ogden, Henry Alexander (1856-1936)
B. Philadelphia, Pennsylvania, July 17. D. June 15. Lived: New York City. *AAA;* Fielding; Mallett; *WWA; WWWA.*

Ogilby, Robert E. (-)
Lived: California 1852-80. Groce and Wallace; Peters.

O'Keeffe, Georgia (1887-)
B. Sun Prairie, Wisconsin, November 15. Lived: New York City; Abiquiu, New Mexico. *AAA;* Fielding; Mallett; *WWA; WWAA.*

Oldfield, Otis (1890-1969)
B. Sacramento, California, July 3. Lived: Nevada; Idaho; Montana; San Francisco, California. Mallett; *WWAA.*

Olds, Elizabeth (1897-)
B. Minneapolis, Minnesota, December 10. Lived: Omaha, Nebraska. *AAA;* Mallett; *WWAA.*

Olson, Albert Byron (1885-1940)
B. Montrose, Colorado, May 3. D. March 9. Lived: Denver, Colorado. *AAA;* Fielding; Mallett; *WWAA.*

Olstad, Einar Hanson (1876-)
B. Lillehammer, Norway, 1876. Lived: South Dakota Badlands region. Barr; *Minneapolis Sunday Tribune Picture Magazine,* April 19, 1953.

Olstad was brought to South Dakota from Norway when he was a year old. In his teens he began copying pictures and sketching outdoor subjects. Not until 1936, however, did he do any serious art work. With very little formal study Olstad achieved recognition for his paintings of cowboy life and landscapes in the North Dakota Badlands—scenes familiar to him ever since he homesteaded there as a young man. In 1951 he was photographed

in his studio for *National Geographic*'s article, "North Dakota Comes Into Its Own." That year brought Olstad further recognition when he made the Honor Roll of the American Artists Professional League.

Onderdonk, Julian (1882-1922)
B. San Antonio, Texas, July 30. D. San Antonio. Lived: San Antonio. *AAA;* Fielding; Mallett.

Onderdonk, Robert Jenkins (1852-1917)
B. Catonsville, Maryland, January 1852. D. San Antonio, Texas, 1917. Lived: San Antonio and Dallas, Texas. Work: Eleanor Onderdonk Collection, San Antonio. Fielding; Mallett; Pinckney.

Onderdonk was one of the few artists of his generation to forego European study. Instead, he was talked into going to Texas where, it was said, an artist could make enough in a short time to finance European study. Onderdonk did not find that to be the case. During Onderdonk's first three years in San Antonio, he spent considerable time sketching at a nearby ranch. In 1881 he opened a studio downtown and commuted by mule car from his home on the outskirts of the city. He carried with him a paint box and thin panels of wood, sometimes cigar box tops, on which to paint the scenes which attracted his attention.

To Onderdonk belongs the distinction of organizing the Art Students' League in Dallas, and serving as its director from 1889 to 1896.

O'Neill, James Knox (c.1848-1922)
D. Omaha, Nebraska, June 6. Lived: Omaha. Bucklin.

Osgood, Samuel Stillman (1808-1885)
B. Boston, Massachusetts, June 9. D. California. Lived: New York; California. Fielding; Groce and Wallace; Mallett; *WWWA.*

Osthaus, Edmund H. (1858-1928)
B. Hildesheim, Germany, August 5. D. January 30. Lived: Los Angeles, California; Toledo, Ohio. *AAA;* Fielding; Mallett; *WWA; WWWA.*

Ostner, Charles Leopold (1828-1913)

B. Baden, Germany, 1828. D. Boise, Idaho, 1913. Lived: San Francisco, California; Boise, Idaho. Work: Idaho Historical Society, Boise. Groce and Wallace; LeRoy.

Little is known about this German-born painter and carver, except that he studied art at Heidelburg University, came to this country in the 1840s, and went to California by way of New Orleans. From 1856 to 1859 he was listed in the San Francisco city and business directories as sculptor and carver. In 1864 Ostner moved to Garden Valley, Idaho Territory, and later settled in Boise where he spent the rest of his life. Most of his paintings were of horses, and his preoccupation with that motif was further emphasized by his horse and rider insignia.

Ostner did not completely abandon carving, for in 1869 he dedicated to Idaho pioneers a carved statute of George Washington mounted on his horse, a task which took four years of his spare time.

Otis, Fessenden Nott (1825-1900)

B. Ballston Springs, New York, March 6. D. New Orleans, Louisiana, May 24. Groce and Wallace; California State Library, Sacramento.

Otis, George Demont (1877-)

Lived: Burbank, California. *AAA;* Mallett; *WWAA.*

Ottinger, George Martin (1833-1917)

B. Springville Township, Pennsylvania, February 8, 1833. D. Salt Lake City, Utah, October 29, 1917. Lived: Baltimore, Maryland; Lancaster, Pennsylvania; Salt Lake City. Work: Dr. and Mrs. Franz Stenzel Collection, Portland, Oregon. Federal Writers' Project, *Utah;* Haseltine; James 1922.

Ottinger crossed the Plains by ox-team in 1861 to paint scenery for the Salt Lake Theater. Along the way and following his arrival, he sketched such pioneering subjects as caught his fancy. His excellent "Overland Pony Express," done during the 1860s, was reproduced in *Harper's Weekly.*

Ottinger's interest in Prescott's *The Conquest of Mexico* inspired many historical paintings on that theme. He also painted

murals for the ceremonial chambers of the Mormon church and took an active part in the cultural life of Salt Lake City. Although his Hudson River School style was criticized for being "labored, literal, and usually static," he did on occasion turn out some exceptional work.

Owens, Charles H. (1880-1958)
Lived: Los Angeles, California. Dykes; Mallett.

P

Pages, J. F. (1833-1910)
B. France. Lived: San Francisco, California; New York. Mallett; Oakland Art Museum.

Pages, Jules (1867-1946)
B. San Francisco, California. D. San Francisco, May 22. Lived: Paris, France; San Francisco. *AAA;* Bénézit; Fielding; Mallett; *WWAA.*

Palenske, Reinhold H. (1884-1953)
B. Chicago, Illinois, October 4. D. December 29. Lived: Wilmette, Illinois. Mallett; *WWAA.*

Palmer, Jessie A. (1882-)
B. Lawrence, Texas. Lived: Dallas, Texas. *AAA;* Mallett; *WWAA.*

Pape, Hans (1894-)
B. Hamburg, Germany. Lived: Germany. Mallett; Perceval 1949.

Paris, Francois Edmond (1806-1893)
B. Brest, France. D. Paris, France. In Monterey, California during Mexican rule. Van Nostrand.

Paris, Walter (1842-1906)

B. London, England. D. Washington, D.C. Lived: Colorado Springs, Colorado 1870s. *AAA;* Bénézit; *DAB;* Fielding; Mallett.

Park, Hazel A. Hanes (1887-)

B. Waukee, Iowa, September 28. Lived: Los Angeles, California. Collins; *WWAA.*

Parrish, Anne Lodge (-)

Lived: Philadelphia, Pennsylvania; Colorado Springs, Colorado. Groce and Wallace; Shalkop.

Parrish, Charles Louis (-1902)

B. New York. Lived: California about 1850-70. Groce and Wallace; Society of California Pioneers, San Francisco.

Parrish, Maxfield (1870-1966)

B. Philadelphia, Pennsylvania, July 25. D. Plainfield, New Jersey, March 30. Lived: Windsor, Vermont. *AAA;* Bénézit; Fielding; Mallett; *WWA; WWAA; WWWA.*

Parrish, Thomas (1837-)

Lived: Colorado Springs, Colorado 1870s. Ormes and Ormes.

Parrott, William Samuel (1844-1915)

B. Missouri. D. Goldendale, Washington. Lived: Portland, Oregon; Washington. *AAA;* Fielding; Mallett.

Parshall, DeWitt (1864-1956)

B. Buffalo, New York, August 2. D. July 7. Lived: New York; Santa Barbara, California. *AAA;* Fielding; Mallett; *WWA; WWAA; WWWA.*

Parshall, Douglass Ewell (1899-)

B. New York, November 19. Lived: Santa Barbara, California. Fielding; Mallett; *WWA; WWAA.*

Parsons, Charles (1821-1910)

B. Rowland's Castle, Hampshire, England. D. Brooklyn, New York, November 9. Lived: Boonton, New Jersey; New York City; Brooklyn. Fielding; Groce and Wallace; Mallett; *WWWA.*

Parsons, Ernestine (1884-1967)

B. Booneville, Missouri. D. Colorado Springs, Colorado, July 30. Lived: Colorado Springs. Mallett; *WWAA.*

Parsons, Orin Sheldon (1866-1943)

B. Rochester, New York, 1866. D. Santa Fe, New Mexico, September 24, 1943. Lived: New York; Santa Fe. Work: Museum of New Mexico, Santa Fe; Santa Fe Railway Collection; University of New Mexico, Albuquerque. Coke; Ewing 1967; Mallett.

In 1914 Parsons gave up a successful portrait career in New York to live in Santa Fe where he became a well-known painter of southwestern landscapes. He also took an active interest in the town's cultural life and was appointed the Museum of New Mexico's first art curator and director of exhibitions.

Like many other painters new to the Southwest, Parsons was fascinated with the extraordinary light as well as the scenery. The technique he developed to capture this light as it filtered through trees onto adobe buildings and through clouds onto Santa Fe's nearby mountains became a trademark of his work.

Partington, J. H. E. (1843-1899)

Lived: Heysham, England; San Francisco, California. *CAR,* Vol. XV; M. H. De Young Museum, San Francisco.

Partridge, Roi (1888-)

B. Centralia, Washington. Lived: Oakland, California. *AAA;* Fielding; Mallett; *WWA; WWAA.*

Patterson, Viola (1898-)

B. Seattle, Washington. Lived: Seattle. *AAA;* Mallett; *WWAA.*

Paxson, Edgar Samuel (1852-1919)

B. near Buffalo, New York, April 25, 1852. D. Missoula, Montana, November 9, 1919. Lived: Deer Lodge, Butte, and Missoula, Montana. Work: Missoula County Court House; Montana State Capitol; Dr. and Mrs. Franz Stenzel Collection, Portland, Oregon; Whitney Gallery of Western Art, Cody, Wyoming; Historical Society of Montana,

Helena. Ainsworth 1968; Federal Writers' Project, *Montana;* Fielding; Mallett.

Most of Paxson's work was done in Montana where at age 25 he went in search of adventure. There his early experiences as soldier and frontiersman imbued him with a sense of history; to record the western scene became the motivating force behind his art.

From Paxson's standpoint, "Custer's Last Stand," a painting he worked on intermittently for 21 years, is his most important. It is now owned by the Whitney Gallery of Western Art in Cody, Wyoming. Paxson's other work includes many easel paintings and six or more murals for various government buildings in Montana. He is now recognized as one of the most important western frontier painters.

Payne, Edgar Alwin (1882-1947)
B. Washburn, Missouri, 1882. D. Los Angeles, California, April 8, 1947. Lived: Mexico; New York; Los Angeles. Work: National Academy of Design, New York; Southwest Museum, Los Angeles; University of Nebraska, Lincoln; Hubbell Trading Post Museum, Ganado, Arizona. Fielding; Mallett; Perceval 1949.

A Missourian by birth, Payne left home at 14 to paint in the Ozarks, followed by a trip to Mexico. In 1911 he moved to California.

Payne, a largely self taught artist, is well known throughout the Southwest for his mountain and desert landscapes, the latter frequently depicting Indian life as he saw it in northern Arizona.

In California, Payne did many coastal scenes in the Monterey and Laguna Beach areas. He also achieved recognition as a muralist. His paintings are in many collections and his murals are in commercial and public buildings in several western states as well as Indiana and Illinois.

Payne, Elsie Palmer (1884-)
B. San Antonio, Texas. Lived: Beverly Hills and Laguna Beach, California. *AAA;* Mallett; *WWAA.*

Peale, Titian Ramsey (1799-1885)
B. Philadelphia, Pennsylvania, November 17, 1799. D.

Philadelphia, March 13, 1885. Lived: Philadelphia; Washington, D.C. Work: American Philosophical Society, Philadelphia. Ewers 1965; Fielding; Groce and Wallace; Mallett.

T. R. Peale and Samuel Seymour are the first American artists of record to depict the West. Through the influence of his famous father, Charles Wilson Peale, young Peale was assigned to the Maj. Stephen H. Long expedition. In mid-1819 the party proceeded up the Missouri River with Peale as naturalist and Seymour as artist. Peale did water color sketches of Indian, animal, and camp scenes, and made animal studies in line with his interest in zoology. During the following year, the Long party proceeded to the Platte River headquarters, and thence eastward along the Arkansas. Peale made a total of 122 sketches, according to the published report by Edwin James, a member of the party. The American Philosophical Society in Philadelphia now has nearly 50 of Peale's water color and pencil sketches.

Pearce, Helen S. (1895-)
B. Reading, Pennsylvania. Lived: Albuquerque, New Mexico. Collins; *WWAA.*

Pearson, Edwin (1889-)
B. Yuma County, Colorado, December 20. Lived: New York; San Antonio, Texas. *AAA;* Fielding; Mallett; *WWAA.*

Pearson, Ralph M. (1883-1958)
B. Angus, Iowa, May 27. D. April 27. Lived; Nyack, New York; Taos, New Mexico. *AAA;* Fielding; Mallett; *WWA; WWAA; WWWA.*

Pease, Lucius C. [Lute] (1869-1963)
B. Winnemucca, Nevada. D. Maplewood, New Jersey, August 16. Lived: Santa Barbara, California; Alaska; Portland, Oregon; New York City; Maplewood. Mallett; *WWAA.*

Pebbles, Francis [Frank] Marion (1839-1928)
B. Weathersfield, New York. D. Alameda, California. Lived: Oak Park, Illinois. *AAA;* Fielding; Groce and Wallace; Mallett.

Peck, Orrin (1860-1921)
B. Delaware County, New York. D. Los Angeles, California, January 20. Lived: California. *AAA;* Bénézit; Fielding; Mallett.

Peirce, Joshua H. (-)
D. San Francisco, California. Lived: San Francisco 1840s-1850s. Groce and Wallace; Peters.

Peixotto, Ernest Clifford (1869-1940)
B. San Francisco, California, October 15, 1869. D. New York City, December 6, 1940. Lived: San Francisco; France; New York City. *CAR,* Vol. IX; Fielding; Mallett.

One of California's most accomplished painters was Ernest Peixotto who combined an interest in southwestern history with his art. He wrote and profusely illustrated several books, including *Our Hispanic Southwest* and *Romantic California,* which deal with his studies of and travels through Texas, New Mexico, and California. He also wrote and illustrated articles for *Scribner's* and *Harper's.*

Although Peixotto's later life was spent in New York City, his early recognition came in San Francisco where he was born and began his study of art and to which he returned for a time following additional art study in Paris. He was known for murals as well as easel paintings and exhibited widely in this country and abroad.

Pelton, Agnes (1881-1961)
B. Stuttgart, Germany, August 22. Lived: Cathedral City and Palm Springs, California. *AAA;* Fielding; Mallett; *WWAA.*

Penelon, Henri (1827-1885)
Lived: France; in California during Mexican rule. Groce and Wallace; *Antiques,* November 1953.

Penniman, Leonora Naylor (1884-)
B. Minnesota, Minnesota. Lived: Santa Cruz, California. *AAA;* Mallett; *WWAA.*

Pennoyer, A. Sheldon (1888-)
B. Oakland, California, April 5. Lived: New York; Litch-field, Connecticut; Berkeley, California. Mallett; *WWAA.*

Pentenrieder, Erhard (1830-1875)
B. Bavaria, Germany. Lived: San Antonio, Texas. Pinckney.

Percy, Isabelle Clark (1882-)
B. Alameda, California. Lived: New York City; Sausalito, California. *AAA;* Fielding; Mallett; *WWAA.*

Perry, Enoch Wood (1831-1915)
B. Boston, Massachusetts. D. December 15. Lived: Cali-fornia 1862-66; New York City. *AAA; DAB;* Fielding; Mallett; *WWA; WWWA.*

Peters, Charles Rollo (1862-1928)
B. San Francisco, California, April 10, 1862. D. San Fran-cisco, 1928. Lived: San Francisco and Monterey, California; Europe. Work: San Francisco Museum of Art; M. H. De Young Museum, San Francisco. *CAR*, Vol. X; Fielding; Mallett.

Peters was a native Californian who in 1885 left the insur-ance business, in which he was unsuccessful, to become an artist—a decision which brought him considerable success. Following five years of study in San Francisco and Paris, Peters settled in Mon-terey. There he painted a series of old, tiled-roof adobes in moon-light settings which were well received in New York and London. He continued to paint a great many nocturnes until 1909 when he began specializing in daylight scenes.

Peters' home was a gathering place for artists when he wasn't painting, but more often than not his friends and visitors were greeted by a sign on his studio door which said, "This is my busy day."

Peters, Constance Evans (-)
Lived: San Francisco and Monterey, California. *AAA; American Art News*, January 1, 1921.

Petri, Richard (1824-1857)

B. Dresden, Germany, 1824. D. Fredericksburg, Texas, 1857.
Lived: New Braunfels and Fredericksburg, Texas. Work:
Private collections in Austin, Texas. Barker; Federal Writers' Project, *Texas;* Groce and Wallace; Pinckney.

Petri's background was that of a comfortably well-off German art student. He had won numerous awards, had produced some significant work, and had been offered a teaching post in a German art academy. His ill health caused him to decline the offer. Later, his involvement in the 1848 revolution made it expedient to seek a distant home. From 1851 until 1857, Petri lived in New Braunfels, Texas, and then Fredericksburg.

Notwithstanding Petri's lack of pioneer experience, he adjusted remarkably well to his new environment. Even the hostile Comanches, Caddos, and Lipan Apaches became friendly after he won them over with his hospitality and his ability to depict their likenesses in the sketches he gave them. For his portraits they dressed in all their finery, and on one occasion an Indian mother insisted on first making her child a fringed deerskin suit.

Phelps, Edith Catlin (1875-1961)

B. New York City, April 16. D. Santa Barbara, California, July 8. Lived: New York City; Santa Barbara. *AAA;* Fielding; Mallett; *WWAA.*

Phillips, Bert Greer (1868-1956)

B. Hudson, New York, 1868. D. San Diego, California, 1956.
Lived: Taos, New Mexico. Work: Gilcrease Institute of Art, Tulsa, Oklahoma; Museum of New Mexico, Santa Fe; The Harwood Foundation, Taos; Santa Fe Railway Collection. Coke; Fielding; Grant; Mallett.

Bert Phillips and Ernest Blumenschein arrived at Taos in September 1898 after an eventful trip from Denver with horses and wagon, neither of which they could handle well. When they broke a wheel some 30 miles from Taos, it was Blumenschein's lot to get it repaired while Phillips guarded their goods. Years later the broken wagon wheel became the symbol of the Taos Society of Artists which Phillips and Blumenschein are credited with founding.

Blumenschein soon returned East but Phillips stayed on.

Before the first winter had set in, he had joined the Indians in foot races and was beginning to know them as friends. He found inspiration in their myths and their ceremonies. Whenever the latent hostility of a conquered race intruded itself, he sought to understand and overcome it. His paintings can best be evaluated within that context.

Phillips, Claire Dooner (1887-)
 B. Los Angeles, California, January 31. Lived: Los Angeles; Prescott, Arizona. *AAA;* Mallett; *WWAA.*

Piazzoni, Gottardo (1872-1945)
 B. Intragna, Switzerland, April 14, 1872. D. 1945. Lived: San Francisco, California. Work: Dr. and Mrs. Bruce Friedman Collection, San Francisco Bay area; murals: San Francisco Public Library. *CAR,* Vol. VII; Fielding; Mallett; Porter et al; "Three California Painters," *American Magazine of Art,* April 1925.

 Piazzoni received some art training before leaving his native Switzerland in 1887 for Monterey, California. Despite economic hardships, he managed further study in San Francisco where, in later years, he was well known as an interpreter of California scenery. He also did many French, Italian, and Swiss landscapes during his five trips to Europe.

 Monterey, Parkfield near San Miguel, and Marin County were places Piazzoni thoroughly knew. His monotypes and etchings of Monterey scenes and his sketches from a summer in Parkfield were highly praised when they were shown in San Francisco in 1909. The work of a summer in Marin in 1911 brought further recognition. Piazzoni also was known for his teaching at the California School of Fine Arts.

Pickett, James Tilton (1857-1889)
 B. Bellingham, Washington. Lived: Washington; California. Washington State Historical Society, Tacoma.

Pierce, Martha (1873-)
 B. New Cumberland, West Virginia, January 15. Lived: Lincoln and Wayne, Nebraska. *AAA;* Mallett; *WWAA.*

Pierce, Minerva (-)
B. Trinidad, Colorado. Lived: San Francisco, California; Reno, Nevada. Binheim.

Piercy, Frederick (1830-1891)
B. Portsmouth, England, January 27, 1830. D. London, England, June 10, 1891. Lived: London. Work: Missouri Historical Society, Saint Louis. Groce and Wallace; Powell; Taft.

In 1853 Piercy, an English portrait painter, traveled to Utah by way of New Orleans, Saint Louis, and Nauvoo, Illinois. He returned to England the following year with detailed notes and numerous sketches for *Route from Liverpool to Great Salt Lake Valley* which was published in 1855. Accompanying the book was a portfolio of 13 sepia wash drawings and pencil sketches covering such subjects as covered wagon villages, river bluffs, eroded banks, and trees. Several decades ago a portfolio became part of the Missouri Historical Society's collection in Saint Louis.

Little else is known of Piercy's career beyond the fact that he began exhibiting portraits about 1848, and continued to do so well into the 1880s.

Platt, George W. (1839-1899)
B. Rochester, New York, July 16. D. Denver, Colorado, September 16. Lived: Chicago, Illinois; Denver. Groce and Wallace; Richardson.

Podchernikoff, A. (1886-1931)
B. Russia. Lived: Russia. Mallett.

Point, Nicolas (1799-1868)
Lived: Idaho; Oregon 1841-47. Donnelly; Groce and Wallace; *WWWA*.

Pommer, Mildred Newell (1893-)
B. Sibley, Iowa, May 29. Lived: San Francisco, California. Mallett; *WWAA*.

Poole, H. Nelson (1885-)

B. Haddonfield, New Jersey, January 16, 1885. Lived: Hawaii; San Francisco, California. *CAR,* Vol. XI; Fielding; Mallett.

Poole's first etching was made from a scrap of sheet zinc left over from a roofing job and printed on a mangle used for wringing out blue prints at the plant where he worked. From the age of 14 Poole contributed to the support of his family; his training was obtained at night classes in Philadelphia art schools.

In 1914 Poole went to Hawaii for seven years where he etched scenes of unusual interest, made book plates, and drew cartoons for a local newspaper. Then he went to San Francisco where he developed his skill in other media, exhibited regularly for many years, and taught at the California School of Fine Arts.

Poor, Henry Varnum (1888-1970)

B. Chapman, Kansas, September 30. D. New York City, December 8. Lived: Colorado Springs, Colorado; Stanford, California; New York City. *AAA;* Mallett; *WWA; WWAA.*

Poore, Henry R. (1859-1940)

B. Newark, New Jersey, March 21, 1859. D. 1940. Lived: Orange, New Jersey. Work: Fine Arts Academy, Buffalo, New York; City Art Museum of Saint Louis, Missouri; Art Association of Indianapolis, Indiana; Worcester Art Museum, Massachusetts. Fielding; Mallett; Taft.

Poore did some Colorado mining illustrations for *Harper's Weekly* when he was 19, and thereafter made other western trips. He visited Taos in 1888, following Charles Craig by about seven years, and has the distinction of being the first to have a painting of that region reproduced. It was called "Pack Train Leaving Pueblo of Taos, New Mexico."

Poore was one of the 1890 census report artists and was assigned 16 New Mexico pueblos. However, only one of his works was reproduced in *Report of Indians Taxed and Indians Not Taxed.* Like Peter Moran, with whom he studied for awhile, Poore was interested in animal subjects. He also painted western landscapes and did illustrations.

Pope, John (1821-1881)
B. Gardiner, Maine, March 2. D. New York City, December 29. Lived: California 1849-57; New York City. Groce and Wallace; Mallett; *WWWA.*

Pope, Marion Holden (-1956)
B. San Francisco, California. Lived: Oakland, California. *AAA;* Fielding; Mallett; *WWAA.*

Porter, Bruce (1865-)
B. San Francisco, California. Lived: San Francisco. *AAA;* Fielding; Mallett; *WWA.*

Potter, William J. (1883-1964)
B. Bellefonte, Pennsylvania. D. July 10. Lived: Greenich, Connecticut; Broadmoor, Colorado; West Townshend, Vermont. *AAA;* Fielding; Mallett; *WWA; WWAA; WWWA.*

Potthast, Edward Henry (1857-1927)
B. Cincinnati, Ohio. D. New York City, March 9. Lived: New York City. *AAA;* Fielding; Mallett; *WWA; WWWA.*

Powell, H. M. T. (-)
Lived: California 1850s. Groce and Wallace; Powell, *Santa Fe Trail to California* (a diary published in 1931).

Powell, Lucien Whiting (1846-1930)
B. Levinworth, Virginia. D. September 27. Lived: Washington, D.C.; Purcellville, Virginia. *AAA; DAB;* Fielding; Mallett; *WWA; WWWA.*

Powell, Pauline (1876-)
B. Oakland, California. Lived: California. Collins.

Pratt, Henry C. (1803-1880)
B. Oxford, New Hampshire, June 13, 1803. D. Wakefield, Massachusetts, November 27, 1880. Lived: Charleston, South Carolina; Wakefield, Massachusetts. Work: Memorial Museum, University of Texas, Austin; Amon Carter Museum of Western Art, Fort Worth, Texas. Fielding; Groce

and Wallace; Hine; Mallett; Pinckney.

Quite by chance Pratt's talent for drawing was discovered by Samuel F. B. Morse who took the 14-year-old Vermont farm boy to Boston, got him a job, and taught him how to paint. Pratt thereafter became one of the East's most capable and famous artists.

Early in 1851, at his friend John Bartlett's invitation, Pratt joined the Mexican Boundary survey. With oils and water colors he painted portraits of Indians, illustrated their way of life, and made panoramic views of the country through which he traveled. Texas, New Mexico, Arizona, California, and Mexico were pictured in "many hundred sketches," wrote Bartlett in his *Personal Narrative*. Although only 30 of Pratt's paintings were reproduced in Bartlett's published work, some of the originals have been acquired by western art galleries.

Pratt, Lorus (1855-1923)
B. Salt Lake City, Utah, November 27, 1855. D. December 29, 1923. Lived: Salt Lake City; England; Paris. Work: Private collections in Utah. Haseltine; Horne; Mallett.

Pratt was the son of an early Utah pioneer. His life, however, was relatively free of frontier hardships, for he was born in Salt Lake City, attended Deseret University, and later studied art in New York and in Europe. He is credited with being the first Utah art student in Paris to gain recognition. Like other Mormon artists who were sent abroad by the church, Pratt assisted in decorating the Salt Lake City temple upon his return. Thereafter he tried to earn a living with landscape work, but it was many years before his advanced style of painting found a ready market in his native state.

Prendergast, John (-)
B. England. Lived: California 1848-51, principally in San Francisco. Groce and Wallace; Peters.

Preuss, Charles (-c.1853)
Lived: Washington, D.C. 1850 and 1853; in the West as artist and mapmaker on several government surveys. Groce and Wallace.

Price, Clayton S. (1875-1950)

B. Iowa, 1875. D. Oregon, 1950. Lived: Sheridan, Wyoming; Bighorn Basin of Montana; Monterey, California; Portland, Oregon. Work: Portland Art Museum; Oakland Art Museum, California. Ainsworth 1968; Mallett 1940 Supplement; Porter et al; Stenzel and Stenzel 1963; *WWAA*.

Little is known of this cowboy artist who was born in Iowa, and moved to Sheridan, Wyoming, in 1886. He studied for a year at the Saint Louis School of Fine Arts and won a gold medal for the greatest progress made by any student during that year. Price's experience on the range as a bronc buster inspired many horse and cowboy subjects during the early years of his career and brought him recognition but not fame. Price then turned to abstract painting. His earlier work will continue to be of interest to collectors. Both Wyoming and California, and perhaps other western states, provided rangeland scenery for his paintings of that period.

Price, Eugenia (1865-1923)

B. Beaumont, Texas. D. Los Angeles, California. *AAA;* Fielding; Mallett.

Price, Minnie (1877-1957)

B. Columbus, Ohio, August 12. D. Las Vegas, Nevada, December 15. Lived: Las Vegas; probably San Fernando, California. *WWAA*.

Prior, Melton (1845-1910)

B. London, England. D. London, England. In the West 1876, 1878. Hogarth.

Proctor, Alexander Phimister (1862-1950)

B. Bosanquit, Ontario, Canada, September 27. D. Palo Alto, California, September 4. Lived: Seattle, Washington; Wilton, Connecticut; Oregon; Montana; California. *AAA;* Bénézit; Fielding; Mallett; *WWA; WWWA*.

Puthuff, Hanson Duvall (1875-)

B. Waverly, Missouri, 1875. Lived: Denver, Colorado; La Crescenta and Eagle Rock, California. Work: Artists' Club,

Denver. Fielding; Mallett; Porter et al; *WWAA.*

Puthuff was a product of the University Art School of Denver. In the early 1900s he went to Southern California in search of opportunity; it came from landscapes inspired by the colorful surroundings rather than from portraiture which had been his specialty. Art critics acclaimed Puthuff's landscapes for their "classic effect of bigness," their technical excellence and well-organized composition. Ultimately his work brought recognition and wide representation. Although no longer the well-known artist he once was, his early landscapes of the Southern California scene will continue to be of interest to collectors and can be found occasionally in art museums and commercial galleries.

Q

Quigley, E. B. (1895-)

B. Park River, North Dakota, December 20, 1895. Lived: Portland, Oregon. Work: Merrihill Museum of Fine Arts, near Goldendale, Washington, Ainsworth 1968.

A chance encounter with a band of cow ponies during a hunting trip in Washington state in the early 1930s helped turn this commercial artist into a painter of cowboy life. Quigley was not a stranger to the "horse world," for he had been born in a small North Dakota town and also had lived in Idaho. Even more important was his grandfather who had interested him as a child in drawing horses. The 1930s encounter gave Quigley an opportunity to do some on-the-spot sketches which attracted the attention of a local rancher who introduced him to a Yakima Indian chief. An invitation to attend a wild horse roundup on the reservation followed, giving further impetus to Quigley's pony-sketching spree. Since then he has painted many oils of western subjects and has become one of Washington's recognized artists.

Quinton, Cornelia Bentley Sage (1876-1936)

B. Buffalo, New York. D. May 16. Lived: Buffalo; San Francisco and Hollywood, California. *AAA;* Fielding; Mallett; *WWA; WWWA.*

R

Raborg, Benjamin (1871-1918)

B. Missouri. D. San Francisco, California. Lived: California. Washington State Historical Society, Tacoma; *Antiques,* October 1968.

Ralston, J. K. (1896-)

B. Choteau, Montana, March 31, 1896. Lived: Seattle, Spokane, Tacoma, and Vancouver, Washington; Billings, Montana. Work: Private collections; murals: Big Horn County State Bank, Hardin, Montana; 1st National Park Bank, Livingston, Montana. Ainsworth 1968; *WWAA.*

Montana-born Ken Ralston started at age 10 to draw the open range country along the Missouri, and at 15 to use oils. Formal study followed at the Chicago Art Institute when he was 21, but it was interrupted by two years overseas during the First World War. After his marriage, Ralston spent seven years in Washington state doing commercial art work and free-lance illustrating. Then he established a studio in Billings, Montana, and specialized in western historical paintings and illustrations. Research for such paintings as "Surrender of Chief Joseph" has made him somewhat of an expert on the history of the Old West.

Ramsey, Lewis A. (1875-1941)

B. Bridgeport, Illinois. D. Hollywood, California, May 11. Lived: Payson and Salt Lake City, Utah; Hollywood. *AAA;* Fielding; Mallett; *WWAA.*

Randolph, Lee F. (1880-)

B. Ravenna, Ohio, June 3, 1880. Lived: France; Monterey, California; San Francisco; Utah. Work: Utah State University, Logan; San Francisco Bay area art museums. *CAR*, Vol. XV; Fielding; Mallett.

Randolph moved to California in 1913 after many years of study in Paris. Less than a year later he had a one-man show in San Francisco of paintings, pastels, and etchings of several foreign countries and a few landscapes of Monterey and San Francisco Bay scenes. Recognition was immediate, and a teaching position with the University of California followed. Then he became director of the California School of Fine Arts in San Francisco where he remained many years. Summers were devoted to sketching either at Monterey or in Utah. He is represented in museums in Paris, Logan, Utah, and the San Francisco Bay area.

Rankin, Mary Kirk (1897-)

B. El Paso, Texas, September 3. Lived: San Marino, California. Collins; *WWAA*.

Rankin, Myra Warner (1884-)

B. Roca, Nebraska, June 7. Lived: Hartford, Connecticut. Mallett; *WWAA*.

Ranney, William (1813-1857)

B. Middleton, Connecticut, May 9. D. West Hoboken, New Jersey, November 18. Lived: Texas; New Jersey. Fielding; Groce and Wallace; Mallett; *WWWA*.

Ransonnette, Charles (-)

In Monterey, California, during Mexican rule. Van Nostrand.

Raphael, Joseph (1872-1950)

B. Jackson, California. Lived: San Francisco, California; Belgium. *AAA;* Bénézit; Fielding; Mallett; *WWAA*.

Raschen, Henry (1856-1937)

B. Oldenburg, Germany. D. Oakland, California. Lived: San Francisco, California; Europe. California Historical Society, San Francisco; *Antiques,* July 1969.

Rathbone, Augusta Payne (1897-)
B. Berkeley, California, December 30. Lived: San Francisco; New York City. Collins; *WWAA*.

Ratliff, Blanche Cooley (1896-)
B. Smithville, Texas. Lived: Atlanta, Georgia; Fort Worth, Texas. *AAA;* Fielding; Mallett.

Ravalli, Antonio (1811-1884)
B. Ferrara, Italy, May 16. D. Hell Gate, Montana, October 2. Lived: Vancouver, B.C.; Montana; Idaho. Groce and Wallace; *WWWA*.

Rea, Lewis Edward (1868-)
Lived: Sonoma, California. California Historical Society, San Francisco.

Read, Henry (1851-1935)
B. Twickenham, England, 1851. Lived: Denver, Colorado. Work: Denver Art Association. Fielding; Hafen 1948, Vol. II; Mallett.

Read, an English artist, settled in Denver during the 1890s. Although he was not primarily concerned with painting the West, he tried his hand at western subjects and received high praise for his excellent technique and careful attention to detail. Read's principal contribution to Denver, however, was that of teacher at Denver Students' School of Art and his leadership as president of the Denver Art Commission. In the latter capacity he proposed a Civic Center for the city. He also helped with other improvements such as the designing of ornamental street lighting, and he made many helpful suggestions to persons in charge of city planning.

Reade, Roma (1877-1958)
B. Skaneateles, New York. D. Pasadena, California, September 24. Lived: Pasadena. *WWAA*.

Reaser, Wilbur Aaron (1860-)
B. Hicksville, Ohio. Lived: Yonkers, New York; Florence, Italy; New York City. *AAA;* Fielding; Mallett; *WWA; WWWA*.

191

Reaugh, Frank (1860-1945)

B. Morgan County, Illinois, December, 1860. Lived: Oak Cliff, Texas. Work: Panhandle-Plains Historical Museum, Canyon, Texas; Texas Technological University Library, Lubbock, Texas; Dallas Public Library. Ainsworth 1968; Fielding; Mallett; *WWAA*.

Reaugh was 16 when he left Illinois with his family for a Texas ranch near Terrell. He loved the open range country of that state, particularly the longhorn cattle which became the subject of many works and earned him the title "Rembrandt of the Longhorns." Reaugh's determination to do justice to the Texas landscape and its creatures led to formal study in Saint Louis in 1884 and later in Europe. He preferred oils and pastels and an impressionist style.

Although Reaugh worked primarily in Texas, he is well-known throughout the country for both his painting and his teaching. Although he donated his work "to the Southwest at large," the terms of his will have favored Texas. The Panhandle-Plains Historical Museum at Canyon has 500 works and the Texas Tech University library at Lubbock has 200.

Redmond, Granville (1871-1935)

B. Philadelphia, Pennsylvania, March 9. D. May 24. Lived: Menlo Park and Los Angeles, California. *AAA;* Fielding; Mallett; *WWA; WWWA.*

Redwood, Allen C. (1844-1922)

In the Far West 1882, and possibly later. Taft; *Asheville Citizen* (North Carolina), December 26, 1922.

Reed, Doel (1894-)

B. Logansport, Indiana, May 21. Lived: Stillwater, Oklahoma; Taos, New Mexico. *AAA;* Mallett; *WWAA.*

Reedy, Leonard (1899-1956)

B. Chicago, Illinois. Lived: Chicago; on various Western ranches. Baird.

Regamey, Felix Elie (1844-1907)

B. Paris, France. D. Juan-les-Pins, France. In the West 1870s. Hogarth.

Reid, Albert Turner (1873-1955)
B. Concordia, Kansas, August 12. D. November 26. Lived: Topeka, Kansas; New York. *AAA;* Fielding; Mallett; *WWA; WWAA; WWWA.*

Reid, Robert (1862-1929)
B. Stockbridge, Massachusetts. D. Clifton Springs, New York, December 2. Lived: New York City; Colorado Springs, Colorado. *AAA;* Bénézit; *DAB;* Fielding; Mallett; *WWA; WWWA.*

Reiffel, Charles (1862-1942)
B. Indianapolis, Indiana, April 9. D. March 14. Lived: San Diego and Julian, California. *AAA;* Fielding; Mallett; *WWA; WWAA; WWWA.*

Reimer, Cornelia (1894-)
B. San Jacinto, California, December 20. Lived: Sierra Madre, California. Collins; *WWAA.*

Reiss, F. Winold (1886-1953)
B. Germany, 1886. D. New York City, August 29, 1953. Lived: New York City; summers: Glacier National Park, Montana. Federal Writers' Project, *Montana;* Fielding; Linderman; Mallett; *WWAA.*

Reiss came to America from Germany in 1913 to study and paint the Indians. His interest in them began with the reading of James Fenimore Cooper's novels, and for all of his professional life he advocated the use of the Indian theme in murals for schools and other public buildings. Reiss spent many summers teaching art at Glacier National Park which is in the heart of Blackfeet country. He painted 49 pictures of them for Frank B. Lindeman's *Blackfeet Indians,* published in 1935 by the Great Northern Railway. He was particularly adept at portraiture, and in that book he preserved for future generations the likenesses of many important leaders among the Blackfeet, Piegans, and Crows.

Remington, Frederic (1861-1909)
B. Canton, New York, October 4, 1861. D. Ridgefield, Connecticut, December 25, 1909. Lived: Kansas; New Rochelle,

New York. Work: Remington Art Memorial, Ogdensburg, New York; Whitney Gallery of Western Art, Cody, Wyoming; Bradford Brinton Memorial, Big Horn, Wyoming; Amon Carter Museum of Western Art, Fort Worth, Texas; National Cowboy Hall of Fame, Oklahoma City. Fielding; Mallett; Richardson; Taft.

Remington has some 3,000 pictures of the western scene to his credit. He began this pictorial account in 1881, when in search of adventure he went to Montana Territory. His own words for *Collier's Weekly* in 1905 best explain his phenomenal output: "I knew the wild riders and the vacant land were about to vanish forever.... I saw the living, breathing end of three American centuries of smoke and dust and sweat."

To accurately depict the West, Remington lived the strenuous life of its inhabitants: he accompanied military campaigns, prospected for gold, worked as a cowboy, and tried his hand as a sheep rancher. He knew the Indians well and painted them with understanding and respect. Remington's initial fame was as a realistic illustrator in black-and-white, and he did not turn to painting until the early 1890s. In 1895 he began sculpting and quickly became a master in that medium. Remington told the western story as he knew it, and no artist has done a better job.

Revere, Joseph Warren (1812-1880)
 B. Boston, Massachusetts, May 17. D. Hoboken, New Jersey, April 20. Lived: California; New Jersey; France. *DAB;* Groce and Wallace; *WWWA.*

Rey, Jacques Joseph (1820-c.1899)
 B. Bouxviller, Alsace. D. San Francisco, California. Lived: San Francisco. Groce and Wallace; Peters.

Reynard, Grant T. (1887-1968)
 B. Grand Island, Nebraska, October 20. D. August 13. Lived: Leonia, New Jersey. *AAA;* Mallett; *WWAA.*

Reynolds, Harry Reuben (1898-)
 B. Centerburg, Ohio, January 29. Lived: Logan, Utah. *AAA;* Mallett; *WWAA.*

Rhodes, Helen N. (-1938)
B. Milwaukee, Wisconsin. D. June 16. Lived: Seattle, Washington. *AAA;* Mallett; *WWAA.*

Rich, John Hubbard (1876-)
B. Boston, Massachusetts. Lived: Hollywood, California. *AAA;* Fielding; Mallett; *WWAA.*

Richards, Lee Green (1878-1950)
B. Salt Lake City, Utah, July 27. D. February 20. Lived: Salt Lake City. *AAA;* Fielding; Mallett.

Richardson, Mary Curtis (1848-1931)
B. New York, April 9, 1848. D. San Francisco, California, 1931. Lived: San Francisco. *CAR,* Vol. V; Mallett.

One of California's early women artists was Mary Curtis Richardson who in 1850 was brought across the Isthmus of Panama on the back of an Indian, for the Canal was not then in existence. At the time she was on the way with her mother and sister to join her father who had crossed the Plains the previous year. At the age of 20 Mrs. Richardson, with her sister Leila, went into the wood-engraving business, and some years later she turned to portraiture and genre subjects. Mrs. Richardson exhibited at a prominent New York gallery in 1910, and somewhat later at the Pennsylvania Academy and in London. Most of her landscape work was done in and near San Francisco where she maintained a studio on Vallejo Street for over 40 years.

Richardt, Joachim Ferdinand (1819-1895)
B. Brede, Denmark. D. California. Lived: Oakland, California; New York City. Groce and Wallace; Mallett.

Richter, Albert B. (1845-1898)
B. Dresden, Germany. D. Langebrück, Germany. Visited the West 1878. Hogarth.

Richter, Henry L. (1870-)
Lived: Estes Park, California. Centaur Gallery, Denver, Colorado.

Rieber, Winifred (1872-)
B. Carson City, Nevada, January 22. Lived: Los Angeles, California. Mallett; *WWA*.

Riesenberg, Sidney H. (1885-)
B. Chicago, Illinois, December 12. Lived: Yonkers, New York. *AAA;* Mallett; *WWAA*.

Rising, Dorothy Milne (1895-)
B. Tacoma, Washington. Lived: Seattle. Mallett; *WWAA*.

Ritschel, William (1864-1949)
B. Nuremberg, Germany, July 11. Lived: Carmel, California. *AAA;* Fielding; Mallett; *WWA; WWAA; WWWA*.

Ritter, Anne Gregory (1868-1929)
B. Plattsburg, New York. Lived: Denver and Colorado Springs, Colorado. *AAA;* Mallett.

Rix, Julian Walbridge (1850-1903)
B. Peacham, Vermont, December 30, 1850. D. New York City, November 19, 1903. Lived: San Francisco, California; Paterson, New Jersey; New York City. Work: Corcoran Gallery of Art, Washington, D.C.; Walker Art Center, Minneapolis; Toledo Art Museum, Ohio; Metropolitan Museum of Art, New York City. *CAR,* Vol. IV; Fielding; Mallett.

Rix became one of the most successful of the early California artists. By 1881, when he moved from San Francisco to Paterson, New Jersey, he had traveled extensively in the western coastal states and Colorado in search of wild scenery for his landscapes. Thereafter he returned occasionally for visits, further sketching, and exhibitions.

Rix was a self-taught artist who began with black-and-white drawings, followed by pastels and then oils. In the East he experimented with water color, causing much comment with his strange new technique of applying the pigment as if it were oil. He also made etchings, some appearing in *Harper's Magazine* (October 1889) to illustrate an article on California coast range forests.

Robbins, Frederick Goodrich (1893-)
B. Oak Park, Illinois, May 8. Lived: Westboro, Massachusetts. Mallett; *WWAA.*

Robinson, Adah Matilda (1882-)
B. Richmond, Indiana. Lived: Tulsa, Oklahoma; San Antonio, Texas. *AAA;* Fielding; Mallett; *WWAA.*

Robinson, Alfred (1806-1895)
B. Massachusetts. Lived: California 1829-37, 1840-42, and after 1849. Groce and Wallace; Robinson, *Life in California* (1846).

Robinson, Boardman (1876-1952)
B. Somerset, Nova Scotia, Canada, September 6. D. September 5. Lived: Colorado Springs and Denver, Colorado; New York. *AAA;* Fielding; Mallett; *WWA; WWAA; WWWA.*

Robinson, Charles Dormon (1847-1933)
B. Monmouth, Maine, July 17, 1847. D. San Rafael, California, May 8, 1933. Lived: San Francisco and San Rafael; summers: Yosemite National Park. Work: California Historical Society, San Francisco; Crocker Art Gallery, Sacramento; Oakland Art Museum; San Francisco Maritime Museum; Society of California Pioneers, San Francisco. *CAR,* Vol. IV; Fielding; Mallett; Seavey, *Robinson.*

Robinson, who was good with words as well as the brush, once said, "It takes a crank to move the world, and I would rather be a crank than a nonentity." His work with pen and brush tells a story of dedication to the High Sierras and the Pacific Ocean. He wrote articles for *Overland Monthly,* illustrated John Muir's "Kings River Canyon" for *Century Magazine,* and spent most of his life depicting the grandeur of mountains and sea coast.

When Robinson was not living in Yosemite, he was in San Francisco or San Rafael where he could turn his attention to the California coast. His training under George Innes and William Bradford, a famous marine and arctic painter of that time, prepared him for both landscapes and marines.

Rockwell, Cleveland (1837-1907)

B. Youngstown, Ohio, 1837. D. Portland, Oregon, 1907. Lived: New York; California; Portland. Work: Dr. and Mrs Franz Stenzel Collection, Portland, Oregon. Forrest 1961; LeRoy; Stenzel.

Rockwell's professional career began as harbor engineer for the New York Port, and continued as topographer for the War Department during the Civil War. Prior to his next employment as chief of the U.S. Geodetic Survey in 1868, Rockwell spent two years in California. At that time he was an amateur artist. Rockwell's engineering career had allowed time to study art both in this country and during two sabbaticals in England. His work with the Geodetic Survey enabled him to paint the scenic wonders of Oregon and the fishing industry as it was practiced along the Willamette and Columbia Rivers. In 1892 he retired and took up the life of a full-time artist.

Rodriguez, Alfred C. (-)

Lived: California 1862-90. Oakland Art Museum.

Roethe, L. H. (1860-)

B. Shasta, California. Lived: San Francisco. Society of California Pioneers, San Francisco.

Rogers, C. A. (-)

Lived: California 1866-1907. Groce and Wallace; Oakland Art Museum.

Rogers, Charles H. (-)

Lived: California 1856-72. Groce and Wallace; Oakland Art Museum.

Rogers, Margaret Esther (1872-1961)

B. Birmingham, England. D. Santa Cruz, California, March 15. Lived: Santa Cruz and Seabright, California. *AAA;* Mallett; *WWAA.*

Rogers, William Allen (1854-1931)

B. Springfield, Ohio, 1854. D. Washington, D.C., October 20, 1931. Lived: New York. Fielding; Mallett; Rogers; Taft.

Without formal art instruction Rogers held various jobs as

artist and engraver from the age of 16, and in 1877 joined the staff of *Harper's*. His western work began the following year with an unauthorized trip to the Standing Rock Agency of the Sioux. Three months later, after a side trip into Canada, Rogers returned to face the ire of Fletcher Harper. Only the many outstanding sketches procured during the trip saved him from dismissal. From that time on, Rogers' trips were authorized. He was in Colorado and New Mexico in 1879, the mining region of Colorado's Cripple Creek in 1893, and the mining region of eastern Oregon in 1898. From Oregon he returned East by way of California, Arizona, and Texas in 1899. His illustrations—many of them reproductions from water colors—appeared in Harper's publications for over two decades.

Rollins, Helen Jordan (1893-)

B. Hayward, California. Lived: LaCrescenta, California. *WWAA.*

Rollins, Warren E. (1861-1962)

B. Carson City, Nevada, August 8, 1861. D. Arizona, 1962. Lived: San Francisco and San Gabriel, California; Santa Fe and Pueblo Bonita, New Mexico; Paradise Valley and Leupp, Arizona; Baltimore. Work: Oakland Art Museum, Oakland, California; Museum of New Mexico, Santa Fe; Hubbell Trading Post Museum, Ganado, Arizona. Coke; Mallett; Maxwell; *WWAA.*

Born in Carson City, Nevada, and raised in Antioch, California, this son of a Forty-niner is best remembered for his Indian paintings. He was one of the first artists to live among the Indians in the Pueblo villages of Arizona and New Mexico, and to be admitted to their ceremonies. From his experiences came "A Son in the Kiva," "The Stoic," "The Pottery Maker," and many others. Rollins also painted among the Crow and the Blackfeet.

Although Rollins worked primarily with oils, he began in 1925 some experiments with wax crayons which became a life-time interest. "Crayon gives stability," said Rollins. "It never fades or cracks, and may be viewed from almost any angle." Many of his Arizona desert and Santa Fe area scenes were done in that medium.

Rolshoven, Julius C. (1858-1930)

B. Detroit, Michigan, 1858. D. New York City, December 7, 1930. Lived; Florence, Italy; Santa Fe, New Mexico. Work: Museum of New Mexico, Santa Fe; El Paso Museum of Art, Texas. Coke; Fielding; Grant; Mallett.

At the historic Palace of the Governors in Santa Fe a studio was made available to Rolshoven upon his arrival in 1916. There under its territorial-style roof the Indians gathered from miles around to sell their wares, providing a picturesque scene for the artist's brush.

Like other artists trained in the East and in Europe, Rolshoven found the bright, glaring southwestern light difficult to cope with and solved the problem by setting up a tent on the Palace grounds. The light inside was soft and easier to work with. Rolshoven found it ideal for bringing out the dusky skin tones of the Indians and painted many fine portraits there.

Rorphuro, Julius J. (-)

Lived: San Francisco, California 1894-1925. San Francisco City Directories.

Rose, Guy (1867-1925)

B. San Gabriel, California, 1867. D. Pasadena, California, 1925. Lived: Pasadena. Work: Oakland Art Museum, Oakland, California. Berry, January 1925; Fielding; Mallett; Neuhaus 1931.

Rose painted in the impressionist manner long before western art critics recognized the merit of that school. Although an artist of importance when the Panama Pacific International Exposition was held in 1915, his work was rejected. Ten years later *International Studio* brought the matter to light and published a number of Rose's Point Lobos scenes.

Rose was born in San Gabriel, California, and except for a decade or so in France he lived in the southern part of that state, principally in Pasadena. Southern Californians consider him one of their most important early artists, but despite the merit of his work his reputation has been largely local.

Rosenthal, Doris (-1971)
B. Riverside, California. D. Oaxaca, Mexico, November.
Lived: Norwalk, Connecticut; New York; Mexico. *AAA;*
Mallett; *WWAA; WWWA.*

Rosenthal, Toby E. (1848-1917)
B. New Haven, Connecticut. D. Berlin, Germany. Lived:
San Francisco, California; Munchen, Bavaria, Germany.
AAA; Bénézit; Fielding; Mallett; *WWWA.*

Ross, Thomas (-)
Lived: California 1850-81. Oakland Art Museum.

Rothery, Albert (1851-c.1917)
B. Poughkeepsie, New York. Lived: Omaha, Nebraska.
AAA; Bucklin; Mallett.

Rudolph, Alfred (1881-1942)
B. Alsace-Lorraine. D. April 25. Lived: Tucson, Arizona;
La Jolla, California. Mallett; *WWAA.*

Rungius, Carl (1869-1959)
B. Berlin, Germany, August 18, 1869. D. New York, 1959.
Lived: Germany; Wyoming; Alhambra, California; Banff,
Alberta; New York City. Work: Whitney Gallery of West-
ern Art, Cody, Wyoming. Fielding; Mallett; Schaldach;
WWAA.
 Rungius came to this country from Germany in 1894 to
hunt big game in Maine with his uncle from Brooklyn. Unsuc-
cessful in their pursuit, his uncle invited him to stay on and try
again the following season. In 1895 Rungius discovered Wyoming,
and for the rest of the century spent his fall and summer months
painting and hunting big game there. His Wyoming sketches also
included corrals, cow ponies, and picturesque barns.
 In 1901 Rungius sketched in Canada, but returned the fol-
lowing year to Wyoming, and again in 1915. With a studio in Banff,
and another in New York, Rungius spent his summer months in
the Canadian Rockies during most of the years since 1900. He
also sketched and hunted in New Brunswick, and in 1936 and
1937 he spent the winters in Southern California.

Rush, Olive (1873-1966)

B. Fairmount, Indiana. D. August 20. Lived: Santa Fe, New Mexico. *AAA;* Fielding; Mallett; *WWA; WWAA; WWWA.*

Russell, Charles Marion (1864-1926)

B. Saint Louis, Missouri, March 19, 1864. D. Great Falls, Montana, October 24, 1926. Lived: Great Falls; New York; Lake McDonald, Glacier National Park, Montana; Pasadena, California. Work: Whitney Gallery of Western Art, Cody, Wyoming; C. M. Russell Gallery, Great Falls, Montana; Montana Historical Society Museum, Helena; Gilcrease Institute of Art, Tulsa, Oklahoma; Amon Carter Museum, Fort Worth; R. W. Norton Art Gallery, Shreveport, Louisiana; National Cowboy Hall of Fame, Oklahoma City. Ewers 1965; Fielding; McCracken 1952, 1957; Mallett; Taft.

At 16 Russell left his home in Saint Louis to mingle with Indians and cowboys in Montana Territory. With him went bedroll, sketchbook, and water colors. He got a job as sheepherder which didn't last long and was then taken in by a trapper for a couple of years. His next job was night wrangler for a large cow outfit. In 1888 Russell went to Alberta, Canada, where he lived for six months with the Blood Indians. His experiences inspired many paintings of Indian life which were done with great sympathy and understanding.

Until Russell's marriage in 1896 his paintings were sold for a few dollars to his friends or were exchanged for drinks at the nearest bar. A devoted wife with a head for business changed all that. She sold her husband's paintings for what they were worth and helped him achieve the fame he deserved. Russell's more than 2,500 works were executed in almost all media—pencil, pen and ink, water colors, oil, bronze.

Rutland, Emily (1894-)

B. Travis County, Texas. Lived: Robstown, Texas. Mallett; *WWAA.*

Ruxton, George A. F. (-)

Lived: in the West 1840s. Forrest.

Ryder, Chauncey Foster (1868-1949)

B. Danbury, Connecticut. D. May 18. Lived: New York City. *AAA;* Fielding; Mallett; *WWA; WWAA; WWWA.*

Ryder, Worth (1884-1960)

B. Kirkwood, Illinois. D. Berkeley, California, February 17. Lived: Berkeley. *AAA;* Fielding; Mallett; *WWAA; WWWA.*

S

Saint-Clair, Norman (1864-1912)

D. Los Angeles, California. Lived: California. *AAA;* Mallett.

Sample, Paul Starrett (1896-)

B. Louisville, Kentucky. Lived: Hanover, Vermont; Pasadena, California. *AAA;* Mallett; *WWAA.*

Sandham, J. Henry (1842-1910)

B. Montreal, Canada. D. London, England. Lived: Boston, Massachusetts; London. *AAA;* Fielding; Mallett.

Sandona, Matteo (1883-)

B. Schio, Italy, April 15. Lived: San Francisco and Los Gatos, California. *AAA;* Fielding; Mallett; *WWA; WWAA.*

Sandor, Mathias (1857-1920)

B. Hungary, July 10. D. New York, November 3. Lived: New York. *AAA;* Fielding; Mallett; *WWWA.*

Sandusky, William (1813-1846)

B. Ohio. Lived: Austin and Galveston, Texas. Pinckney.

Sandzen, Sven Birger (1871-1954)

B. Blidsberg, Sweden, February 5. D. June 19. Lived: Lindsborg, Kansas. *AAA;* Fielding; Mallett; *WWA; WWAA; WWWA.*

Santee, Ross (1889-)

B. Thornburg, Iowa, August 16, 1889. Lived: New York; Gila County, Arizona; Arden, Delaware. Work: Read Mullan Gallery of Western Art, Phoenix, Arizona. Ainsworth 1968; Federal Writers' Project, *Arizona;* Santee.

Santee the artist is even better known as the author of *Cowboy, Apacheland,* and other western books. After years of ranch life in Arizona, the success as an artist which had eluded him in New York finally materialized. It came after he had mastered the art of communicating what he saw and heard while working on the range—the picturesque landscape with Indian dwellings and lonely ranches, the stories he heard at night around the campfire.

In 1935, twenty years after Santee started horse wrangling in Arizona, he received the O. Henry award for "Water," a short story that he illustrated and wrote. Recognition followed immediately for this artist-writer whose charming sketches of Western scenes are so much a part of his books.

Sargeant, Geneve Rixford (1868-)

B. San Francisco, California, July 14, 1868. Lived: San Francisco; Paris; New York. Work: Mills College Art Gallery, Oakland, California; San Francisco Museum of Art. *CAR,* Vol. XII; Fielding; Mallett; *WWAA.*

Mrs. Sargeant was for years one of San Francisco's most versatile and productive artists. Her work included landscapes, genre subjects, portraits, and still lifes in many media. Landscapes frequently were painted in scenic Bay area and San Fernando Valley spots while her three sons played about.

In the early 1920s Mrs. Sargeant and her husband lived in Paris where their sons studied music. Following her return to San Francisco she kept a studio in the old Montgomery Block, but continued to make trips to Mexico and to New York, ultimately settling permanently in the latter where her son Winthrop is the noted art critic.

Sauerwen, Frank Paul (1871-1910)

B. Cantonsville, New Jersey, March 22, 1871. D. Stamford, Connecticut, June 14, 1910. Lived: Denver, Colorado; Taos, New Mexico; California. Work: West Texas State College, Canyon, Texas; Museum of New Mexico, Santa Fe; Denver Public Library; Hubbell Trading Post Museum, Ganado, Arizona. Coke; Grant; Taft.

Sauerwen spent his short adult life in the West where he painted Indians and Penitentes against a background of pueblos, old adobes, and stark landscapes, and wrote several articles.

With Charles Craig, Sauerwen visited the Ute Indian Reservation in 1893, and Taos in 1898, long before the latter became a fashionable art colony. The culture of Pueblo Indians became the predominant theme of Sauerwen's work during the all too few years remaining to him. His water colors in particular caught the charm of Indian pueblos and western wastelands. Many of his paintings were purchased by the Santa Fe Railroad, but many others found their way into small private collections, especially in Denver where he lived intermittently from 1891 until 1903. Today Sauerwen is recognized as one of the most competent of the Southwestern artists.

Sawyer, Myra Louise (-1956)

D. Peoria, Illinois, January 17. Lived: Salt Lake City, Utah. *AAA;* Haseltine.

Sawyer, Philip Ayer (1877-1949)

B. Chicago, Illinois. D. March 7. Lived: Clearwater, Florida; Tiskilwa, Illinois. *AAA;* Fielding; Mallett; *WWAA.*

Sayre, F. Grayson (1879-1938)

B. Missouri. D. December 31. Lived: Glendale, California. Mallett; *New York Times,* January 3, 1939.

Schafer, Frederick F. (1841-1917)

B. Germany. Lived: California 1878-1900. Oakland Art Museum.

Scherbakoff, Sergey John (1894-)

Lived: San Francisco. *CAR;* Mallett.

Scheuerle, Joe (1873-1948)

B. Vienna, Austria, March 15, 1873. D. South Orange, New Jersey, March 25, 1948. Lived: Cincinnati; Chicago; South Orange. Work: Thornton I. and Margo Boileau Collection, Birmingham, Michigan. Boileau and Boileau.

A commercial artist in the East for all of his professional life, Scheuerle became a regular visitor to Indian reservations of the northern high plains from 1909 until 1938. Like other artists interested in Indians from boyhood, he made them his friends as well as his subjects. From these first-hand acquaintances have come more than 200 portraits. During Scheuerle's life, these portraits were not for sale. They are now in a private collection which had an exhibition in 1973 at the Montana Historical Society.

Many of Scheuerle's posters for circuses and wild west shows are as authentic as his portraits, for whenever possible he sought out the performers. He met Buffalo Bill Cody and his Plains warriors in Chicago in 1900 when the 101 Ranch Wild West Shows were in full swing.

Schimonsky, Stanislas W. Y. (-)

Lived: Nebraska. Federal Writers' Project, *Nebraska;* Groce and Wallace.

Schiwetz, Edward M. [Buck] (1898-)

B. Cuero, Texas. Lived: Houston, Texas. Mallett; Schiwetz; *WWAA.*

Schonbrun, Anton (-)

In the West 1860s-1870s. *Kennedy Quarterly,* June 1967.

Schott, Arthur (1813-1875)

B. c. 1813. D. Washington, D.C., July 26, 1875. Lived: Washington, D.C. Work: New York Historical Society, New York. Groce and Wallace; Hine; Taft.

During the Mexican Boundary Survey of 1849-1857, Schott was employed to keep records and make drawings. His official position was that of first assistant surveyor to William H. Emory, but his contribution was that of an artist and a naturalist. Actually he was also a physician, a professor of music and German, and an engineer. Two hundred twenty-six drawings of birds, ani-

206

mals, Indians, and historical scenes in Emory's published report are credited to Schott. Twenty-five of the plates are in color and depict the Yuma, Papago, Lipan, Rigueno, and Co-Co-Pa Indians.

From 1856 to 1866 Schott lived in Washington, D.C., where he was a frequent contributor of Rio Grande subjects to the *Smithsonian Reports.*

Schreck, Horst (1885-)

B. Herisau, Switzerland. Lived: El Paso, Texas. *Southwestern Art,* November 1967.

Schreyvogel, Charles (1861-1912)

B. New York City, January 4, 1861. D. Hoboken, New Jersey, January 27, 1912. Lived: Hoboken; summers: Ute and Sioux Reservations, and Fort Robinson, Nebraska. Work: Metropolitan Museum of Art, New York; Philbrook Art Center, Tulsa, Oklahoma; Amon Carter Museum of Western Art, Fort Worth, Texas. Fielding; Horan; McCracken 1952; Mallett; Taft.

Schreyvogel grew up in Hoboken, New Jersey, where his first Western subjects were the cowboys, Indians, and animals at the eastern headquarters of Buffalo Bill's Wild West. Not until 1893, when Schreyvogel was the guest of an army surgeon on the Ute Reservation, did he see the West. There his contact with the troopers inspired him to depict their dangerous and sometimes gallant lives. "My Bunkie," which skyrocketed him to fame when it received a National Academy award in 1900, is such a painting. During Schreyvogel's subsequent western trips, he sketched, made photographs, and collected firearms and Indian attire which were used in his Hoboken studio to depict many moving scenes of combat between the troopers and the Indians.

Schuchard, Carl (1827-1883)

B. Hesse-Cassel, Germany, 1827. D. Mexico, May 4, 1883. Lived: California; Arizona; Texas; Mexico. Work: Most of it destroyed in 1865 Smithsonian Institution fire. Groce and Wallace; Pinckney; Taft.

Schuchard was a German-born and educated mining engineer whose interest in gold brought him to California in 1849. Lack of success made it necessary to secure other work, and

Schuchard became a topographical artist for A. B. Gray's Survey of a route for the Southern Pacific Railroad along the 32nd parallel. Instructions to the survey party were to "note carefully the country . . . the climate, geology, plants and animals and the character and development of its inhabitants." Just such instructions to members of the early western surveys have enriched beyond measure our store of historical knowledge. Gray commended Schuchard in the published reports for an excellent job and used 32 of his drawings of Texas and New Mexico scenes as illustrations.

Schultz, Hart Merriam [Lone Wolf] (1882-1970)

B. Montana. D. Tucson, Arizona, February 9. Lived: Montana; Arizona. Dyke.

Schwartz, Davis Francis (1879-1969)

B. Paris, Kentucky. D. January 1. Lived: California. California Historical Society, San Francisco.

Scott, Clyde Eugene (1884-1959)

B. Bedford, Iowa, January 24. D. Los Angeles, California, October 6. Lived: Los Angeles. Mallett; *WWAA*.

Scott, Julian (1846-1901)

B. Johnson, Vermont, February 15, 1846. D. Plainfield, New Jersey, c. July 4, 1901. Lived: Plainfield. Work: University of Pennsylvania Museum of Art, Philadelphia; Smithsonian Institution, Washington, D.C.; Hubbell Trading Post Museum, Ganado, Arizona. Fielding; Mallett; Taft.

Scott was one of the five artists who were commissioned by the government in 1890 to assist with the Indian census. He spent some time among the Oklahoma Indians that year, but most of his paintings were done in 1891 when he did an outstanding portrait of Washakie, chief of the Shoshone, near Fort Washakie, Wyoming, and spent considerable time on the Hopi Reservation. Most of his 30 illustrations for the 683-page government document, *Indians Taxed and Indians Not Taxed,* deal with Hopi Indians. Scott was a well-known eastern artist when he undertook the census assignment. Most of the Indian portraits from his western trips belong to the Museum of Art at the University of Pennsylvania.

Seltzer, Olaf Carl (1877-1957)

B. Copenhagen, Denmark, August 14, 1877. D. December 1957. Lived: New York; Great Falls, Montana. Work: Gilcrease Institute of Art, Tulsa, Oklahoma; Montana Historical Society Museum, Helena; Great Falls Clinic, Great Falls, Montana. Ainsworth 1968; Kennedy; "The Old West Revisited," *The American Scene*, 1967.

One of Montana's most famous and productive artists was O. C. Seltzer, a native of Denmark. At age 12 he had been admitted to a Copenhagen art academy. Three years later he moved to the Great Falls area where he found an outlet for his talent sketching among the Blackfeet and the Piegan, the cowboys and the frontiersmen. After working a year on a ranch, Seltzer got a job in the machine shops of the Great Northern where he remained until 1926.

Seltzer's phenomenal output of oils and water colors reached nearly 2,500, many of them about the West he learned to know so well. A series on gamblers, rustlers, cowboys, and other colorful inhabitants has been publicized under the title "Characters of the Old West."

Seton, Ernest Thompson (1860-1946)

B. South Shields, England, August 4, 1860. D. Seton Village, Santa Fe, New Mexico, October 23, 1946. Lived: Manitoba, Canada; Greenwich, Connecticut; Santa Fe. Work: Mrs. Ernest Thompson Seton Collection, Santa Fe. Fielding; Mallett; Seton; *WWAA*.

Seton was born in England, grew up in Canada, and studied art in England and in France. Toward the end of the 19th century he began his illustrated accounts of animal life in the western states. Among his early sketches were some of Indians, early settlers, and pioneer habitations. For the rest of his long life he continued to draw and paint western subjects, and we remember him particularly for his animal drawings.

He was born Ernest Evan Thompson, often used the inherited family name Seton, and in 1898 legally adopted the name Ernest Thompson Seton. His art work is variously signed Ernest E. Thompson, E.S.T., Ernest Seton-Thompson, and Ernest Thompson Seton.

Seton's interest in the out-of-doors and what it could do

209

for young people led him to assist in founding the Boy Scouts of America. He wrote the organization's first handbook and served as its first Chief Scout, a position he held for five years. In 1930 he settled near Santa Fe where he and his wife developed now famous Seton Village.

Seward, Coy Avon (1884-1939)
B. Chase, Kansas, March 4. D. July 31. Lived: Topeka and Wichita, Kansas. Fielding; Mallett; *WWA; WWAA; WWWA.*

Seyffert, Leopold (1887-1956)
B. California, Missouri, January 6. D. June 13. Lived: Colorado Springs, Colorado; New York City. *AAA;* Fielding; Mallett; *WWA; WWAA; WWWA.*

Seymour, Samuel (1797-1823)
B. England, c. 1797. D. c. 1823, possibly in New York City or Philadelphia, Pennsylvania. Lived: Philadelphia. Work: Yale University Library, New Haven, Connecticut; Joslyn Art Museum, Omaha, Nebraska; New York Public Library. Fielding; Groce and Wallace; McCracken 1952; Mallett; Taft.

Seymour joined the Major Stephen H. Long expedition in 1819 to explore the upper reaches of the Missouri River. It was Seymour's job as official artist to furnish landscapes of noteworthy views and miniature likenesses of Indians and their mode of living. Before the region was fully explored, Congressional action required the party to move southward to the Platte headwaters and thence eastward along the Arkansas and Red Rivers to the Mississippi. According to a published report by Edwin James, a member of the Long expedition, Seymour finished 60 paintings from a total of 150 sketches. Unfortunately less than a dozen of them have survived.

Little is known about Seymour, except that he was a painter and an engraver in Philadelphia for some 20 years.

Shapleigh, Frank Henry (1842-1906)
B. Boston, Massachusetts. D. Jackson, New Hampshire, May 30. Lived: Boston; Jackson; winter: Florida. Fielding; Mallett; *WWWA.*

Sharp, Joseph Henry (1859-1953)
B. Bridgeport, Ohio, September 27, 1859. D. Pasadena, California, August 29, 1953. Lived: Cincinnati, Ohio; Taos, New Mexico; Pasadena. Work: Gilcrease Institute of Art, Tulsa, Oklahoma; Museum of New Mexico, Santa Fe; Arizona State University, Tempe; Hubbell Trading Post Museum, Ganado, Arizona; Southwest Museum, Los Angeles; University of California, Berkeley; Butler Institute of American Art, Youngstown, Ohio. Coke; Fielding; Mallett; Richardson.

Sharp, who began studying art at 14, was more interested in drawing and painting Indians than any other subject. In 1883 he went to New Mexico, California, and the Columbia River basin to sketch Pueblo, Umatilla, Klikitat, Shoshone, and Ute Indians. Ten years later he returned to the Southwest where he "discovered" Taos and later persuaded other artists to settle there. In 1902 Sharp resigned from the Cincinnati Art Academy to paint full time among the Indian tribes of the West. Whenever possible he spent the summer at Taos, and in 1912 moved there permanently.

Shaw, Harriet McCreary Jackson (1865-1933)
B. Fayetteville, Arkansas, March 17. D. November 3. Lived: Denver, Colorado; Seattle, Washington. *AAA;* Mallett; *WWA; WWAA; WWWA.*

Shaw, Stephen William (1817-1900)
B. Windsor, Vermont, December 15. D. San Francisco, February 12. Lived: California. *AAA;* Fielding; Groce and Wallace; Mallett.

Shaw, Sydney Dale (1879-)
B. Walkley, England, August 16. Lived: New York; Pasadena, California. *AAA;* Fielding; Mallett; *WWA; WWAA.*

Shed, Charles D. (1818-1893)
Lived: California 1855-93. Oakland Art Museum.

Sheets, Nan (1889-)
B. Albany, Illinois, December 9. Lived: Oklahoma City, Oklahoma. *AAA;* Fielding; Mallett; *WWAA.*

Shepard, William E. (1866-1948)
B. Oneida, New York. Lived: Lincoln, Nebraska. George Nix Gallery, Colorado Springs, Colorado.

Sherman, John (1896-)
B. Brooklyn, New York, April 26. Lived: Omaha, Nebraska. Mallett; *WWAA.*

Shettle, William Martin (-1923)
B. England. Lived: Colorado Springs, Colorado. Ormes and Ormes.

Shindler, A. Zeno (c.1813-1899)
B. Germany. Lived: Philadelphia, Pennsylvania; Washington, D.C. Fielding; Groce and Wallace; Mallett.

Shirlaw, Walter (1838-1909)
B. Paisley, Scotland, August 6, 1838. D. Madrid, Spain, December 26, 1909. Lived: Chicago, Illinois; New York. Work: Century, Lotos, and Salmagundi Clubs, New York City. Fielding; Groce and Wallace; Mallett; Neuhaus 1931; Shirlaw; Taft.

Shirlaw came to this country from Scotland in 1852, and worked as a banknote engraver. Before leaving for seven years of art study in Munich, he is supposed to have spent six months on the Plains in 1869. His western illustrations came, however, from a government census assignment in 1890 during which he painted among the Crow and the Cheyenne Indians. Later he wrote and illustrated an article about a tragic incident which he witnessed while among the Cheyenne. It was published in the November 1893 issue of *The Century* and entitled "Artists' Adventures: The Rush to Death."

Shirlaw was well known for his genre paintings, murals, and portraits, and also for his teaching at the Art Students' League during its early days.

Shonnard, Eugenie Frederica (1886-)
B. Yonkers, New York. Lived: New York; Santa Fe, New Mexico. *AAA;* Fielding; Mallett; *WWAA.*

Shrader, Edwin Roscoe (1879-1960)
B. Quincy, Illinois, December 14. D. Los Angeles, California, January 20. Lived: Los Angeles; La Canada, California. *AAA;* Fielding; Mallett; *WWA; WWAA.*

Shuster, Will (1893-1969)
B. Philadelphia, Pennsylvania, November 26, 1893. D. Albuquerque, New Mexico, February 9, 1969. Lived: Santa Fe, New Mexico. Work: Museum of New Mexico, Santa Fe; Newark Museum, New Jersey; Brooklyn Museum, New York; New York Public Library. Coke; Fielding; Mallett; *WWAA.*

Shuster, who moved to Santa Fe in 1920, helped form *Los Cinco Pintores* and began exhibiting with that group the following year. He was primarily a realistic painter but occasionally did some abstract work such as his Indian series of 1922.

Shuster had the distinction of having designed "Zozobra" or "Old Man Gloom," the giant puppet that is burned at the outset of Santa Fe's annual Fiesta. His interest in Santa Fe was as acute as his interest in painting, and he remained there the rest of his life.

In 1924 Shuster made a sketching trip to Carlsbad Caverns. Upon his return he was moved to comment: "The cave has made a cubist, vorticist, and post-impressionist of me against my will."

Siegriest, Louis (1899-)
B. Oakland, California, February 24. Lived: Oakland and San Francisco. Mallett; *WWAA.*

Silva, William Posey (1859-1948)
B. Savannah, Georgia, October 23. D. February 10. Lived: Chattanooga, Tennessee; Washington, D.C.; Carmel, California. *AAA;* Fielding; Mallett; *WWA; WWAA; WWWA.*

Simons, George (1834-1917)
B. Streeter, Illinois, January 22, 1834. D. Long Beach, California, 1917. Lived: Council Bluffs, Iowa; Long Beach. Work: Council Bluffs Public Library. Bucklin; Federal Writers' Project, *Nebraska;* Groce and Wallace; Mallett.

From 1853 until moving to California sometime near the

turn of the century, Simons lived in Council Bluffs, Iowa, where he was active as an artist and photographer. Much of his work, however, consisted of eastern Nebraska scenes, principally steamboat landings, Mormon caravans, Indians, and trading posts.

In 1854 Simons was engaged by N. P. Dodge, brother of General Grenville Dodge, to do pencil sketches of scenes around Omaha and Council Bluffs. Among them were such historical items as "Pawnee Indian Village on the Platte River Opposite Fremont in 1854," "First Claim Cabin in Nebraska," and "The Ill-fated Handcart Expedition Leaving Florence, Nebraska, in 1856."

Simpson, William (1823-1899)
B. Glasgow, Scotland. D. London, England. In the West April-June 1873. Hogarth; William Simpson, *Meeting the Sun* (London, 1874; Boston, 1877).

Skeele, Anna Katherine (1896-)
B. Wellington, Ohio. Lived: Monrovia and Pasadena, California. *AAA;* Mallett; *WWAA.*

Skelton, Leslie James (1848-1929)
B. Montreal, Canada, April 27. D. Colorado Springs, Colorado, January 10. Lived: Colorado Springs. *AAA;* Fielding; Mallett; *WWA; WWWA.*

Skinner, Charlotte B. (1879-)
B. San Francisco, California. Lived: San Francisco. *AAA;* Mallett; *WWAA.*

Skinner, Mary Dart (1859-)
B. San Luis Obispo County, California. Lived: San Jose, California. Binheim.

Sloan, John (1871-1951)
B. Lock Haven, Pennsylvania, August 2. D. September 7. Lived: New York City; Santa Fe, New Mexico. *AAA;* Fielding; Mallett; *WWA; WWAA; WWWA.*

Smalley, Katherine (-)
B. Waverly, Iowa. Lived: Denver and Colorado Springs, Colorado. McClurg.

Smart, Emma (1862-1924)
B. Buffalo, New York. Lived: Utah. Springville [Utah] Museum of Art, *Permanent Collection Catalog.*

Smedley, William Thomas (1858-1920)
B. Chester County, Pennsylvania. D. Bronxville, New York, March 26. Lived: New York. *AAA;* Bénézit; Fielding; Mallett; *WWWA.*

Smet, Pierre-Jean (1801-1873)
B. Termonde, Belgium. Lived: Saint Louis and Florissant, Missouri; among the Indians along the Platte and Columbia Rivers. Groce and Wallace; *WWWA.*

Smillie, George Henry (1840-1921)
B. New York. D. Bronxville, New York, November 10. Lived: New York. *AAA;* Fielding; Groce and Wallace; Mallett; *WWWA.*

Smillie, James David (1833-1909)
B. New York City, January 16. D. New York City, September 14. Lived: New York City. *AAA;* Bénézit; Fielding; Groce and Wallace; Mallett; *WWWA.*

Smith, Dan (1865-1934)
B. Izigtut, Greenland, 1865. D. New York, December 10, 1934. Lived: New York. Mallett; Taft.

Smith came to this country from Greenland, and later studied art in Copenhagen, Denmark, and in Philadelphia. He joined the art staff of *Leslie's Illustrated Weekly* about 1890, and until 1897 did numerous western illustrations. A ranch near Albuquerque, New Mexico, which he visited on one or more occasions, provided a setting for his cowboy subjects; his Oklahoma, and perhaps his South Dakota, illustrations were redrawn from photographs.

For the last 20 years of his life Smith drew the covers for

the Sunday magazine section of the *New York World,* thereby becoming one of the best known of early twentieth century illustrators.

Smith, David H. (1844-1904)
B. Nauvoo, Illinois, November 18. D. Elgin, Illinois, August 27. Lived: Utah; Illinois. Groce and Wallace; *WWWA.*

Smith, De Cost (1864-1939)
B. Amenia, New York, 1864. D. December 7, 1939. Lived: Amenia, New York. Mallett; Taft.

Smith's interest in western Indians began in 1884 after seeing the work of George de Forest Brush. That year Smith spent the winter among the Sioux at Fort Yates and Standing Rock Agencies in Dakota Territory. Several years later he teamed up with E. W. Deming to sketch among the Indians and write articles about their experiences for *Outlook* magazine. "Sketching Among the Sioux" was published in October 1893, "Sketching Among the Crow Indians" in May 1894, and "With Gun and Palette Among the Red Skins" in February 1895. Smith also wrote a book about his sketching experiences, *Indian Experiences,* published posthumously in 1943.

Smith, Dorman Henry (1892-1956)
B. Steubenville, Ohio, February 10. D. March 1. Lived: Cleveland and Columbus, Ohio; Des Moines, Iowa; Chicago, Illinois; San Francisco, California; New York City. Mallett; *WWA; WWWA.*

Smith, F. Carl (1868-)
B. Cincinnati, Ohio, September 7. Lived: Pasadena and Laguna Beach, California. *AAA;* Fielding; Mallett; *WWA; WWAA.*

Smith, Francis Drexel (1874-)
B. Chicago, Illinois, June 11. Lived: Colorado Springs, Colorado. *AAA;* Fielding; Mallett; *WWAA.*

Smith, Francis Hopkinson (1838-1915)
B. Baltimore, Maryland, October 23. D. April 7. Lived: New York. *AAA;* Fielding; Groce and Wallace; Mallett; *WWWA.*

Smith, Gean (1851-1928)
B. New York. D. Galveston, Texas, about December 7. Lived: New York City; Galveston. *AAA;* Mallett.

Smith, Helen Stafford (1871-)
B. Saint Charles, Illinois. Lived: Southern California. Springville [Utah] Museum of Art, *Permanent Collection Catalog.*

Smith, Isabel E. (-1938)
B. Smith's Landing, Ohio. D. October 4. Lived: Pasadena, California. *AAA;* Fielding; Mallett; *WWA; WWAA; WWWA.*

Smith, J. H. (1861-1941)
B. Pleasant Valley, Illinois, 1861. D. Vancouver, B.C., c. March 8, 1941. Lived: Vancouver, B.C. Taft.

Smith began his western travels at 18. For a time he did illustrations for *Leslie's Weekly*—Montana scenes and events, including the apocalyptic Ghost Dance. With Charlie Russell he did a series in 1889 called "Ranch Life in the Northwest—Bronco Ponies and Their Uses—How They Are Trained and Broken." Like Russell, Smith was in a position to know, for he had grown up on a farm and had broken western horses.

After years of wandering all over the West, working at various odd jobs, Smith married a girl who was part Indian and settled in British Columbia where he painted with oils his earlier observations of western life.

Smith, Jack Wilkinson (1874-1949)
B. Paterson, New Jersey. Lived: Alhambra, California. *AAA;* Fielding; Mallett; *WWAA.*

Smith, Ralph Waldo (1877-)
B. Minnesota. Lived: Dickinson, North Dakota. Barr.

Smith, Russell (1812-1896)
B. Glasgow, Scotland, April 26. D. Glenside, Pennsylvania, November 8. Lived: Philadelphia and Weldon, Pennsylvania; Boston, Massachusetts; Baltimore, Maryland; Washington, D.C. Fielding; Groce and Wallace; Mallett; *WWWA.*

Smythe, William (1800-1877)
B. England. D. Turnbridge Wells, England, September 25. Lived: England; San Francisco and Monterey, California, 1826-27. Groce and Wallace; Webb.

Sohon, Gustavus (1825-1903)
B. Tilsit, Germany, December 10, 1825. D. Washington, D.C., September 3, 1903. Lived: briefly in San Francisco, California; Washington, D.C. Work: Washington State Historical Society, Tacoma; Smithsonian Institution, Washington, D.C. Ewers 1965; Groce and Wallace; Taft.

At age 17 Sohon migrated to this country from Germany. After 10 years in Brooklyn where he worked at bookbinding and wood carving, Sohon enlisted in the army and was sent to the West. With Lieutenant John Mullan he helped blaze the famous Mullan Road from Fort Benton across the Coeur d'Alene Mountains to Walla Walla. Sohon's natural aptitude for languages and drawing enabled him to learn difficult Indian languages and to record pictorially the treaty negotiations which he attended as interpreter. He also prepared maps, compiled meteorological data, and made illustrations for government reports (e.g., see *Pacific Railroad Reports*).

Sohon spent nine years in the Northwest, both as enlisted man and as civilian, in the latter capacity serving as guide and interpreter. Over a hundred of his sketches have been preserved, and his importance as an early western artist is becoming more generally known.

Sonnichsen, Yngvar (1875-)
B. Christiania, Norway, March 9. Lived: Seattle, Washington. *AAA;* Bénézit; Fielding; *WWA; WWAA; WWWA.*

Soutter, Louis J. (1871-1942)
B. Morges, Switzerland. D. Ballaigues, Switzerland. Lived: Colorado Springs, Colorado; Switzerland. Shalkop.

Spalding, Eliza Hart (1807-1851)
B. Berlin, Connecticut, August 11. D. Brownsville, Oregon, January 7. Lived: Oregon Territory. Groce and Wallace; Rasmussen (ms).

Sparks, Arthur Watson (1870-1919)
B. Washington, D.C. March 17. D. August 6. Lived: Pittsburgh, Pennsylvania. *AAA;* Fielding, Mallett; *WWWA.*

Sparks, Will (1862-1937)
B. Saint Louis, Missouri, February 7, 1862. D. San Francisco, California, March 30, 1937. Lived: Denver, Colorado; San Francisco. Work: Toledo Art Museum, Ohio; City Art Museum of Saint Louis. *CAR,* Vol. XI; Fielding; Mallett.
Sparks was a graduate physician who turned to art and writing. Before making California his home, he studied art in Paris, worked on an English-Italian publication, and did some anatomical drawing for Louis Pasteur. The closest he came to practicing medicine was patching up colleagues during his rough-and-tumble newspaper days in Fresno and Stockton in the late 1880s. Thereafter he lived in San Francisco. The old landmarks of the West interested Sparks most of all. He painted all the missions including two in Mexico. His work is in many museums and private collections, and he is one of San Francisco's nationally known artists.

Spencer, Robert (1879-1931)
B. Harvard, Nebraska, December 1. D. July 10. Lived: New Hope, Pennsylvania. *AAA;* Fielding; Mallett; *WWA; WWWA.*

Spens, Nathaniel (1838-1916)
B. Edinburgh, Scotland, June 21. D. Mountainville, Utah, November 25. Lived: American Fork and Mountainville, Utah. Haseltine.

Spivak, H. David (1893-1932)
B. Philadelphia, Pennsylvania. Lived: Denver, Colorado. *AAA;* Mallett.

Sprague, Isaac (1811-1895)
B. Hingham, Massachusetts, September 5. Lived: Cambridge and Grantville, Massachusetts. Groce and Wallace.

Sprague, Julia Frances (1826-1886)
B. Huron, Ohio. D. Tacoma, Washington. Lived: Tacoma. Washington State Historical Society, Tacoma.

Springer, Eva (1882-1964)
B. Cimarron, New Mexico. Lived: Washington, D.C.; Philadelphia, Pennsylvania. Fielding; Mallett; *WWAA*.

Squires, Harry (1850-1928)
B. Putney, Surrey, England, October 9. D. Salt Lake City, Utah. Lived: Salt Lake City. Haseltine.

Squires, Lawrence (1887-1928)
B. Salt Lake City, Utah, March 14. D. January 18. Lived: Utah; Arizona. *AAA;* Mallett.

Squires, Warren (1886-1938)
B. Fostoria, Ohio. D. Riverside, California. Lived: Idaho; California. Mallett; Riverside Public Library.

Stackpole, Ralph (1885-)
B. Williams, Oregon, May 1. Lived: San Francisco, California. *AAA;* Fielding; Mallett; *WWAA*.

Stanley, Charles St. George (-)
Lived: England; Colorado. Marturano.
 Stanley was an early but little-known artist who settled briefly in Denver in 1867, and did some sketching which received favorable coverage in the *Rocky Mountain News*. He returned to Colorado during the 1870s, illustrated life in Leadville for *Leslie's Weekly,* and painted landscapes for the Colorado Central Railroad.
 Stanley accompanied General George Crook in 1876 to sketch battles with the Sioux for both *Leslie's* and *Harper's Weekly*. In 1878 he opened a studio in Georgetown, and two years later in Leadville where he combined his art work with that of engineer. He was also a draftsman and writer.

No record of Stanley's birth and death can be found, but it is likely that he was born in England, for he studied art at the Royal Academy in London.

Stanley, John Mix (1814-1872)

B. Canandaigua, New York, January 17, 1814. D. Detroit, Michigan, April 10, 1872. Lived: Washington, D.C.; Buffalo, New York; Detroit, Michigan. Work: Detroit Institute of Arts; Phoenix Art Museum, Arizona; Smithsonian Institution, Washington, D.C.; Denver Public Library, Colorado; Amon Carter Museum, Fort Worth. Groce and Wallace; McCracken 1952; Richardson; Taft.

The largely self-taught Stanley began his western paintings in 1842 with the Indians of Oklahoma Territory. A few years later he traveled from Fort Leavenworth to California as official recorder for W. H. Emory's military reconnaissance, and in 1853 he joined Isaac I. Stevens' Survey of a northern railway route from St. Paul to the Northwest coast. Reproductions of his work are in the published reports of Emory and Stevens.

Indians were of foremost interest to Stanley, and in 1847 he went to Oregon specifically to paint portraits of the Northwestern Indians. Like Catlin, Stanley wanted his Indian collection in the Smithsonian where it could be preserved intact, and like Catlin he suffered disappointment and debt because Congress failed to appropriate the necessary funds.

Stansfield, John Heber (1878-1953)

B. Mount Pleasant, Utah, May 11, 1878. D. December 25, 1953. Lived: Mount Pleasant and Ephraim, Utah; summers: California coast. Work: North Cache Jr. High School, Richmond, Utah; Mrs. John H. Stansfield Collection. Haseltine.

Stansfield was a prolific but virtually unknown artist outside his native Utah. In early life he was a sheepherder. He took up art on a trial and error basis; his first works were charcoal drawings. He also watched James Harwood and Henry Culmer at work in their studios. Later in California Stansfield painted along the coast during summers and met the famous Thomas Moran, another influence on his work. Stansfield produced some 1,500 works of art and taught at Snow College in Ephraim, Utah.

Stanson, George C. (1885-)
B. France. Lived: Los Angeles, California. Fielding.

Stanton, John A. (1860-)
B. California. Lived: San Francisco, California until 1896; perhaps thereafter. Porter, et al.

Staples, Clayton Henri (1892-)
B. Osceola, Wisconsin, February 4. Lived: Wichita, Kansas. *AAA;* Mallett; *WWAA.*

Stark, Jack Gage (1882-1950)
B. Jackson County, Missouri. D. December 2. Lived: California; Silver City, New Mexico. Mallett; *WWAA.*

Stegall, Irma Matthews (1888-)
B. Llano, Texas, January 5. Lived: Texas; Montgomery, Alabama. Mallett; *WWAA.*

Stein, Aaron (1835-1900)
Lived: California. Oakland Art Museum; Society of California Pioneers, San Francisco.

Steinegger, Henry (c.1831-)
Lived: California 1854-80. Groce and Wallace; Society of California Pioneers, San Francisco.

Sterling, Dave (c.1887-1971)
D. Estes Park, Colorado; June 13. Lived: Estes Park. Denver Public Library.

Sterne, Maurice (1877-1957)
B. Libau, Russia, August 13. D. July 23. Lived: California; Santa Fe and Taos, New Mexico; Mount Kisco, New York. *AAA;* Fielding; Mallett; *WWA; WWAA; WWWA.*

Stevenson, Edna Bradley (1887-)
B. Hebron, Nebraska, February 8. Lived: Oklahoma City, Oklahoma. Mallett; *WWAA.*

Stewart, Le Conte (1891-)
B. Glenwood, Utah, April 15. Lived: Salt Lake City, Utah., Fielding; Mallett; *WWAA*.

Stieffel, Hermann (1826-1886)
D. December 14. Lived: in the Far West during military service, 1857-82. Groce and Wallace; Edgar M. Howell, "Hermann Stieffel, Soldier Artist of the West" (Washington, D.C., 1960).

Stobie, Charles S. (1845-1931)
B. Baltimore, Maryland, May 18, 1845. D. Chicago, Illinois, August 17, 1931. Lived: Denver and Grand Lake, Colorado; Chicago. Work: State Historical Society of Colorado, Denver; Ute Indian Museum, Montrose, Colorado. Marturano; Stobie 1930, 1933.

Stobie crossed the Plains by wagon train in 1865. The following year he was with the Utes, even participating in their warfare with the Arapahoe and Cheyenne. Among the Utes he was called *Paghaghet* or "Long Hair." A year or so later he became a scout; his colleagues called him "Mountain Charlie."

Stobie was also a buffalo hunter and an artist. In the latter capacity he painted portraits of famous Indian chiefs, Indian camps and fighting scenes, and cowboy scenes. Several years before his death in Chicago, the Colorado State Historical Society received his collection of 32 oil paintings, various Indian garments and accessories, and his scouting equipment. Many of these items are still on exhibit at the State Museum in Denver.

Stockfleth, Julius (1857-)
B. Germany. Lived: Galveston, Texas. Pinckney.

Stonier, Lucille Holderness (1886-)
B. Uvalde, Texas, April 24. Lived: Asheville, North Carolina. Collins; *WWAA*.

Stoll, John Theodor Edward (1889-)
B. Goettingen, Hanover, Germany, September 29. Lived: San Francisco, California. Mallett; *WWAA*.

Stoops, Herbert Morton (1888-1948)

D. May 19. Lived: Idaho; Utah; San Francisco, California; Chicago, Illinois; New York. Mallett; *WWAA.*

Storm, Alfrida Anna (1896-)

B. Sweden. Lived: Seattle, Washington; Greeley, Colorado; New York City. *AAA;* Mallett.

Story, Julian (1857-1919)

B. Walton-on-Thames, England. D. February 24. Lived: Philadelphia, Pennsylvania. *AAA;* Bénézit; Fielding; Mallett; *WWWA.*

Strang, Ray (1893-1954)

B. Sandoval, Illinois, 1893. D. Tucson, Arizona, 1954. Lived: New York; Tucson, Arizona. Work: Private collections in Tucson. Carlson 1942; Mallett; Mayer.

In the mid-1930s, after 17 years as an illustrator, Strang moved to Tucson to recover his health. After turning a bunkhouse into a studio by putting in a skylight, he settled down to paint the prospectors and ranchers of the back country. His paintings told a story of patient, courageous, rugged individuals who lived lonely lives of hard work and privation.

Although Strang is not well known outside of Tucson, his paintings command high prices. He was especially adept at depicting the ranch horse. "You can smell the dust and sweat and hear the leather creak," commented one ranch hand to another as they gazed at a saddled horse in one of Strang's paintings on exhibit at a state fair.

Strater, Henry (1896-)

B. Louisville, Kentucky, January 21. Lived: New York; Ogunquit, Maine. Mallett; *WWAA.*

Straus, Meyer (1831-1905)

B. Bavaria, Germany. D. California. Lived: California 1874-1905. Oakland Art Museum.

Strobel, Oscar (1891-1967)

B. Cincinnati, Ohio, May 9. Lived: Scottsdale, Arizona; Hollywood, California. *AAA;* Mallett; *WWAA.*

Strong, Elizabeth (1855-1941)
B. Hartford, Connecticut, February 2. Lived: Carmel, California. *AAA;* Mallett; *WWAA.*

Strong, Joseph Dwight, Jr. (1852-1900)
B. Bridgeport, Connecticut. D. San Francisco, California, April 4. Lived: San Francisco. *AAA;* Mallett; Oakland Art Museum.

Struck, Herman (1887-1954)
Lived: Mill Valley, California. Mallett; *WWAA.*

Stuart, Frederick D. (c.1816-)
B. New York. Lived: New York; Washington, D.C. Groce and Wallace.

Stuart, James E. (1852-1941)
B. Dover, Maine, 1852. D. San Francisco, 1941. Lived: Ashland and Portland, Oregon; New York; Chicago; San Francisco. Work: Oakland Art Museum; Kalamazoo Art Association, Michigan; Los Angeles Museum of History, Science, and Art. Febraché; Fielding; Mallett; Stenzel and Stenzel 1963; *WWAA.*

Stuart was brought to California by his parents in 1860. After receiving some art training in Sacramento, he studied with Virgil Williams and Raymond Yelland in San Francisco. In 1881 Stuart began his sketching and studio painting, traveling throughout the United States and parts of Mexico and Alaska. In 1912 he returned to California.

Stuart was the grandson of Gilbert Stuart. At the turn of the century he was almost as well known, having achieved international recognition for his landscapes of the West Coast and New England. His work is in the White House and in many public and private collections. He is also known for inventing a process of painting on aluminum which he considered indestructible, but his critics deny its validity.

Sturges, Lee (1865-)
B. Chicago, Illinois. Lived: Melrose Park and Elmhurst, Illinois. *AAA;* Fielding; Mallett; *WWA; WWAA.*

Sully, Alfred (1820-1879)

B. Philadelphia, May 22, 1820. D. Washington, D.C., April 27, 1879. Lived: Monterey, California; Washington, D.C. Work: Oakland Art Museum, California. Fielding; Groce and Wallace; McCracken 1952.

Alfred Sully, son of Thomas Sully the famous painter, was a West Point graduate whose distinguished military career is now less important than his water colors of the West where he served so many years. In 1846 Sully was sent to the Rio Grande, and the following year to California where he was quartermaster at Monterey for four years. Thereafter he served for some time in campaigns against the Indians of the Northwest. He painted his observations and experiences, usually in water color, and made a reputation as an amateur artist. His work is now highly prized by museums and collectors and has considerable historical importance in addition to its aesthetic appeal.

Suydam, Edward Howard (1885-1940)

B. Vineland, New Jersey, February 22. D. Charlottesville, Virginia, December 23. Lived: Boston, Massachusetts; Charlottesville. *AAA;* Fielding; Mallett; *WWAA.*

Swain, Francis W. (1892-)

B. Oakland, California. Lived: San Francisco, California; Cincinnati, Ohio. *AAA;* Fielding; Mallett.

Swan, James G. (1818-1900)

B. Medford, Massachusetts. D. Port Townsend, Washington. Lived: Washington. Washington State Historical Society, Tacoma.

Swan, Walter Buckingham (1871-)

B. Boston, Massachusetts, July 13. Lived: Omaha, Nebraska. Mallett; *WWAA.*

Swasey, William F. (-)

B. Bath, Maine. Lived: California. Groce and Wallace.

Sweeney, Dan (1880-1958)

B. Sacramento, California. Lived: San Francisco Bay Area; New York. Mallett; Reed 1966.

Swing, David Carrick (1864-1945)

B. Cincinnati, Ohio, September 26, 1864. D. Phoenix, Arizona, June 1, 1945. Lived: Pasadena, California; Phoenix. Work: Phoenix Public Library. *NCAB,* Vol. 34.

Swing, who was both artist and musician, spent most of his adult life in the Southwest. From 1905 to 1914 he was president of the Los Angeles Engraving Company. He had an art studio in Pasadena, and in addition played trumpet in the Pasadena Municipal Band. In 1917 Swing moved to Arizona where he played violin and cello in the Phoenix Symphony and taught art at Phoenix Junior College. During his career as artist he painted 14 murals of Arizona and New Mexico landmarks for the Golden Gate International Exposition in San Francisco, and several murals for the Masonic Temple in Phoenix. He also did a number of large canvases which are distinctive for their subtle coloring of the Arizona desert.

Swinnerton, James Guilford (1875-)

B. Eureka, California, November 13, 1875. Lived: New York; Palm Springs and Palo Alto, California. Work: Read Mullan Gallery of Western Art, Phoenix, Arizona. Ainsworth 1960; Carlson 1951; Fielding; Mallett.

Swinnerton the cartoonist went to Palm Springs in 1903, very ill with tuberculosis. Desert climate restored his health and desert beauty inspired him to become a landscape painter. After years of effort his paintings became as well known as his cartoons. In addition to many California desert scenes, Swinnerton painted remote places in southern Utah, northern Arizona, and New Mexico, where he made friends among the traders and the Indians. His paintings of that region are among his best. From his association with the natives came "Canyon Kiddies"; with that cartoon Swinnerton tried to correct some of the misconceptions people have about Indians.

Sykes, John (1773-1858)

B. England. In the Far West 1790-95. Groce and Wallace.

Symons, George Gardner (1865-1930)

B. Chicago, Illinois. D. Hillside, New Jersey, January 12. Lived: New York City. *AAA;* Fielding; Mallett; *WWA; WWWA.*

T

Tabor, Robert Byron (1882-)
B. Independence, Iowa, February 12. Lived: Olanthe, Kansas. Mallett; *WWAA*.

Tallant, Richard D. (1853-1934)
B. Zanesville, Ohio, 1853. D. Estes Park, Colorado, c. February 14, 1934. Lived: Denver and Estes Park. Work: Denver Public Library; Denver Art Museum; Estes Park Public Library, Colorado.

Tallant lived and painted in Estes Park, Colorado, since the turn of the century. His numerous and delightful water colors of the surrounding mountain peaks testify to his preference for that subject. Some of those paintings can be seen there today, hanging on the walls of business establishments and public buildings. Of more interest, historically, are Tallant's genre paintings: the Pueblo Indians of New Mexico whom he sketched in 1887 while visiting Santa Fe, his Cripple Creek fire painting of 1896, and his landscapes of central and southern Colorado mountain ranges as he viewed them at the turn of the century.

Tappan, William Henry (1821-1907)
B. Manchester, Massachusetts, October 30, 1821. D. Manchester, January 22, 1907. Lived: Clark County, Washington; Manchester. Work: Wisconsin Historical Society, Madison. Fielding; Groce and Wallace; Rasmussen 1942; Taft; *Wisconsin Magazine of History*, September 1928.

Tappan was a topographical artist and an engraver from Manchester, Massachusetts, who settled in Clark County, Washington, and served on the first Territorial Council. In 1876 he returned to Massachusetts, wrote a history of Manchester, and served in the legislature and the senate.

Fifty drawings of Tappan's overland trip to Oregon in 1849 are owned by the Wisconsin Historical Society, and several reproductions can be found in the Joseph Shaefer edition of *California Letters of Lucius Fairchild*.

228

Tavernier, Jules (1844-1889)

B. Paris, France, April 1844. D. Honolulu, Hawaii, May 18, 1889. Lived: Monterey and San Francisco, California; Honolulu. Work: California Historical Society, San Francisco; The Bohemian Club, San Francisco; Wichita Public Museum, Wichita, Kansas. *CAR*, Vol. IV; Mallett; Taft.

Tavernier began his western work in 1873 when, with Paul Frenzeny, he was commissioned by *Harper's Weekly* to report pictorially their observations as they crossed the country. Upon reaching California, Tavernier and Frenzeny joined the art colony in San Francisco and soon were invited to become members of the Bohemian Club.

Tavernier was to become one of California's best-known artists. However, his addiction to drink and aversion to work left him little choice but to flee his creditors. This he accomplished in 1884 by going to Hawaii where he died five years later of alcoholism. His excellent work occasionally appears in San Francisco Bay area galleries and private collections.

Taylor, Bayard (1825-1878)

B. Kenneth Square, Pennsylvania. D. Berlin, Germany, December 19. Lived: Pennsylvania; Europe; Washington, D.C. Groce and Wallace; Taft; *WWWA*.

Taylor, Frederick T. (c.1840-1927)

B. Virginia. D. Steilacoom, Washington. Lived: Washington. Washington State Historical Society, Tacoma.

Taylor, James Earl (1839-1901)

B. Cincinnati, Ohio, December 12, 1839. D. New York City, June 22, 1901. Lived: New York. Groce and Wallace; Mallett; Taft.

Little is known about this precocious artist who graduated from the University of Notre Dame at age 16 and painted a panorama of the Revolutionary War two years later. In 1863 he became an artist and war correspondent for *Leslie's Illustrated Weekly*. Taylor's first trip West may have been in 1867 when he attended the Medicine Lodge treaty negotiations with the Plains Indians which he illustrated for *Leslie's*. He is supposed to have made many other trips to the Great Plains to depict Indian and

frontier life, and has been referred to as "the Indian artist." In 1883 Taylor left *Leslie's* to become a free-lance illustrator and water colorist.

Teague, Donald (1897-)
B. Brooklyn, New York. Lived: New Rochelle, New York; Carmel, California. *AAA;* Mallett; *WWA; WWAA.*

Teasdale, Mary (1863-1937)
B. Salt Lake City, November 6, 1863. D. Los Angeles, California, April 11, 1937. Lived: Salt Lake City, Utah. Work: University of Utah, Salt Lake City; Carnegie Public Library, Smithfield, Utah. Fielding; Haseltine; Horne; Mallett.

Mary Teasdale had the distinction of being Utah's first artist to have work exhibited at the International French Exposition and Utah's second artist to have work in the Paris Salon.

Although Miss Teasdale grew up with the desire to be an artist, it was not until her merchant father lost his business that she was able to leave home and study art seriously. She went first to New York, and then to Paris where she studied under several famous teachers, including Whistler, her favorite. When Miss Teasdale returned to Utah, she was appointed to the governing board of the Art Institute in Salt Lake City. By 1908 her impressionist landscapes, primarily of Utah scenes, began to win prizes and to bring recognition.

Teichmueller, Minette T. (1872-)
B. La Grange, Texas, January 26. Lived: San Antonio, Texas. Mallett; *WWAA.*

Thayer, Emma Homan (1842-1908)
B. New York, February 13. Lived: Denver, Colorado. *WWA; WWWA.*

Thomas, Stephen Seymour (1868-1956)
B. San Augustine, Texas, August 20. D. February 29. Lived: Los Angeles and La Crescenta, California. *AAA;* Bénézit; Fielding; Mallett; *WWA; WWAA; WWWA.*

Thomason, John William, Jr. (1893-1944)
B. Walker County, Texas, February 28. D. March 12.
Lived: Washington, D.C. Mallett; *WWA.*

Thompson, John Edward (1882-1945)
B. Buffalo, New York, January 3. D. May 23. Lived: Denver, Colorado. Fielding; Mallett; *WWAA.*

Tibbles, Yosette La Flesche (1854-1903)
B. Bellevue, Nebraska, 1854. D. Lincoln, Nebraska, May 27, 1903. Lived: Lincoln and Bancroft, Nebraska. Bucklin; Federal Writers' Project, *Nebraska.*

Yosette La Flesche Tibbles has been called the "only artist of any consequence during the early years" of Nebraska's statehood. She was of the Omaha Tribe, born at Bellevue just south of Omaha. Her Indian name was *Insthatheamba,* meaning "Bright Eyes." At age 15, Miss La Flesche was sent by an eastern woman to a college in Elizabeth, New Jersey. Following her education she taught school and served as interpreter to the Ponca Indians. In the latter capacity she met Thomas H. Tibbles, a newspaperman, whom she married in 1882.

For many years, on behalf of the Indians, Mrs. Tibbles lectured in this country and abroad where she is said to have been welcomed by royalty and people of culture wherever she spoke. Her art study was done at the University of Nebraska. She did many paintings and some illustration work.

Tidball, John Caldwell (1825-1906)
B. Ohio County, West Virginia, January 25, 1825. D. May 15, 1906. Lived: Western U.S. and Alaska. Work: Oklahoma Historical Society, Oklahoma City. Groce and Wallace; Taft; *Newark Evening News* (N.J.), May 16, 1906.

Tidball was a topographical artist from West Point who accompanied A. W. Whipple's survey of the 35th parallel for the War Department. Also in the party which left Fort Smith, Arkansas, in 1853 was the German artist and writer Heinrich Möllhausen. In crediting the two artists in the various printings of Whipple's report there is some confusion over which artist did the illustration; Tidball's sketches are superior to Möllhausen's. Among Tidball's scenes were campsites in the "Valley of Bill

Williams' Fork" in the present state of Arizona, and "Valley of the Mojave" in California, both done in 1854 (see *Pacific Railroad Reports,* Vol. III). There is some confusion over Tidball's name itself; he is also referred to as Joseph Tidball and as J. S. Tidball.

Tindall, N. (-)
B. England. Visited the West 1874 (Utah, Kansas, etc). Hogarth.

Todhunter, Francis (1884-1962)
B. San Francisco, California, July 29. D. San Francisco. Lived: San Francisco and Mill Valley, California. Mallett; *WWAA.*

Tofft, Peter (1825-1901)
B. Kolding, Denmark, 1825. D. London, England, 1901. Lived: San Francisco; Denmark; London. Work: Oakland Art Museum and Robert B. Honeyman, Jr. Collection, Southern California. Mallett; Mills; Taft.
Tofft, a native of Denmark, panned gold along the Trinity River in Northern California during the early days of the Gold Rush. He was serious about his art and well known in San Francisco's art circles but doubtful about his ability. "I sketch, my friends say, with considerable power ... but I commenced too late in life to acquire the knowledge necessary for a finished picture."
In 1866 Tofft accompanied Colonel Cornelius O'Keefe across the Northwest and illustrated O'Keefe's "Riders Through Montana," published the following year by *Harper's Magazine.* In 1868 Tofft returned to Europe. During his stay in this country he used several spellings for his name: Toffts, Toft, Tufts.

Tojetti, Domenico (-)
Lived: California 1871-92. Oakland Art Museum.

Tojetti, Eduardo (1852-1930)
B. Rome, Italy. D. San Francisco, California. Lived: San Francisco. *AAA;* Mallett.

Tompkins, Florence W. (1883-)

B. Washington, D.C. Lived: Pasadena, California. Collins; Mallett.

Tonk, Ernest (1889-)

B. Evanston, Illinois, November 24, 1889. Lived: Cashmere, Washington; Glendale and Garden Grove, California. Work: The Willis Carey Historical Museum, Cashmere, Washington. Ainsworth 1968.

Tonk's drawings at age 19 so impressed Buffalo Bill Cody that he urged him to go west while there was yet time to portray frontier life. Tonk took his advice, and to support himself worked at various wrangling and logging jobs. When he settled down on a fruit ranch near Cashmere, Washington, it was with the idea of devoting full time to painting when the busy season was over. Tonk's work progressed rapidly and earned him sufficient recognition to attract an offer to paint action scenes at Universal Pictures and later on at Metro-Goldwyn-Mayer. Tonk did not abandon easel painting, however, and returned frequently to Cashmere for subject matter. He also wrote and illustrated a book on how to draw.

Torrey, Elliot Bouton (1867-1949)

B. East Hardwick, Vermont, January 7. D. March 9. Lived: Boston, Massachusetts; New York City; San Diego, California. *AAA;* Fielding; Mallett; *WWA; WWAA; WWWA.*

Tracey, John M. (1844-)

B. Rochester, Ohio. Lived: California 1870-73; and possibly later. Mallett; Oakland Art Museum.

Travis, Olin Herman (1888-)

B. Dallas, Texas. Lived: Dallas. *AAA;* Fielding; Mallett; *WWAA.*

Trobriand, Philippe Régis de (1816-1897)

B. Tours, France, June 4, 1816. D. Bayport, Long Island, New York, July 15, 1897. Lived: New Orleans and New York. Work: Waldron Kintzing Post Collection, New York City. Robinson; Ruth; Trobriand.

Philippe Régis Denis de Keredern de Trobriand came to the United States from France in 1841, married a New York woman in Paris several years later, and officially adopted this country when he enlisted in the Civil War in 1861. A colonel in the regular army in 1867, he was assigned to Fort Stevenson in Dakota Territory. His famous illustrated diary, *Vie militaire dans le Dakota: notes et souvenirs (1867-1869)*—for he was a writer of note as well as an artist—covered two years of experiences at that post. In 1869 Trobriand was transferred to Fort Shaw in Montana Territory, in 1871 to Utah Territory, and later that year to Fort Steele in Wyoming Territory where he remained through much of 1872. His pencil sketches and oil paintings included forts, ranches, canyons, the Missouri and the Sun rivers, and Indian portraits, lodges, and paraphernalia.

Trotter, Newbold Hough (1827-1898)
B. Philadelphia. D. Atlantic City, New Jersey, February 21. Lived: Philadelphia, Pennsylvania. *AAA;* Fielding; Groce and Wallace; Mallett; *WWWA.*

Truax, Sarah E. (-)
B. Marble Rock, Iowa. Lived: San Diego, California. *AAA;* Mallett; *WWAA.*

True, Allen Tupper (1881-1955)
B. Colorado Springs, Colorado, May 30, 1881. D. Denver, Colorado, November 8, 1955. Lived: Denver, Littleton, and Silt, Colorado. Work: Colorado State Capitol, Denver; Wyoming State Capitol, Cheyenne; Denver Public Library. Fielding; Hafen 1948, Vol. II; McClurg; Mallett.

In Colorado where True was born there is ample evidence of his lifetime residence. Many commercial and public buildings contain his western murals and paintings, and his illustrations for magazines frequently depict the Colorado scene. Two motifs that True used more than others are the Indian and the trapper, both with sympathy and understanding. An especially popular work is his "Indian Memories," a series painted for the Colorado National Bank in Denver, emphasizing the beauty and mysticism of Indian culture. True also worked for the Bureau of Reclamation as color consultant. Among his assignments were Shasta, Grand Coulee, and Hoover dams.

234

Truesdell, Edith Park (1888-)
B. Derby, Connecticut. Lived: Los Angeles, California; Brookvale, Colorado. *AAA;* Mallett; *WWAA.*

Truitt, Una B. (1896-)
B. Joaquin, Texas. Lived: Houston, Texas, Mallett; *WWAA.*

Tucker, Alan (1866-1939)
B. Brooklyn, New York. Lived: New York. *AAA;* Fielding; Mallett.

Tuckerman, Lilia (1882-)
B. Minneapolis, Minnesota. Lived: Carpenteria, California. *AAA;* Mallett; *WWAA.*

Tullidge, John (1836-1899)
B. Weymouth, England, April 17, 1836. D. June 20, 1899. Lived: Salt Lake City, Utah. Work: University of Utah, Salt Lake City; Springville Art Museum, Springville, Utah. Federal Writers' Project, *Utah;* Haseltine; Horne.

Tullidge, Ottinger, and Weggeland were the three artists brought to Utah to paint scenery for the Salt Lake Theater. In 1863 they established the Deseret Academy of Fine Arts. Before that pioneer institution closed 10 months later for want of paying pupils, Tullidge taught landscape and figure painting, sketching, and perspective. Tullidge, who painted in the Dusseldorf style, had not studied art outside of England where he was born. His reputation as a landscape artist was largely confined to Utah where he spent most of his adult life. Like Ottinger and Weggeland, Tullidge also painted murals for the ceremonial chambers of the Mormon church.

Turner, Elmer (1890-1966)
Lived: New York. Mallett; Harwood Foundation Library, Taos, New Mexico.

U

Ufer, Walter (1876-1936)

B. Louisville, Kentucky, 1876. D. Albuquerque, New Mexico, 1936. Lived: Chicago, Illinois; Taos, New Mexico. Work: Art Institute of Chicago; Los Angeles County Museum; Arizona State University, Tempe; University of Notre Dame, South Bend, Indiana. Coke; Fielding; Mallett; Richardson.

Ufer received his early training as a lithographer's apprentice, and then he worked for a time as a printer and a draftsman. His desire to be a painter prompted him to study art in Europe. Upon his return he went to Chicago where he did portrait and commercial art work. In 1914 he went to Taos, New Mexico. Ufer's work changed considerably in Taos. In Chicago he posed his models in his studio; in Taos he posed them at the scene. "Studio work dulls the mind and the artist's palette," he contended. Also, he found at Taos the inspiration he needed to give originality to his work.

Utley, Tabor (1891-)

B. Tuscaloosa, Alabama, February 23. Lived: Denver and Colorado Springs, Colorado. Mallett; Denver Public Library.

V

Valencia, Manuel (1856-1935)

B. California. D. Sacramento, California, July 6. Lived: San Francisco, San Jose, and Sacramento. Mallett; *WWAA*.

Van Briggle, Artus (1869-1904)

B. Felicity, Ohio. D. Colorado Springs, Colorado. Lived: Colorado Springs. Shalkop.

Van Cleve, Helen (1891-)

B. Milwaukee, Wisconsin. Lived: Berkeley and Pacific Palisades, California. Mallett; *WWAA.*

Van Ryder, Jack (1898-1968)

B. near Tucson, Arizona, 1898. D. 1968. Lived: Tucson and Elgin, Arizona; Hollywood, California. Work: Arizona Historical Society, Tucson. Mallett; Arizona Historical Society.

Van Ryder was a native Arizonian who ran away from home at age 11 and got a job on a Nevada ranch. In 1926 while looking for another line of work he was hired by the old Mack Sennett studio in Hollywood. There a huge relief map of California was in progress which Van Ryder finished. The map is now familiar to thousands, because it hung for many years in the San Francisco Ferry building. While painting the map it occurred to Van Ryder to take up art. Thereafter he did many Western scenes portraying Indians, horses, and cowboys. He is best known in Tucson where his dry-point etchings and oil paintings are frequently seen. He is also known there as a rancher and a writer.

Van Sloun, Frank (1879-1938)

B. Saint Paul, Minnesota, November 4. Lived: San Francisco, California. *AAA;* Fielding; Mallett.

Van Soelen, Theodore (1890-1964)

B. Saint Paul, Minnesota, February 15, 1890. D. Santa Fe, New Mexico, May 14, 1964. Lived: Albuquerque, Santa Fe, and Tesuque, New Mexico. Work: Pennsylvania Academy of Fine Arts, Philadelphia; Everhart Museum, Scranton, Pennsylvania; Museum of New Mexico, Santa Fe; Library of Congress, Washington, D.C.; IBM Collection, New York. Ainsworth 1968; Coke; Fielding; Mallett; *WWAA;* "Van Soelen's New Mexico Pleases," *Art Digest,* January 1936.

After living briefly in Utah and Nevada where he had gone for his health, Van Soelen moved permanently to New Mexico in 1916. For a few years he lived in Albuquerque where he did commercial illustrations and some paintings for exhibition and sale.

Van Soelen was primarily interested in depicting the Indian culture and the ranching activities of the Southwest, and he believed in living with his subjects. During 1920 and 1921 he stayed

at an Indian trading post in San Ysidro, New Mexico. When he worked on cowboy subjects he went to Texas and stayed at a ranch. When he painted the Spanish-Americans he lived among them first in Santa Fe and then in nearby Tesuque where he made his home from 1926 to 1964.

Van Veen, Pieter (1875-)
B. The Hague, Holland, October 11. Lived: New York; Belgium. *AAA;* Fielding; Mallett; *WWAA.*

Van Vleck, Durbin (-)
Lived: California 1852-84 principally in San Francisco. Groce and Wallace.

Varian, Lester E. (1881-1967)
B. Denver, Colorado. D. Denver. Lived: Denver. *AAA;* Mallett; *WWAA.*

Vaudricourt, Augustus (-)
Lived: New Orleans, Louisiana; Boston, Massachusetts; New York City; Texas 1850-51. Groce and Wallace; Taft.

Vavra, Frank J. (1898-1967)
B. Saint Paul, Nebraska, March 19. Lived: Bailey, Colorado. Mallett; *WWAA.*

Vierra, Carlos (1876-1937)
B. near Monterey, California, 1876. D. 1937. Lived: New York; Santa Fe, New Mexico. Work: Museum of New Mexico, Santa Fe. Coke; James 1920; Mallett.
Vierra was an ex-seaman from California who settled in Santa Fe in 1904 and became its first resident artist. There he became interested in Mission and Indian architecture and led the movement to acquaint the public with its merit and to perpetuate its use. Using the Santa Fe Art Museum as an example of such architecture, Vierra wrote: "No matter which way one looks, or from what vantage point, there is a different architectural composition, a new charm, a different pattern and design, in which sunlight and ever-moving shadows have a determining part." Undoubtedly Vierra and his group of artists deserve much credit

for the beautiful adobe structures built during this century, but today he is best remembered for his architectural paintings of the old missions and the adobe dwellings of the Indians.

Villa, Hernando G. (1881-1952)
B. Los Angeles, California. Lived: Los Angeles. Mallett.

Villiers, Frederick (1852-1922)
B. London, England. D. Bedhampton, Hampshire, England. Visits to the West 1880, 1890s, and after World War I. Hogarth.

Viojet, Jean Jacques (1799-1855)
B. Switzerland. D. San Jose, California. Lived: San Francisco and San Jose. Groce and Wallace; Oakland Art Museum.

Visher, Edward (1809-1879)
B. Bavaria, April 6, 1809. D. 1879. Lived: San Francisco, California. Groce and Wallace; Peters.

Visher moved to California during the Gold Rush after 14 years in Mexico where he had served for a time as American consul at Acapulco. In San Francisco he became a merchant, sketched in his spare time, and ultimately established a reputation as a landscape painter. Following a trip in 1861 to California's Calaveras Big Trees area, Visher lithographed and published a series of sketches he had made there. About the same time he published a series of the Washoe Mining District for which he also supplied the text. Visher's major venture, however, was the publication in 1870 of *Pictorial California*, which contains 150 views with text and historical notes of California as he saw it in the 1860s.

Vitousek, Juanita Judy (1892-)
B. Portland, Oregon, May 22. Lived: California; Honolulu, Hawaii. Mallett; *WWAA.*

Vollmer, Grace Libby (1889-)
B. Massachusetts. D. Laguna Beach, California, before 1947. Lived: Laguna Beach. *AAA;* Mallett; *WWAA.*

239

Von Perbandt, Carl (-1905)
B. Prussia. D. Germany. Lived: California 1877-1903. Oakland Art Museum; Society of California Pioneers, San Francisco.

Von Schmidt, Harold (1893-)
B. Alameda, California, May 19, 1893. Lived: San Francisco, California; Westport, Connecticut. Work: California State Capitol, Sacramento; Montana Historical Society, Helena; U.S. Military Academy, West Point, New York; National Cowboy Hall of Fame, Oklahoma City. Ainsworth 1968; Mallett; Reed 1966, 1972; WWAA.

Von Schmidt learned about the West from his grandfather, a Forty-niner, and later from his own experiences as cowhand, lumberjack, and construction worker. Inspired by the paintings of Remington and Russell, von Schmidt studied art at Oakland and San Francisco with a view to following in their footsteps. After teaching painting for a time at the San Francisco Art Institute, von Schmidt went to New York to study with Harvey Dunn, the well-known illustrator and teacher. He has since done many western subjects, both for popular magazines and private sale. At the Governor's office in Sacramento are 12 von Schmidt paintings depicting the Gold Rush of 1849.

W

Wachtel, Elmer (1864-1929)
B. Baltimore, Maryland, 1864. D. Guadalahara, Mexico, August 31, 1929. Lived: Los Angeles, California. Work: Hubbell Trading Post Museum, Ganado, Arizona. Fielding; Mallett; Porter.

One of the earlier landscape artists in Southern California was Elmer Wachtel who moved there about 1883. He was largely self-taught, having found it difficult to endure art school instruc-

tion. After working with water colors for about two decades, he turned to oils. If any one time of day was painted by Wachtel with greater understanding and technical ability than another, it was the late afternoon. His light and shadow treatment of southwestern desert and mountain country is said to have made him a best seller in Los Angeles. He was no less successful with his paintings of Hopi country and, in later years, his High Sierra scenes.

Wachtel, Marion Kavanaugh (1875-)

B. Milwaukee, Wisconsin, 1875. Lived: Los Angeles and Pasadena, California. Work: Hubbell Trading Post Museum, Ganado, Arizona. Binheim; Fielding; Mallett; Porter; *WWAA*.

Mrs. Wachtel had been a successful figure and portrait painter prior to moving from Milwaukee to Southern California in the early 1900s. Her later reputation as an outstanding landscape artist was based on her water colors of the mountains and canyons of that colorful region. With her artist husband she sketched in the nearby desert-mountain area, the snow-capped Sierras, and the land of the Hopi.

Mrs. Wachtel is said to have painted the Southern California landscape in all its moods and in all seasons. She exhibited regularly with the New York Water Color Club, and her paintings were popular in San Francisco, Chicago, and New York, as well as in the Los Angeles area.

Wadsworth, W. (-)

Lived: San Francisco, California 1858-60. Groce and Wallace; San Francisco City Directories.

Wagner, Robert Leicester [Rob] (1872-1942)

B. Detroit, Michigan, August 2. D. July 20. Lived: Detroit; Beverly Hills, California. *AAA;* Fielding; Mallett; *WWA; WWAA; WWWA.*

Waldo, Eugene Loren (1870-)

B. New York. Lived: Ponca City, Oklahoma. *AAA;* Mallett.

Walker, James (1819-1889)

B. England, June 3, 1819. D. Watsonville, California. Au-

gust 29, 1889. Lived: New York; Los Angeles area and Watsonville, California. Work: Denver Art Museum; California Historical Society, San Francisco; California Historical Society, San Marino. Ainsworth 1968; Fielding; Groce and Wallace; Mallett.

Walker had a most varied career from the time he was a fugitive in Mexico during the War of 1846 until his death in Watsonville, California. Following Walker's return to New York City after years of travel in Mexico and South America, his work reflected a particular interest in historical battles. Following his move to California in 1884, it reflected his interest in the remains of the earlier Mexican culture, especially in the San Fernando Valley: cattle scenes, grizzly bear and wild horse hunts, and Spanish dons who presided over their disintegrating rancheros. No other artist has captured so much of California's romantic Mexican era.

Walker, William A. (1838-1921)
B. Charleston, South Carolina. Lived: Galveston, Texas 1876; Louisiana; Florida. Groce and Wallace; Mallett; Pinckney.

Wallace, Lewis [Lew] (1827-1905)
B. Brookville, Indiana, April 10. D. Crawfordsville, Indiana, February 15. Lived: Indiana; Santa Fe, New Mexico (governor 1878-81); Turkey. Paul Horgan, *The Centuries of Santa Fe.*

Walters, Emile (1893-)
B. Winnipeg, Canada, January 30. Lived: Grand Forks, North Dakota; New York City. *AAA;* Fielding; Mallett; *WWA; WWAA.*

Walton, Henry (1820-1873)
B. England. D. San Francisco, California. Lived: Ithaca, New York; California. Groce and Wallace; Society of California Pioneers, San Francisco.

Wandersforde, Ivan Buckingham (1817-1872)
B. England. Lived: San Francisco, California. Barker; Oakland Art Museum.

242

Wanker, Maude Walling (1882-)

B. Oswego, Oregon, October 22, 1882. Lived: Portland and Wecoma Beach, Oregon. Federal Writers' Project, *Oregon;* Mallett; *WWAA.*

An artist with a sense of history, Maude Wanker set out in the early 1930s to paint Oregon's historical sites and buildings. Before that decade came to a close, she had virtually accomplished her task, having painted nearly a hundred of them.

Throughout Maude Wanker's long career she exhibited regularly, with one-woman shows in most of the western and midwestern states. In addition, she taught art many years and gave art lectures throughout the Pacific Northwest. She also founded and directed the Lincoln County Art Center and Gallery, and founded the Oregon Coast Artists Association and the Master Watercolor Society of Oregon.

Ware, Florence Ellen (1891-1971)

B. Salt Lake City, Utah, May 6. Lived: Salt Lake City. *AAA;* Mallett; *WWAA.*

Warner, Nell Walker (1891-)

B. Richardson County, Nebraska, April 1. Lived: La Crescenta and Carmel, California. *AAA; WWAA.*

Warre, Henry James (1819-1898)

B. 1819. D. London, England, April 3, 1898. Lived: London. Work: Dr. and Mrs. Franz Stenzel Collection, Portland, Oregon; American Antiquarian Society, Worcester, Massachusetts. Federal Writers' Project, *Washington;* Groce and Wallace.

Capt. Warre, the British topographical artist, traveled and sketched the area between Montreal and the mouth of the Columbia River in 1845. Some of Warre's Washington and Oregon views were published in his *Sketches in North America and the Oregon Territory* (London, 1848; reprinted 1970). Wright Howes says of those lithographs that "they remain the only western color plates comparable in beauty to those by Bodmer accompanying Maximilian's *Travels.*" Warre is credited with several Rocky Mountain views which are considered the earliest ever made, and his drawings and paintings of Astoria, Oregon City, and Fort

Vancouver are of great historical importance. His work is most often seen in Oregon and Washington museums and collections.

Warshawsky, Abel George (1883-1962)
B. Sharon, Pennsylvania, December 28. D. Monterey, California, May 30. Lived: Paris, France; Monterey. *AAA;* Fielding; Mallett; *WWA; WWAA; WWWA.*

Watrous, Harry Willson (1857-1940)
B. San Francisco, California. D. May 9. Lived: New York City. *AAA;* Fielding; Mallett; *WWA; WWAA; WWWA.*

Waud, Alfred R. (1828-1891)
B. London, England, October 2. D. Marietta, Georgia, April 6. Lived: New York City; Marietta. Groce and Wallace; Mallett.

Weaver, Buck (1888-)
B. England. Lived: New Mexico; San Francisco, California. Perceval 1949.

Webb, Vonna Owings (1876-1964)
B. Sunshine, Colorado, June 2, 1876. D. Manhattan Beach, California, July 27. 1964. Lived: Deer Lodge, Montana; Chicago, Illinois; Indianapolis, Indiana; Seaside and Portland, Oregon; Bozeman, Montana; Laguna Beach, California.

It has been said of Vonna Webb that she painted for 81 of her 88 years. She grew up in Montana where her father Dr. John Hood Owings was surgeon for the Northern Pacific Railroad, and it was to Montana years later that she returned as professor of art after teaching in Indianapolis, Indiana. Her summers were spent conducting institutes, so interested was she in introducing the teaching of art into Montana public schools.

Following marriage in 1905, Vonna Webb lived for a few years in Chicago and then in Oregon. The final 35 years of her life were spent in California where she painted seascapes and desert landscapes.

Webber, John E. (1751-1793)

B. near London, England, October 6, c. 1751. D. London, April 29, 1793. Lived: England. Work: Edward W. Allen Collection, Seattle, Washington. Groce and Wallace; LeRoy; Mallett.

Webber was a well-known English artist of Swiss ancestry who visited the Pacific Northwest in 1778 with Captain James Cook. His sketches of present-day Oregon and Washington were later made into finished paintings and reproduced in Cook's report of the expedition. Following Webber's four-year voyage with Cook, he painted landscapes in Switzerland, Italy, and Great Britain. In 1871 he was made a Royal Academician. During the latter years of Webber's life, he published 16 hand-colored etchings of views he had sketched during the Cook voyage. Although his works are extremely limited in number, they are of considerable documentary importance because of his early travel in the Pacific Northwest.

Weggeland, Daniel (1827-1918)

B. Christiansand, Norway, March 31, 1827. D. Salt Lake City, Utah, June 2, 1918. Lived: Salt Lake City. Work: Brigham Young University, Provo, Utah; Springville Art Museum, Springville, Utah. Federal Writers' Project, *Utah;* Haseltine.

Weggeland was born in Norway where he attended art school before seeking additional training in Copenhagen and Berlin. In 1861 he studied briefly in New York, and then moved to Florence, Nebraska. The following year he left for Salt Lake City with a wagon train, making sketches along the way. Like other early Utah artists, Weggeland participated in painting murals for the Mormon church. He also did easel paintings depicting pioneer life and his favorite subject, the fjords of Norway. His landscapes were low-keyed in tone and did not reach popularity until the latter years of his career when he received various awards. However, his early work for the Salt Lake Temple is considered by some critics to be his best.

Weisser, Leonie O. (1890-)

B. Guadalupe County, Texas. Lived: San Antonio and New Braunfels, Texas. *AAA;* Mallett; *WWAA.*

Welch, Ludmilla (1867-)

Lived: San Francisco Bay area. California Historical Society, San Francisco.

Welch, Thaddeus (1844-1919)

B. Indiana, July 14, 1844. D. Santa Barbara, California, December 1919. Lived: Oregon; Boston; New York; Munich, Germany; Marin County and Santa Barbara, California. Work: Oakland Art Museum, Oakland, California; California Historical Society, San Francisco. *CAR*, Vol. III; Neuhaus 1931.

The life of Thad Welch, successful California landscape painter, is best told in his own words, written to his San Francisco dealer and friend, A. L. Gump:

"I was born in Indiana, July 14, 1844. Crossed the plains to Oregon in 1847. Learned the printer's trade, and came to California in 1866. Went to Munich to study art in 1874, and remained there six years, securing three bronze medals. Studied in Paris three and one half years, and exhibited in the Salon in 1880. Lived in Boston, New York, and other places till 1892, when I returned to California, where I expect to be buried. I was married in 1883 and not divorced yet and never stole anything worse than a watermelon. So help me God."

Wells, Lucy D. (1881-)

B. Chicago, Illinois, September 4. Lived: Seattle and Spokane, Washington. *AAA;* Mallett; *WWAA.*

Wenck, Paul (1892-)

B. Berlin, Germany. Lived: Mount Vernon and New Rochelle, New York. Mallett; *WWAA.*

Wenderoth, August Frederick (1825-)

B. Cassel, Germany. Lived: Philadelphia, Pennsylvania; California. Groce and Wallace; Oakland Art Museum.

Wendt, Julia Bracken (1871-1942)

B. Apple River, Illinois, June 10. D. June 22. Lived: Chicago, Illinois; Laguna Beach, California. *AAA;* Bénézit; Fielding; Mallett; *WWA; WWAA; WWWA.*

Wendt, William (1865-1946)

B. Germany, February 20, 1865. D. Laguna Beach, California, December 29, 1946. Lived: Chicago; Los Angeles and Laguna Beach. Work: Chicago Art Institute; Museum of History, Science and Art, Los Angeles; Cincinnati Art Museum; Art Association of Indianapolis, Indiana. Fielding; Mallett; Neuhaus 1931.

Wendt came to this country at an early age and in 1903 moved to Los Angeles. He brought to the area high artistic standards and great technical ability which he had acquired in the East, enabling him to be a pacemaker in the community. Wendt's fame rests upon his landscapes of Southern California country, for he became somewhat of a sensation when they were exhibited at the Chicago Art Institute early in the 20th century. From then on this self-taught artist received many awards and enjoyed wide representation. Wendt's well-organized paintings depicted Southern California in its varied moods and seasonal changes. Like many other American artists of that era he was concerned with pattern for pattern's sake, but his paintings never failed to be convincing and truthful.

Werntz, Carl N. (1874-1944)

B. Sterling, Illinois. D. Mexico City, October 27. Lived: Chicago, Illinois. *AAA;* Fielding; Mallett; *WWAA.*

West, Virgil William (1893-1955)

B. Benkelman, Nebraska, June 18. Lived: Sonora, California. Denver Public Library, Denver, Colorado; *Pony Express,* April 1961, May 1963, and August 1967.

Weygold, Frederick P. (1870-1941)

B. Saint Charles, Missouri. D. Louisville, Kentucky, August 17. Lived: Louisville. *WWAA.*

Weyss, John E. (1820-1903)

B. c. 1820. D. Washington, D.C., June 24, 1903. Lived: In the West many years while with the Western Surveys; Washington, D.C. Work: Still Pictures, National Archives, Washington, D.C. Goetzmann 1959; Groce and Wallace; Pinckney; Taft.

John Weyss, also known as John Weiss, served as topographer for several years with the Mexican Boundary Survey team which began its work in 1849, working westward along the Texas border. Like Arthur Schott, he contributed many illustrations to William H. Emory's *Report on the United States and Mexican Boundary Survey under the Direction of the Secretary of the Interior, 1849-1857.*

Following the Civil War, in which Weyss served as a major, he returned to the West to do topographic work for the George M. Wheeler Survey of the Colorado Plateau and the Grand Canyon. Several of his illustrations appeared in Wheeler's *United States Geographical Survey* report of that 1869 expedition.

White, Nona L. (1859-)
B. Illinois. Lived: Pasadena, California. *AAA;* Mallett.

White, Orrin Augustine (1883-)
B. Hanover, Illinois. Lived: Pasadena, California. *AAA;* Fielding; Mallett; *WWA; WWAA.*

Whiteside, Frank Reed (1866-1929)
B. Philadelphia, Pennsylvania. D. Philadelphia, September 19, 1929. Lived: Philadelphia. Work: Pennsylvania Academy of Fine Arts, Philadelphia. Fielding; Mallett; Phoenix Art Museum; David David, Inc., Philadelphia.

Whiteside was a student at the Pennsylvania Academy of Fine Arts when he made his first trip to the Southwest in 1890. Reminiscent of that trip are several San Gabriel Mission paintings, at least one signed and dated—a practice he seldom followed in later years.

Whiteside's Zuni series was started in 1894. It included such anthropological subjects as ceremonies, interiors and exteriors of Zuni dwellings, water holes, and hunting scenes. A competent artist, Whiteside did not allow these paintings to bog down with anthropological detail; important to him was the challenge of desert light and color, so essential to pueblo and mesa subjects. Other southwestern Indians also provided Whiteside with material, especially the Hopi and Walpi.

A native of Philadelphia, Whiteside achieved considerable recognition there as a landscape painter and teacher. Unfortunately his work has seldom been seen in the West.

Whittredge, Worthington (1820-1910)

B. Springfield, Ohio, May 22, 1820. D. Summit, New Jersey, February 25, 1910. Lived: New York City; Summit, New Jersey. Work: Corcoran Gallery of Art, Washington, D.C.; Century Club, New York City; Worcester Art Museum, Worcester, Massachusetts; Yale University, New Haven, Connecticut. Fielding; Groce and Wallace; Mallett; Taft.

One of the first prominent American landscape artists to paint in New Mexico was Whittredge, who painted "Pecos Church" in 1865. During the summer of the following year, Whittredge sketched in the Rocky Mountains near Denver. From that trip came several well-known paintings such as "Crossing the Ford, Platte River, Colorado." In 1870 he was back in the West with John F. Kensett and Sanford R. Gifford, also landscape artists.

Whittredge's early life was that of a pioneer farm boy in southern Ohio. After studying at the Cincinnati Art School he spent ten years in Europe. Upon his return he maintained that there was little value in long periods of foreign study for American artists. Details of his thoughts and travels can be found in an autobiographical account in the *Brooklyn Museum Journal,* Vol. 1 (1942), edited by John Baur.

Whymper, Frederick (-)

Lived: California 1864-82. Oakland Art Museum.

Widforss, Gunnar Mauritz (1879-1934)

B. Stockholm, Sweden, October 21, 1879. D. Grand Canyon National Park, November 30, 1934. Lived: Europe; New York; Florida; Arizona; San Francisco, California. Work: Museum of Northern Arizona, Flagstaff, Arizona; Yosemite National Park, California; Los Angeles Department of Water and Power, Los Angeles, California. Belknap; Mallett.

Gunnar Widforss, internationally known Swedish artist, discovered the West in 1921 on the way to the Orient. From then until his death more than a decade later, the Grand Canyon was his great challenge. His work was widely reproduced in this country, especially on Fred Harvey postcards. In the minds of many he became *the* painter of the Grand Canyon. He also painted Bryce and Zion Canyons, the Yellowstone Canyon, Yosemite, and

the California coast. With the 1969 publication of a book about his life, Widforss will undoubtedly regain much of the fame dimmed by intervening years.

Wieczorek, Max (1863-1955)
B. Breslau, Germany, November 22. D. September 25. Lived: Los Angeles, Long Beach, and Pasadena, California. *AAA;* Fielding; Mallett; *WWA; WWAA; WWWA.*

Wieghorst, Olaf (1899-)
B. Viborg, Jutland, Denmark, April 30, 1899. Lived: New York; New Mexico; El Cajon, California. Work: Read Mullan Gallery of Western Art, Phoenix, Arizona; Cowboy Hall of Fame, Oklahoma City, Oklahoma. Ainsworth 1968; Reed 1969; interview, Mrs. Samuel Campbell, Tucson, Arizona.

Late in 1918 Danish-born Wieghorst jumped ship in New York harbor and swam ashore. After living there for a time with his uncle, he enlisted in the army and spent three years patroling the Rio Grande border. Then he got a job as cowpuncher on a New Mexico ranch, experiencing at last the life he had dreamed of as a boy. Wieghorst had ridden horses from the age of three and performed as a bareback rider while in his teens. Riding horses was as important to him as drawing them. In 1924 Wieghorst returned to New York where he worked for 24 years as a mounted policeman; he painted in his spare time. Then he moved to a ranch near El Cajon, California, and has since devoted full time to painting western subjects.

Wiggins, Myra Albert (1869-1956)
B. Salem, Oregon, December 15. D. Seattle, Washington, January 14. Lived: Seattle. *AAA;* Mallett; *WWAA.*

Wiles, Lemanuel Maynard (1826-1905)
B. Perry, New York, October 21. D. New York City, January 28. Lived: Washington, D.C.; New York City. *AAA;* Fielding; Groce and Wallace; Mallett; *WWWA.*

Wilke, William Hancock (1880-)
B. San Francisco, California. Lived: San Francisco and Berkeley, California. Mallett; *WWAA.*

Wilkins, James F. (c.1808-1888)

B. England, c. 1808. D. at his farm near Shobonier, Illinois, June 18, 1888. Lived: Saint Louis, Missouri; Fayette County, Illinois. Work: State Historical Society of Wisconsin, Madison; Missouri Historical Society, Saint Louis. Groce and Wallace; McDermott.

Wilkins was a St. Louis artist who joined an 1849 caravan bound for the California gold fields and made some 200 water color sketches along the way to be used later in a huge panorama. Fifty of the original sketches, together with Wilkins' diary, are in the Huntington Library at San Marino, California. In 1967 they were reproduced in *An Artist on the Overland Trail* and the diary edited by John Francis McDermott.

Wilkins' panorama was a three-reel affair which was enthusiastically received by the audiences of that day but unfortunately is no longer in existence.

Williams, James Robert [Jim] (1888-1957)

B. Halifax, Nova Scotia, Canada, March 30. D. June 17. Lived: Prescott, Arizona; San Marino, California. Mallett; *WWA; WWAA; WWWA.*

Williams, Virgil (1830-1886)

B. Taunton, Massachusetts, 1830. D. at his ranch near Mount Saint Helena, California, December 18, 1886. Lived: Italy; Boston, Massachusetts; San Francisco. *CAR*, Vol. IV; Groce and Wallace; Mallett.

Williams, who had studied in Rome for 10 years, never tired of painting the Italian scene. However, his long residence in California resulted in many excellent charcoal drawings of animal and woodland scenes of the San Francisco Bay area. In his later years he had a ranch near Saint Helena where he sketched and hunted. He did a number of landscape and genre paintings of that wine-growing region which were "admired for their delicacy of color and fine feeling of nature."

Williams was an outstanding teacher. He was the first director of San Francisco's California School of Design and he made that institution his life work.

Wilwerding, Walter Joseph (1891-1966)

B. Winona, Minnesota, February 13. D. September 19. Lived: Minneapolis, Minnesota; Old Greenwich, Connecticut. Mallett; *WWAA; WWWA.*

Wimar, Charles (1828-1862)

B. Siegburg, Germany, February 19, 1828. D. Saint Louis, Missouri, November 28, 1862. Lived: Saint Louis. Work: Phoenix Art Museum, Phoenix, Arizona; City Art Museum of Saint Louis; Washington University, Saint Louis. Groce and Wallace; McCracken 1952; Mallett; Taft.

Wimar was 15 when he came from Germany to join his father who ran a roadhouse on the outskirts of Saint Louis. There Wimar made friends with the Indians who came to town to trade their furs. When Wimar returned to Germany in 1852 to study art in Dusseldorf, he frequently made paintings of Indian subjects from memory. They sold well in Germany, but those he sent home did not find a ready market.

In 1858 Wimar made his first long sketching trip up the Missouri, boarding a river boat early in the season and returning in November. He sketched the Assiniboins at Fort Union, and spent several months among the Crows on the Yellowstone.

Winkler, John W. (1890-)

B. Austria. Lived: Berkeley and San Francisco, California. *AAA;* Fielding; Mallett; *WWAA.*

Wisby, J. (1870-1940)

Lived: San Francisco Bay area. California Historical Society, San Francisco.

Withrow, Eva Almond (1858-1928)

B. Santa Clara, California, December 19, 1858. D. San Diego, California, June 17, 1928. Lived: London, England; San Francisco and San Diego, California. *CAR,* Vol. V; James 1917.

Although not primarily interested in Indian subjects, Miss Withrow did some significant work among the Hopi, Navajo, Pueblo, and Southern California Indians and Mexicans. In 1895, as a result of her travels in Southern California, she used San

Gabriel Mission as the setting for a painting called "El Pastore" or "The Shepherd." Similarly a Hopi kiva overlooking the Painted Desert provided a setting for a medicine man's rites at sunrise.

Miss Withrow was best known in San Francisco and London where she painted portraits of celebrities. George Wharton James found in her work "daring, independence, and originality, combined with a deep spirituality." The latter quality was especially prevalent in her genre paintings of southwestern Indians.

Wolle, Muriel Sibell (1898-)
B. Brooklyn, New York, April 3, 1898. Lived: Boulder, Colorado. Work: Denver Art Museum; Springfield Art Association, Springfield, Illinois. Mallett; *WWAA*.

A Colorado vacation in 1926 got Muriel Sibell, an eastern artist, started on a lifelong project to record the story of western mining. Twenty-two years later she published her 527-page book, *Stampede to Timberline*, which has gone through 14 printings. In the first chapter she describes her method of drawing and painting the mining camps and ghost towns without resorting to compositional changes, yet making them artistically pleasing. The book is about Colorado mining and covers some 240 communities. *The Bonanza Trail*, published in 1953, covers mining communities in all the western states. *Montana Pay Dirt* followed in 1963.

For many years Mrs. Wolle was Professor of Fine Arts at the University of Colorado in Boulder. Her books are a remarkable fusion of artistic and literary talent, and constitute a comprehensive and authentic record of western mining.

Wood, A. M. (-)
Lived: Colorado; California; Europe. California Historical Society, San Francisco.

Wood, Stanley (1894-)
B. Bordentown, New Jersey. Lived: Carmel, California. Fielding; Mallett; *WWAA*.

Wood, Stanley L. (-c.1942)
B. England. D. England. Visited the West 1888. Hogarth.

Woodville, Richard Caton (1856-1927)

B. London, England. D. London, England. In the West (Montana, Wyoming, Dakotas, British Columbia) 1890. Hogarth; Mallett; Stenzel and Stenzel 1963.

Wores, Theodore (1860-1939)

B. San Francisco, California, August 1, c. 1860. D. San Francisco, September 11, 1939. Lived: San Francisco; Japan; Saratoga, California. Work: Los Angeles County Museum, Los Angeles, California; M. H. De Young Memorial Museum, San Francisco. *CAR*, Vol. X; Fielding; Mallett.

Wores was a native San Franciscan. He painted landscapes, portraits, and genre subjects in many parts of the world, and received international recognition. He also taught art and wrote articles on that subject.

Wores' interest in San Francisco's Chinatown resulted in a series highly praised for documentary emphasis as well as artistic merit. Likewise, his paintings of the Indians in Arizona, New Mexico, and Calgary, Canada, had these qualities.

In his later years Wores maintained a studio in an abandoned church in Saratoga, California, where he painted many landscapes of the surrounding countryside. His work of that period is frequently seen in San Francisco Bay area art and antique stores.

Worrall, Henry (1825-1902)

B. Liverpool, England, April 14, 1825. D. Topeka, Kansas, June 20, 1902. Lived: Topeka, Kansas. Work: Kansas State Historical Society, Topeka. Dary; Groce and Wallace; Taft.

Worrall brought several talents to Topeka, Kansas, when he settled there in 1868. A musician as well as an artist—apparently self-taught in both fields—Worrall also lectured on various subjects, established a vineyard, and participated in local affairs.

Although Worrall introduced caricature into much of his work, he was careful not to detract from the verity of the scene. Among his best-known illustrations is a series of eight called "The Opening of the Cherokee Strip, September 16, 1893." *Harper's, Leslie's,* and other periodicals published his work. His illustrations for *Historic Sketches of the Cattle Trade* by Joseph G. McCoy and *Buffalo Land* by W. E. Webb are also of importance to the western scene.

Wostry, Carlo (1865-)
B. France. Lived: France; briefly in the West between 1890 and 1905. Bénézit.

Wray, Henry Russell (1864-1927)
B. Philadelphia, Pennsylvania. D. Colorado, July 29. Lived: Philadelphia; Colorado Springs, Colorado. *AAA;* Fielding; Mallett

Wright, Alma Brockerman (1875-1952)
B. Salt Lake City, Utah, November 22. D. Dordogne, France, December 5. Lived: Hawaii; Canada; Arizona; France; Salt Lake City. *AAA;* Fielding; Mallett; *WWAA.*

Wright, Thomas Jefferson (1798-1846)
Lived: Kentucky; Houston, Texas. Groce and Wallace; Barker.

Wueste, Louise Heuser (1803-1875)
B. Gummersback, Germany, 1803. D. Eagle Pass, Texas, 1875. Lived: Germany; San Antonio and Eagle Pass, Texas. Work: Witte Museum, San Antonio; private collections in San Antonio. Barker; Groce and Wallace; Mallett; Pinckney.

The German-born Mrs. Wueste abandoned her career for a time following her marriage in 1821, but resumed it after her son and two daughters were grown. They, however, had to leave their revolution-torn country in 1852, and moved to Texas. Not long afterward, Mrs. Wueste joined them in San Antonio. There she opened a studio, painted portraits, and taught art. During the early 1870s Mrs. Wueste moved to Eagle Pass, Texas. In that pioneer town on the border along the Rio Grande she found little in the way of portrait work, but her interest in the Mexicans provided subject matter for a number of paintings.

Wyant, Alexander Helwig (1836-1892)
B. Evans Creek, Ohio, January 11. D. New York City, November 29. Lived: New York City. Bénézit; Fielding; Groce and Wallace; Mallett; *WWWA.*

Wyeth, N. C. (1882-1945)
B. Needham, Massachusetts, October 22. D. Chadds Ford, Pennsylvania, October 19. Lived: Chadds Ford. *AAA;* Fielding; Mallett; *WWA; WWAA; WWWA.*

Y

Yard, Sydney Janis (1855-1909)
B. Illinois. Lived: California 1892-1906. Neuhaus 1931.

Yates, Frederick (1854-1919)
Lived: California 1869-1900. California Historical Society, San Francisco.

Yeager, Walter (1852-1896)
B. Philadelphia, Pennsylvania. Lived: New York City; in Far West 1877. Taft.

Yelland, Raymond Dabb (1848-1900)
B. London, England, February 2, 1848. D. Oakland, California, July 27, 1900. Lived: San Francisco and Oakland. Work: Oakland Art Museum; University of California, Berkeley; California Historical Society, San Francisco. Fielding; Mallett; Mills; Neuhaus 1931; Seavey 1964.

Yelland, who studied in Paris and at the New York School of Design where he was offered a teaching post, moved to California in 1880. Although he painted a number of landscapes and scenes of Indian life, he was best known as a teacher and marine painter. Many of Yelland's paintings and pastels are of marsh and inlet scenes bordering San Francisco Bay, relieved of their flatness by a distant church tower or other vertical object.

An example of Yelland's ethnological approach to painting Indian subjects is "Early Days, Yosemite," an Indian camp scene with a detailed description on the back of the camp's appointments; this item is now in the Robert B. Honeyman Jr. Collection.

Yens, Carl (1868-1945)

B. Hamburg, Germany. D. Laguna Beach, April 13. Lived: Washington, D.C.; New York City; Los Angeles, Pasadena, and Laguna Beach, California. *AAA;* Fielding; Mallett; *WWA; WWAA; WWWA.*

Young, Aretta (1864-1923)

B. Idaho. D. Provo, Utah. Lived: Provo. *AAA.*

Young, Florence (1872-)

B. Fort Dodge, Iowa, November 6. Lived: Alhambra, California. Mallett; *WWAA.*

Young, Harvey B. (1840-1901)

B. Post Mills, Vermont, 1840. D. Colorado Springs, Colorado, May 14, 1901. Lived: California; Denver, Manitou Springs, Aspen, and Colorado Springs, Colorado. Work: Colorado College, Colorado Springs; Denver Public Library, Denver, Colorado; Oakland Art Museum, Oakland, California. Federal Writers' Project, *Colorado;* Groce and Wallace; McClurg; Mallett.

Young was in the West as early as 1859, with burro, sketch box, and gold pan—traveling through the Rockies but never striking it rich. Eight years of art training in France and Germany intervened before he was to make and lose a fortune in mining. Intermittently, Young painted in California and Colorado, making the latter his home in 1879. In 1881 he settled in Colorado Springs —about the same time as Charles Craig, and they became known as the town's first resident artists.

For a time the Denver & Rio Grande Railroad provided Young with a studio car from which he painted many landscapes for the company's advertising brochures. Many of his water colors appear to be oils because of the varnish process he perfected. His most popular paintings depict the burro, his faithful companion on many a mining venture.

Young, John J. (1830-1879)

B. c. 1830. D. Washington, D.C., October 13, 1879. Lived: Washington, D.C. Groce and Wallace; Taft.

Young was for many years a topographical engineer,

draftsman, and engraver for the War Department. In 1855 he spent six months in California and Oregon with the Williamson-Abbot railroad survey which sought a route connecting the Sacramento Valley with the Columbia River. Some of the most spectacular views made by Young were of Lassen Peak in California, and Diamond Peak and Mount Hood in Oregon. In 1859 Young accompanied J. N. Macomb in exploring the region from Santa Fe to the junctions of the Grand (now Gunnison) and Green rivers with the Colorado. His illustrations for the reports of both surveys were outstanding, demonstrating again the talent displayed by early draftsmen during their western assignments.

Young, Mahonri (1877-1957)

B. Salt Lake City, Utah, August 9, 1877. D. Norwalk, Connecticut, November 2, 1957. Lived: New York; Leonia, New Jersey; Norwalk, Connecticut. Work: University of Utah, Salt Lake City; Read Mullan Gallery of Western Art, Phoenix, Arizona. Fielding; Haseltine; Hind; Horne; Mallett.

Young once said, "I have tried to make good drawings, not to make drawings that looked good." As a painter, sculptor, and an etcher, drawing was basic to his work. For a sculpturing project at the Natural History Museum in New York, Young made three sketching trips to the West—to Hopi country in 1912, and to the lands of the Apache and the Navajo in subsequent years. He made hundreds of drawings showing many aspects of their lives. An art critic who saw Young's Navajo drawings wrote in an article for *International Studio* that a "glance at them shows the artist's extraordinary instinct for suggesting atmospheric actuality." This quality in Young's work makes his Indian studies of documentary as well as aesthetic importance.

Young-Hunter, John (1874-1955)

B. Glasgow, Scotland, 1874. D. Taos, New Mexico, August 9, 1955. Lived: New York; Taos, New Mexico. Work: Harwood Foundation, Taos, New Mexico. Coke; Mallett.

Young-Hunter was a popular portrait painter in Scotland for a number of years before he went to Taos in 1916 with the express purpose of painting Indians. From the time of his youth, when he had seen a Buffalo Bill show in London, Indians held

his interest. In the sagebrush just outside Taos, Young-Hunter built a magnificent studio where he continued his portrait business but devoted considerable time to the theme of his choice. His paintings of the Indians were romantic in nature and found a ready market, including the Santa Fe Railway which reproduced many of them for distribution.

Young, Phineas (1847-1868)
B. Florence, Nebraska, December 31. D. Salt Lake City, Utah, March 13. Lived: Salt Lake City. Haseltine.

Z

Ziegler, Eustace Paul (1881-)
B. Detroit, Michigan, July 24. Lived: Seattle, Washington. *AAA;* Mallett; *WWAA.*

Ziegler, Henry (1889-)
B. Sherman, Texas. Mallett; *American Art Student,* October 1923.

Zimbeaux, Frank Ignatius (1861-1935)
B. Pittsburgh, Pennsylvania. Lived: Carthage, Missouri; Salt Lake City, Utah. Haseltine.

Zimmerman, Ella A. (-)
Lived: Colorado Springs, Colorado. McClurg.

Zogbaum, Rufus Fairchild (1849-1925)
B. Charleston, South Carolina, 1849. D. New York City, October 22, 1925. Lived: New York. Work: Library of Congress, Washington, D.C.; family collections; murals: State Capitol, Saint Paul; Williams College, Williamstown,

Massachusetts. Alter; Fielding; Mallett; Reed 1966; Taft.

Zogbaum was primarily a military artist. His trips to Montana and Oklahoma in the 1880s were in line with that specialty but included other aspects of frontier life as well. His experiences and observations inspired both articles and illustrations; *Harper's* published several in 1885 such as "Across Country With a Cavalry Column" and "A Day's 'Drive' With Montana Cow-Boys." During that decade Zogbaum's book *Horse, Foot, and Dragoons* also was published.

Because Zogbaum wrote about his experiences and dated his illustrations, some of them can be tied in with specific happenings. In addition, his use of the cowboy motif is said to have set the style for later generations of western illustrators.

Bibliography

ART AND OTHER DIRECTORIES

American Art Annual, Washington, D.C.: The American Federation of Arts, 1898-1934.

Bénézit, E. *Dictionnaire—Critique et Documentaire des Peintres, Dessinateurs, Graveurs et Sculpteurs.* Paris: Ernest Grund Editeur, 1907-1950.

Binheim, Max (comp. and ed.). *Women of the West.* Los Angeles: Publishers Press, 1928.

Clement, Clara Erskine and Laurence Hutton. *Artists of the Nineteenth Century and Their Works.* Boston: Houghton Mifflin, 1899.

Collins, J. L. *Women Artists in America.* J. L. Collins, 1973.

Dictionary of American Biography. New York: Charles Scribner's, 1964.

Earle, Helen L. (comp.). *Biographical Sketches of American Artists.* Charleston, South Carolina: Garnier & Co., 1972 (unabridged republication of 1924 edition, Michigan State Library, Lansing).

Fielding, Mantle (James F. Carr, comp.). *Mantle Fielding's Dictionary of American Painters, Sculptors and Engravers.* New York: James F. Carr, 1965.

Groce, George C. and David H. Wallace. *New York Historical Society's Dictionary of Artists in America 1564-1860.* New Haven: Yale University Press, 1957.

Macdonald, Colin S. (comp.). *A Dictionary of Canadian Artists.* Ottawa: Canadian Paperbacks, 1968.

Mallett, Daniel Trowbridge. *Mallett's Index of Artists.* New York: Peter Smith, 1948. See also 1935 edition; 1940 and 1948 Supplements.

Who's Who in America. Chicago: A. N. Marquis Co.

Who's Who in American Art. Dorothy B. Gilbert (ed.), American Federation of Arts. New York: R. R. Bowker Co.

Who Was Who in America. Chicago: A. N. Marquis Co.

Who's Who in California. Russell Holmes Fletcher (ed.). Los Angeles: Who's Who Publications Co.

Who's Who in the Pacific Southwest. Los Angeles: Times-Mirror Printing and Binding House, 1913.

Who's Who in the West. Chicago: A. N. Marquis Co.

BOOKS AND ARTICLES

Abert, J. W. *Western America in 1846-1847.* Edited by John Galvin. San Francisco: John Howell Books, 1966.

Ainsworth, Ed. *The Cowboy in Art.* New York and Cleveland: The World Publishing Co., 1968.

——————.*Painters of the Desert.* Palm Desert, California: Desert Magazine, 1960.

Alter, Judith MacBain."Rufus F. Zogbaum and the Frontier West." *Montana the Magazine of Western History,* Fall 1973.

Anonymous. "A New Art in the West." *International Studio,* November 1917.

Bailey, L. R. (ed.). *The A. B. Gray Report.* Los Angeles: Western-lore Press, 1963.

Barker, Virgil. *American Painting: History and Interpretation.* New York: Macmillan, 1950.

Barr, Paul E. *North Dakota Artists.* Grand Forks: University of North Dakota Library Studies, No. 1, 1954.

Belknap, Bill and Frances Spencer Belknap. *Gunnar Widforss: Painter of the Grand Canyon.* Flagstaff: Northland Press, 1969.

Berger, John A. *Fernand Lungren.* Santa Barbara: The Schauer Press, 1936.

Berry, Rose V. S., "California and Some California Painters." *American Magazine of Art.* June 1924.

——————. "A California Painter." *International Studio,* January 1925.

——————. "A Patriarch of Pasadena." *International Studio,* May 1925.

Bickerstaff, Laura M. *Pioneer Artists of Taos.* Chicago: Sage Books, 1955.

Boileau, Thornton I. and Margo Boileau. "Joe Scheuerle: Modest Man with Friendly Palette." *Montana the Magazine of Western History,* Autumn 1971.

Borg, Carl Oscar. *The Great Southwest.* Edited by Everett C. Maxwell; text by Borg, Gustavus A. Eisen, and Leila Mechlin. Santa Ana, California: The Fine Arts Press, 1936.

Boswell, Peyton. *Modern American Painting.* New York: Dodd, 1939.

Brace, Ernest. "Adolf Dehn." *American Magazine of Art,* February 1936.

Brown, J. Ross. *A Tour Through Arizona 1864 or Adventures in the Apache Country.* Tucson: Arizona Silhouettes, 1950.

Browne, Lina Fergusson. *J. Ross Browne, His Letters, Journals and Writings.* Albuquerque: University of New Mexico Press, 1969.

Bucklin, Clarissa (ed.). *Nebraska Arts and Artists.* Lincoln: University of Nebraska School of Fine Arts, 1932.

Burk, Dale A. *New Interpretations.* Missoula, Montana: Western Life Publications, 1969.

California Art Research, Vols. I-XX, First Series 1936-1937 (mimeo.). San Francisco, 1937. [see "Manuscript" section]

Carlson, Raymond. "About Ray Strang." *Arizona Highways,* January 1942.

Carlson, Raymond (ed.). *Gallery of Western Paintings.* New York: McGraw-Hill, 1951.

Carter, Kate B. (comp.). *Heart Throbs of the West.* Salt Lake City: Daughters of Utah Pioneers, n.d.

Carvalho, S. N. *Incidents of Travel and Adventure in the Far West.* New York: Derby & Jackson, 1958.

Charles, Kate Howland. "Jack Howland, Pioneer Painter of the West." *The Colorado Magazine,* July 1952.

Coke, Van Deren. *Taos and Santa Fe.* Albuquerque: University of New Mexico Press, 1963.

Comstock, Helen. "An Artist Finds a Desert." *International Studio,* August 1922.

─────────────. "Painter of East and West," *International Studio,* March 1925.

Curtis, Natalie. "An American Indian Artist." *Outlook*, January 14, 1920.

Dary, David. "Henry Worrall's Place in Western Art." *Old West*, Winter 1971.

Dehn, Adolf. "U.S.A.—Adolf Dehn Depicts It in Words and Colors on His Coast to Coast Trips." *Life*, August 11, 1941.

DeVoto, Bernard. *Across the Wide Missouri*. Boston: Houghton Mifflin, 1947.

Dobie, J. Frank. "Texas Art and a Wagon Sheet." *Dallas Morning News*, March 11, 1940.

Dellenbaugh, Frederick S. *A Canyon Voyage*. New York: Putnam's, 1908.

Donaldson, Thomas. *Moqui Pueblo Indians of Arizona and Pueblo Indians of New Mexico, Extra Census Bulletin, Eleventh Census of the United States*. Washington, D.C., 1893.

Donnelly, Joseph P. (ed. and trans.). *Wilderness Kingdom: Indian Life in the Rocky Mountains, 1840-1847. The Journals of Nicolas Point, S. J.* New York: Holt Rinehart and Winston, 1967.

Dutton, Clarence E. *Tertiary History of the Grand Cañon District with Atlas*. 48 Cong., 2 Sess., H.R. Misc. Doc. No. 35. Washington, D.C., 1882.

Dyke, Paul. "Lone Wolf Returns." *Montana the Magazine of Western History*, Winter 1972.

Dykes, Jeff C. "High Spots of Western Illustrating." *The Trail Guide*, December 1963. (Kansas City: Missouri Posse, The Westerners.)

——————————. "Tentative Bibliographic Check Lists of Western Illustrators." *The American Book Collector*, 1963-1968 series.

Eggenhofer, Nick. *Wagons, Mules and Men: How the Frontier Moved West*. New York: Hastings House, 1961.

Ewers, John C. *Artists of the Old West*. New York: Doubleday, 1965; revised ed., 1973.

——————————. "The Plains Indian: Symbol of the North American Indian." *Southwestern Art*, Summer 1966.

Federal Writers' Project, American Guide Series: *Arizona, California, Colordo, Idaho, Kansas, Montana, Nebraska, Nevada, New Mexico, North Dakota, Oklahoma, Oregon, South Dakota, Texas, Washington, Wyoming,* and *Utah.*

Fryxell, Fritiof (ed.). *Thomas Moran: Explorer in Search of Beauty.* New York: East Hampton Free Library, 1958.

Galvin, John. *The Etchings of Edward Borein.* San Francisco: John Howell-Books, 1971.

Genthe, Arnold. *As I Remember.* New York: Reynal & Hitchcock, 1936.

Gibberd, Eric W. *The Painting of Gibberd.* Taos: Eric W. Gibberd, 1969.

Goetzmann, William H. *Army Exploration in the American West 1803-1863.* New Haven: Yale University Press, 1959.

——————. *Exploration and Empire. The Explorer and the Scientist in the Winning of the American West.* New York: Knopf, 1966.

Gollings, E. W. "Autobiography of Elling William Gollings, the Cow-Boy Artist." *Annals of Wyoming,* October 1932.

Goodrich, Lloyd and Doris Bry. *Georgia O'Keeffe.* New York: Praeger, 1970.

Grant, Blanche C. *When Old Trails Were New.* New York: The Press of the Pioneers, 1934.

Gregg, Andrew K. *New Mexico in the 19th Century: A Pictorial History.* Albuquerque: University of New Mexico Press, 1968.

Hafen, LeRoy R. *Colorado and Its People.* New York: Lewis Historical Publishing, 1948.

——————. *History of Colorado.* Denver: Linderman Co., 1927.

Hafen, LeRoy R. and Ann W. Hafen (eds.). *Central Route to the Pacific by Gwinn Harris Heap.* Glendale, California: Arthur H. Clark, 1957.

——————. *Colorado: A Story of the State and Its People.* Denver: The Old West Publishing Co., 1943.

—————— (eds.). *The Diaries of William Henry Jackson.* Glendale, California: Arthur H. Clark, 1959.

Haley, J. E. *F. Reaugh, Man and Artist.* El Paso: Carl Hertzog, 1960.

Hammond, George Peter (ed.). *The [Thomas Oliver] Larkin Papers,* 10 vols. Berkeley: University of California Press, 1951-64.

Harper, J. Russell. *Paul Kane's Frontier.* Austin: University of Texas Press, 1971.

Haseltine, James L. *One Hundred Years of Utah Painting.* Salt Lake City: Salt Lake Art Center, 1965.

Hayden, F. V. *The Yellowstone National Park, and the Mountain Regions of Idaho, Nevada, Colorado and Utah.* Boston: L. Prang and Co., 1876.

Hind, C. Lewis. "Mahonri Young's Drawings." *International Studio,* April 1918.

Hine, Robert V. *Bartlett's West.* New Haven: Yale University Press, 1968.

Hogarth, Paul. *Artists on Horseback: The Old West in Illustrated Journalism 1857-1900.* New York: Watson-Guptill, 1972.

Hoopes, Donelson F. *The American Impressionists.* New York: Watson-Guptill, 1972.

Horan, James D. *The Life and Art of Charles Schreyvogel.* New York: Crown Publishers, 1969.

Horne, Alice Merrill. *Devotees and Their Shrines; a Handbook of Utah Art.* Salt Lake City: The Deseret News, 1914.

Hubbard, Robert H. (ed.). *An Anthology of Canadian Art.* Toronto: Oxford University Press, 1960.

Jackson, Clarence S. "I Remember Jack Howland." *The Colorado Magazine,* October 1949.

——————. *Picture Maker of the Old West.* New York: Charles Scribner's, 1947.

Jackson, W. H. *Time Exposure, the Autobiography of W. H. Jackson.* New York: Putnam's, 1940.

James, George Wharton. *Arizona the Wonderland.* Boston: Page Co., 1917.

——————. *New Mexico The Land of the Delight Makers.* Boston: Page Co., 1920.

——————. *Utah The Land of Blossoming Valleys.* Boston: Page Co., 1922.

——————. *Wonders of the Colorado Desert.* Boston: Little, Brown, 1906.

"The John D. Howland Collection." *The Colorado Magazine,* January 1931.

Kennedy, Michael Stephen. "O. C. Seltzer: Meticulous Master of Western Art." *Montana the Magazine of Western History,* Summer 1960.

Kleiber, Hans. *Songs of Wyoming.* Sheridan, Wyoming: Mills Company, 1963.

Kuhler, Otto C. "Painting the Land of Lost Souls." *The Westerners Brand Book*. Denver 1964.

Kurz, R. F. *Journal of Rudolph Friederick Kurz*. Bureau of American Ethnology Bulletin 115. Washington, D.C.: Smithsonian Institution, 1937.

La Farge, Oliver. *Santa Fe: The Autobiography of a Southwestern Town*. Norman: University of Oklahoma Press, 1959.

Linderman, Frank B. *Blackfeet Indians*. Saint Paul: Great Northern Railway, 1935.

Look, Al. *Harold Bryant: Colorado's Maverick Paint Brush*. Denver: Golden Bell Press, 1962.

Loran, Erle. "Artists from Minnesota." *American Magazine of Art*, January 1936.

Lowry, Robert. "Steve Harley and the Lost Frontier." *Flair*, June 1950.

Luhan, Mable Dodge. *Taos and Its Artists*. New York: Duell, Sloan and Pearce, 1947.

Lummis, Charles F. *Some Strange Corners of Our Country*. New York: Century Co., 1892.

Mahood, Ruth I. (ed.). *A Gallery of California Mission Paintings*. Los Angeles: Ward Richie Press, 1966.

Maribeth. "Carmel Artist Linked Old and New." *Palo Alto Times*, May 21, 1969.

Marquis, Neeta. "The Paintings of Ralph Davison Miller." *International Studio*, July 1918.

Matthews, E. C. (ed.). *Sketches of the Old West*. St. Louis: New Era Studio, 1962.

Maxwell, Everett Carroll. *Art and Artists of the Great Southwest* (articles from the *Fine Arts Journal* for 1910). Chicago 1910.

McCormick, William B. "Groll Rebels against Groll." *International Studio*, September 1922.

McCracken, Harold. *The Charles M. Russell Book*. New York: Doubleday, 1957.

——————. *George Catlin and the Old Frontier*. New York: Bonanza Books, 1959.

——————. *Portrait of the Old West*. New York: McGraw-Hill, 1952.

McDermott, John Francis (ed.). *An Artist on the Overland Trail* (the 1849 diary and sketches of James F. Wilkins). San Marino, California: The Huntington Library, 1968.

McWilliams, Carey. *Southern California Country*. New York: Duell, Sloan and Pearce, 1946.

Meigs, John. *The Cowboy in American Prints*. Chicago: Swallow Press, 1972.

Merrild, Knud. *A Poet and Two Painters*. New York: Viking Press, 1939.

Montes, Elena. "Art and Artists of New Mexico." *New Mexico Magazine,* September 1962.

Mora, Jo. *Californios*. New York: Doubleday, 1949.

——————. *Trail Dust and Saddle Leather*. New York: Charles Scribner's, 1946.

Mumey, Nolie. "James M. Bagley (1837-1910): The First Artist, Wood Engraver and Cartoonist in Denver." *The Colorado Magazine,* July 1955.

Musick, Archie. *Musick Medley*. Colorado Springs: Jane and Archie Musick, 1971.

Neuhaus, Eugen. *The History and Ideals of American Art*. Stanford: Stanford University Press, 1931.

——————. *William Keith the Man and the Artist*. Berkeley: University of California Press, 1938.

O'Brien, Esse F. *Art and Artists in Texas*. Dallas: Tardy Publishing Co., 1935.

"The Old West Revisited: The Private World of Doctor Philip Cole." Gilcrease Institute, *The American Scene,* 1967.

Ormes, Manly Dayton and Eleanor R. Ormes. *The Book of Colorado Springs*. Colorado Springs: The Denton Printing Co., 1933.

"The Painter of the Blackfoot." Denver *Post Empire Magazine,* May 9, 1954.

Parker, Charles H. "A Painter of Silent Places." *International Studio,* June 1918.

Patterson, Patrick. *Woolaroc Museum*. Bartlesville, Oklahoma: The Frank Phillips Foundation, Inc., 1965.

Perceval, Don Louis. *Maynard Dixon Sketch Book*. Flagstaff: Northland Press, 1967.

——————. "The Art of Western America." *The Westerners Brand Book*. Los Angeles, 1949.

Perry, Lawrence. "Rear Platform Impressions of the Southwest." *Scribner's Magazine,* March 1919.

Peters, Harry Twyford. *California on Stone*. New York: Doubleday, 1935.

Pinckney, Pauline A. *Painting in Texas: The Nineteenth Century*. Austin: University of Texas Press, 1967.

Porter, Bruce et al. *Art in California*. San Francisco: R. L. Bernier, 1916.

Powell, Mary M. "Three Artists of the Frontier." *Bulletin of the Missouri Historical Society*, October 1948-July 1949.

Proctor, Edna Dean. *The Song of the Ancient People*. Boston: Houghton Mifflin, 1893.

Rasmussen, Louise. "Artists of the Explorations Overland, 1840-1860." *Oregon Historical Quarterly*, March 1942.

Rathbone, Perry T. (ed.). *Westward the Way* (Saint Louis City Art Museum). St. Louis: Von Hoffmann Press, 1954.

Read, Georgia W. and Ruth Gaines (eds.). *Gold Rush*. New York: Columbia University Press, 1944.

Reed, Walt. *Harold von Schmidt Draws and Paints the Old West*. Flagstaff: Northland Press, 1972.

————————. *The Illustrator in America 1900-1960's*. New York: Reinhold Publishing, 1966.

Reed, William. *Olaf Wieghorst*. Flagstaff: Northland Press, 1969.

Remington, Frederic. "A Few Words from Mr. Remington." *Collier's Weekly*, March 18, 1905.

Report on Indians Taxed and Indians Not Taxed in the United States (Except Alaska) at the Eleventh Census: 1890 (U.S. Census Bureau). Washington, D.C., 1894.

Richardson, E. P. *Painting in America*. New York: Thomas Y. Crowell, 1965.

Ringe, Fred Hamilton. "Taos, a Unique Colony of Artists." *American Magazine of Art*, September 1926.

Robinson, Elwyn B. *History of North Dakota*. Lincoln: University of Nebraska Press, 1966.

Robinson, F. Warner. "Dunton—Westerner." *American Magazine of Art*, October 1924.

Rogers, William Allen. *A World Worth While*. New York: Harper & Bros., 1922.

Rossi, Paul A. and David C. Hunt. *The Art of the Old West*. New York: Knopf, 1971.

Ruth, Kent. *Great Day in the West*. Norman: University of Oklahoma Press, 1963.

Santee, Ross. "The West I Remember." *Arizona Highways,* October 1956.

Schaldach, William J. *Carl Rungius Big Game Painter.* West Hartford, Vermont: The Countryman Press, 1945.

Schiwetz, E. M. *Buck Schiwetz' Texas: Drawings and Paintings by E. M. Schiwetz.* Austin: University of Texas Press, 1960.

——————. *The Schiwetz Legacy: An Artist's Tribute to Texas, 1910-1971.* Austin: University of Texas Press, 1972.

——————. *Texas' Buck Schiwetz.* San Antonio: Institute of Texas Cultures, 1972.

Seeber, Louise Combes. *George Elbert Burr 1859-1939.* Flagstaff: Northland Press, 1971.

Selkinghaus, Jessie A. "Etchers of California." *International Studio,* February 1924.

Seton, Julia M. *By a Thousand Fires.* New York: Doubleday, 1967.

Shirlaw, Walter. "Artists' Adventures: The Rush to Death." *Century Magazine,* November 1893.

Spaulding, Edward S. *Adobe Days Along the Channel.* Santa Barbara, California, 1957.

——————. *Ed Borein's West.* Santa Barbara: Press of the Schauer Printing Studio, 1952.

——————. *Etchings of the West.* Santa Barbara, 1950.

Steadman, William E. *La Tierra Encantada.* Tucson: Walter Lithocraft, 1969.

Stein, Ewald A. "R. Farrington Elwell." *Arizona Highways,* October 1959.

Stenzel, Franz. *Cleveland Rockwell: Scientist and Artist 1837-1907.* Portland: Oregon Historical Society, 1972.

Stobie, Charles S. "With the Indians in Colorado." *The Colorado Magazine,* March 1930.

——————. "Crossing the Plains to Colorado in 1865." *The Colorado Magazine,* November 1933.

Swanton, John R. "William Henry Holmes." National Academy of Sciences *Biographical Memoirs,* Vol. XVII, 1937.

Taft, Robert. *Artists and Illustrators of the Old West 1850-1900.* New York: Charles Scribner's, 1953.

Taylor, Frank J. (ed.). *Burbank Among the Indians.* Caldwell: Caxton Printers, 1944.

"Three California Painters." *American Magazine of Art,* April 1925.

Trobriand, Philippe Regis de. *Military Life in Dakota: The Journal of Philippe Regis de Trobriand.* Edited and translated by Lucile M. Kane. St. Paul: Alvord Memorial Commission, 1951.

Van Nostrand, Jeanne. *A Pictorial and Narrative History of Monterey.* San Francisco: California Historical Society, 1968.

Van Nostrand, Jeanne and Edith Coulter. *California Pictorial: A History in Contemporary Pictures, 1786-1859.* Berkeley: University of California Press, 1948.

"Van Soelen's New Mexico Pleases." *Art Digest,* January 1936.

Wallace, Edward S. *The Great Reconnaissance.* Boston: Little, Brown, 1955.

Warre, H. *Sketches in North America and the Oregon Territory.* (Introduction by Archibald Hanna, Jr.) Barre, Massachusetts: Imprint Society, 1970.

Waters, Frank. *Leon Gaspard.* Flagstaff: Northland Press, 1964.

Wearin, Otha Donner. *Clarence Arthur Ellsworth: Artist of the Old West.* Shenandoah, Iowa: World Publishing Co., 1967.

Webb, Edith Buckland. *Indian Life at the Old Missions.* Los Angeles: Warren F. Lewis, 1952.

Weitenkampf, F. *American Graphic Art.* New York: Macmillan, 1912.

Westermeier, Clifford P. *Colorado's First Portrait: Scenes by Early Artists.* Albuquerque: University of New Mexico Press, 1970.

Wilkins, Thurman. *Thomas Moran: Artist of the Mountains.* Norman: University of Oklahoma Press, 1966.

Wills, Olive. "Artists of Wyoming." *Annals of Wyoming,* October 1932.

Wolle, Muriel Sibell. *The Bonanza Trail.* Bloomington: Indiana University Press, 1953.

——————. *Montana Pay Dirt.* Chicago: Swallow Press, 1963.

——————. *Stampede to Timberline.* Chicago: Swallow Press, 1949.

Wuerpel, Edmund H. "Oscar E. Berninghaus." *New Mexico Quarterly,* Summer 1951.

Young-Hunter, John. *Reviewing the Years*. New York: Crown Publishers, 1963.

CATALOGS

Artists of Santa Fe, Their Works and Words. C. R. Wenzell Publications, 1965.

Baird, Joseph Armstrong, Jr. *Grace Carpenter Hudson*. San Francisco: California Historical Society, 1962.

—————. *The West Remembered*. San Francisco: California Historical Society, 1973.

Bimson, Walter. *The West and Walter Bimson*. Tucson: University of Arizona Museum of Art, 1971.

Colorado Collectors/Historic Western Art/Nostalgia of the Vanishing West. Denver: Denver Art Museum, 1973.

Coke, Van Deren. *Kenneth M. Adams: A Retrospective Exhibition*. Albuquerque: University of New Mexico Press, 1964.

Curry, Larry. *The American West: Painters from Catlin to Russell*. New York: Viking Press, 1972.

Eberstadt, Edward. *Distinguished Collection of Western Paintings*. Catalog No. 139. New York: E. Eberstadt & Sons.

Ewing, Robert A. *50th Anniversary Exhibition*. Santa Fe: Museum of New Mexico, 1967.

—————. *Henry C. Balink*. Santa Fe: Museum of New Mexico, 1966.

Ferbraché, Lewis. *The Dr. and Mrs. Bruce Friedman Collection*. San Francisco: California Historical Society, 1969.

Forest, James Taylor. *The Artist in the American West, 1800-1900*. Santa Fe: Museum of New Mexico, 1961.

—————. *Hans Kleiber, Artist of the Big Horns*. Big Horn, Wyoming: The Bradford Brinton Memorial, 1968.

Hinkhouse, F. M. *An Exhibition of Paintings of the Southwest from the Santa Fe Railway Collection*. Phoenix: Phoenix Art Museum, 1966.

Hubbard, Robert H. (ed.).*Catalogue of Paintings and Sculptures*. Toronto: University of Toronto Press, 1959.

Hubbard, Robert H. and J. R. Ostiguy. *Three Hundred Years of Canadian Art*. Ottawa: The National Gallery of Canada, 1967.

LeRoy, Bruce. *Northwest History in Art, 1778-1963*. Pacific Northwest Historical Pamphlet No. 3. Washington State Historical Society, April 1963.

Mayer, A. Kiefer. *Ray Strang: Painter of the West*. Tucson: Cosmos Art Gallery, 1966.

Mills, Paul (ed.). *Early Paintings of California in the Robert B. Honeyman, Jr. Collection*. Oakland: Oakland Art Museum, 1956.

Monthan, Doris (ed.). *Dorothy Harmsen's Western Americana*. Flagstaff: Northland Press, 1971.

Morse, A. Reynolds. *George Elbert Burr, Etcher of the American West 1859-1939*. Denver: The Reynolds Morse Foundation and The Denver Public Library, 1967.

Muno, Richard. *Cowboy Artists of America: Sixth Annual Exhibition*. Flagstaff: Northland Press, 1971.

Phoenix Art Museum. *Art of the Western Scene 1880-1940*. Phoenix: Western Art Associates, 1969-1970.

_____. *Frank Reed Whiteside 1866-1929: The Zuni and the Indian Country*. Phoenix: Western Art Associates, 1971.

Portland Art Museum. *Early Days in the Northwest*. Portland, Oregon.

Saint Louis City Art Museum. *Mississippi Panorama*. Saint Louis: Caledonia Press, 1950.

Santa Fe Industries, Inc. *Paintings from the Collection of the Santa Fe Industries, Inc*. Chicago [1973].

Seavey, Kent L. *Charles Dorman Robinson*. San Francisco: California Historical Society, 1965.

_____. *Francis John McComas*. San Francisco: California Historical Society, 1965.

_____. *Raymond Dabb Yelland*. San Francisco: California Historical Society, 1964.

Shalkop, Robert L. *A Show of Color*. Colorado Springs: Colorado Springs Fine Arts Center, n.d.

Springville Museum of Art. *Permanent Collection Catalogue*. Springville, Utah, 1972.

Stenzel, Franz R. and Mrs. F. R. Stenzel. *Art of the Oregon Territory*. Eugene: Museum of Art, University of Oregon, 1959.

_____. *An Art Perspective of the Historic Pacific Northwest*. Franz R. Stenzel, 1963.

Manuscripts

California Art Research. Federal WPA project, never officially published, but a few copies duplicated and bound. [available at several California libraries]

Maturano, Mary Lou. "Artists and Art Organizations in Colorado." Thesis, University of Denver. [available also at the Denver Public Library]

Mc Clurg, Gilbert. "Brush and Pencil in Early Colorado Springs." [available at the Denver Public Library]

Rasmussen, Louise. "Art and Artists of Oregon, 1500-1900." [available at Oregon State Library, Salem]

Richard, O. H. Address honoring Evelyn Corthell Hill. [available at University of Wyoming Library, Laramie]

Acknowledgments

To M. Milton Seick of Palo Alto, California, who urged me to write this book, and whose discerning eye found the frontispiece painting; to Paul F. Huldermann of Scottsdale, Arizona, who read parts of the first draft and made suggestions based on years of experience as journalist and editor in other lands before coming to this country; to my husband David R. Dawdy and my daughter Barbara Dahl who share my interest in Western art and history; to my friends who loaned me articles and books; and to staff members, too numerous to mention by name, of libraries, museums, historical societies, and commercial galleries, I say thank you each and all. Without your interest, kindness, assistance, and support, this book would not have been written.

D.O.D.